JASPER JOHNS

JASPER JOHNS

By Michael Crichton

A REVISED AND EXPANDED EDITION

THAMES AND HUDSON

Editor: Beverly Fazio
Designers: Patrick Cunningham and Dirk Luykx
Picture Editor: David Whitney

The first edition of this book was published in 1977 in conjunction with
an exhibition organised for the Whitney Museum of American Art, New York,
by David Whitney, assisted by David White.

First published in the United States of America in 1977
by Harry N. Abrams, Incorporated, New York
First published in Great Britain in 1977
by Thames and Hudson Ltd, London
This revised and expanded edition 1994

British Library Cataloguing-in-Publication Data

A catalogue record for this book is available from the British Library

ISBN 0–500–09240–0

Printed and bound in Japan

Contents

Preface to the First Edition 6

Preface to the Revised Edition 7

JASPER JOHNS by Michael Crichton

1. Impressions of THE ARTIST 11
Notes 25

2. A Brief History of THE WORK 27
Notes 76

3. The Function of THE OBSERVER 81
Notes 101

Plates 103

Selected Bibliography 289

Index of Illustrated Works by Jasper Johns 292

Photograph Credits 296

Preface to the First Edition

"There is a deep question," writes psychologist Jerome Bruner, "whether the possible meanings that emerge from an effort to explain the experience of art may not mask the real meanings of a work of art."

That's one problem.

"Whatever you say about something," notes semanticist Alfred Korzybski, "it is not."

That's another problem.

The explanation of a joke is never funny.

That's a third problem.

This book attempts to thread a path through the logical minefield bordered by these concepts. It is an outsider's attempt, but I am indebted to many people in the art world. One measure of Johns' excellence is the quality of the critical writing about him; I have drawn heavily on the work of three scholars in particular—Leo Steinberg, Max Kozloff, and Barbara Rose. Leo Castelli, Tatyana Grosman, and Ken Tyler talked with me at length about Johns. Robert Motherwell introduced me to the work of Anton Ehrenzweig. In preparing the manuscript I was assisted by the comments and suggestions of Mark Lancaster, David Whitney, Bob Gottlieb, Margo Leavin, Kurt Villadsen, Sally Welch Conner, and Arnold Mandell. Finally, Jasper Johns submitted cheerfully to many interviews over a period of eight months in 1976. All these people have my profound thanks. Whatever errors and misconceptions remain in the text are mine.

<div align="right">

M.C.
Los Angeles
January 1977

</div>

Preface to the Revised Edition

The previous edition of this book reviewed Johns' work from 1954 to 1976. This volume includes work done in the sixteen years since then. I have also revised passages of the earlier text: shifting text, correcting errors, eliminating redundancies and digressions, and generally tightening the focus.

My intention here remains the same as in the previous edition: to provide a brief discussion of Johns' work, and the critical response to it. The new text relies on the writing of several Johns scholars in recent years, particularly Richard Francis, Nan Rosenthal, Ruth E. Fine, and Mark Rosenthal. And, as before, I am indebted to Jasper Johns for several interviews in late 1991 and early 1992.

M.C.
Los Angeles
September 1992

"We see, not change of aspect, but change of interpretation."
—Ludwig Wittgenstein

"I am just trying to find a way to make pictures."
—Jasper Johns

1.

Impressions of
THE ARTIST

I AM WAITING for an answer. Jasper Johns sits in an Eames chair in the room beneath his studio at Stony Point, New York, in 1976. The walls are whitewashed and bare. He is a big, solid-looking man wearing faded jeans, a turtleneck sweater, and heavy boots. He stares out at the spring woods. His back is to the sunlight.

"I think you can be more than one person," he says finally. "I think *I* am more than one person. Unfortunately." And then he laughs.

Robert Hughes wrote: "Jasper Johns' face . . . resembles that of William S. Hart, the silent gunslinger of the silent Westerns. The narrow, crinkled eyes stare flatly, with an expression of ironic watchfulness, across the V of a gun-sight or the end of a paintbrush at—in either case—a target. It is the mask of cool, of a dandy who shuts up *and* puts up. What goes on behind that mask has provoked reams of critical speculation. . . . "[1]

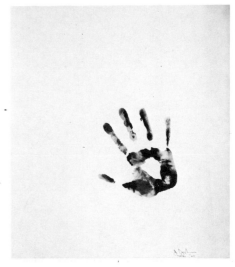

HANDPRINT. 1964. Oil on paper, 53.2 x 43.8 cm (20⁵/₁₆ x 17¼"). Collection the artist

An interviewer wrote: "Johns is a highly intelligent, nervous and totally attentive personality. He speaks with great lucidity in King James version rhythms. . . . Questions are met by long silences, then answered with a precision that is partly legalistic, partly reminiscent of a dialogue with G. E. Moore. . . . He has a remoteness that, while very amiable, makes all questions sound vaguely coarse and irrelevant. . . . It is hard . . . to reconcile Johns' aura of sociability with the other impression of almost priestly apartness."[2]

A conversation with Jasper Johns has a quality difficult to describe, but so distinctive that people in the art world refer to "a Johnsian conversation." I will never forget my first.

In 1973, Johns made a series of lithographs at Gemini G.E.L. workshop in Los Angeles, based on his 1964 painting ACCORDING TO WHAT. Johns had begun work by visiting the painting again; he had had it photographed for reference, and he had taken some measurements. In this way, he could use the same proportions for the prints. This seemed to me a slavish process, but Johns explained that by using his previous decisions, he was free to concentrate on other things as he made the prints. I watched carefully to see if I could determine what the "other things" were.

His method of working was not slow, but it was deliberate and punctuated by periods of staring. In fact, he seemed to welcome the hectic atmosphere of the print shop, where he was often interrupted by printers asking questions, or needing a decision. Because his method had this stop-and-go quality, I thought it might be accessible to outside analysis, since I could view his work as a sequence of before-and-after steps.

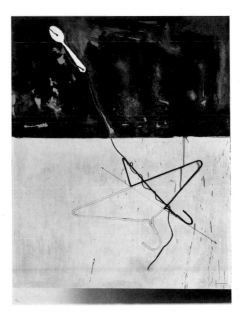

FRAGMENT—ACCORDING TO WHAT—COAT HANGER AND SPOON. 1971. Lithograph, 86.4 x 62.3 cm (34 x 25¼"). Published by Gemini G.E.L.

Working on one print, he drew a spoon and a wire. He worked on the handle of the spoon for some time. After one of his judicious pauses, he changed the handle considerably. I could see the change but I could not understand what had provoked it.

"Why did you make that change?"

"Because I did." His tone implied great reasonableness, as if that were the only possible answer.

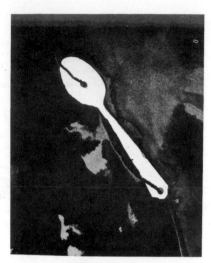

I persisted: "But what did you *see*?"

"I saw that it should be changed."

Since I wasn't getting anywhere, I tried another approach. "Well, if you changed it, what was wrong with it before?"

"Nothing. I tend to think one thing is as good as another."

"Then why change it?"

By now, he was getting exasperated with me. He sighed. There was a long pause. "Well," he said finally, "I may change it again."

"Why?"

"Well, I won't know until I do it."

The art critic Leo Steinberg has recorded another conversation: "I asked [Johns] about the type of numbers and letters he uses—coarse, standardized, unartistic—the type you associate with packing cases and grocery signs.

Q: You nearly always use this same type. Any particular reason?

A: That's how the stencils come.

Q: But if you preferred another typeface, would you think it improper to cut your own stencils?

A: Of course not.

Q: Then you really do like these best?

A: Yes.

This answer is so self-evident that I wonder why I asked the question at all; ah, yes—because Johns would not see the obvious distinction between free choice and external necessity. Let me try again:

Q: Do you use these letter types because you like them or because that's how the stencils come?

A: But that's what I like about them, that they come that way."[3]

A Johnsian conversation may seem frustrating, but the artist is not being difficult. Quite the contrary: he struggles to find the plainest way of talking about a situation. His friend, the composer John Cage, recalled sitting on the porch at Johns' house in South Carolina, with "records filling the air with Rock-n-Roll. I said I couldn't understand what the singer was saying. Johns (laughing): That's because you don't listen."[4]

"He has the most literal mind of anyone I have ever met," said a critic at a dinner, in the 1970s. Johns sat at the head of the table, not listening. In those days Johns wore a full beard, giving him an elegant, ducal appearance. It was difficult to avoid the feeling that night that Johns was holding court, and the critic had been banished to the far end of the table, excluded, and pretending not to care.

"I think that literalness shows in his work," the critic continued, more loudly. "He is a very puzzling man. He always takes you exactly at your word."

"How else should I take you?" Johns said, looking down the table.

"Oh, you know what I mean, Jasper."

"No," Johns said seriously, "I don't."

"There," the critic said, triumphant, turning to the table. "You see what I mean?"

"Whether or not you see what he means—and all that *that* means—is a central issue in Jasper's work," says a dealer. "Of course it reflects his personality. Jasper in person is very much like one of Jasper's paintings."

One night after dinner he offered to teach me to play backgammon. "I am a very good teacher," he said, "because I always lose."

"His work is a constant negation of impulses," said a critic who has known him a long time. "Wouldn't you say so, Jasper?"

"No," Johns said, and laughed.

"You should see how he works," said a friend. "I've seen it happen time and again. He'll make something that's just *beautiful*, it's so beautiful it makes your eyes water. But he puts it aside. Too pretty. Too easy. Too sensuous, too seductive. He isn't satisfied with that."

"Jasper is very elusive," said a critic. "But he wants to be found out."

"Have you found him out?"

"I don't think anybody has found him out," the critic said.

An old acquaintance of Johns', who had known him during his early days in New York in the fifties, called him up. The two had not seen each other in many years. Johns invited the man to dinner.

"We hardly said two words," the friend said afterward. "We had a nice dinner—he is a very good cook—and then we played backgammon all night until I went home. After all these years, we just played backgammon."

"It's difficult for him to talk," says a woman who has known him a long time. "But of course, that's why he is a painter. His *sensitivity* is what is so amazing. He is the most sensitive person I have ever met."

I am sitting with him in his living room in Stony Point. He is in the chair; I am sitting on a couch. Between us is an opened book of his paintings; he has brought it out to make some point about the early targets.

The conversation has moved on to other things. As I frame my next question, I stare out at the green woods. My eye passes over the opened book, noticing the images, and I have a fleeting sense of distraction. It is so quick I am hardly aware of it: it is something about the green woods and the red targets, the immediacy of nature and the small artificial reproductions. Almost subliminally I think, *I wish the book were closed.*

As I ask my next question, Johns reaches over and closes the book.

GRAY ALPHABETS. 1968. Lithograph, 152.4 x
106.7 cm (60 x 42"). Published by Gemini G.E.L.

He came to California for a week and the weather was bad. A friend drove him to the airport and apologized for the gray and gloomy weather. "That's all right," he said. "Gray is my favorite color."

His memory is remarkably specific. David Hockney was in Paris once when Johns was there. "I asked him how he was liking Paris and he said that he wasn't. Hmm. Oh well, all right. I didn't see him again for months after that; he went back to the States, and I went to the South. Then I saw him in a restaurant. I asked him how he found Paris. He stared off into space the way he does, and then he slowly turned and looked at me, that slow way his head turns. He said, 'You never give up, do you, David.'"

Moving through a friend's garden, he is suddenly animated, alert. His usual deliberateness is gone; his entire behavior changes. He bends over, moving from plant to plant, touching, looking. He knows a great deal about growing things. He speaks quickly, gives advice about what to do, no pauses, no hesitation; he takes everything in at once. He seems to be at ease in the natural world, in a way he is not in an urban environment.

 "You must remember that Jasper is really a Southern gentleman," said a dealer. "He has the most extraordinary, graceful manners. It's natural to him. You can see it around people he doesn't know, people he has no reason to pay attention to. He is very gentle, and very kind."

"He can be incredibly cruel. He can make you feel like *nothing*."
 "In what way?"
 "It's impossible to describe, it's so subtle."

"His method is to be oblique," says another woman. "He never comes right out and tells you. He *shows* you. He makes you see it for yourself. It's almost as if it's too painful for him to be direct."

He is direct about his work. Once, at a dinner, a wealthy collector who owned several important Johns paintings announced that he had an idea for a print that Johns should do. He said that Johns should make a print, in color, of an American map. The collector argued his case knowledgeably. He pointed out that Johns had done other prints in color based on paintings from that period; he alluded to the significance of such a print to the whole body of Johns' work; he mentioned the opportunities for the sort of image transformation which Johns' other color prints had explored; and he pointed out the peculiar arbitrariness that had led Johns to make map prints several times in black-and-white, but never in color. A hush fell over the table. There was a good deal of tension. On the one hand, one doesn't tell an artist what to do, but on the other hand, the suggestion was not uninformed, and it did not come from a source the artist could casually alienate.

 Johns listened patiently. "Well," he said finally, "that's all very well, but I'm not going to do it."

 "Why not?" asked the collector, a little offended.

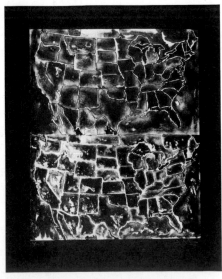

TWO MAPS II. 1966. Lithograph, 84.4 x 66 cm
(33¼ x 26"). Published by ULAE

"Because I'm not," Johns said.

And he never has.

Driving in the car one day, he said, "I think artists are the elite of the servant class."

"He likes to play games," says an acquaintance. "He plays games all the time. He plays backgammon, he plays Monopoly, and he plays games in real life, too."

"What is remarkable about him is the way he never plays games," says another painter. "I know he agonizes over decisions in painting, sometimes. But he makes up his mind and sticks to it. I admire that. He has a kind of acceptance that is extraordinary."

"Jasper plays with things," said Tatyana Grosman, at whose workshop, Universal Limited Art Editions, he has made nearly a hundred prints. "He likes to see the choices. He plays, but he doesn't *try*. Jasper never tries. He does it. Nothing is half-spoken in his work. You only live once, there is no trying. You do it."

Of his working methods, he says, "I never developed good habits. I don't have discipline." He does not work every day, or at any particular hour. On the other hand, his methods are rigorous in a certain way. He works on only one painting at a time, he says, because he cannot know what to do next until the last painting is finished, and he has learned whatever he needs to learn from the experience.

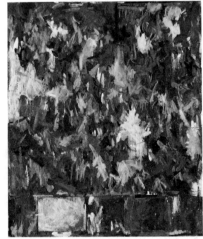

His friend John Cage once wrote: "If it comes to his notice that someone else had one of his ideas before he did, he makes a mental or actual note not to proceed with his plan. (On the other hand, the casual remark of a friend can serve to change a painting essentially.)"[5]

In 1959 Johns was working on the painting HIGHWAY, which contained the word of the title. Cage walked in and said, "You've put it right in the middle." Johns immediately painted out the letters, although they can still be discerned by the careful observer.

HIGHWAY. 1959. See Plate 66

"I've never watched you paint."

"Neither have I," he said, and laughed.

Cage wrote this description of Johns at work, in the 1960s: "He had found a printed map of the United States that represented only the boundaries between them. . . . Over this he had ruled a geometry which he copied enlarged on a canvas. This done, freehand he copied the printed map, carefully preserving its proportions. Then with a change of tempo he began painting quickly, all at once as it were, here and there with the same brush, changing brushes and colors, and working everywhere at the same time rather than starting at one point, finishing it and going on to another. It seemed that he was going over the whole canvas accomplishing nothing, and, having done that, going over it again, and

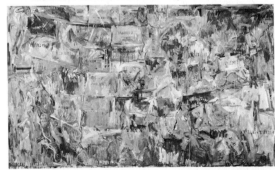

MAP. 1961. See Plate 74

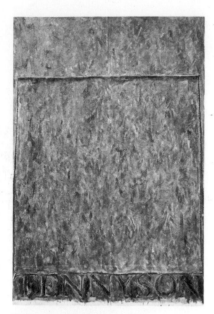

TENNYSON. 1958. See Plate 48

again incompletely. And so on and on. Every now and then using stencils he put in the name of a state or the abbreviation for it, but having done this represented in no sense an achievement, for as he continued working he often had to do again what he had already done. . . . I asked how many processes he was involved in. He concentrated to reply and speaking sincerely said: It is all one process."[6]

Some years ago, Johns visited his painting TENNYSON. He offered to buy it back from the owners, who did not want to sell. A woman was amazed by his attitude. She said, "Well, if you want it so much, why don't you just make yourself one?" Johns could not explain why this was impossible. To do something again is to do it differently.

"How do you work on a painting?"
 "Well, I begin at the beginning, and go on from there."

Once I drove him from his house at Stony Point into New York City. We were going to some destination I did not know. I asked him how to get there. "Well, I'm not sure, I'll know when I see it, as we go."
 We drove for a while longer, crossing the George Washington Bridge. I asked again. "Well, I don't know. Turn right here, and we'll figure out the rest later."
 I became frustrated. I like to know where I am going, I like to plan ahead. He stays firmly in the present: we are going down this street now, and when we get to the end, we will decide which way to turn, and having decided that, we will wait until it is time to make another decision.
 We chatted about his family; he was relaxed, I was going crazy. But we finally arrived. We began at the beginning and went on from there.

"I can't play chess," he once said. "I don't have the right kind of head for it. I can't think of all those possibilities in advance."

Tatyana Grosman: "Once I visited Jasper in his studio. I talked about some work we had scheduled for the future. Jasper was vague and he kept looking out the window. Then I said, 'Oh, and I have these proofs for you to see.' Right away he is paying attention, very interested, no more looking out the window. So I said to him, 'Jasper, when I show you something, you are interested, but when I talk about the future you are bored.' He said yes. He said when he was young he had so many desires and wishes, that he trained himself to think only of the present, and not of his wishes for the future."

"I always wanted to sell a painting for a million dollars," he said in the 1970s, after turning down an offer. There is that side to him: the man who at one time lived in a bank, converted into a studio,[7] and kept his paintings in the vault. He is an astute collector of his own work. The finest collection of Jasper Johns is owned by Jasper Johns. "I think that's to be expected," he said.

One museum curator reported a dream in which Jasper Johns spoke with quotation marks around every comment, "as if he was directing his remarks to art history, the way everything he says always is."

The art world is full of double binds. If Johns becomes popular and paints as many canvases as he can sell, he is accused of pandering to popular taste, an early criticism of his work.[8] On the other hand, if he declines to meet the demand for his work, he is manipulating the art world to raise his own prices. For Johns, with his fine sense of irony, there must be great irony here.

In 1980, the Whitney Museum of American Art purchased THREE FLAGS for one million dollars. It was at the time the highest price ever paid for a work by a living artist. In November 1986, OUT THE WINDOW was sold at Sotheby's for 3.6 million dollars, the highest price ever paid at auction for the work of a living artist. In May 1988, DIVER sold for 4.2 million dollars, once again the record for a living artist. In November 1988, WHITE FLAG sold for more than 7 million dollars, and FALSE START sold for more than 17 million dollars.

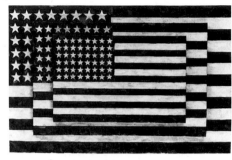

THREE FLAGS. 1958. See Plate 40

A television interviewer asked him how he felt to be the most highly valued living artist, to have his paintings command such high prices.

Johns gave a very personal reply. He said that when he was younger, the art world was small, and he knew everyone who was interested in his work, and who collected his paintings. These people were his friends; he saw them socially, knew their children, and so on. But now the art world was much larger, and his paintings were sold at auctions around the world, often to people he did not know. As a result, he said, his experience now was very different, less intimate and personal. Johns spoke with calm detachment, but the underlying sense of loss was unmistakable.

DIVER. 1962. See Plate 106

The interviewer, wanting some expression of pleasure at being a rousing American success, did not include this reply in the final broadcast.

Almost universally acclaimed the greatest living American artist, Johns still hesitates to speak of his childhood, his upbringing. It seems irrelevant to him, and in a sense we must accept this from an artist who for so many years explicitly claimed to be impersonal in his work. "I have attempted to develop my thinking in such a way that the work I've done is not me—not to confuse my feelings with what I produced. I didn't want my work to be an exposure of my feelings."[9]

Tatyana Grosman: "I knew him so well through his work it never occurred to me to think about his background, where he came from. It was just his work, and what he represented in working. . . . Sometimes he would stop at the workshop on his way to someplace else, and sometimes he would stop on his way home. I lost track of when he was going, and when he was coming. It was just Jasper. There. Now."

He was born in Augusta, Georgia, on May 15, 1930. His parents separated after

he was born. John Cage: "His earliest memories concern living with his grand-parents in Allendale, South Carolina. Later, in the same town, he lived with an aunt and uncle who had twins, a brother and sister. Then he went back to live with his grandparents. After the third grade in school he went to Columbia, which seemed like a big city, to live with his mother and stepfather. A year later, school finished, he went to a community on a lake called The Corner to stay with his Aunt Gladys. . . . He stayed there for six years studying with his aunt who taught all the grades in one room, a school called Climax. The following year he finished high school living in Sumter with his mother and stepfather, two half-sisters and his half-brother. He went to college for a year and a half in Columbia where he lived alone. He made two visits during that period, one to his father, one to his mother. Leaving college he came to New York. . . . "[10]

As a young child living in his grandfather's house, he remembers being dressed in the kitchen, by the cook, in a new white linen suit. He didn't want to wear it, and threw off the suit, which landed in a skillet of hot grease on the stove. His grandfather came in and began throwing him in the air, catching him, and spanking him as he fell. He was terrified.

He lived with his grandfather, but his father lived in the same town and Johns saw him intermittently. Once his father promised him his watch when he was grown up. Soon after, Johns decided that he was grown up; he went to his father's house and took the watch. His father came and took it back. "I guess I wasn't grown up, after all."

For as long as he can remember, he has wanted to be an artist. His grandmother had been an artist. He grew up with the idea that an artist was socially useful, as well as "a good, exciting person."

A frequently cited passage from his notebooks reads:

> *Take an object*
> *Do something to it*
> *Do something else to it*
> *" " " " "*

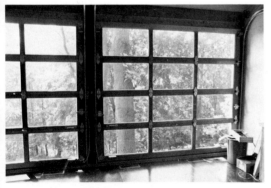
Interior of Jasper Johns' house, Stony Point, New York

His house in Stony Point is a rebuilt farmhouse—it had been moved in pieces to its present location—which Johns later changed in various ways. One change is particularly striking.

In both his upstairs studio and the room beneath it, he has used garage doors for walls. The garage doors are of the multi-hinged variety that slide on over-head tracks. When the doors are closed, they form the walls of his house. When he opens them, they slide up toward the ceiling, and thus open the house to the breezes of the woods.

Johns has left the doors with all their galvanized handles, the manufacturer's plates, intact. He has also left the curving overhead tracks exposed. Thus the doors are both walls and doors, at the same time.

Yet the doors serve a transformed function, and they are literally changed; they have glass panels instead of wood, and this means they were specially constructed. (He thinks; he isn't sure.)

When asked how he came to have garage doors for walls, he is characteristically diffident. A friend suggested it, and an architect carried out the design.

"Jasper is much too intelligent to think that a piece of art means what he says it means," observed curator Nan Rosenthal. "Nor does he believe in telling you what it means because for him, meaning is always in a state of flux."[11]

"I'll tell you a secret," he once said. "I don't know anything about art."

A critic who watched him paint said, "I think when he is working, Jasper is totally concentrated on those surfaces. He lives in those surfaces. The surfaces are his whole world, they are everything. He loses himself in them. They are everything."

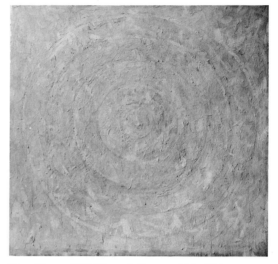

WHITE TARGET. 1957. Wax and oil canvas, 76.2 x 76.2 cm (30 x 30"). Collection Whitney Museum of American Art, New York. Purchase 71.211

Finally, after many years, I briefly saw him paint. I had gone to Johns' house in New York to have dinner with him. Sarah Taggart, his assistant, showed me into the living room. "Jasper will be with you in a minute," she said. And she added, "He's painting." And then she left the room.

Johns' townhouse in New York has a central courtyard. From the living room, it is possible to look across the courtyard into the studio. Through the studio windows, I saw him at work. Johns held a small brush, and was in constant movement, working rapidly—darting forward, stepping back, darting forward again to make a mark with the outstretched brush. His movements were fluid and quick. I had the impression of athleticism: a dance, or a fencing match.

After a moment, I turned away.

I felt as if I were prying.

In the 1980s, a filmmaker called to say he was making a documentary about Johns, and he wanted to ask me some questions. I said, "Does Jasper know about this?"

The filmmaker began to laugh. "Every person I've called, that's the first thing they say: 'Does Jasper know about this?' What *is* it about him? Why is everyone so protective of him?"

"Jasper is too isolated," said a critic recently. "It shows in his work. It's become too hermetic, too self-referential."

"Hasn't his work always been hermetic and self-referential?"

"Yes, but now it's too much."

In 1985, Johns finished building a house on the Caribbean island of St. Martin, where he had gone to work for more than a decade. "I saw Jasper in St. Martin," said a gallery owner. "In his new house. He had several very *glamorous* paintings on the walls. Have you been down there?"

I said I hadn't.

"He holds court there," the owner said. "People from all over the world come to see him. It's quite something to see."

"Johns is by no means a loner," observed Deborah Solomon in 1988. "Evenings when he's not home watching television ('Mostly I just switch the channels') or indulging his omnivorous taste for literature (he reads everything from Wittgenstein to dime-store mysteries) he can often be found at dinner parties. He is said to be an excellent cook who enjoys entertaining at his Manhattan town house and at his island retreat on St. Martin. 'He's very sociable,' says Leo Castelli, his art dealer. 'You can't imagine how many people he knows.' "[12]

A wealthy executive rented a yacht for Christmas and cruised the Caribbean. "You'll never guess who I had New Year's dinner with," he said. "A bunch of people, including your friend Jasper Johns. I thought he was supposed to be so difficult to talk to. He's really very gregarious and charming."

In the 1980s I asked him to speak at a conference. I had never made a personal request of this sort. He said he would consider it.

A few days later, he called back to say he hoped it would not cause too much difficulty, but he had decided not to speak at the conference. I was disappointed and angry. "Why not?" I said.

"Because I'm not going to," he said.

John Cage observed: "He never hesitates to answer the phone."

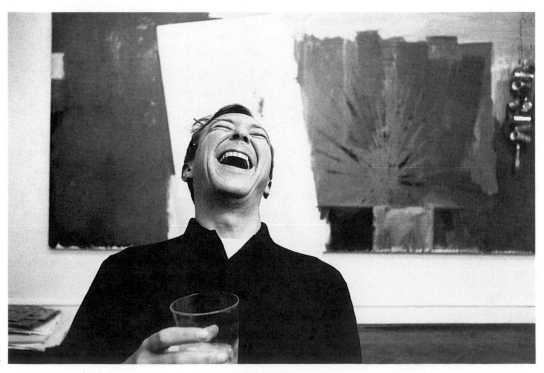

Jasper Johns at Riverside Drive, 1964. Photograph by Ugo Mulas

A documentary filmmaker called in despair. He had conducted an hour-long interview with Johns and it was a disaster.

"What happened?"

"When I asked him a question, he gave very literal answers."

"Yes, he does that."

"And sometimes, he'd pause for five or ten seconds in the middle of his answer, before he finished."

"Yes. . . . "

"Well, I can't use it," the filmmaker said. "'This is *film*. I can't wait through those pauses. On film, they go on *forever*."

The filmmaker said he would send me the film to look at, so that I could advise him. "I must be doing something wrong. I think he hates me."

The film arrived a few days later. As the filmmaker had described, it would be difficult to use. But what was recorded was remarkable.

On film, Johns behaved exactly as he always did, answering questions thoughtfully and deliberately. Confronted with a television camera, he did not speak more rapidly, or become more animated. In an era where everyone exposed to the media is expected to create a lively persona for themselves, Johns did nothing of the sort. He remained exactly the same. Jasper Johns on film was exactly like Jasper Johns in person.

This integrity was so rare, and so unexpected, it took me a while to recognize what I was looking at. By not giving in to the accelerated pace of filmic time, Johns had highlighted the artifice of ordinary media portrayals. He had also shown himself as he really was.

I called the filmmaker back to explain what I had seen, and why it was so remarkable. I suggested he run it, pauses and all.

"I can't," the filmmaker said, "and I don't understand why he won't just give short answers for the camera, like everybody else."

"Jasper doesn't pose," said Hans Namuth, a photographer who knew him since the early days.[13]

"Now that Jasper has turned sixty," a critic said, "the only things that interest him are the things that assure his prestige, and his place in art history. That's what all these artists want, you know: immortality. At a certain level, at a certain point in life, that becomes the game."

I learned that a prestigious university had offered him an honorary degree, and he had declined. "Why did you turn it down?"

"I turn them all down," he said. "Because if you accept, you have to go and get them. You have to sit up there all day and listen to people giving speeches. I would rather do something else."[14]

"His new work is so much more personal now," said a friend. "It's very hard for him. I think it costs him to work in this way."

"When you are young," he said recently, "the world seems open in a certain way. Anything is possible in work. You do not have all the unavoidable associations to your past work. Later, these can become quite burdensome. But I don't know there is anything one can do about it." He paused. "At least, nothing that I can think of."

Walking down a street in New York with him, I said, "Years ago, you said that while you are working, your principal feeling was boredom."

"Yes," he said, nodding. "To which I would now add, boredom *and anxiety*."

And then he laughed.

"There are evidently more persons in him than one,"[15] wrote John Cage. And the contrasts are striking—the reclusive logician who can be charming and outgoing; the self-conscious artist who proceeds by intuition; the intellectual who will not explain himself in intellectual terms; the man who has been called both generous and perverse, oblique and literal; the creator of enigmatic work based upon mundane imagery; the ascetic who is a marvelous cook; the man who says that most of his life is haphazard and accidental, but who allows no accidents in his pictures; the artist who undoubtedly strives to convey doubt.

These contrasts are not only striking. In many ways, they are what his work is about.

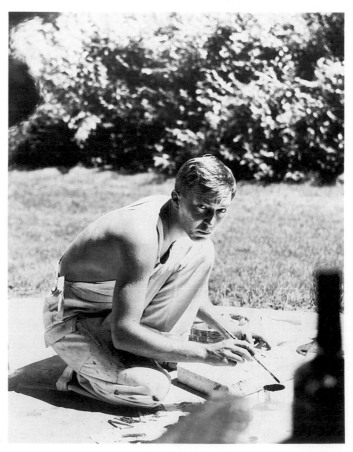

Johns at ULAE, 1962. Photograph by Hans Namuth

NOTES

1. Robert Hughes, "Jasper Johns' Elusive Bull's-Eye," *Horizon*, 14, Summer 1972, p. 21.

2. Vivian Raynor, "Conversation with Jasper Johns," *Art News*, 72, March 1973, pp. 20–22.

3. Leo Steinberg, "Jasper Johns: The First Seven Years of His Art" (1962), *Other Criteria: Confrontations with Twentieth-Century Art*, Oxford University Press, New York, 1972, p. 32.

4. John Cage, "Jasper Johns: Stories and Ideas," in *Jasper Johns*, exhibition catalog, The Jewish Museum, New York, 1964, p. 21.

5. *Idem.*

6. *Ibid.*, p. 32.

7. The actual location was a former New York Provident Loan Society building.

8. Hilton Kramer: "Johns, like Rauschenberg, aims to please and confirm the decadent periphery of bourgeois taste." ("Month in Review," *Arts*, 33, Feb. 1959, p. 49.)

9. Raynor, *op. cit.*, p. 22.

10. Cage, *op. cit.*, p. 23.

11. Kristine McKenna, "Drawing the Lines," *Harper's Bazaar*, April 1990, p. 222.

12. Deborah Solomon, "The Unflagging Artistry of Jasper Johns," *New York Times Magazine*, June 19, 1988, p. 66.

13. Hans Namuth, "Artists' Portraits," *Art International*, 5, Spring 1989, p. 48.

14. There is one exception. In 1969 he accepted an Honorary Degree of Doctor of Humane Letters from the University of South Carolina, which he says he did out of respect for his first college teacher.

15. Cage, *op. cit.*, p. 22.

2.

A Brief History of
THE WORK

ONE DAY IN 1954, Jasper Johns, then 24 years old, methodically destroyed all the work in his possession. This was the first of several acts of self-destruction by an artist who would eventually be known for his skill and daring at rebuilding his past.

The four pieces that survive were in the hands of others, and provide our earliest clues to his formative interests. UNTITLED (c. 1953) is a small square oil and collage on silk, an array of green rectangular strips in a grid-like pattern.[1] CONSTRUCTION WITH TOY PIANO (1954) is a collage incorporating a toy piano, its keys at the top of the composition. The keys are numbered; when pressed, they make sounds.[2] A third, UNTITLED (c. 1954), is a collage of printed matter in a box, with a cast woman's face at the bottom.[3] STAR (1954) is a Jewish star made of a variety of materials—canvas, wood, glass, and encaustic.[4]

Reviewing these early efforts, critic Max Kozloff observed: "What can be deduced about the creator of these virtual cabinet pieces is a predilection for compartmental divisions, stained surfaces, and nostalgic references. . . . He creates memento boxes." And while Kozloff notes that the appearance of the numbers, the incorporation of the cast face, and the ambivalent attitude toward the surface "presage the artist to come," he concludes that "these are fragmented, rather precious objects," and compares them unfavorably to the work of Joseph Cornell.[5]

The creator of this work was a shy young man from South Carolina, one year out of the army, who had come to New York to continue college. But after the first day—a lecture on *Beowulf*, a French lesson, and a drawing class—he quit. He got a job in a bookstore and painted sporadically. His life seems to have been uncertain, tentative, unfocused. There was a sense of waiting.

Then came the day when he tore everything up. It coincided with what he has called a spiritual change: "Before, whenever anybody asked me what I did, I said I was going to become an artist. Finally I decided that I could be going to become an artist forever, all my life. I decided to stop *becoming* and to *be* an artist."

The change was profound, and it implied not only a commitment to work, but also a method. "I decided to do only what I meant to do, and not what other people did. When I could observe what others did, I tried to remove that from my work. My work became a constant negation of impulses."

His attitude recalls the views of another Southerner, Edgar Allan Poe: "The fact is, that originality . . . demands in its attainment less of invention than negation."[6] But Johns has never shown much interest in novelty per se, and by his own account, his "negation of impulses" was not so much a search for originality as it was a young man's quest for self-identity in work. "I had a wish to determine what I was. I had the feeling that I could do anything. . . . But I wanted to find out what I did that other people didn't, what I was that other people weren't. It was not a matter of joining a group effort, but of isolating myself from any group. . . . I wanted to know what was helpless in my behavior—how I would behave out of necessity."

At this time, Johns had little money and few friends; he knew few artists, and

UNTITLED. c. 1954. Oil and collage on silk, 22.5 x 22.5 cm (8⅞ x 8⅞").
Menil Collection, Houston

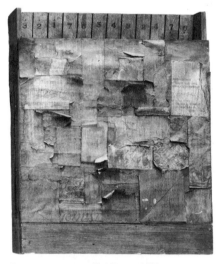

CONSTRUCTION WITH TOY PIANO. 1954. Graphite and collage with objects, 27.9 x 22.9 cm (11 x 9"). Oeffentliche Kunstsammlung, Kunstmuseum Basel

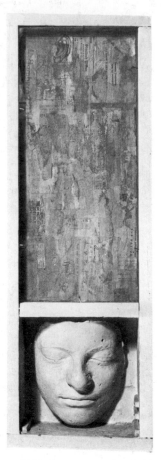

UNTITLED. c. 1954. Construction, oil and collage with plaster casts, 66.6 x 22.2 cm (26¼ x 8¾"). Hirshhorn Museum and Sculpture Garden, Smithsonian Institution, Washington, D.C.

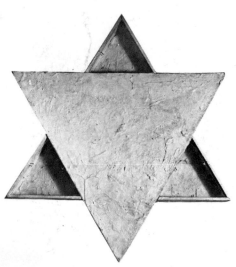

STAR. c. 1954. Encaustic on canvas with glass and wood, 57.5 x 50.2 cm (22⅝ x 19¾"). Menil Collection, Houston

he had seen very little art of any sort. He was a provincial artist from South Carolina, working alone in New York City, following his inner impulses with the only tools he had—a ruthless logical sense, and a remarkable technical virtuosity.

He was experimental, willing to try anything ("I did everything I could think to do"), but two technical interests were to prove particularly significant in later work. One was the use of encaustic—a difficult, seldom-employed technique in which pigment or collage elements are mixed with hot wax and applied to a surface. Johns has always been attracted to the most demanding technical challenges, and several commentators have observed that the difficulty of encaustic must have appealed to him. But he remembers that he began to use wax simply to solve a problem:

"I wanted to show what had gone before in a picture, and what was done after. But if you put on a heavy brushstroke in paint, and then add another stroke, the second stroke smears the first, unless the paint is dry. And paint takes too long to dry. I didn't know what to do. Then someone suggested wax. It worked very well; as soon as the wax was cool I could put on another stroke and it would not alter the first."

A second interest was plaster casting. Johns made casts of heads and body parts of himself, and of friends, in part because of an exuberant fascination with the process itself. He would continue to incorporate casts in his paintings over the next forty years.

In 1954, Johns had a dream in which he saw himself painting a large American flag. Soon after, he did his first one, in encaustic. He recalls thinking: "It was something I could do that would be mine." Paradoxically, in that impersonal image, the young artist found his self-identity.

Painting a flag triggered many related ideas. "Using the design of the American flag took care of a great deal for me because I didn't have to design it. So I went on to similar things like the targets—things the mind already knows. That gave me room to work on other levels."[7]

This sense of "other levels" is critical to Jasper Johns' method of operation. If he does not create an image, but uses ready-made designs, images, and lettering, what does his work consist of?

We have a clue in a further elaboration: he considers the flags and targets similar because "they're both things which are seen and not looked at, not examined, and they both have clearly defined areas which could be measured and transferred to canvas."[8]

There are two ideas here: first, the notion of an image which is seen and not seen, because of its familiarity. And second, the idea of an image which can be precisely measured and put onto canvas—an object identified by its fixed proportions. An accurately reproduced flag is familiar, and therefore "not looked at." But by painting the image in encaustic, with its heavily worked, encrusted surface, Johns' flag image becomes familiar and unfamiliar at the same time, and therefore draws our notice.

It also provokes more abstract considerations. One concerns the idea of painting a flag. In the 1950s that act seemed to many observers an absurdity: an

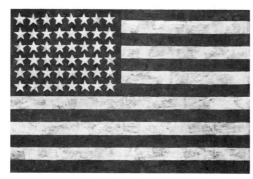

FLAG. 1955. See Plate 1

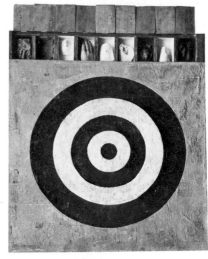

TARGET WITH PLASTER CASTS. 1955. See Plate 7

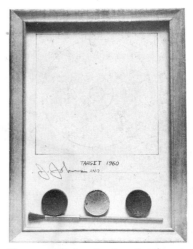

TARGET. 1960. Pencil on board with brush and watercolor disks, 17.1 x 11.8 cm (6¾ x 4⅝"). Private collection

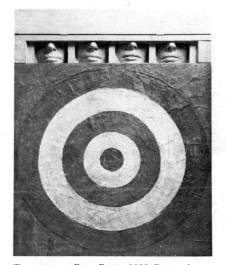

TARGET WITH FOUR FACES. 1955. Encaustic and collage on canvas with objects, 75.5 x 66 cm (29¾ x 26").
The Museum of Modern Art, New York.
Gift of Mr. and Mrs. Robert C. Scull

American flag might be many things, but it was certainly not art. Yet Johns presented a carefully worked, elegantly executed painting. Such a painting was surely art—or was it? That became a problem for the viewer, alone. Johns is gone; he has already made the painting, he has already presented the problem. The viewer is left to resolve it as best he can.

Johns' targets explored ideas suggested by the early flags, but more abstractly. An American flag is always the same, while a target can be any number of things —all that unites targets is a common format of concentric circles. A flag is bound to one nation; a target is universal. The colors of the flag are fixed; in the target, they need only be contrasting.[9]

The target also focuses attention on the theme of viewing. The contrasting circles of the target are meant to aid distant vision; the target is something to see clearly, to aim at. This makes the target a true visual display—it has no other purpose, no other reason for existence. (Blind archers shoot at a "target" of sound.)

But even in his first target painting, Johns went beyond any simple treatment of targets as a symbol. TARGET WITH PLASTER CASTS (1955) joins a collage bull's-eye with plaster casts of body parts, set behind hinged doors. Johns was aware of echoing the composition of the earlier CONSTRUCTION WITH TOY PIANO, in which the rectangular keys appear at the top of the image; he originally intended the hinged doors to be keys, attached to wires that ran behind the canvas. When the observer pressed one of the trap-door "keys," a sound would issue from the canvas target. But Johns abandoned this idea when he couldn't think of a suitable hidden mechanism for making sound. So he substituted the casts of body parts, painted in different colors. The row of colored rectangles reminded him, he says, of watercolor sets with their dishes of paint—an association made explicitly in the later TARGET (1960), which includes paints and a brush beneath the concentric circles.

In the smaller TARGET WITH FOUR FACES (1955), cut-off plaster casts stand above the target surface. The faces are all from the same woman, cast serially. In each successive casting, the woman was more relaxed and the mouth more open. Johns originally intended to arrange the casts in the order they were made, but he was obliged to rearrange the casts so that there was no sense of a progression, of "a mouth about to speak," which he did not want.

Tango (detail). 1955. See Plate 13

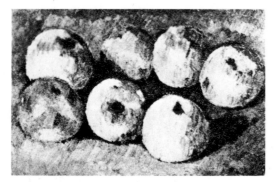

Paul Cézanne. *Apples.* 1873–77.
Collection Lady Keynes, London

FIGURE 7. 1955. See Plate 5

His interest in an image combined with sound led to TANGO, painted the same year. TANGO incorporates a music box into the painting, with an exposed key to be wound. The music box originally played "Silent Night," but Johns altered it so it just made plinking sounds.[10] With both TANGO and the targets, he says, "I wanted to suggest an active physical relationship to the pictures. In the targets, one could stand back or one might go very close and lift the lids and shut them. In TANGO, to wind the key and hear the sound, you had to stand relatively close to the painting, too close to see the outside shape of the picture."

Thus Johns was influencing the observer's physical position in relation to the painted surface. And he did it by providing a temptation, a source of curiosity, a reason to move closer and then to step back. The painting provokes an interaction with the observer: it takes two to tango.

There is another notable feature of TANGO—the painted surface stops short of the bottom of the canvas, suggesting a distinction between what is painted and what underlies the painted surface. Johns has used this device in many paintings since, but it first appeared here, and it arose from his own interaction in movement with the picture: "In painting a large canvas, it was too hard to reach down to the bottom, to bend over. So I just didn't do it. Then when I noticed what I had done, I decided I liked it, and left it."

In 1955 he also painted his first numbers. For an artist interested in flat, mundane imagery, the choice of numbers as a subject might seem obvious. But it is actually a further step into abstraction. An American flag has a physical reality—the reality of the rippling flag atop the pole. Johns never paints a rippling flag; he restricts himself to the literal design, and makes a "thing" that hangs on the wall. But the image does have a reference to a physical object in the environment. Similarly, targets also exist as physical objects, in various forms for various purposes.

But numbers exist only in the imagination. We write them every day, we use them all the time, but they remain stubbornly abstract in a peculiar way. Johns paints his numbers as if they had some inherent concrete reality—and indeed the very act of painting produces a kind of concrete reality. What is that painting? It is a painting of the number 7, the shape of the numeral, standing without a context. Cézanne painted seven apples; Johns just paints 7.[11]

Such lack of context for the ostensible "subject," the painted figure, makes us acutely aware of the painting as a physical object. This quality has often been emphasized by Johns. Early in his career, he said that people should be able to look at a painting "the same way you look at a radiator,"[12] in other words, as an ordinary object. No special vision or knowledge was required.

At times, his interest in "things seen and not seen" had unexpected results. Following the first red, white, and blue American flag, Johns painted WHITE FLAG, on a huge scale, using the same encaustic technique. One of his largest paintings, it covered most of a wall. "I remember having it in my studio when somebody—I've forgotten who it was, I don't think it was someone involved with art, except perhaps a mover or someone like that who had come to move something—simply went up to my painting and leaned against it. He saw it as a wall—it was hanging on a white brick wall."[13]

With WHITE FLAG, Johns had begun to alter his mundane images in surprising

ways. Soon after, he painted FLAG ABOVE WHITE. "Originally the shape of the canvas was determined by the subject matter. Then I tried to extend the surface beyond the subject matter—or what most people would call the subject matter."

In summary, the work of 1955 represents a remarkable progression. In a single year, we see a man of 25 take one idea—an American flag on a canvas—and push it, stretch it, extend it, with great invention and inexorable logic. Even today there is a taut, controlled excitement about these pictures that cannot be missed.

At this time, Johns was living in a loft on Pearl Street in New York, and Robert Rauschenberg moved into the same building. Five years older than Johns, Rauschenberg already had a reputation as a provocative and engaging young man; he had appeared in *Life* magazine, and had had several shows. In one he had exhibited pictures made of dirt, and although it was not yet widely known, he had done something even more startling: he had erased a de Kooning drawing and signed the result as his own work.

Rauschenberg and Johns became close friends, although their personalities were very different. Rauschenberg was voluble and outgoing where Johns was reserved; Rauschenberg was explosively energetic where Johns was patient and deliberate; Rauschenberg was hectic where Johns was precise; Rauschenberg was shocking where Johns never desired to shock. At the same time, the two men shared certain characteristics: both Southern, both impoverished and struggling.

Their closeness led them, on occasion, to paint each other's pictures. Johns said: "When you are young, you think you can do anything. I didn't see why I couldn't do a Rauschenberg if I wanted to. So I tried once or twice. But it didn't work; someone saw my Rauschenbergs and noticed there was something funny about them."

Johns and Rauschenberg shared certain attitudes toward art which led them, when they both finally became established, to be discussed together as "neo-Dadaists." These attitudes included a belief that art sprang from life experiences, but that the painter was not obliged to be "self-expressive" in the manner then popular; a belief that the commonplace should be incorporated into art; a belief that in looking at art, you should see whatever you ordinarily saw; and a belief that the hard distinction between representation and abstraction overlooked an ambiguous middle area of great interest to them both. The similarity of their underlying attitudes led more than one critic to see their work as similar; Johns was occasionally criticized for a canvas Rauschenberg had made.[14]

Johns and Rauschenberg worked for several years in close association, seeing each others' work daily, and supporting each other in a time of isolation. Rauschenberg said later that they gave each other "the permission to do what we wanted."[15]

Through Rauschenberg, Johns met another important figure in his life, the composer John Cage. Cage was considerably older than either man; Rauschenberg had known him from his time at Black Mountain College in North Carolina. Johns has said: "Knowing John had a great effect on my work. John was intellectually generous and also he had a kind of tendency to teach which was

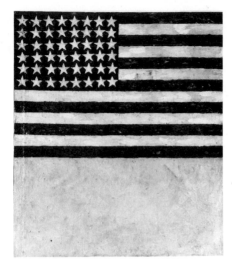

FLAG ABOVE WHITE. 1955. Encaustic on canvas, 55.9 x 48.3 cm (22 x 19″). Private collection

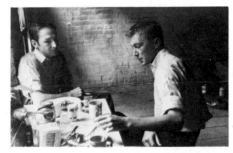

Robert Rauschenberg and Jasper Johns

John Cage.
Photograph by James Klosty

Merce Cunningham.
Photograph by James Klosty

FLORAL DESIGN. 1961. Pencil, watercolor, and collage on paper, 56.5 x 47.9 cm (22¼ x 18⅞"). Collection the artist

DRAWER. 1957. See Plate 14

useful to other people. He was capable of grasping ideas in different disciplines and making relationships among them. He was probably the first person I met who took such pleasure in ideas."

Johns has said that any influence from Cage came more from living, from attitudes toward work and life, than from talk about art. For example:

"Whenever I was stopped from what I wanted to do, I would get frustrated. John never did. One day we were driving on the New Jersey turnpike. It was raining; the car went through a deep pool of water and stalled. I was furious. John didn't mind at all. We got the car over to the side of the road. Then John took out a Scrabble game and we had a sort of party until the engine dried and we could go on. His attitude was really much better: there was no point getting upset since there was nothing we could do. But you don't think to act that way, unless you see someone else doing it."

Association with Cage brought Johns another lifelong friend, the choreographer and dancer Merce Cunningham. For twelve years, Johns served as artistic adviser to the Merce Cunningham Dance Company; he was involved in fundraising efforts; he also designed costumes, and on one occasion designed a set based on Duchamp's *Large Glass*.[16] But Johns is a retiring man whose own dramatic sense is finely muted; unlike Rauschenberg, Cage, and Cunningham, he has never been drawn to perform himself.

Thus, when several artists performed during a John Cage concert in Paris in 1961,[17] Johns did not even appear onstage; he sent a floral wreath in the shape of a target as a stand-in for his own presence. It is a gesture rich with suggestion—wreaths are appropriate for holidays and funerals, triumphs and tragedies; and Johns has always been fascinated with the idea of the stand-in, with the surrogate, with one thing representing another.

In retrospect, the primary influence of the middle 1950s was Rauschenberg, the gregarious, frustrating, instantaneously brilliant Rauschenberg.[18] Johns said: "Bob was the first person I knew who was a devoted painter, whose whole life was geared to painting. I had never met anyone like that."

Such comments convey a sense of Johns' early isolation, which continued for several years to come. For the next three years—"It seemed like a very long time"—only a handful of people saw and commented upon his work.

During this period he patiently elaborated upon his previously determined themes—the mundane image, the flat abstraction, "the things the mind already knows," the painting-as-object. The years 1956–57 mark the first use of objects attached to the painted surface—with the works CANVAS, BOOK, and DRAWER. The fact that the attached objects were painted over, as if they were part of the original surface, throws doubt upon the meaning of surface in a disturbing way. The effect is heightened by painting the sides of the canvas as well, something he did often during this period.[19] His treatment again emphasizes the idea of the painting as a physical object hanging on the wall. "One of the extreme problems of paintings as objects is the other side—the back. It can't be solved; it's in the nature of the work." His concern with surfaces and "the other side" continued for several years more, in a series of paintings that includes GRAY RECTANGLES (1957), SHADE (1959), DISAPPEARANCE (1960), and DISAPPEARANCE II (1961).

He also extended his repertoire of ordinary flat imagery. The arrangement of GRAY ALPHABETS (1956) is straightforward, its effect reminiscent of a typographer or an ophthalmologist—someone who cares about the letters for more than their usual, literal meaning.

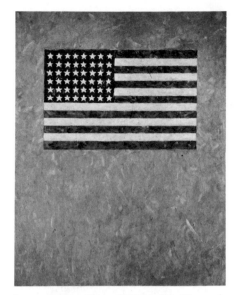

FLAG ON ORANGE FIELD. 1957. See Plate 22

In 1957, he elaborated an idea first seen in FLAG ABOVE WHITE, by working with an image and a surrounding color field, in FLAG ON ORANGE FIELD. The critic Barbara Rose has said: "Between the early and later works lie a number of transitional paintings. . . . Perhaps the most important . . . is the *Flag on Orange Field*. A punning title, presumably a pun on 'flag' as a synonym for iris. . . . If we accept the flower image established through a pun, Monet's *Field of Red Poppies* comes to mind as a possible source for the sunny Impressionist landscape Johns has created. In *Flag on Orange Field,* several new elements are introduced. Although the flag is still an *a priori* image, a context, of which the original flags were deprived, is introduced in the form of the Impressionist field which acts as a frame for the flag."[20]

In an interview some years later, Johns said: *"Flag on Orange* was involved with how to have more than one element in the painting and how to be able to extend the space beyond the limits of . . . the predetermined image. . . . It got rather monotonous, making flags on a piece of canvas, and I wanted to add something—go beyond the limits of the flag, and to have different canvas space. I did it early with the little flags with the white below, making the flag hit three edges of the canvas and then just adding something else. And then in the *Orange,* I carried it all the way around."[21]

Claude Monet. *Poppy Field near Giverny.* 1885. Museum of Fine Arts, Boston

In this straightforward comment, Johns reminds us of the orderly progression of his treatment of images. Dissatisfied with the limits of his self-imposed working arena, he strives to move beyond those limits. How he does so is typical of his procedures: "I wanted to add something." He doesn't say he wants to make a break, or that he wants to do something else. Rather he wishes to build—to add to what is already there. In this sense, his approach is fundamentally conservative.

In 1958, he painted ALLEY OOP—a comic strip on a color field—using the format of FLAG ON ORANGE FIELD. He said, "I was trying to find some way to apply color in an arbitrary fashion, to incorporate the image within a color field."

Again we note his conservative tendency. Having established the format for FLAG ON ORANGE FIELD, he employs it again for another painting, rather than invent a new composition. This use of a previous composition directs us back to other instances of his work, and by suggesting alternatives, makes us look again at these similarly composed paintings.

But beyond this, we sense another aspect of Johns' methods. Again and again, Johns defines his concerns by strictly limiting his own contribution, and by employing arbitrary devices for everything else. If he needs an image, he chooses something that already exists; if he needs letters, he takes stencils not of his making; if he needs color, he finds a way to make the choice according to some fixed rule he is not responsible for. In these early paintings, his work never appears to express any personal preference; the decisions in his paintings can all be explained by some logical, impersonal plan.

ALLEY OOP. 1958. See Plate 33

Sketch for THREE FLAGS. 1958. Charcoal on paper, 12.3 x 24 cm (4¹³⁄₁₆ x 9⁷⁄₁₆″). Whitney Museum of American Art, New York. Gift of the artist

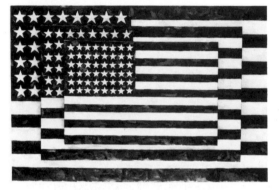

THREE FLAGS. 1958. See Plate 40

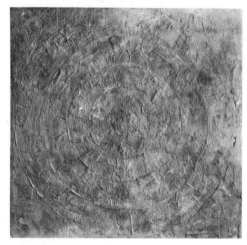

GREEN TARGET. 1955. See Plate 12

As Johns extended his use of color, he also extended his control of surfaces, and objects attached to the surface, with THREE FLAGS (1958). The idea for this remarkable painting, he says, "came to me all at once—the thought was complete. I have a sketch done on the back of an envelope for it. I was eager to start the picture; I remember I had to wait for the canvas stretchers to be made specially; they had to be bolted to one another. And I remember having a kind of moral conflict about whether to paint the covered portions, because the idea of doing work which will be covered, and is therefore not a part of the necessary information about the picture—that idea conflicts with the teasing quality of the picture, which suggests that you have done it. I solved it by telling myself that I was doing the painting for myself, and I knew that I hadn't painted it." In fact, he painted in the covered areas of the image in gray.

By now, Johns was painting full-time; from Rauschenberg he had learned the trick "of only working when you needed money." He and Rauschenberg designed window displays for Tiffany & Co., Bonwit Teller, and other New York stores whenever money ran low. In fact, two of Johns' paintings were first seen in window displays in New York.[22]

But they were seen nowhere else publicly until, at the urging of Allan Kaprow, GREEN TARGET (1955) was included in a group show at the Jewish Museum.[23] There the painting caught the attention of Leo Castelli.

Trieste-born Leo Castelli was an art collector and self-described playboy who decided, at the age of 51, to open a gallery in New York.[24] He had begun by selling paintings from his own collection; he also approached several young artists whose work interested him. In March 1957, after the Jewish Museum show, Castelli went to Pearl Street to invite Rauschenberg to show at his gallery. In passing, Castelli mentioned that he had seen a painting by someone with the peculiar name of Jasper Johns,[25] and that he would like to meet the artist. "Well, that's very easy," Rauschenberg said, "he's downstairs."

"I walked into the studio," Castelli recalled, "and there was this attractive, very shy young man, and all these paintings. It was astonishing, a complete body of work. It was the most incredible thing I've ever seen in my life."

For Johns, who did not want to be associated with any particular group of painters, Castelli's gallery was ideal, since it was new and had no specific identity. Castelli showed Johns' FLAG (1955) in a group show at his gallery later in 1957, and in 1958 he gave Johns his first one-man show. Here Johns displayed the result of more than three years of sustained effort: his flags, his targets, his numbers and alphabets. Johns became "an overnight sensation,"[26] and was immediately plunged into a critical controversy that continued for several years.

To understand the controversy, one must recall the attitude of the New York art world in the middle 1950s. Abstract Expressionism—that movement which took as its fundamental tenet the necessity of communicating subjective content through an abstract art—reigned supreme in the city. The importance of Abstract Expressionism was confirmed by the fact that, for the first time in history, an indigenous American art movement had gained international significance.

The New York art world cherished Abstract Expressionism; it was almost

impossible to conceive of anything else, to imagine any other premise for painting. As Rauschenberg said of that time, a young painter had "to start every day moving out from Pollock and de Kooning, which is sort of a long way to have to start from."[27] The burden was very heavy.

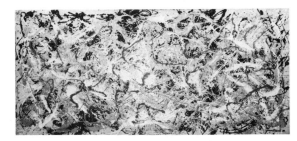

Jackson Pollock. *Number 27*, 1950. Whitney Museum of American Art, New York

At the same time, the second generation of Abstract Expressionist painters were often perceived to have "slavishly imitated"[28] their predecessors. The early shock and excitement of the movement were gone. "As the art market was glutted with the works of de Kooning's admirers, the real achievements of de Kooning and his generation were becoming obscured."[29] There was a sense of waiting for something fresh and new, and newly provocative.

Johns provided the provocation. His assured and finely worked paintings of flags and targets offered an alternative to Abstract Expressionism, and reintroduced representation—the recognizable image—into painting.

Critical opinion on the value of Johns' work, the artist's intention, the implied meaning, and the way the paintings acted on the viewer was divided and contradictory. There was even disagreement about whether the pictures were well-executed: some wrote of "the commanding sensuous presence of . . . Johns' elegant craftsmanship,"[30] while others found the pictures "messily painted."[31]

Established artists were not pleased. Leo Steinberg recalls:

> I was interested in the reaction to Jasper Johns of two well-known New York abstract painters. One of them said, "If this is painting, I might as well give up." And the other said, resignedly, "Well, I am still involved with the dream." He, too, felt that an age-old dream of what painting had been, or could be, had been wantonly sacrificed—perhaps by a young man too brash or irreverent to have dreamed yet.[32]

FIGURE 5. 1955. See Plate 4

The controversy surrounding Johns' show was heightened by its popularity. Nearly all the paintings were sold, many to influential collectors: Soby, Rockefeller, Johnson, Miller. Alfred Barr bought three, including TARGET WITH FOUR FACES, for the Museum of Modern Art. That purchase became a political act,[33] a gesture of confidence and encouragement, that was hotly debated. A year later Ben Heller wrote:

> Johns has been as much a pawn in the current art world game of power politics as the bearer of a new or individual image. As a result of this . . . [he] risks the subtle, swift, and cruel fate befalling one who becomes a fad. . . . He has perhaps suffered as much as gained by his notoriety and success.[34]

This debate about Johns' work continued for nearly half a decade. By then, a new generation of young painters had rejected Abstract Expressionism for postpainterly abstraction and Pop Art. And Johns himself had gone on to make pictures distinctly different in imagery and technique from his early flags, targets, and numbers.

Johns denies that his early paintings were a reaction to Abstract Expressionism. He says that he didn't know enough, hadn't seen enough, to make such a response. As for the critical controversy, he said: "In those days, the art world was very much smaller than it is now. People had the sense that they knew every-

thing that was going on in the art world in New York. But the fact that nobody had seen these paintings—nobody knew they were being done—increased the surprise when they were finally shown. They were surprising because no one had seen them before."

Was he personally affected by the controversy? "Well, I liked the attention. And I thought it was interesting that other people had a reaction to my work, because prior to that time I had assumed it was mostly of interest only to myself."[35]

In 1959, *Time* magazine announced: "Jasper Johns, 29, is the brand-new darling of the art world's bright, brittle avant-garde. A year ago he was practically unknown; since then he has had a sellout show in Manhattan, has exhibited in Paris and Milan, was the only American to win a painting prize at the Carnegie International, and has seen three of his paintings bought for Manhattan's Museum of Modern Art."[36] The accompanying picture shows a brooding, solemn young man in a coat and tie standing beside one of his paintings. He looks doubtful and a little suspicious.

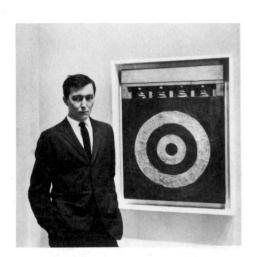

Jasper Johns at age 29.
Photograph by Ben Martin

Barbara Rose has observed that Johns' initial recognition did not bring with it understanding; she suggests that much of his early notoriety had less to do with the work itself than with the ease of mass-media dissemination of his simple American images.[37] If Johns found the attention agreeable, he may also have felt it was occurring for the wrong reasons. In any case, that same year he altered his methods radically. Identified with encaustic, he began to work with oil. Known for targets and flags, he stopped painting them, at least for a while. Recognized as an enigmatic, intellectual artist, he now produced pictures with fewer obvious paradoxes and contradictions.

Thus we are presented with a young artist, having just attained international renown, abandoning the techniques and imagery that had made him famous. The results of his transformation—and perhaps the cost—are seen clearly in two major paintings of 1959 that can be considered together, FALSE START and JUBILEE.

FALSE START is an explosive picture; it seems to be blowing itself apart in a pyrotechnic display. Brushstrokes are large; color is riotous; composition is not predetermined by a recognizable image. The picture lacks the calm, dignified repose of Johns' earlier paintings; it appears nervous, risky, unsure of itself. Most striking, FALSE START does not seem to *use* color; it is *about* color, a suspicion confirmed by JUBILEE, its negative in somber black-and-white.

Johns says he was sitting in the Cedar Tavern, a bar favored by artists of the time, when he saw a racing print titled "False Start"; he took that for the name of his own painting. But many observers sensed a reference to the artist's state of mind, or his feeling while working. Barbara Rose: "A 'False Start' does not occasion a fresh start, but an attempt to retrieve a situation heading out of control."[38] Max Kozloff: "An agitated picture . . . [which] implies an imminent dissolution."[39]

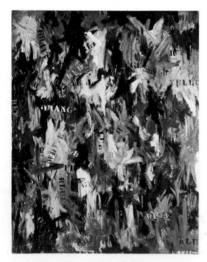

FALSE START. 1959. See Plate 51

The stenciled labels for colors draw attention, since these are often "wrong"— the word GRAY is painted in red letters on a patch of yellow, and so on. Much critical commentary has been devoted to the contradictions inherent in this mislabeling. The commentary itself is paradoxical; nearly everyone begins by

saying the device is uninteresting, and then discusses it at length. (It is well-known to psychologists, who have long studied mislabeled colors as the Stroop effect, powerfully disorienting to viewers.[40])

Faced with the painting, critics noted the conflict, or counterpoint, between the color labels and the splashes of color which they do not really identify. But no one really recognized that Johns—an artist who had already set a course toward increasingly abstract treatment of painting ideas—might logically move from images to color, one of the components of images, and that he would deal with color in the same implacably abstract way. To observers at the time, this logical progression was not clear. FALSE START seemed to represent a major departure from past pictures. Leo Castelli recalls that "Alfred Barr almost blanched . . . he was so disappointed. He said he didn't understand it at all."

Johns himself saw no radical break.[41] Two years earlier, he had become aware of "certain limitations in my work, and I had the need to overcome those, to break with certain habits I had formed, certain procedures I had used. The flags and targets have colors positioned in a predetermined way. I wanted to find a way to apply color so that the color would be determined by some other method." The first paintings to attempt this were FLAG ABOVE WHITE and FLAG ON ORANGE FIELD. The next step was ALLEY OOP. Then came FALSE START.

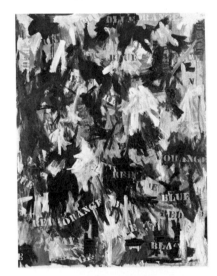

JUBILEE. 1959. See Plate 52

"It started from an idea about color—the decisions in the painting aren't based on visual sensation primarily. The idea is that the names of colors will be scattered about on the surface of the canvas and there will be blotches of color more or less on the same scale, and that one will have all the colors—but all the colors by name, more than by visual sensation." In his view, the interplay of labels and colors retained "the objectness of the painting—I had a need to maintain that quality in the work."

The schematic organization of FALSE START is reinforced by the black-and-white version, JUBILEE; the pictures were painted one after the other, and they are clearly meant to be considered together. The idea of such paired images is itself an innovation of great importance to Johns' later work. In succeeding years, he returned again and again to the idea of the doubled or repeated image, until it finally became a central theme of his work.

But with JUBILEE, there is at least the suspicion of something more—not merely that the painting relates to its colored twin, but that it may have come from actual experience.

Johns has always insisted he is a poor colorist, with little ability to discriminate between colors he sees. He says he is worse at this than the average person. Then he reports this anecdote. "I was working on a colored numbers painting. When I worked on it for longer than a minute, the entire painting would turn gray to me. I couldn't see any of the colors, and I would have to stop."

The experience of seeing a painting turn gray before his eyes must have made work difficult and frustrating; puzzled, "I mentioned this to Duchamp. He said, 'Perhaps you have a physiological need. . . .'"

FALSE START (detail). 1959. See Plate 51

Johns first met Marcel Duchamp in 1959.[42] The French painter was brought to his studio by critic Nicolas Calas. Johns never knew Duchamp well, or saw him often. Most of the time he saw him with John Cage, who studied chess with

Marcel Duchamp.
Photograph by Fred McDarrah

Duchamp. Although Duchamp is usually considered an important influence on Johns' work and ideas, Johns has always cast doubt on conventional notions of artistic influence; he once said to an interviewer, "Everything influences me."

And speaking of Duchamp, he observed: "After one's youth, an 'influence' really implies an underlying congruity of thought." Certainly Jasper Johns at 29, a newly successful and active painter, had much in common with Marcel Duchamp, then 72, an artist who had not worked publicly for many years.[43] Both were highly intellectual, highly sensual artists; both worked through negation, producing teasing, cryptic, hide-and-seek creations; both employed ready-made elements in their work; both concerned themselves with the interplay of thought and language, chance and intent, representation and perception. Personally, there were similarities as well. Both were private men with a distinctive sense of humor; and both were often perceived as detached, austere, and cold.

Thus it is perhaps not surprising that their work was first seen to be related. Duchamp is usually considered the father of Dada, the anti-art movement of the 1920s. And Johns was at first perceived as "neo-Dada" in his efforts and intentions. It was some time before the real difference in the attitudes and work of the two men became clear.

Years later, Johns wrote that Duchamp's work moved "into a field where language, thought and vision act upon one another. There it changed form through a complex interplay of new mental and physical materials. . . ."[44] It is not a bad description of Johns' own concerns, as indicated in a picture of 1959, DEVICE CIRCLE.

DEVICE CIRCLE seems to bridge the new and the old. It is done in the familiar medium of encaustic, and its circular enclosure echoes the targets. We can see how the circle was made—the "device" is left attached to the canvas. But what the circle encloses is problematical; inside and outside are not distinct; we sense the artist who could once be labeled hermetic bursting beyond his self-imposed borders.

In Johns' own view of the painting, the idea of boundaries is significant. "In my earlier pictures, the gestures [of painting] have to conform to the boundaries. That's the only thing they have to do, stay within the lines. But in the paintings of this [later] time, there was an attempt to find a way that gestures would make up an image: the gestures would determine the boundaries."

And the device had the arbitrary, impersonal quality so important to Johns' work: "I was trying to find something to do that would determine a large part of the nature of the work."

Max Kozloff:

The "device circle" . . . is not an emblem, like the flag, or a system, like the numbers and alphabets, or a "subject," like the maps. . . . *Device Circle* can be thought of as a *False Start* ground upon which a circle was to be drawn. . . . Johns employs a stick for his compass, and then, the job done, leaves it attached to the surface. The circle corrals the denser chromatic splutters— red, white, yellow, and blue—into the center, where they are physically constrained, if not formally harmonized, by the *tondo* shape. There is, then, an uneasy compromise between the interior and exterior of the circle. . . . And

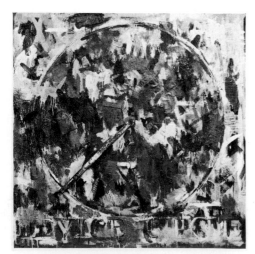

DEVICE CIRCLE. 1959. See Plate 46

almost painful is the contrast between the easily made and perfect arc and the labored, newspaper-clotted facade.[45]

The uneasy compromise between interior and exterior may have characterized the artist's life in those days as well. One senses it in the young man standing diffidently beside the TARGET WITH FOUR FACES, almost as if he does not want to be associated with his own work. But the work always reflects the inner state of the artist, even if he explicitly denies any correlation between his feelings and his creations.

When Johns said, in a much-quoted comment, "I didn't want my work to be an exposure of my feelings," he was really divorcing himself from the tenets of Abstract Expressionism, where the point of the work was to make some statement of subjective emotion. Johns never had this goal.

Quite the reverse: when Johns first received public attention, he refused to be drawn into a critical dialogue. In 1958, he told a *Newsweek* interviewer, "I have no ideas about what the paintings imply about the world. I don't think that's a painter's business. He just paints paintings without a conscious reason."[46]

This is an attitude Johns would consistently express all his working life; more than two decades later he said, "My (work) has no conscious goal in relation to the viewer."[47]

Of course, such statements can be viewed as disingenuous; Johns is a highly self-aware painter. And over the years, Johns has become much less reticent to speak about his work. Yet his lifelong tendency has been to direct attention away from himself, and toward the work—to let the work "speak" for itself. As Nan Rosenthal observed, "Jasper is much too intelligent to think that a piece of art means what he says it means. Nor does he believe in telling you what it means because for him, meaning is always in a state of flux."[48]

Back in the late 1950s, Johns was getting his first taste of what the established art world was really about. Years later he said, "The art world works on many levels. Most of them are not publicly acknowledged."

THE CRITIC SMILES. 1959. See Plate 62

He expressed something of his feelings—in a sense—in a sculpture of 1959, THE CRITIC SMILES. This is clearly a response to public attention; one cannot imagine it being made a few years before by the patient creator of flags and targets that nobody saw. This is a reaction to *being seen.*

On one level, THE CRITIC SMILES operates as an illusion, in the same way as Picasso's *Baboon and Young* (1951); it exemplifies Johns' dictum that "you can see more than one thing at a time"; and it demonstrates a reversal of the acted and the acted-upon, the teeth and the bristles.

Later, he said about it: "I had the idea that in society the approval of the critic was a kind of cleansing police action. When the critic smiles it's a lopsided smile with hidden meanings. And of course a smile involves baring the teeth. The critic is keeping a certain order, which is why it is like a police function. The handle has the word 'copper' on it, which I associate with police. I imagined the sculpture to be done in various metals—the base lead, the handle silver, the teeth gold."

Picasso. *Baboon and Young* (detail). 1951. The Museum of Modern Art, New York. Mrs. Simon Guggenheim Fund

The puns suggested by his description should not obscure another aspect, his interest in working with different materials. Johns has always strived to extend

FLASHLIGHT I. 1958. See Plate 30

PAINTED BRONZE. 1960. See Plate 67

PAINTED BRONZE. 1960. See Plate 68

his technical facility. New techniques never intimidate him; he has moved into lithography, serigraphy, etching, and offset printing with a boldness that has astonished many around him. In part this must reflect self-confidence: from the beginning of his career, Johns has been recognized as an artist with an awesome technical facility.

In 1958 he made his first sculptures—ordinary objects, flashlights, and light bulbs. If we ignore the theme of illumination, we find his initial interest was again provoked by materials—the idea of combining glass and some other substance into a single object. He was also aware of playing on the confusion of the handmade object, and the ready-made object. FLASHLIGHT I (1958), his first, is sculp-metal over an actual store-bought flashlight; later flashlights were made from scratch in papier-mâché, and in plaster.

The confusion of illusive art and concrete object, always a theme in his painting, was carried to a kind of logical extreme with his famous 1960 sculpture of ale cans, PAINTED BRONZE.

It began with a chance remark. "Somebody told me that Bill de Kooning said [of Leo Castelli] that you could give that son of a bitch two beer cans and he could sell them. I thought, what a wonderful idea for a sculpture." He made it soon after, two ale cans ("I was drinking ale at the time"). They were made in plaster of paris, in a complicated way. "Parts were done by casting, parts by building up from scratch, parts by molding, breaking, and then restoring. I was deliberately making it difficult to tell how it was made." The sculpture was then cast in bronze, reworked when it came back from the foundry, and finally painted.

Soon after, he did the sculpture PAINTED BRONZE (1960), the Savarin can with brushes. "The idea for the ale cans was like a present. I felt I should already have known to do it as a sculpture: it had the right scale, it was already there—all I had to do was look over and see it, and then do it. Doing the ale cans made me see other things around me, so I did the Savarin can. I think what interested me was the coffee can used to hold turpentine for brushes—the idea of one thing mixed with another for a purpose."

In 1960, he began work in another medium, lithography. Tatyana Grosman, who had started Universal Limited Art Editions in her house at West Islip, Long Island, wrote Johns to invite him to work there. He sent her a card from South Carolina, saying that he would come when he was next in New York. Eventually an appointment was set.

Mrs. Grosman recalled, "I was sitting in the living room waiting for Jasper, and suddenly very fast a young man walks in, and I think, what does he want? I think perhaps he is lost, or wanting directions. I didn't want to be disturbed, because I was waiting for Jasper. . . . I didn't understand that he *was* Jasper." After their first meeting, she arranged for two lithograph stones to be taken to his studio in New York, for him to work on.

There has been a revival in the last three decades of fine-art printing around the world, and it is difficult now to imagine how peculiar a lithograph stone—and the very idea of making prints—seemed to American artists in the 1960s, when the tactful Mrs. Grosman first began her rounds. Robert Rauschenberg's

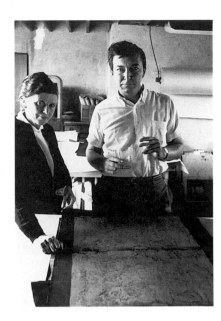

Tatyana Grosman and Jasper Johns,
West Islip, 1965

view was typical: he thought the latter part of the twentieth century was no time to start writing on rocks.

"I left the stones with Jasper," Mrs. Grosman recalled, "and after a time he said I could come to collect them. There were two: a target and a zero. . . . The stones were brought down to the car by Jasper and another young man. He was funny; he said, 'That's art, to carry something so heavy.' That was the first time I met Rauschenberg."

The first lithograph to be printed and released was TARGET (1960), which in scale and technique suggests a conté crayon drawing made directly on the stone. It is also the clearest suggestion we have that a target can be compared to the pupil of an eye.

But if this first lithograph was much like a drawing, Johns was quick to explore the potential of the medium. In the same year, 1960, he executed FLAG I, II, and III, a series of transformed images that provides a very good idea of what he is about—from the initial flag, in tusche, printed black on white; to the second state, in which the stone is changed by the addition of lines of wash and crayon, giving a more "scribbled" appearance, and printed in white on kraft paper; to the third state, in which the stone is again changed by a pattern of scratches which furthers the idea of the crayon lines. All together these images exemplify the Johns dictum, "Take an object/Do something to it/Do something else to it."[49]

Even more challenging was the second stone Johns had given Mrs. Grosman: "The target was all right, but the other one! He explained that the zero had to be printed, and then the drawing partially erased, and a numeral one printed, and then that would be erased. . . . I didn't know if it was even possible to make these changes, but I said we would try."

Eventually that stone resulted in the extraordinary series of prints 0–9 (1960–63). Johns recalls that he drew all the numbers zero through nine at the top in two rows, and then, because there was more space below, he drew a large zero. But then he felt that this print alone was "a little peculiar." So he conceived the idea of doing a series of ten prints, all based on this single stone, which would be worked again and again to create a full series of numbers.

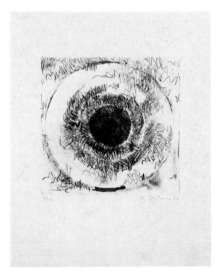

TARGET. 1960. See Plate 69

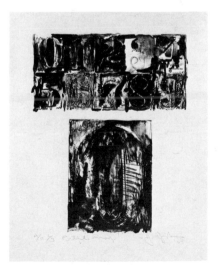

FIGURE 0 from 0–9. 1960–63. Lithograph, 52.1 x 40 cm (20½ x 15¾"). Published by ULAE

43

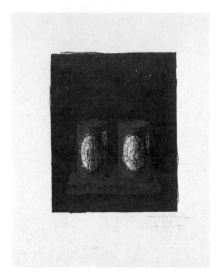

ALE CANS. 1964. See Plate 122

MAP. 1960. Encaustic on paper on canvas, 20.3 x 27.9 cm (8 x 11"). Collection Robert Rauschenberg

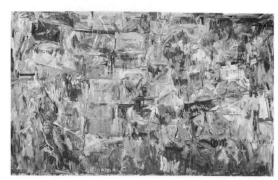

MAP. 1961. See Plate 74

This project was not carried out for two years, because Mrs. Grosman could not find the proper paper to use. It was finally printed as three series of ten prints. One series was printed in gray on eggshell paper; a second in black on off-white paper; a third in color on white paper.[50] Thus each stone was printed in three different ways, then redrawn, printed again, and so on. Observed Calvin Tomkins: "As a result of Johns' incredibly skillful drawing and the transparency of the lithographic inks, the series is not only a bravura demonstration of the possibilities of the medium but a subtle essay on change, seen in the visual symbols of change."[51]

At first, Johns' prints reworked well-established images in his repertoire. Thus in 1960 Johns painted PAINTING WITH TWO BALLS, but his lithographs referred to much older imagery: the target, coat hanger, and numerals 0 through 9. This delay between painting and print continued for a time; he made a print of PAINTING WITH TWO BALLS I in 1962, and his magnificent ALE CANS in 1964. Eventually the order was reversed; the print DECOY (1971) actually preceded the painting of the same name.

In any case, within five years, Johns was an acknowledged master of printmaking. By the end of the decade, he had made more than 120 prints. Much of his work during the late 1960s concerned print—so much, in fact, that there were dark rumors that Jasper Johns was finished, burned out, as a painter.

There were no such rumors in 1961, a year of further confident growth. The large MAP represents an addition to his repertoire of imagery. The previous year, Rauschenberg had given Johns a schematic American map of the sort used in a school notebook, and Johns had painted over it; he used those proportions to paint the larger map.[52]

Paint drips are a prominent feature of this MAP; they are much more striking than in previous paintings, and remind us of the role of accident in the creation of his work. In ordinary life, such drips usually imply a mistake, or sloppy indifference. And there is a persistent theme in modern art, a theme of using chance events, which the viewing public has often mistrusted.

Duchamp, who employed chance in his working method, once said, "Your chance is not the same as my chance."[53] He meant that the outcome of probability events is actually an expression of the artist's subconscious. This idea that you control what you do not control may at first seem surprising. In fact it is widely held. D. T. Suzuki on swordfighting:

Some may ask: How can the sword which implements the will to kill work out its function by itself without the willer's directive behind it? What originality, what creative work, can an inanimate mechanical tool be made to carry out all by itself? . . . The point is: When the sword is held by the swordsman whose spiritual attainment is such that he holds it as though not holding it, it is identified with the man himself, it acquires a soul, it moves with all the subtleties which have been imbedded in him as a swordsman. The man . . . is not conscious of using the sword; both man and sword turn into instruments in the hands, as it were, of the unconscious, and it is this unconscious that achieves wonders of creativity.[54]

Johns' own view is not so no-minded: "There are no accidents in my work. It sometimes happens that something unexpected occurs—the paint may run—but then I see that it has happened, and I have the choice to paint it again or not. And if I don't, then the appearance of that element in the painting is no accident."

Some observers are put off by ideas such as these. The artist does not seem to be struggling to bring forth a preexisting vision, but rather is engaged in a process where the outcome may or may not conform to the initial idea, and where accidents along the way are incorporated. The idea of following a process in artistic creation makes people uneasy; the idea of a struggle—birth pangs—is much more acceptable.

Thus the cliché that the artist is never satisfied with his work, that it never turns out to be what he "had in mind." The usual explanation for this state of affairs assumes that imagination has a richness beyond what the fingers can actually perform, and so disappointment inevitably follows. Much has been written about the eternal striving of the artist to reproduce the wondrous visions in his brain.

In fact, one can argue that human imagination is far paler than its concrete manifestations. Certainly imagination is often simply wrong. For example, in 1958, Johns did a drawing, COAT HANGER, and a painting the following year. The drawing shows the coat hanger–bar parallel to the bottom of the picture. A thoughtful viewer will sense that something is wrong, and something is—coat hangers don't hang that way, except in the idealized imagination. Johns was surprised to discover his error, when he actually executed the painting with a real coat hanger.

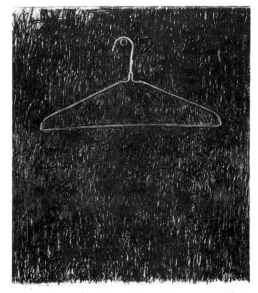

COAT HANGER. 1958. See Plate 34

Similarly, there is often a disparity between the imagined way an idea will be carried out, and the way it is actually executed. In PAINTING WITH TWO BALLS, Johns envisioned two spheres wedged between horizontal panels of a three-paneled painting. He intended to make the painting by bolting the canvases together and then pushing the balls into the position he wanted. He was surprised to find this didn't work: the canvas wrinkled badly. To create the effect he had imagined, he was obliged to take an unforeseen step—the construction of two special curved canvas stretchers.[55]

A great many surprises occur while making something, and if you live with those surprises long enough, they begin to seem like an ordinary feature of work. They cease to be remarkable; they are like the swells that rock a boat; you begin to compensate for them, to ride them, to go along with them. Soon there is little useful distinction between what you intended and what you are doing. Work is the outcome of a thousand apparently accidental events that are permitted—or not permitted—to enter the final work.

Seen in this way, creation is *only* a process, and the idea has no significance beyond its ability to set the process in motion. The relationship between the initial idea and the final creation is always doubtful. As psychologist Jerome Bruner said, "You are more likely to act yourself into feeling than to feel yourself into action."[56] Johns himself echoes the idea: "Sometimes I see it and then paint it. Other times I paint it and then see it."[57]

Returning to the 1961 MAP, with all its drips, we can imagine that the paint

COAT HANGER. 1959. Encaustic on canvas with objects. 70.5 x 53.9 cm (27¾ x 21¼"). Private collection

PAINTING WITH TWO BALLS. 1960. See Plate 63

THE CRITIC SEES II. 1964. Sculp-metal on plaster with glass, 8.3 x 15.9 x 5.4 cm (3¼ x 6¼ x 2⅛″). Collection the artist

THE CRITIC SEES. 1962. Pencil and collage on paper, 26.7 x 36.2 cm (10½ x 14¼″). Collection Leo Castelli, New York

THE CRITIC SEES (angled view). 1961. See Plate 90

started to drip, and the artist liked it, left it, and perhaps even encouraged it. One might even imagine sustained effort to produce apparently accidental drips. In any case, it is so prominent a feature of the painting that it cannot be considered accidental.

We should note in passing that the process of creation, the activity of fabrication, inevitably obliges the artist to be aware of artifice and illusion in a way that the viewer may not be. The viewer sees PAINTING WITH TWO BALLS in the way the artist first imagined it—as two balls wedged between canvas panels—but the artist knows that this is not what is actually being presented. A particular image is not necessarily executed in the way it seems to be. For Johns, the inevitability of illusion became an increasingly overt theme in his later paintings, where he incorporated trompe l'oeil techniques and explicit, often familiar optical illusions into his work.

Finally, to emphasize the process of creation is to cast doubt on the significance of the "idea" behind a created work. There is a long-standing debate among artists themselves about whether the underlying idea is central or peripheral to the finished work. Of literature, Jorge Luis Borges wrote: "The composition of vast books is a laborious and impoverishing extravagance. To go on for five hundred pages developing an idea whose perfect oral exposition is possible in a few minutes! A better course of procedure is to pretend that these books already exist, and then to offer a resume, a commentary."[58] Similarly, Marcel Duchamp said that he was interested only in the idea of a painting, and not in the surrounding vehicle of its transmission.

This was one difficulty Johns had with Duchamp's thought; Johns felt that it was impossible to distinguish between the idea and the creation—after all, when the work was done, the idea *was* the painting. There could be no difference.

In the work of 1961, we see an increasingly personal reference in the titles: BY THE SEA, GOOD TIME CHARLEY, IN MEMORY OF MY FEELINGS—FRANK O'HARA. This is a departure from the flat, literal titles that Johns first gave his paintings, and it may reflect Duchamp's influence. "I like what Duchamp said, that a title should be like another color to the work."

There was a new influence in this period, the philosopher Ludwig Wittgenstein, whom Johns read avidly during the early 1960s. (He dates his exposure to Wittgenstein from the painting FOOL'S HOUSE.) As with Duchamp, one senses a kindred spirit, for Wittgenstein is preoccupied with language, meaning, measurement, structured relationships, and the interpretation of visual information.

This latter is important in a 1961 sculpture, THE CRITIC SEES. It was created in response to an experience: "I was hanging a show of sculpture and drawings, and a critic came in and started asking me what things were. He paid no attention to what I said. He said, what do you call these? and I said sculpture. He said why do you call them sculpture when they're just casts? I said they weren't casts, that some had been made from scratch, and others had been casts that were broken and reworked. He said yes, they're casts, not sculpture. It went on like that."

Like the earlier THE CRITIC SMILES, this piece functions as an optical pun, as an

implied comment about the art world, and as a more general statement about the nature of perception. There is a clear suggestion that seeing and talking are related, and perhaps even equated;[59] there is also the idea that what is visually interesting provokes speech.

Most commentary has focused on the raised image, ignoring the brick-like structure of the sculpture as a whole. It is impossible to miss the sense of imprisonment, of being boxed in, that the piece implies. THE CRITIC SEES is funny, but not very optimistic.

Neither is a painting from that same year, a kind of penultimate statement of negation, NO. On a somber surface, a screw-eye suspends a wire which goes into the canvas, then reemerges to dangle the metal letters: NO. The letters stand away from a painted NO beneath. When illuminated, the metal casts one, or sometimes two shadow Nos on the painted surface. It is a picture full of NO.

About this time, Johns began to turn away from the routines of the New York art world. He was sufficiently established that he was no longer obliged to have an annual show; he stopped having them. He lived only part of the year in New York; the rest of the time he spent at a house in Edisto Beach, South Carolina.

Increasingly, his work turned inward upon itself, becoming more self-referential, more difficult, more disturbing. Rose refers to "the artist's own string of self-accusations: *Liar; Good Time Charley; Fool's House.*"[60] Kozloff says, "Unavoidable is the impression of a world gone awry, tumultuously churning up one's experience. . . . These works . . . tend to convey an underlying desperation."[61]

Whether that desperation was in the mind of the artist or the critic struggling to make sense of the new paintings, the paintings of 1961–64 often seemed peculiarly resistant to interpretation.

The paintings tend to be simply composed into horizontal or vertical segments, either because they are made of several canvas panels, or because some hanging object forms a division. There is the usual Johnsian progression, the conservative tendency, in composition and imagery. Thus, the triple horizontal RED YELLOW BLUE panels which first appear in OUT THE WINDOW (1959)—where they are reminiscent of FALSE START—reappear in the single canvas of OUT THE WINDOW NUMBER 2 (1962), as well as in BY THE SEA (1961), DIVER (1962), PASSAGE (1962), PERISCOPE (HART CRANE) (1963), LAND'S END (1963), and WATCHMAN (1964). This reworking of a compositional idea makes the horizontal RED YELLOW BLUE a kind of "flag" which, once conceived, is repeatedly renewed and shown in different ways.[62]

Increasingly, Johns leaves his literal impression in the picture—his hands and feet, sometimes his whole arm, and eventually his photographic image, printed in a souvenir plate.[63] In this regard, a series of drawings, STUDIES FOR SKIN I–IV (1962), is important. These beautiful, ghostly images, made by pressing oiled skin to paper, then rubbing charcoal over the oil residue, were done for a specific reason.

In 1962 Johns had the idea of casting an entire head, then making a thin rubber mask from the cast and, cutting the rubber, placing it flat on a surface, and casting the entire work in bronze. The result would be a "map" of skin, but the question remained of how to cut the rubber skin and lay it out. The studies were done for this reason. (The piece was not completed.[64])

No. 1961. See Plate 80

OUT THE WINDOW. 1959. See Plate 56

OUT THE WINDOW NUMBER 2. 1962.
See Plate 102

47

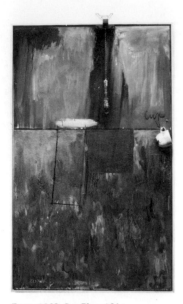

ZONE. 1962. See Plate 101

Perhaps the most striking feature of Johns' paintings from 1961–64 is his use of attached or hanging household objects—kitchen utensils, cups, brooms—or artist's devices—rulers, paintbrushes, rags, small hinged canvases. These hanging objects are usually named, yet their presence remains disturbing and troublesome.

Certainly, the connections within these paintings are doubtful. The pictures suggest less and less some relationship to the outside world of the spectator, and more and more some set of relationships within their own boundaries. Barbara Rose: "Their meanings, if decipherable, lie entirely within the world created on canvas or paper. Within this world, not the identity of the objects, but the nature of their relationships counts."[65]

Johns himself has confirmed this view. For example, of ZONE he said, "The idea was the interaction of two areas, one encaustic, one oil." And at least obliquely, he has confirmed the critics' feelings of his desperation. LAND'S END, he said, was given that title "because I had the sense of arriving at a point where there was no place to stand." It is a point where nothing is certain anymore, where everything is "confused by thought," and where, whatever you decide about a painting, you can find the reverse within the same canvas borders.

No can be taken as the beginning of this particularly troublesome group of paintings. Johns said of this picture: "Small differences are important. Or if they are not important, they could be seen as important to someone who devoted himself to that kind of thing." The painting combines a great many materials—canvas, collage, wax, wood, lead, galvanized wire, steel, sculp-metal—in ways that are not obvious. The title pun on "know," and the variety of materials, whether perceived or not, remind one of Virchow's classic comment, "We see what we know."[66]

The problems of perception—of seeing what we know, and knowing what we see—are emphasized by the titles, which tend to have a geographical reference, or a statement of the observer's position: BY THE SEA, LAND'S END, OUT THE WINDOW, PERISCOPE (HART CRANE). The latter title is taken from a passage in Crane's poem "Cape Hatteras":

> . . . while time clears
> Our lenses, lifts a focus, resurrects
> A periscope to glimpse what joys or pain
> Our eyes can share or answer—then deflects
> Us, shunting to a labyrinth submersed
> Where each sees only his dim past reversed. . . .[67]

In fact, a submersed labyrinth is not a bad description of this group of paintings. They have the hidden undercurrents, the redundancy, the jarring juxtapositions of a dream. That they are more difficult than earlier paintings may be expected. Jung said: "Initial dreams are often amazingly lucid and clear-cut. But as the work of analysis progresses, the dreams tend to lose their clarity. . . . As a rule, dreams get more and more opaque and blurred soon after the beginning of the treatment, and this makes the interpretation increasingly difficult."[68]

But whether it is correct to perceive these paintings as expressions of personal desperation or artistic entrapment, a distinct break did occur in 1964, with a trip

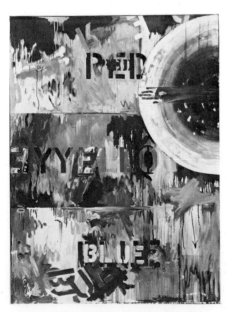

PERISCOPE (HART CRANE). 1963. See Plate 105

to Hawaii and Japan. Johns and his friends John Cage and Lois Long spent a month on Oahu, where Johns began sketches for three important paintings: WATCHMAN, SOUVENIR, and ACCORDING TO WHAT. En route they had stopped in San Francisco, where Cage's music was performed in a series of concerts honoring the musician David Tudor at the Tape Music Center. During a performance, Johns saw a spot of light moving over the ceiling of the darkened hall. He eventually determined that this was coming from a woman's compact mirror. The light, mirror, and reflected spot made him think, "That will be in my next painting."

SOUVENIR. 1964. See Plate 116

In SOUVENIR,[69] a flashlight shines onto a bicycle mirror in a corner of the canvas, and this light is reflected onto a plate—similar to the cheap souvenir plates found the world over—which contains the artist's photograph, and the words RED YELLOW BLUE around the perimeter. The canvas itself is dark, a heavily worked encaustic surface. Johns thought of the painting as a souvenir of Japan. It is an image of indirection as well; the flashlight, a familiar object in Johns' repertoire, now illuminates the artist's replica of himself, by bouncing its light all over the painting. (The fact that this system does not work very well—a much-discussed feature of the picture—was another discovery of working. Johns expected the light to shine nicely onto the plate, but it just didn't turn out that way.)

SOUVENIR can be taken as a metaphor for how Johns thinks of his work: the past is strongly evident, but in a disguised or altered form; the artist has left his own image, but it is illuminated indirectly. All these events take place around the borders of the canvas surface, distractions which carry us away from any examination of that surface, which is dim and forbidding.

The painting WATCHMAN provoked critical interest in part because of notes Johns published. These notes seem to suggest an explanation, or a further illumination, of the images:

> The watchman falls "into" the "trap" of looking. The "spy" is a different person. "Looking" is and is not "eating" and "being eaten." (Cézanne?—each object reflecting the other.) That is, there is continuity of some sort among the watchman, the space, the objects. The spy must be ready to "move," must be aware of his entrances and exits. The watchman leaves his job & takes away no information. The spy must remember and must remember himself and his remembering. The spy designs himself to be overlooked. The watchman "serves" as a warning. Will the spy and the watchman ever meet? In a painting named *Spy*, will he be present? The spy stations himself to observe the watchman. If the spy is a foreign object, why is the eye not irritated? Is he invisible? When the spy irritates, we try to remove him. "Not spying, just looking"—Watchman.[70]

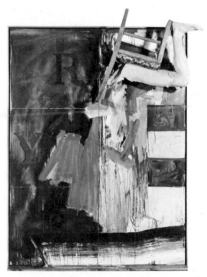

WATCHMAN. 1964. See Plate 118

The notes suggest that this is a picture about looking. They identify the cast of the leg and chair,[71] inverted in one corner; that is the watchman (falling into the trap of looking?). The rest of the painting initially suggests a typical Johnsian division into horizontal segments labeled RED YELLOW BLUE. The left side is relatively colorless; the primary colors appear on the right. At the bottom there is a smear of paint which makes a gray scale. The smearing "device" is left there,

propped against a ball. The paint strokes emanating from the seated figure strike out and disrupt the loose organization of the painting as a whole. We are told that "there is continuity of some sort among the watchman, the space, the objects." What sort of continuity? Evidently, the raw materials of perception are exposed here—words and letters, gray scale, primary colors, casts, real objects—but if we are to "see" it all, we are immediately trapped into asking questions, into bringing our intellect to bear. Perception is not passive, but active; a process of interpretation and "digestion." And even to be given the raw materials, the ·basic block of vision, is also to be provided with food for thought.

It may be that Johns got from Duchamp the idea of allowing notes to reflect on a painting, for Duchamp's notes for his *Green Box* can be thought of as an important part of the work itself. Johns was, to some degree, caught up with Duchamp during these years. He had several memorable dreams about him. One was: "I dreamed there was a party, with a lot of people. Marcel was lying flat on a table and I saw him from his feet, like that painting. The party went on in a very lively way but Marcel did not move. Finally someone began tapping him on the leg, and saying, 'There's something wrong with Marcel, there's something wrong with Marcel.' By then I had moved up to his head, so I saw him from a different perspective. This person kept saying, 'There's something wrong with Marcel.' Marcel sat up very abruptly, said something extremely funny, and everyone laughed. Then he fell backward, and Teeny [Duchamp's wife] said, 'Only Marcel would do a thing like that.' When I woke up, I tried to remember what Marcel had said, but of course I couldn't."

This dream, a wake for Marcel Duchamp who is not awake, could be interpreted to be saying that there is something wrong with Duchamp, which is corrected, and even made humorous, when Johns sees him from a different perspective. This different perspective on Duchamp might be said to appear in the 1964 painting ACCORDING TO WHAT.

It is the largest, most ambitious painting Johns had made until that time. In many ways it suggests a catalog and a summary. It is a compendium of past Johnsian elements—the inverted chair and cast leg of WATCHMAN, the hinged canvases of PORTRAIT—VIOLA FARBER and SLOW FIELD, and the spectrum letters of the FIELD painting, the bent coat hangers of EVIAN, the spoon of GRAY PAINTING WITH SPOON, the primary color blocks of many paintings, the gray scale of DIVER. And this picture shows a typically simple underlying composition of vertical canvas panels, crossed by a band of silkscreened newsprint. Once again, the picture seems to suggest a complex internal world in which the parts are related to one another, according to . . . what?

Duchamp's profile appears on the inside of the hinged canvas, lower left, and indeed ACCORDING TO WHAT can be considered a response to Duchamp's large painting *Tu m'*. Barbara Rose observes that both paintings catalog "the varieties of representation": both contain real objects, both have the shadows of objects, both contain painted images, and both show representations in perspective. Rose suggests that Johns adds two more varieties: reproduction, with the silkscreened swath of newsprint, and replication ("A three-dimensional cast of a human leg . . . is essentially a replica of leg . . . "[72]).

For Johns, this representational index is directly turned to questions of per-

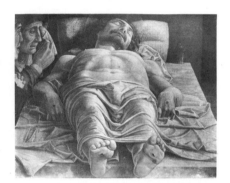

Andrea Mantegna. *Dead Christ.* After 1466. Brera Gallery, Milan

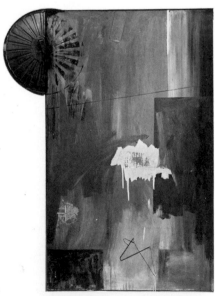

EVIAN, 1964. Oil on canvas with objects, 174 x 127 cm (68½ x 50"). Private collection

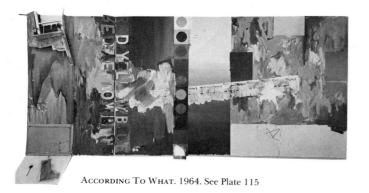

According To What. 1964. See Plate 115

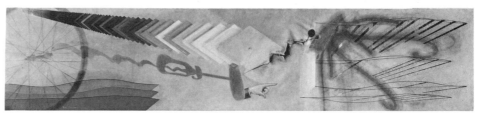

Marcel Duchamp. *Tu m'*. 1918. Yale University Art Gallery, New Haven.
Gift from the Estate of Katherine S. Dreier

ception. The brushy colored area in the upper right contrasts with the primary color blocks that represent its origins, the painter's starting point; the gray scale is a continuous spectrum while the adjacent color circles show the discontinuous effects of addition and subtraction in typical Johnsian fashion (yellow plus blue makes green; green minus yellow makes blue; blue plus red makes purple; and so on). These colored circles are reminiscent of the color scales used in printing, and indeed Johns places color scales at the borders of later paintings. We are also reminded of Cage's statement that Duchamp showed the value of addition, with his moustache on Leonardo's *Mona Lisa;* Rauschenberg showed the usefulness of subtraction, with the erased de Kooning drawing; and, Cage concluded, Johns was likely to discover the usefulness of trigonometry.[73] In Johns' work, that has often meant the interaction of intellectual constructs and verbal concepts with visual material, here represented by the color spectrum Red Yellow Blue, not painted, like the gray scale, but written (in appropriate colors) and, in fact, made three-dimensional with attached hinged letters. The fact that the letters are often bent or warped adds another level of complexity, as does the cast, which is shown reversed, so that we see the "other side" of something that does not logically have another side. Or put another way, the representation has features of its own that do not correspond to the referent; Johns emphasizes these. "Blue" is a word referring to a color; its referent is a concept that cannot be said to be bendable, but Johns has bent *his* Blue. And while a human leg has an anatomical interior filled with structures, it has no "inside" of the sort we are shown. Only a cast has an inside.[74]

Finally, we might note that both Johns' painting and Duchamp's each represents a turning point in its creator's approach to the subject. For Duchamp, *Tu m'* was literally the final work; he never made another painting. For Johns, According to What was the point of another redefinition of himself and his past, of the sort he had already done twice, and would do many times again in the future.

Johns' self-revisions have been variously received. In the early 1960s, he was called "one of America's liveliest and most original younger artists,"[75] and "the white, or gray, hope of American painting."[76] In 1963, *Newsweek* magazine said, "Jasper Johns at 32 is probably the most influential younger painter in the world. He has produced surprise after surprise. . . . "[77]

51

But there were other ways to see his work. Dore Ashton looked at DIVER and complained, "What about these objects [attached to the canvas]? It is impossible in this painting to decide just what merit they have."[78] And in 1964, Sidney Tillim said, "It seems ridiculous to speak of the *decline* of an artist not yet thirty-five years old. Yet such is the conclusion I feel one has to draw from the Jasper Johns retrospective at the Jewish Museum. . . . He has . . . been unable to achieve a really major style. . . . Where Johns is really vulnerable is in his dependence on ideas which are exhausted rapidly."[79]

In fact, the characteristic logical progression of Johns' work may be easier to see now than it was three decades ago. There is a recurrent feature of his paintings—a sense of impasses created, explored, and finally overcome, with a subsequent burst of new freedom. In the mid-1960s, the results of his new freedom are clearly seen in two very different paintings which follow ACCORDING TO WHAT.

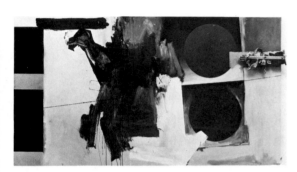

EDDINGSVILLE. 1965. See Plate 120

EDDINGSVILLE (1965) incorporates many of the images of its predecessor, but in a much freer, more spontaneous way. It has a less logical quality, and it conveys a more pleasurable sensation. It exists, as if to say that the same elements can be used another way, but there is also a different feeling.

Another painting, FLAGS (1965), was illustrated in *Time* magazine: "With the advent of op art, somebody was sure to paint something not really there. And now Jasper Johns has done it, by painting a U.S. flag . . . that appears only in the eye's retina. High school students of science know the trick: colors produce afterimages of their complements."[80]

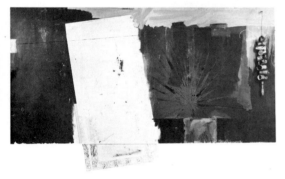

STUDIO. 1964. See Plate 119

Johns described knowing about this optical feature of perception, and the fact that he finally used it, in this way: "People know well that if you drop a glass on the floor, it will break. But some go through life never dropping glasses. For me, this painting was like dropping a glass." It was also a hint of things to come: in later years, well-known optical illusions would become increasingly important in his work.

Meanwhile, he further elaborated the idea of the imprint—the trace of something pressed literally into the paint surface. We can trace this progression from the DEVICE CIRCLE of 1959, through No (1961), in which a bronze cast of Duchamp's *Feuille de Vigne Femelle (Female Fig Leaf)* was pressed into the encaustic surface ("it was something metal that could be heated and pressed into the wax, and it was something I had around the studio"), through the artist's own handprints, footprints, armprints, until finally we have STUDIO and STUDIO 2, in 1964 and 1966,[81] where the screen door, a palmetto leaf, and windows of the studio leave their literal imprint. The trace of natural and architectural elements leads directly to the origin of a new image, and a major painting, HARLEM LIGHT (1967).

STUDIO 2. 1966. See Plate 128

It has a peculiar background. Johns was taking a taxi to the airport, traveling through Harlem, when he passed a small store which had a wall painted to resemble flagstones. He decided it would appear in his next painting. Some weeks later, when he began the painting, he asked David Whitney to find the flagstone wall and photograph it. Whitney returned to say he could not find the wall anywhere. Johns himself then looked for the wall, driving back and forth across Harlem, searching for what he had briefly seen. He never found the wall, and finally had to conclude that it had been painted over or demolished. Thus

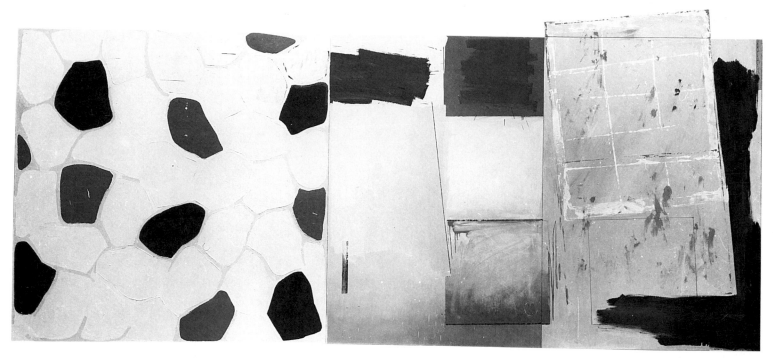

HARLEM LIGHT. 1967. See Plate 129

he was obliged to re-create the flagstone wall from memory. This distressed him. "What I had hoped to do was an exact copy of the wall. It was red, black, and gray, but I'm sure that it didn't look like what I did. But I did my best."

Explaining further, he said: "Whatever I do seems artificial and false, to me. They—whoever painted the wall—had an idea. . . . I wanted to use that design. The trouble is that when you start to work, you can't eliminate your own sophistication. If I could have traced it I would have felt secure that I had it right. Because what's interesting to me is the fact that it isn't designed, but taken. It's not mine."

Once again we are reminded of Johns' often-expressed desire to "work on other levels"; he does not want to invent the flagstone design, but to transform it, once given. That transformation is made more difficult for him, if nothing is given in the first instance. A second idea has to do with "small differences"; one suspects he feels acutely that he cannot re-create the nuances of the original; in working from memory, he will smooth out the roughness, simplifying what is not really so simple—in short, as he says, imposing his own sophistication. Two notebook entries consider this question:

What does it mean?
"There are differences but they are not noticed"

And again:

Making distinctions where

Voice. 1964–67. Oil on canvas with objects, 243.8 x 176.6 cm (8' x 5'9½"). Private collection

Voice. 1966–67. Lithograph, 122.5 x 80.6 cm (48¼ x 31¾"). Published by ULAE

Screen Piece. 1967. See Plate 131

None has existed
None has been said to exist
None has been made

In any case, the final painting exemplifies another Johns dictum, also recorded in his notebooks: " . . . to see that something has happened. Is this best shown by 'pointing' to it or by 'hiding' it?" In Harlem Light a painted-out black swatch crosses two canvas panels. It is hidden, but so visible that it immediately draws the eye. Johns observes: "That's what hiding is—you know it still exists."

The flagstones are an ideal Johnsian image. Like the early flags, they have a referent in reality; they have a pattern that can be seen as abstract or concrete; they have fixed proportions that limit the area of artistic invention; and they were originally taken from the artist's experience, not from his imagination.

Once painted, the flagstone panel of Harlem Light was immediately taken as an impersonal image, to be used in further painting. It appeared repeatedly in later work. So does another image of 1967, first seen in the literally titled Screen Piece: the fork and spoon with the directions, "Fork Should Be 7" Long." The presence of eating utensils reminds us of Johns' comment that "my work feeds upon itself"; in this case, it almost literally does.

Johns had made a two-paneled painting, Voice (1964–67), which included a wire with a spoon and fork. He later made a print of the same name, in which he incorporated the wire, spoon, and fork. These elements were photographed from the painting, to make a photographic plate for the print. Instructing the printers, Johns wrote on the photograph that the fork should be seven inches long—the dimension of the fork in the final Voice print.

Later Johns found the photo lying around the studio. By then it seemed like an object to him, an impersonal thing available for use. He was struck by the small photo with his written instruction to make the image life-size; he decided to enlarge the image to much greater than life-size, but to leave the original instruction. He silkscreened the image onto canvases, and then painted over it. Screen Piece may be a perplexing final result, but it suggests a past, and an origin, even a mundane origin, which in fact it has.

Screen Piece also reminds us that for Johns, printmaking is not a secondary activity to painting, but as important as the painting itself. Screen Piece is mysterious, but it is utterly unfathomable without the understanding of his interest in printmaking, and the interaction of his experiences in printing and painting.

Johns' prints in the late 1960s show a marked exuberance, exemplified by the brilliant series of Figures in Color done at Gemini G.E.L. in 1969. The year before, Johns had gone to California and made a series of ten numerals in black-and-white. Later, he executed a colored series from the same stones.[82] The delicately banded colors were applied laterally—in a sketchbook note, Johns originally considered applying them vertically—with a roller inked with a spectrum of colors.

An insight into Johns' formal procedures comes from the progression of the colors he employed. Johns wanted to begin at zero with the primary colors—red, blue, yellow—and to finish at nine with the secondary colors—orange,

green, purple. In between, he was obliged to construct a series of transformations. These he worked out as a succession of additions and subtractions. That is, Figure 0 is blue-yellow-red. Figure 1 is yellow and red, add blue, giving purple, the new top band. Figure 2 is red and purple, subtract red, giving blue, the top band. Figure 3 is purple and blue, add yellow; and so on. A similar color progression was employed in Johns' 1963 0–9 lithographs, and again later in a series of prints based on Cicada 1979.

Mention must be made of Johns' enormous painting, Map, for the 1967 World's Fair Exposition in Montreal. Based on Buckminster Fuller's dymaxion conception of spatial topography, Map is a huge painting, more than 15 by 30 feet—nearly four times as large as According to What. The painting was so large Johns could work on it only in sections. When he saw it in place, he was dissatisfied with what he had done, and so he repainted it. This enormous effort to rework, to retrieve a false start, is characteristic of his methods. Some artists let it go, saying that their work represents their feelings at the time; Johns reconsiders, even at great cost to himself. Of Map, Lawrence Alloway said: "In appearance the painting is ungainly, splayed jaggedly on the wall, taking its form from Fuller's triangulation. . . . This is not, I think, a failure on Johns's part; on the contrary, it is a part of his move away from the elegant paradoxes of his early work to a brute style, of which this unruly painting is a climax."[83]

This has subsequently proved correct.

Like the dymaxion map, the three panels of Voice 2 (1971) were painted more than once. In its treatment of space, Voice 2 can be related to an earlier painting, Fool's House (1962). In Fool's House, the title is split to suggest a curved space—that is, if the canvas which we see flat on the wall were actually curved in a cylinder, then the title letters would read continuously as one walked counterclockwise around the canvas. Johns did not actually make this space; he merely provides clues to suggest another space. Similarly a flat map contains clues that it represents a curved reality, the globe of the earth.

Map (based on Buckminster Fuller's Dymaxion Airocean World). 1967–71. Encaustic and collage on canvas, 4.72 x 10.06 m (15'6" x 33'). Museum Ludwig, Cologne

It may be that Johns' work on the dymaxion MAP reawakened these thoughts of curvature. VOICE 2 is also intended to represent a curved space; that is why the panels can be arranged in several different orders. In Johns' notebook directions, they can be hung as

A B C

or

B C A

or

C A B

This is the equivalent of having the three canvases bent into a circle, which seen from above looks like this:

In other words, a walk around this imagined circle would give various possibilities for the order of the canvases, depending on where one started. The fact that the canvases are presented as flat—with a circular space only suggested—

leads to suggestions of matching and congruity, which has been a significant theme in his work since 1971.

For example, there is DECOY (1971)—so named because "it was supposed to draw the birds"—which stands in a similar position to his prints as ACCORDING TO WHAT does to his paintings seven years before. It is a catalog of Johnsian imagery, a summary of many years of work.[84] Taken purely as a print, it incorporates elements of the prints PASSAGE I and PASSAGE II, notably the bent spectrum and the cast leg; the ALE CANS; and below, in boxes, the panoply of flag, flashlight, light bulb, ale cans, paintbrushes, and numbers. Overall the composition suggests an inverted "target with plaster casts," but it is distinctly a print, and not a painting.

In fact, one might think of DECOY as PASSAGE III. Years before, Johns made his two PASSAGE prints, and then attempted a third version, which was to consist of elements from the earlier prints, rotated about an axis. He abandoned the project when he found that he could not make this rotation clear; the idea behind the print could not be discerned by the observer. But he revived elements of this idea with DECOY, in presenting elements of former work in a new perspective, a new spatial orientation. In doing so, Johns provokes a powerful impulse to "match up" this image with others he has made. Although the title suggests that this effort is false—the work is a decoy, deluding the follower—the impulse to assemble fragments and ideas remains.

Another example of "matching," and of an imagined space hinted at—but not represented—by the configuration of the paintings, is shown in UNTITLED (1972). This is a four-panel painting. On the right, there is a panel of wood strips, to which wax casts of body parts are attached. Johns originally intended to cut holes in the canvas, and attach the casts onto the canvas flaps. But the flaps would have fallen down under the weight of the casts, and the panel would have been unwieldy for movement and storage. So he settled instead on wooden strips, fastened by bolts with wing nuts. Having decided that, he felt that he ought to number and color-code them, for easy assembly and disassembly (or dismemberment).

Next to the wax-cast panel are two central panels of flagstone images. And on the left, a fourth panel composed of crosshatching marks, a new Johnsian motif.

The crosshatching image had its origins in a fleeting visual experience. "I was riding in a car, going out to the Hamptons for the weekend, when a car came in the opposite direction. It was covered with these marks, but I only saw it for a moment—then it was gone—just a brief glimpse. But I immediately thought that I would use it for my next painting." The experience, and the image, remind us of the flagstones—man-made marks, glimpsed from a passing car, making an indelible impression.

The crosshatch elements in UNTITLED are juxtaposed to the other panels: the flagstones and the cast pieces. These apparently unrelated elements provoke a visual search. An overall visual coherence is provided by the similar size of the elements in all the panels. At the same time, the two central panels share the same imagery, making four panels when one might logically expect only three. And the midpoint break between the two flagstone panels seems arbitrary; it bothers the eye, until one sees that the images in the two flagstone panels par-

DECOY. 1971. Lithograph, 104.1 x 73.7 cm (41 x 29"). Published by ULAE

UNTITLED. 1972. See Plate 148

57

tially overlap, thus forming, in the mind's eye, a single central panel. But the flagstones do not overlap at the center, but rather at their left and right sides. Once noticed, this has the further quality of suggesting that the panels might be out of order, or that they might be arranged in some other fashion. We might also suspect more panels could be added at either end. Thus there are conflicting ideas of unity and discontinuity, openness and integration. But chiefly one comes away from this painting with the sense of subtle provocation and search—notions that would be increasingly elaborated by Johns in the years to come.

CORPSE AND MIRROR. 1974. See Plate 162

The crosshatches in the fourth panel of UNTITLED (1972) became the principal motif, the chief visual language of his work for the next eight years. The paintings of 1973–82 are primarily crosshatch paintings.[85]

CORPSE AND MIRROR (1974) is a largely black-and-white painting in two panels which immediately suggests a further extension of Johns' concerns with the theme of matching. The title derives from art history. According to André Breton, the Surrealists devised a game—actually a child's game—using a piece of paper folded into several sections:

> EXQUISITE CORPSE—*Game of folded paper which consists in having several people compose a phrase or a drawing collectively, none of the participants having any idea of the nature of the preceding contribution or contributions. The now classical example, which gave its name to the game, is the first phrase obtained in this manner:* The exquisite corpse—shall drink the young—wine.[86]

Johns has said that he executed this work by painting the three sections of the left-hand panel without reference of one to another, and then creating a modified mirror image of the result on the right-hand panel. Thus the corpse, and the mirror of the corpse. The large X in the right-hand panel has provoked critical commentary; Johns thought of it as a cancellation mark, the way printing plates are cancelled with an X. This further denotes the right-hand image as a mirror image, just as a printing plate is a mirror image.

This idea of the corpse and mirror—of the panels related to each other in various ways—suggested to Johns a number of other ideas, as the original flags had triggered further ideas. And just as the early paintings of 1955–58 seemed to emerge fully elaborated, as a coherent and self-contained body of work, so too did his crosshatch paintings of 1973–82 quickly come to stand as a complete body of ideas in a new visual idiom.

Most of the compositional ideas for these paintings can be formally expressed by the way the crosshatch lines intersect different panels of the paintings. These paintings have rigorous formal plans, just as a flag does. But the plans are not necessarily obvious, and thus they often provoke visual search, or a comparison.

Consider the intricate and tantalizing SCENT (1973–74). This is a large painting in three panels, each painted in different material: oil paint covered with varnish, oil paint without varnish, and finally encaustic. The title suggests the hunt; it also recalls Jackson Pollock's final painting, of the same name.[87]

Yves Tanguy, Joan Miro, Max Morise, and Man Ray. *Figure (Cadavre exquis).* 1926–27. The Museum of Modern Art, New York

True to its name, SCENT hints at a more complex underlying order. At first it appears to be a random array of secondary colors, green, orange, and purple painted with a distinctness that evokes the flagstones. Then one notices that the underlying arrangement cannot be random, since no crosshatch area abuts another area of the same color. The presence of a second level of order is suggested by the faintly visible vertical lines that divide each panel into three sections; they are particularly visible in the leftmost panel. That Johns did not obscure these lines reminds us of his ideas about "hiding."[88] In fact, SCENT is structured as a painting with nine separate elements. From FOOL'S HOUSE and VOICE 2, we are alerted to the possibility of a curved space, as indicated by a congruity of the extreme right- and left-hand borders of the painting. We find it again in SCENT: the first element on the extreme left is repeated as the ninth element on the extreme right. Continuing this idea, we see that the elements which abut the junctions between the canvases are always identical; only the middle element of each canvas is unique. In other words, if the three vertical elements of the first canvas were labeled A B C, the second canvas would be C D E, and the third E F A. The possibility that the canvases could be rearranged is clearly indicated.

SCENT provokes a search, and exemplifies Johns' use of the painting as a subject of inquiry. Other paintings of this period seem more involved with the idea of the painting as surrogate, a stand-in for some other reality, an artificial creation which represents something else. Thus THE BARBER'S TREE (1975), painted in flesh-and-blood colors, and reminiscent of a striped barber pole, was actually

THE BARBER'S TREE. 1975. See Plate 166

The Barber's Tree. Photograph by Charles O'Rear

THE DUTCH WIVES. 1975. See Plate 167

UNTITLED. 1975. Oil, encaustic, and collage on canvas, 127.3 x 127.3 cm (50⅛ x 50⅛″). Private collection

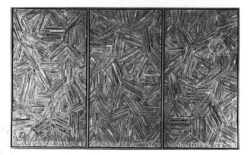

USUYUKI. 1977–78. Encaustic and collage on canvas, 89.2 x 143.8 cm (35⅛ x 56⅝″). The Cleveland Museum of Art. Leonard C. Hannah, Jr., Fund

USUYUKI. 1979. Ink and acrylic on plastic, 84.1 x 130.5 cm (33⅛ x 51⅜″). Mr. and Mrs. Barton Cohen

suggested to Johns by a photograph in the *National Geographic,* which showed a Mexican barber who had painted his tree.[89] Probably the underlying idea of painting over reality was what interested Johns.

THE DUTCH WIVES (1975), two panels in subtle blacks and grays, is a kind of reverie on duplication. They are done in encaustic, and the newspaper strips are repeated in the two panels. One thinks of Johns' concerns with mirror images and doubles; and his idea that having done something once, it could be done again differently. The painting seems to ask what the difference is, or what constitutes a difference in the mind's eye, and its title directs our attention to the notion of a surrogate. (A Dutch wife is a board with a hole, used by sailors as a surrogate for a woman.) The two panels of THE DUTCH WIVES are not identical, as some observers have taken them to be. Their edges are largely identical, but as one moves toward the center, the differences between the panels become more pronounced.

His fascination with distinctions at the borders continued with UNTITLED (1975), a painting which explores a geometrical idea: to provide all the possibilities for the interactions of lines in a single painting. UNTITLED is a square image composed of four panels, one large and three small rectangles. The large panel is arranged in such a way that the top and bottom, and right and left edges are the same—that is, if red lines run off at the top, they will run off at the same position on the bottom, and so on.

The adjacent smaller panels meet at five junctions. Reading down, they are ordered in this way: 1) the lines are mirror images; 2) directions of lines and colors change; 3) colors continue but directions change; 4) directions continue but colors change; 5) directions and colors continue unchanged.

A later painting, USUYUKI (1977–78), conveys an airy, even cheerful sense of harmony, although its underlying structure is intricate. The title is the Japanese word for "light snow," and its three panels suggest swirling snowflakes. The three panels in fact contain fifteen repeating elements, which spiral downward.

G	H	I	L	J	K	N	O	M
D	E	F	I	G	H	K	L	J
A	B	C	F	D	E	H	I	G

The spiral plan calls for most elements in the left-hand panel to repeat one step down and one step to the right, in the middle panel, and again down and to the right on the right panel. This formal arrangement is far more complex than earlier crosshatch images, and unlike some previous paintings, USUYUKI offers no easy clues to its existence. There is no suggestion in this first painting that the plan is meant to be discovered; it is simply the way the image was created.

Johns later reworked the image, modifying this plan in various ways. Thus a 1979 drawing made the plan more explicit, by clearly dividing the panels into

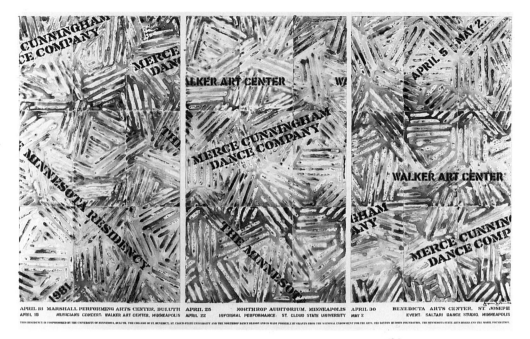

USUYUKI (study for poster for Merce Cunningham Dance Company). 1981. Ink and watercolor on plastic with lithography, 92.1 x 129.5 cm (36¼ x 51″). Collection Robert and Jane Meyerhoff, Phoenix, Maryland

CELINE. 1978. See Plate 176

CICADA. 1979. See Plate 179

twenty-seven numbered units, thus defining the blocks that composed the image. At the same time, the plan itself was slightly changed, so that the swirl became somewhat different. Another drawing suggested an upward spiral, and used color in the panels to give explicit clues to the plan. And still later, Johns chose this same colored image as the basis for a poster for the Merce Cunningham Dance Company (1981). Here, his truncated text (echoing his interest in labels) at last reveals the plan unambiguously, and adds a new element of search. But by now his image has moved a long way from Japanese snow.

Although many of the crosshatch images, such as CORPSE AND MIRROR, SCENT, and USUYUKI, are colorful and bright, seeming to delight in their formal arrangements, Johns executed a number of darker images as well during this same period.

In END PAPER (1976), Johns returned to the original association of crosshatches and flagstones, creating a dark, rather grim painting in secondary colors. END PAPER is notable for the visual equation of the two motifs; here Johns has straightened the edges of the flagstones to make them reiterate the composition of the crosshatches. By doing so he emphasizes both motifs as units within a superimposed structure—as the earlier alphabets were units within a structure. This association with alphabets is fitting, for the title derives from Johns' collaboration on a book with Samuel Beckett.[90] The book, *"Foirades/Fizzles,"* was published in 1976, and these two images, the flagstones and the crosshatches, form the endpapers.

Similarly, CELINE (1978), named for the French writer, is shadowy and disturbing, its dark order confining. Observes Mark Rosenthal: "The frantic hand prints in CELINE suggest . . . the spirit of the writer's *Journey to the End of the Night,* wherein death is pervasive. . . . "

An important crosshatch drawing of the next year, CICADA, follows still another formal plan: its lines reverse, from horizontal, secondary colors at the

CICADA (detail). 1979

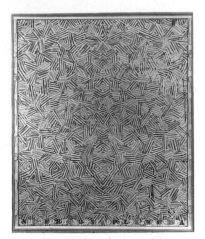

Dancers on a Plane. 1979. See Plate 181

Mystical Form of Samvara Embracing His Shakti (reproduced in Dancers on a Plane)

Tantric Detail. 1980. Charcoal on paper, 147.3 x 104.1 cm (58 x 41"). Private collection

periphery, to vertical, primary colors in the center.[91] Johns notes: "I wanted to do one thing that suggests two things." He was interested in the fact that the cicada contains another version of itself inside its shell, an insect that eventually becomes winged and flies away. Below the crosshatch area, the artist has drawn a series of images which at first give the impression of doodles or sketches. Some images, like the skull and crossbones, are already familiar from Johns' earlier work, but others appear here for the first time—testicles, a burning Tantric lamp or funeral pyre, a yoni, a necklace of skulls, and four images of a cicada. A newspaper headline ("Pope Prays at Auschwitz/'Only Peace'") adds a contemporary source. Critics noted that "the range of subjects . . . clearly evokes cycles of life: acts of creation, periodic change, as in the long growth period and short adult life of the insect; and death."[92] Many of these images would reappear in paintings over the next two years.

That a cicada is a creature that emerges into day after living seventeen years underground has not escaped critical notice. And the image presaged a period in which many observers felt that Johns himself was at last emerging into day.

Early in his career, Johns stated repeatedly that he did not want his work to be an exposure of his feelings.

But in a 1978 interview, he revised this view: "In my early work, I tried to hide my personality, my psychological state, my emotions. This was partly due to my feelings about myself and partly due to my feelings about painting at the time. I sort of stuck to my guns for a while but eventually it seemed like a losing battle. Finally one must simply drop the reserve. I think some of the changes in my work relate to that."[93]

Dancers on a Plane (1979) is painted in the bright primary colors of the early crosshatch images, but its fixed symmetry conveys a sense of bleak, rigid constraint. Johns has indicated that when he painted it, he was going through a difficult time. He was looking at Tantric art, "thinking about issues like life and death, whether I could even survive. I was in a very gloomy mood at the time I did the picture, and I tried to make it in a stoic or heroic mood. The picture is almost uninflected in its symmetry. There is no real freedom. The picture had to be executed in very strict fashion or it would have lost its meaning."

Johns has related this painting to a seventeenth-century Nepalese work, *Mystical Form of Samvara Embracing His Shakti*. And indeed the composition Dancers on a Plane subtly reiterates the Tantric original.

Johns planned a second version of the painting, in darker tones. "Having finally accomplished the first picture in this even fashion, I started thinking of the same information in a different order—or tone of voice—or emphasis. But by the time I got around to it, I wasn't in that mood. I didn't think of the information that way. . . . The second picture took the same information and was more playful."

The underlying sexual imagery becomes explicit in the second painting: testicles and an erect penis appear, as do elements of the Tantric original. Thus the vertical dotted line that bisects the canvas, Johns says, is "all that is left" of a string of pearls around the neck of the goddess.

Further versions were even more explicit. After a 1980 drawing, Tantric

62

DETAIL, he executed three paintings based on the same image. "I wanted to make a more overt reference, a clearer reference to that aspect of those pictures." These later images all include a centrally placed skull and testicles, and thus suggest, however obliquely, a human figure in the midline of the image.

The perception that Johns might now be exploring ways to portray a human figure in his work is, in a sense, confirmed by BETWEEN THE CLOCK AND THE BED, a crosshatch image that relates to a painting by Edvard Munch.

In 1981, a friend sent Johns a postcard of a self-portrait by Munch entitled *Between the Clock and the Bed.* The friend had noticed the bedspread, with its crosshatch motif so similar to Johns' own. But it is likely that Johns was more interested in the possibility of suggesting a figure. He was struck by the title: "The Munch painting is tantalizing, but I don't think the title is even his. You would think it would be called 'The Artist Between the Clock and the Bed.'" He notes further that "'Between the clock and the bed' implies three things, not two." That third thing, unstated in the title, is the image of the artist himself.

Johns executed a watercolor, and then the first of his paintings entitled BETWEEN THE CLOCK AND THE BED, the same year. Like other crosshatch paintings, these follow an explicit formal plan. There are three panels; the left and right panels mirror each other, while from the center panel, the lines continue straight across from the left, and are reflected on the right.

But although such formal considerations once appeared to determine the painting, here they are almost secondary, for Johns' image refers directly to major pictorial elements of Munch's own composition—a grandfather clock on the left, a bed on the right, and Munch himself, standing uneasily in the center.

Johns' third painting of BETWEEN THE CLOCK AND THE BED (1982) reverses the crosshatch structure, but retains the original positions of the elements of Munch's composition. With each variation, the crosshatches seem increasingly to convey a sense of entrapment, from which the artist struggles to break free. Johns himself made a break in the very next painting he did.

Both the title and the imagery of IN THE STUDIO (1982) suggest we are looking at a view of the artist's studio wall. A real stick leads us to the painted space, which includes a cast arm hanging from a real nail alongside a painted drawing of the inside of the cast, nailed on the wall with painted nails. To the right, two versions of BETWEEN THE CLOCK AND THE BED appear, the second melted in encaustic. The drips run toward the lower quadrant, where an unsized canvas leans against the studio wall.

The idea for the painting was suggested to Johns by a canvas propped against the wall. He noticed it as an interesting shape, and decided to make a picture using it. Similarly, other elements of the painting are taken from his studio: Johns had cast the arm of a child over a period of years, intending to make use of it eventually. As part of this work, he had made drawings of the inside of the cast, to work out where he would apply colors when he cast the arm, since the colors were added during the casting process, not afterward; and he had been working on a drawing of BETWEEN THE CLOCK AND THE BED at the time.

These elements from life are revised in the painting. The cast hand does not follow the plan of the drawing; the yellow and blue colors are reversed. The two

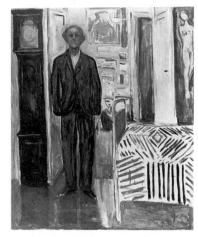

Edvard Munch. *Between the Clock and the Bed.* 1940–42. Munch-museet, Oslo

BETWEEN THE CLOCK AND THE BED. 1981. Watercolor and pencil on paper, 56.7 x 78.7 cm (22⅓ x 31″). Private collection

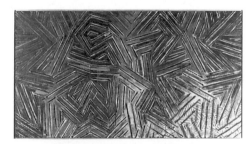

BETWEEN THE CLOCK AND THE BED. 1982–83. See Plate 188

IN THE STUDIO. 1982. See Plate 190

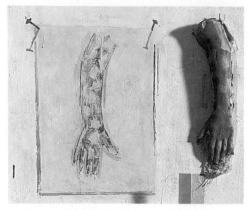

IN THE STUDIO (detail). 1982

PERILOUS NIGHT. 1982. See Plate 191

Matthias Grünewald. *Resurrection,*
right wing of the *Isenheim Altarpiece.*
c. 1510–15. Musée Unterlinden, Colmar

Matthias Grünewald. *Resurrection,* right wing of the
Isenheim Altarpiece (detail)

images of BETWEEN THE CLOCK AND THE BED are not the same, even before the lower one began to melt. And there is a good deal of overt illusionistic play: the painted nails; the painted drawings and canvases; the paint spatters on the wall; and the melting encaustic from the drawing, which is made to clearly disrupt the illusion of the leaning canvas below.

Johns says he considers IN THE STUDIO reminiscent of innocence and childhood, noting the lightness and division of the colors, the youthfulness of the cast hand, and the patterning which he considers "rather light and tender." He observes, "There is nothing very coercive about the painting."

Very different in mood is a second painting of that same year, PERILOUS NIGHT, in which many of the same pictorial elements reappear. Once again, Johns paints a wall, though this one is dark and somber. Again, a stick is appended, though here it is placed far to the side. Again, cast arms hang, this time three casts of clearly different ages. An image that seems to relate to BETWEEN THE CLOCK AND THE BED appears beneath the middle arm. Again, there are drips on the wall. And again, there is illusionistic play, particularly in the handkerchief nailed to the wood-grained wall. The title of the painting derives from a composition by John Cage, whose score is silkscreened onto the upper right corner of the painting.

But PERILOUS NIGHT seems to be dominated by a large, darkly painted image on the left half of the canvas, which is repeated in a smaller version on the right, where it is nailed to the wall. The identity of the dark image is not immediately apparent, but Johns has said it is a detail from the *Isenheim Altarpiece,* painted by Matthias Grünewald about 1510–15. The meaning of this "embedded image" in Johns' painting has aroused considerable critical speculation.

Johns first visited the cathedral at Isenheim in 1976, and saw the Grünewald altarpiece then. "It's very impressive, very big, it seems to explode through the space. It has a quality that is very glamorous, sort of like a movie." Aware that Johns admired the work, a friend later sent him a portfolio of prints showing details from the altarpiece. As Johns looked through them, he had an intuition. "I found the details so interesting and handsome, that as I looked at them I had the feeling there was something in the way these things are structured that was important, and free of the information that the images convey." To understand what it might be, he began to trace the drawings.

"I felt there was some aspect that seemed to be 'underneath' the meaning— you could call it composition—and I wanted to trace this, and get rid of the subject matter, and find out what it was. I tried to approach it by tracing and filling it in with a loose wash.

"I only got a few of them to work, from my point of view. I probably tried five of them—but only a few seemed to be free of the original imagery enough to suggest what I had in mind. With the others, you can't get away from what they mean. The organization is such that they can't give way to be suggestive. But two or three seemed to work."

One of those images, the fallen soldiers in the Resurrection panel of the altarpiece, appears, reversed and rotated, in the left panel of PERILOUS NIGHT. And it is repeated, in another configuration, on the right.

This was not the first time Johns had traced the work of other artists; he had

traced a reproduction of Cézanne's *Les Grandes Baigneuses* in 1977, and a Jacques Villon etching of Duchamp's *The Bride* the following year. An artist who deals in precise measurement, his interest in tracing has been apparent throughout his career, and has been employed to many different ends.

In the case of the Grünewald altarpiece, his description of the tracing suggests he was interested in understanding how another artist had achieved his effects. Or what it was that gave an image power even when deprived of context and literal meaning.[94] As for why he included his tracing experiment in PERILOUS NIGHT, Johns has never answered directly, but in another context he has said, "I think that one wants from a painting a sense of life. . . . The final statement has to be not a deliberate statement but a helpless statement. It has to be what you can't help saying."[95]

Whatever the reason, PERILOUS NIGHT marks the start of a period in which Johns explicitly embedded traced images of other artists, transformed and revised, within his own work.

Once established, the divided-wall composition was reworked and elaborated in subsequent paintings. The wall appears again in UNTITLED (1983), but here it is a bathroom wall, with faucets and a wicker clothes hamper. The painting has been made from the point of view of someone sitting in the tub. (Johns has identified this as the bathroom at his house at Stony Point.) Again, there is a cast arm; an image from Johns' repertoire (the Savarin cans, against a background of cross-hatching); an image not his own (a Swiss sign with skull and crossbones, warning of avalanches). And another embedded detail from the *Isenheim Altarpiece:* a crouching demon, here drawn in a manner that suggests both the earlier cross-hatch paintings and a puzzle. Though not as gloomy as its predecessor, UNTITLED is still ominous and doubtful.

In RACING THOUGHTS (1983), trousers hang from a hook on the wall, and the pictorial elements are again changed or revised: a photo of Leo Castelli as a puzzle; a collaged Mona Lisa iron-on; a Barnett Newman print; the Swiss avalanche sign; and resting on the wicker hamper, a George Ohr pot and a commemoration cup for the Silver Jubilee of Queen Elizabeth II. The painting conveys a strong sense of personal reference; all the objects portrayed were actually found at Johns' house in Stony Point.

But in RACING THOUGHTS, they seem about to break away, to float free. There is a sense of impending chaos, of rapid change, reinforced by the title. Johns recalls, "I was in St. Martin and I kept having images race through my head when I tried to go to sleep. I mentioned it to a child psychologist who was staying at a hotel there, and he said, 'We call those racing thoughts.' I remember thinking, 'Oh, they have a name for it. They have a name for my problem.'"

In his next painting, VENTRILOQUIST (1983), the elements do break free. The divided-wall composition is represented as a real bathroom door, complete with realistic hinges. But the door contains an embedded image, based on a Barry Moser engraving for *Moby Dick*. And while the faucets and hamper are reassuringly present, the Jubilee cup stands in unclear relationship to the wall behind it; a Barnett Newman print has been reversed, and its left frame painted out; and seven Ohr cups float in an uncertain space that seems differently defined in

TRACING (after Cézanne). 1977. Ink on plastic, 9.8 x 14.3 cm (3⅞ x 5⅝"). Private collection

TRACING (after *The Bride*). 1978. Ink on plastic, 59.7 x 40.6 cm (23½ x 16"). Private collection

UNTITLED. 1983. See Plate 198

VENTRILOQUIST. 1983. See Plate 197

Barry Moser. *Moby Dick*
(illustration detail)

different parts of the canvas. This ambiguous space seems particularly uncertain at the borders of the reverse-color TWO FLAGS taped to the door and the wall.

Johns has said, "My experience of life is that it's very fragmented. In one place, certain kinds of things occur, and in another place, a different kind of thing occurs. I would like my work to have some vivid indication of those differences. I guess, in painting, it would amount to different kinds of space being represented in it."[96]

Later, Johns observed, "I think most of the power of painting comes through the manipulation of space." And he added, "But I don't understand that."

In the brightly colored large canvas UNTITLED (1984) the floating quality has vanished. Here the elements are firmly fixed, outlined in black; and the painting seems to follow a rigid formal structure. Three images of casts—feet, knee, and face—are evenly spaced across a bisected canvas. The overlapping images on the wall behind contain many subtle repeating rhythms and paired images. Johns notes the appearance of two vases; two heads in one vase; two heads again in the illusion picture. We might add further pairings—two taps for the tub, two embedded images, two faces, two bisected images, two sexual allusions.

This painting is also the first to include the well-known optical illusion which can be seen as either an old woman or a young girl with her head turned away. Based on a 1915 drawing by W. E. Hill called "My Wife and My Mother in Law" it is a classic example of an ambiguous figure. Johns had previously not hesitated to use well-known illusions, turning them to his own ends: the complementary colors of FLAG (1965) intended to make an eidetic image, and the figure-ground profile goblet he first employed in SKETCH FOR CUPS 2 PICASSO (1971), in which he drew profiles of Duchamp and Picasso. His interest in these illusions had led him to acquire the cup made to celebrate Queen Elizabeth's Silver Jubilee, containing the profiles of Elizabeth and Prince Philip, which has appeared in several paintings starting with RACING THOUGHTS. Johns later added to this repertoire of ambiguous figures the duck/rabbit which, according to Barbara Rose, Johns first saw in a publication by Ludwig Wittgenstein.

W. E. Hill. Illusionistic drawing:
wife/mother-in-law (detail)

SKETCH FOR CUPS 2 PICASSO. 1971.
Watercolor on paper, 52.1 x 39.4 cm
(20¼ x 15½″). Collection the artist

UNTITLED. 1984. See Plate 204

The orderly progression of Johns' paintings, widely recognized as a feature of
his work, is often thought to reflect a rigorous step-by-step working method. In
fact, Johns' records reveal a much freer procedure, as indicated by the order in
which he made paintings in the period from 1982 to 1984:

UNTITLED (1981–82)
DANCERS ON A PLANE (1982)
IN THE STUDIO (1982)
PERILOUS NIGHT (1982)
USUYUKI (1982)
BETWEEN THE CLOCK AND THE BED (1982–83)
FLAG (1983)
BETWEEN THE CLOCK AND THE BED (1983)
BETWEEN THE CLOCK AND THE BED (1983)
BETWEEN THE CLOCK AND THE BED (1983)
UNTITLED (1983)
RACING THOUGHTS (1983)
VENTRILOQUIST (1983)
RACING THOUGHTS (1984)
UNTITLED (1984)

Because Johns returns again and again to earlier images, it is perhaps not sur-
prising that he should undertake a new image, the studio wall, and elaborate
upon it in PERILOUS NIGHT, but then go back to do a fourth version of USUYUKI.
Next, he paints a third version of BETWEEN THE CLOCK AND THE BED, and then
another FLAG. Following that, he paints three small versions of BETWEEN THE
CLOCK AND THE BED, before finally returning to the motif of the bathroom wall,
which he then elaborates in three successive major paintings of 1983.

There are several implications in this order of paintings. One is that Johns
does exactly what he says he does, painting "what I am helpless to do." His pic-
tures may represent the flow of his ideas, leading him from one canvas to the

next; certainly Johns has many times stated his preference that his work be considered in chronological order, suggesting that this flow is important. But the actual progression of his ideas is more complex than critical assessments ordinarily allow. Thus, critical commentaries which draw comparisons between one image and another must be understood as simplified impositions of structure on a body of work which actually occurs in a far more complex way—a perception that would be heightened if one were to include the twenty-four drawings and nine prints Johns also made during this two-year period.

Finally, one must consider the possibility that Johns' preference for found images may underlie his tendency to wait a period of time before returning to a new image, and elaborating upon it. Certainly this tendency can be found throughout his career. For example, the tripartite RED YELLOW BLUE "flag" of OUT THE WINDOW (1959) became an available composition that was employed in a series of paintings years later, beginning with PASSAGE (1962). And the crosshatch imagery first appeared as one panel of a painting in 1972. Johns next painted two flags; a target; and he made a number of drawings and prints, before finally returning to the crosshatches as a motif in the following year.

In 1985, Johns executed several UNTITLED paintings which can be understood as details or elaborations of the now-established bathroom wall composition. The images are notable for a concealed structure: the letter I, with its simultaneous puns on construction, illumination, smiles, primacy, identity, singularity, vision, and affirmation; one might even say these paintings allow the viewer to catch Johns' eye.[97]

Later that same year, an entirely new image appeared in his work. Johns had recently moved into a Caribbean studio on the island of St. Martin, and he was contemplating moving into a new house in New York as well. It was a time of transition, and dislocation. Looking through David Duncan's book of photographs *Picasso's Picassos,* he was struck by a small 1936 painting, *Minotaur Moving His House.*

"It was the subject matter more than the structure of the painting that interested me. . . . More than most of his paintings, the catalog of things is very layered. . . . And, of course, it was very odd to see the cart before the horse: the minotaur is pulling the cart, and on it is a horse giving birth. There was something very wonderful, very interesting in an unexpected way. It's not the pursuit of logic. I thought, how did he have that thought? I wouldn't have that thought."

Soon after, Johns began a painting that referred to the work. The bisected canvas contained Johns' own shadow on the left, cast across the green tiles of his studio in St. Martin. On the right, a rope, ladder, and layered imagery suggested by the Picasso painting—although in this instance the baggage was Johns' own. Along with the device circle, paired flags, Mona Lisa iron-on, embedded imagery, and floating Ohr cups, two new references appeared. There were a circle, triangle, and square, suggested to Johns by a nineteenth-century brush painting by the Zen master Sengai; and a sea horse, which can be thought to refer to his Caribbean residence, and also to the horse in Picasso's work.

This painting was still untitled when Johns was asked to contribute to a special

SUMMER. 1985. See Plate 213

volume of Wallace Stevens poetry. Recalling Stevens' poem "The Snow Man," Johns thought he might do four prints of the seasons to illustrate the book. It occurred to him then that the painting he had just completed could serve as SUMMER in such a series.

The original painting, intended to stand alone, now had to form the basis for three further images. He recalls, "It was sort of difficult to keep them from being boring, trying to decide what could be added or subtracted." Since the original painting was divided in half, he thought to make successive images that shifted by a quarter. This would move the figure to the sides, and place the objects in the center. Another quarter turn would place the objects on the left, the shadow on the right. A final quarter turn would place the objects on the sides, the figure in the center. "That's the way I began to think about how to get four, without having four of the same thing."

He painted WINTER next, but he executed it in the format intended for FALL. "Riva Castleman visited my studio and pointed out that I was doing it wrong." Johns was obliged to cut the left quarter of the canvas, and reposition it on the right. Subsequently, he painted FALL, and then SPRING, completing the last of the canvases in 1986.

In addition to the formal, progressive compositional structure that unites the four images, Johns added many further linkages. The four shadows are cast on four different walls, each referring to one of Johns' residences: SUMMER has bricks from his Stony Point house, glazed green; WINTER has tiles from the courtyard of his new house in New York; FALL has boards from his residence on Houston Street; and SPRING has tiles from his house in St. Martin. The shadow in SPRING, obscured by rain, is clear by SUMMER and FALL, but in WINTER is again obscured by snow. A bare tree buds in SPRING, leafs in SUMMER, breaks in FALL, and is snow-covered in WINTER. The hand that describes the device circle is nearly vertical in SPRING, but points progressively downward by WINTER. The ladder which holds together the objects is unformed in SPRING, solid in SUMMER, broken in FALL (where the objects literally fall), and wired together in WINTER. Beyond this, the objects follow their own progression. The cups that point upward in SPRING and SUMMER, tumble down in FALL, are inverted in WINTER.

Within this progression, Johns adds suggestions of circularity as well; the youthful imagery of spring, with such illusions as the duck/rabbit, are replaced by the flags and by Duchamp's profile, only to be echoed in the childlike snowman that appears in winter, as if to say seniority brings its own renewed simplicity.

Taken together, the four paintings can be read as Johns' meditation on the human life cycle, or as a narrative of his own life as an artist. Characteristically, Johns casts doubt on such perceptions. He has said: "I don't really see that it's a narrative, in that I don't see what it narrates—unless you think that the narration of the seasons is in itself a narrative. I don't see it that way. In a sense, none of it represents me. And in a sense, all of it represents me. It's like any other painting in that respect. You can say that it does, or you can say it doesn't."[98]

In any case, the layers of imagery and allusion have formed the basis for a large number of drawings and etchings based on THE SEASONS in the years since. Of that extended effort, Johns says, "I would like to be rid of it, but I continue to

WINTER. 1986. See Plate 215

FALL. 1986. See Plate 214

SPRING. 1986. See Plate 212

UNTITLED. 1984. Pastel and pencil on paper, 56.5 x 41.9 cm (22¼ x 16½"). Collection the artist

UNTITLED. 1990. Oil on canvas, 45.7 x 45.7 cm (18 x 18"). Private collection

UNTITLED. 1991. Oil on canvas, 152.4 x 101.6 cm (60 x 40"). Private collection

think of things to do. Often it seems to me I have worked with it for too long, but something keeps popping up. . . ." And he adds, "Part of working has the appearance of a detail that you have to attend to. Whether you enjoy it or not has nothing to do with it. You have to do it, or you aren't doing your work properly. From the point of view of the audience, the work wouldn't be seen that way. But that is my experience in doing it."

In 1988, Johns, then 58 years old, was the American entrant at the Venice Biennale, where he won the Grand Prize, the Golden Lion. A major retrospective at the Philadelphia Museum of Art that same year provoked extensive critical evaluation of Johns' mature work.

Unlike some earlier shifts in Johns' work, his later paintings were generally received with pleasure. The critical response focused on their complex puns and references, their dreamlike quality, and their presumed preoccupation with mortality. William Gass observed that "Johns worked on the layout and execution of a set of symbols, which, taken together, might be said to be 'in the studio of the artist's head.' "[99] Richard Francis: "They are clearly being seen with the mind's eye, and as you would expect with imagery of this kind they locate themselves below, above, and between the layers of the real world. . . ."[100] Carter Ratcliff: "A secret order seems to pervade Johns' paintings. It may elude the mind, but the eye senses it—a relentless will to find clarity in chaos, a reason for hope amid intimations of mortality."[101] Robert Hughes: "Inevitably, the centerpiece of the Biennale is the . . . show of Jasper Johns' work. . . . One leaves it convinced he is the deepest of living American artists, a painter whose subtlety and richness of imagination stand beyond doubt even when, as sometimes happens, one cannot find a direct way among the hints, inversions, repetitions and false scents in which his art abounds."[102]

Back in 1984, Johns had made a drawing of a human head in which the eyes, lips, and nose were positioned at the edges of the paper. Johns first related this "rectangular head" to a 1936 Picasso painting, *Straw Hat with Blue Leaf.* "I became interested in looking at that painting in the book—suddenly it held my

attention. It became extremely poetic, something that conveys many meanings at once. While looking at it, it interested me that Picasso had constructed a face with features on the outer edge. I started thinking in that direction, and it led me to use the rectangle of the paper as a face and attaching features to it."

The idea that the head is related to a piece of paper is made playfully explicit in a later painting. But the actual inspiration for this rectangular head remains unclear. Johns says he associates the head with "something infantile," which is not an association one would necessarily make to the Picasso original. And some time after he had established the image, Johns recalled something he had seen in *Scientific American* years before. A search of back issues yielded a 1952 article by Bruno Bettelheim on the art of a schizophrenic child—and a drawing by a disturbed young girl which closely resembled the image Johns had drawn, thirty-four years later.[103]

Whatever its origin, Johns originally used the rectangular head as a back-ground on which to pin an embedded image from the *Isenheim Altarpiece*. Then in 1985, before starting the painting that would eventually be SUMMER, Johns executed a small UNTITLED painting which repeated the rectangular head, this time with a watch nailed to it. Over the next two years, while he worked on the paintings of THE SEASONS, Johns continued to elaborate this new imagery as well, in seven paintings that he has referred to as "little pictures made tentatively."

The rectangular head motif was first integrated into a large canvas with other images in 1987, when Johns executed an UNTITLED encaustic and collage paint-ing. Here, the rectangular head, the Picasso head, and the wife/mother-in-law figure appear illusionistically nailed to a background wall of Isenheim imagery.

And in the years since, the rectangular head has served as the basis for several other paintings which make more explicit reference to Johns' own childhood. Two paintings of 1989, both entitled MONTEZ SINGING, show the rectangular face with a draped handkerchief, on which appears a boat with a red sail. The image refers to his step-grandmother, Montez Johns. ("She often sang 'Red Sails in the

Illustration from *Scientific American*

MONTEZ SINGING. 1989. See Plate 226

GREEN ANGEL. 1989. Encaustic and sand on canvas, 190.8 x 127.5 cm (75⅛ x 50⁵⁄₁₆″). Walker Art Center, Minneapolis. In Honor of Martin and Mildred Friedman

UNTITLED. 1990. Oil on canvas, 84.5 x 64 cm (33¼ x 25¼″). Private collection

Sunset.'") Johns' treatment of these images, using the face as a frame or background to a central image, accomplishes his intention to find "an expression that combines something infantile and something adult." Certainly the sense of memory, of pieced-together fragments from a remembered past, is very strong in these works.

Throughout the 1980s, much critical discussion focused on Johns' embedded images: their source, their treatment, and their meaning in his work. A 1987 article by Jill Johnston[104] identifying a second Isenheim image in Johns' paintings drew subsequent critical attention toward a literal "decoding" of his work in a way that he says he never intended to happen. Later, critical interest in a drawing, UNTITLED (1983–84), in which Johns had traced part of a liquid drain-cleaner advertisement from the 1950s, intensified his feeling.[105] "I got annoyed that pictures were being discussed in terms of imagery that could not be perceived—though once something is said to be something, then everyone accepts it. I thought it was of no particular interest that [an image] was once one thing or another or something else."

As Johns had once directed attention away from himself, saying that his work was not meant to be an expression of his feelings, he now directed attention away from the origins of the imagery he employed. In drawings and paintings of 1989, he introduced a new embedded image, and this time he refused to identify it. "From my point of view, my perception is altered by knowing what it is, even though what it is is not what interests me. . . . So when I made this picture I decided I wasn't going to say what it was."

Johns' attitude is certainly consistent with the artist who has worked to break images free of clear context and associations, and to locate them in a new region of ambiguity and doubt. But as this unidentified image reappears in various puzzling transformations in his newest work, it seems ironic to note that an artist who began his career painting immediately recognizable, mundane images of flags, targets, and numbers should, by his own inexorable logic over nearly four decades, finally be drawn to painting an image that is indecipherable, and unknown. These images are beautiful, tantalizing, endlessly and inventively re-created, but ultimately mysterious. They have that in common with all of Johns' work.

Whatever one says about Johns' work, the opposite can always be found. Even as he worked with this mysterious image, he introduced another whose source was widely known.

"Riva Castleman said to me, 'I wish you'd make me a picture about a person and their pet.' I hadn't asked her, but when someone says something like that to you, your mind starts to work. How would you make a work like that—if you were going to do it, what would you do?" Some time later, he saw a poster for a Holbein show in Basel. The image showed a man with a marmoset. "When I saw it, I thought, 'Oh, there's Riva's picture.'"

He executed the first of the drawings, UNTITLED 1990, soon after. All together he did three drawings on plastic, and one pastel in bright colors. Although they are executed in a manner reminiscent of certain other embedded images, these

new images are generally far more explicit. As a rule it is not difficult to discern the human figure.

In passing, we might note that for those who suspected, back in the late 1970s, that Johns was trying to find a way to introduce the human figure into painting, he has now clearly succeeded, through a remarkable and extended progression. From the earliest literal signs of a human presence in his work—handprints, casts, the arm of the device circle—to the painted skulls and genitalia, the fragmentary body parts; to the hinted crosshatch allusions; to the deeply concealed, embedded figure tracings; to the human shadows cast on walls; to the final image of a man holding an animal, Johns has found a way to address his concerns using imagery that is both borrowed, and unmistakably made his own. And to compare these recent works with the flags which first brought him international acclaim as an artist is to see just how far, with his relentless logic, his profound good humor, and his intense awareness, he has come.

In summary, what can we say of his methods of working? For if a Johns painting does not unambiguously reveal his emotions, it unquestionably reveals his intellectual attitudes, and something that might be called his philosophy of life.

"Right conduct," John Cage called it.[106] Some time later Barbara Rose elaborated: "[Johns is] perhaps the only artist operating today in the dimension of a mental physics, that is of a true metaphysic. We infer that Johns sees no separation between decisions made in art and those made in life. His decisions have unmistakable moral implications, for he is among those artists for whom the activity on the canvas is the exemplar of his understanding of right human conduct."[107]

What of that conduct? A strong sense of acceptance of things as they are—surely an undercurrent in his willingness to use preexisting imagery and objects. The belief that something, once begun, must be carried to a conclusion—an attitude that shows in his attempts to retrieve a painting, to rework it, even at the expense of the elegance and finesse which usually characterize his work. The recognition of the doubtful interplay between what is seen and what is known. The patience and the self-possession to follow his own methods, his own sense of the way to proceed, toward an outcome or a conclusion which is not necessarily to his liking, but which embodies his deep sense of the truth of his life, and his understanding of the world.

One can argue that Johns can best be understood as an artist who is blessed and burdened with profound self-awareness. Most people who have met him come away with the impression of a priestly or Zen aspect to his personality. His actions, speech, and dress have a striking simplicity.

One consequence of this awareness is that Johns is uneasy making the kinds of ordinary choices that lead to artistic invention. One often feels he would prefer not to invent at all. ("Whatever I do seems artificial and false, to me.") Acutely aware of his choices at every step, he finds no reason to prefer one over another; all choices seem equally good. He has said this explicitly many times. Because any choice is ultimately arbitrary, his solution is to declare that arbitrariness explicitly, by assembling elements which appear to him to be given, to

Poster for Holbein show

TRACING. 1989. Ink on plastic, 92.4 x 66 cm (36³⁄₁₆ x 26″). Private collection

UNTITLED. 1989. Pastel on paper, 97.2 x 74.3 cm (38¼ x 29¼″). Collection Robert and Jane Meyerhoff, Phoenix, Maryland

exist independently at the start, before he begins work. Such concerns appear literally and figuratively reflected in a recent work, MIRROR'S EDGE (1992). Through increasingly ambiguous layers of imagery, the painting can be taken as addressing questions of subjective response, of how reality is constructed by both artist and viewer. The painting employs images and treatments that are familiar from previous work, here freshly revised, and presented anew.

On the simplest level, Johns' procedure grounds his work in reality. He paints from life, and he uses materials that he sees all around him. He does not want to make things up: "I think I have a kind of resentment against illusion when I can recognize it."[108]

On an intellectual level, one can think of him as a strict logician, setting forth

MIRROR'S EDGE. 1992. Oil on canvas, 167.6 x 111.8 cm (66 x 44"). Collection Mr. and Mrs. S. I. Newhouse, Jr.

the postulates from which his own work will begin. If paintings by Johns can be compared to poetry—as they often are—they can equally be compared to mathematical proofs. And like mathematical proofs, their elegance derives in part from a recognition of what has been done, based on what is given at the start.

On a practical level, Johns' method defines the boundaries within which his own creation occurs. By choosing design elements which are not his own, and by following an explicit formal plan, Johns directs attention away from these features, and reinforces the idea that his own work occurs "on other levels."[109]

But however one chooses to think about Johns' procedures, and however much his imagery may have changed over the years, his working method has remained remarkably consistent. Having established an image—whether a mundane image, such as the early flags or targets, or a later composition of his own which, like the flags, follows a formal plan—Johns proceeds to take the image as if it were a found object, and rework it. Recently, speaking of the body of his work, he has said this: "In all cases, the outlines of particular forms are followed rather faithfully, but not entirely faithfully, and filled in with some variation in color and texture."[110]

We should note there are several inevitable consequences of his procedure. First, Johns is necessarily conservative in his chosen imagery, since to employ an image only once and then abandon it would be wasteful; he has rarely done this.[111] Second, the repertoire of imagery he employs is small, compared to other artists. Although one occasionally still hears this as a complaint about his work, it is no limitation: Johns' retrospectives are remarkable for the freshness, energy, and variety which his work conveys. Third, Johns' work necessarily has a strongly self-referential quality. Much of the pleasure one takes in his work derives from the surprising ways he can use an image, use it again, and then use it again.

Beyond these speculations, we may look for some idea of the artist himself, as he portrays his own role in his work. Since Johns works with alternatives, mirror images, and oppositions, it is not surprising that we can form opposing ideas about him—often in the same canvas. On the one hand, he is coldly rigorous, formal, adult, intellectual. On the other hand, he does not hesitate to be playful, punning, literal, even childish. He is detached, and he is emotional. He is calculating, and he is impetuous.

As for his own attitude toward working, here are two notebook entries:

I have meant what I have done. OR—I have often meant what I have done. OR—I have sometimes meant what I have done. OR—I have tried to mean what I was doing.

And again:

To Give Up
Or
To Do the Work
To Doubt that the Work Needs Doing?
At any rate, the time passes.

NOTES

1. Johns: "I was working in a bookstore, and you had little rectangular pads of paper to write orders on. I used to fold these sheets and then tear them, so that when they were opened the tears made a symmetrical design. This collage was a collection of torn sheets. The idea was to make something symmetrical that didn't appear to be symmetrical."

2. Johns: "I was interested in the idea of a painting that did more than one thing, that had another aspect. That was the reason for the sound."

3. The face is that of Rachel Rosenthal, at one time owner of the piece.

4. STAR was his first commission. He had done a painting in the shape of a cross, and Rachel Rosenthal said she would buy it if it were a Jewish star. Johns made one; she bought it.

5. Max Kozloff, *Jasper Johns,* Abrams, New York, 1969, p. 15.

6. Edgar Allan Poe, "The Philosophy of Composition" (1846), in *The Selected Poetry and Prose,* Modern Library, New York, 1951, p. 370.

7. Leo Steinberg, "Jasper Johns: The First Seven Years of His Art" (1962), *Other Criteria: Confrontations with Twentieth-Century Art,* Oxford University Press, New York, 1972, p. 31.

8. Johns, quoted in Walter Hopps, "An Interview with Jasper Johns," *Artforum,* 3, March 1965, p. 34.

9. Johns has made monochromatic targets, beginning with GREEN TARGET (1955), but such treatment of the symbol emphasizes the nature of targets by eliminating contrasting colors. In addition, there is a tendency in Johns to explore the attributes of a thing through deprivation—one way to know that our ordinary conception of a target involves contrasting colors is to see it without such contrast. (Leo Castelli did not see the target in GREEN TARGET when he first saw the painting.)

10. "His Heart Belongs to Dada," *Time,* 73, May 4, 1959, p. 53.

11. The painter and critic Sidney Tillim observed, "Johns' paintings and drawings of numbers . . . are drawn as if they should have been apples." ("Ten Years of Jasper Johns," *Arts Magazine,* 38, April 1964, p. 22.) The review was unsympathetic; perhaps Tillim wanted to contradict the comment of Edward Lucie-Smith that "Johns' innovations, especially his use of signs and letters buried in the paint, have continued to bear fruit. . . . " ("Round the New York Art Galleries: Letters and Figures," *The Listener,* Jan. 10, 1963, p. 71.)

12. *Time, loc. cit.* About this comment Johns later said, "I mean that one shouldn't approach a work of art with a preexisting attitude. . . . (laughing) But then someone pointed out to me that I had gone and boxed-in all my radiators, so you didn't see them!"

13. Paul Taylor, "Jasper Johns," *Interview,* July 1990, p. 96.

14. Emily Genauer (*New York Herald Tribune,* 119, April 3, 1960, section 4, p. 7) noted that Johns "likes to attach empty coke bottles to his canvas," a reference to Rauschenberg's *Curfew* (1958). In the *Sunday Herald Tribune Magazine,* 124, Sept. 6, 1964, p. 21, she spoke of "Johns' oversized abstractions complete with appended coke bottles and dirty brooms."

15. Calvin Tomkins, *The Bride and the Bachelors,* Viking, New York, 1965, p. 213 (hereafter: Tomkins, *The Bride and the Bachelors*).

16. Johns was artistic adviser for the Cunningham company from 1967 to 1979. The set based on THE LARGE GLASS was first seen in Buffalo, N.Y., March 10, 1968.

17. June 20, 1961. David Tudor played *Variation II* by John Cage at the American Embassy theater in Paris. The participating artists were Robert Rauschenberg, Niki de Saint-Phaille, Jean Tinguely, and Jasper Johns. Along with the target, Johns made the painting ENTR'ACTE, which was brought onstage during the intermission.

18. Rauschenberg was, and still is, an extraordinarily forceful personality. Tatyana Grosman recalled that in the early days of ULAE, "I really wanted to invite Rauschenberg [before Johns] but I was a little afraid that I might not be strong enough, that he would be too disruptive": (Calvin Tomkins, "Profile: Tatyana Grosman," *The New Yorker,* 52, June 7, 1976, p. 62; hereafter: Tomkins, "Profile: Tatyana Grosman"). Castelli observes that "even though Jasper was around Bob all the time, he was entirely original right from the start. It is really quite remarkable that anyone could stand up to Bob's personality in that way. It shows the strength of Jasper's own personality."

19. Johns relates the idea of painting the sides of the canvas to his earlier notion of provoking the spectator to move around the picture, and to see it from changing perspectives.

20. Barbara Rose, "The Graphic Work of Jasper Johns: Part II," *Artforum,* 8, Sept. 1970, p. 71 (hereafter: Rose, "Graphic Work of Jasper Johns, II"). There are no flagstones in any of the five SCREEN PIECE paintings. The author was probably thinking of WALL PIECE (1968) or HARLEM LIGHT (1967).

21. Hopps, *op. cit.,* p. 35.

22. FLAG ON ORANGE FIELD and the small WHITE FLAG were in Bonwit Teller's windows in 1957–58. Such exhibition of his work perhaps emphasized to Johns the objectness of his pictures.

23. *Artists of the New York School: Second Generation,* The Jewish Museum, New York, 1957. As a curious historical incident, a Johns painting was seen at the Stable Gallery in 1956, as part of a Rauschenberg painting. In

those days, artists of the Stable Gallery could each propose two new painters to be included in an annual show at the gallery. Rauschenberg intended to propose his ex-wife, Susan Weil, and Johns. But that year the gallery changed its policy, so Rauschenberg exhibited a canvas with two doors, and behind the doors he put a small Johns flag and a small Weil painting.

Leo Castelli later acquired the Rauschenberg with the two doors. He kept the painting in his warehouse. One day he examined the painting and discovered that the Johns flag had been stolen. Castelli recalls a final episode in the story:

> Years later, a dealer—we do not need to say who—came to me and said, "Someone has brought me this Johns painting and I don't know it, and I wondered if you could tell me about it, the date and so on." I knew immediately what it was; it was the stolen painting. I said, "The painting has been stolen and I would like to keep it right here. I don't want it to leave my gallery." But this person said he had promised the person he got it from, and he didn't feel he could leave it with me, and he said he would have to talk to the other person, and he was very insistent. So I said, "Well, all right." I never saw the painting again.

24. He had previously had a gallery in Paris, before World War II; he described himself as a playboy in *Holiday* (M. Elkoff, "Antic Arts: Leo Castelli: The Artful Entrepreneur"), 37, June 1965, p. 99.

25. Because his name is so unusual, some people have suspected that Jasper Johns made it up himself. (He didn't; his name is Jasper Johns, Jr.) The origin of the name is suggested by Charles F. Stuckey ("Johns: Yet Waving?" *Art in America,* 64, May–June 1976, p. 5):

> Perhaps only a curious coincidence related to Johns' flags is the existence of several 19th-century works of art that portray the heroism of one Sergeant William Jasper: the two best known are Emanuel Leutze's *Sergeant Jasper Rescuing the Flag on Fort Moultrie,* 1859, and Alexander Doyle's 1888 bronze in Madison Square, Savannah. Jasper, one of the South's most glorious Revolutionary heroes, distinguished himself by twice recovering our fallen flag (during the bombardment of Charleston Harbor, June 1776, and in the assault upon Savannah, Oct. 1779.) Was Jasper Johns in some way the namesake of the famous soldier? I wonder whether the school books in South Carolina, where he spent his childhood, underlined for Johns the brave daring of the hero who kept our flag visible.

As a boy Johns was shown the statue of Sergeant Jasper by his father, who told him that the figure was the namesake of them both.

26. Barbara Rose, "Decoys and Doubles: Jasper Johns and the Modernist Mind," *Arts Magazine,* 50, May 1976, p. 69 (hereafter: Rose, "Decoys and Doubles").

27. Tomkins, *The Bride and the Bachelors,* p. 213.

28. Barbara Rose, *American Art Since 1900,* rev. ed., Praeger, New York, 1975, p. 179 (hereafter: Rose, *American Art Since 1900*).

29. *Ibid.,* p. 210.

30. "In the Galleries," *Arts,* 32, Jan. 1958, p. 55.

31. *Time, loc. cit.*

32. Leo Steinberg, "Contemporary Art and the Plight of Its Public" (1962), *Other Criteria: Confrontations with Twentieth-Century Art,* Oxford University Press, New York, 1972, p. 13.

33. Certainly Alfred Barr saw it that way. In a letter to Johns dated 27 August 1959, he wrote:

> I am sending you an advance copy of our new Bulletin on paintings and sculptures added to our collection during 1958. A friend . . . asked me whether there was any special significance in my having reproduced your three pictures in one cut instead of individually. I . . . intended to emphasize the fact that we had acquired three. . . . As you know, the Museum and I myself have been under some criticism for having bought three works by one artist and he rather little known. I think the Bulletin emphasizes rather than soft pedals this controversial action.

34. Ben Heller, "Jasper Johns," *School of New York: Some Younger Artists,* ed. B. H. Friedman, Grove Press, New York, 1959, p. 30.

35. Apparently he was not so coolheaded at the time. Mrs. Catherine Rembert, one of Johns' teachers at the University of South Carolina, was to have dinner with him on the night of his first one-man show. Johns arrived late, "picked her up and danced her about the room. The Museum of Modern Art had just bought three of his paintings for its permanent collection." In D. R. Dickborn, "Art's Fair-Haired Boy," *The State* (Columbia, S.C.), Jan. 15, 1961, pp. 20–21.

36. *Time, loc. cit.* "Carnegie International" refers to "The 1958 International Exhibition of Contemporary Painting and Sculpture," Museum of Art, Carnegie Institute, Pittsburgh.

37. Rose, "Decoys and Doubles," p. 69.

38. Rose, "Graphic Work of Jasper Johns, II," p. 68.

39. Kozloff, *op. cit.,* pp. 26–27.

40. Psychologist J. Ridley Stroop's 1935 doctoral thesis reported the difficulties of experimental subjects who were asked to read aloud the names of colors that had been printed in contrasting ink. Since then, more than

700 published reports have concerned the Stroop effect. According to psychologist Colin MacLeod, "The Stroop effect has never been adequately explained, making it a source of continuing theoretical fascination." See Bruce Bower, "Brother Stroop's Enduring Effect," *Science News,* 141, May 9, 1992, pp. 312–13, 316.

41. Johns told Walter Hopps: "There *was* a change. I don't think of it as drastic" (Hopps, *op. cit.,* p. 35).

42. This is the date suggested by Johns and by most of the scholars of his work. There is no real reason to think he was aware of Duchamp before 1959. Attempts to get around the facts have sometimes been ingenious. Robert Pincus-Witten, attempting to establish a Duchampian influence from 1955, is forced to say that "the artist's mind, unlike that of the historian, does not thrive on niggling one-to-one details. . . ." In "Theater of the Conceptual: Autobiography and Myth," *Artforum,* 12, Oct. 1973, p. 42.

43. The question of whether Duchamp was working or not is the subject of considerable speculation—heightened by Duchamp himself, who enjoyed making contradictory statements. Certainly it is true that he worked in secret on *Etant donnes* during the late 1960s; it was finally exhibited July 7, 1969, in the Philadelphia Museum of Art.

44. Jasper Johns, "Marcel Duchamp (1887–1968): An Appreciation," *Artforum,* 7, Nov. 1968, p. 6.

45. Kozloff, *op. cit.,* p. 29.

46. *Newsweek,* 51, March 31, 1958, p. 96.

47. Quoted in Kristine McKenna, "Drawing the Lines," *Harper's Bazaar,* April 1990, p. 222.

48. McKenna, *op. cit.*

49. Jasper Johns, "Sketchbook Notes," *Art and Literature* (Lausanne), 4, Spring 1965, p. 192 (hereafter: Johns, "Sketchbook Notes").

50. Actually, it is more complicated than this. In each portfolio the edition number is signified by the appropriate numeral printed with an extra stone. That is, edition number 3 has an extra stone printed for the number three, and so on. There are also some artist's proofs with no extra stones, and for each edition, one series in which all the prints are done with two stones. See Richard S. Field, *Jasper Johns: Prints 1960–1970,* The Philadelphia Museum of Art, in conjunction with Praeger, New York, 1970, cat. nos. 17–46.

51. Tomkins, "Profile: Tatyana Grosman," p. 62.

52. Johns has done American flags, but no other; American maps, but no other. The Expo '67 world MAP is the sole exception.

53. Tomkins, *The Bride and the Bachelors,* p. 33. John Cage's attitude toward probability as a working procedure was also widely influential among artists. Cage differed from Duchamp in his desire to use chance not only as a means of getting around the conscious mind, but the unconscious as well. This is probably what Cage meant when he spoke of using chance to get rid of his own taste in music.

54. Daisetz T. Suzuki, *Zen and Japanese Culture,* Bollingen Series LXIV, Pantheon Books, New York, 1959, p. 146.

55. The stretchers are bent trapezoids, but the canvas panels are not. Of this painting, Johns has said, "In the painting now there is no tension. It's all an illusion." The illusion is furthered by the addition of metal plates to join the stretcher panels together. They are not structurally necessary: "They are there to give some idea of what was happening."

56. Jerome S. Bruner, *On Knowing: Essays for the Left Hand,* Belknap Press, Cambridge, Mass., 1962, p. 24.

57. Quoted in *Sixteen Americans,* ed. Dorothy C. Miller, exhibition catalogue, The Museum of Modern Art, New York, 1959, p. 22.

58. Jorge Luis Borges, *Ficciones,* Grove Press, New York, 1962, p. 15. A similar thought occurs in his statement that "it is enough that a book be possible for it to exist" (*ibid.,* p. 85n.).

59. Rose relates the piece to the equation of looking and eating, which is certainly an idea later expressed in Johns' notebooks—and which may be implied by Johns' use of eating utensils in the work of the 1960s. At the same time, the antecedent story for THE CRITIC SEES seems to involve talking. In any case, the sculpture is biting; it gives us something to chew over, or ruminate; and we can all enjoy mouthing off about what it is saying. Or what we see it says. Or what we say it sees.

60. Rose, "Graphic Work of Jasper Johns, II," p. 65.

61. Kozloff, *op. cit.,* p. 33.

62. Johns: "The conservative treatment [of panels] is partly to do with the idea of play, showing a thing in different ways, and partly to do with my lack of invention."

63. In ARRIVE/DEPART (1963–64) there is also an impression of a skull in the lower right corner. Leo Castelli speculates: "The Sculls were important collectors of Jasper's work, but there was a disagreement, and at the time of Jasper's 1964 retrospective at the Jewish Museum. They refused to loan their pictures for the exhibit. I finally convinced them, but I think Jasper had his revenge in that painting."

64. Actually, Jim Dine had recently shaved his head, and he served as a model for the plaster cast. A rubber mask was made, attached to a piece of wood, and painted. Johns considered the work completed, but after a few days, decided he did not like it, and destroyed it.

65. Rose, "Graphic Work of Jasper Johns, II," p. 66.

66. Rudolf Virchow (1821–1902), a German nineteenth-century Renaissance man, is best remembered as a medical pathologist. He was also an anthropologist of stature, and accompanied Heinrich Schliemann to

Troy. In addition, he was an important liberal politician; Bismarck challenged him to a duel in 1865. As a politician and advocate of public health, Virchow constructed Berlin's sewage system and water supply. Virchow discovered and named leukemia, embolism, and thrombosis. Pathologists still repeat Virchow's dictum that "we see what we know"; it is common experience for medical students to stare directly at a tumor of liver or kidney and fail to see anything abnormal. Even quite striking changes remain invisible to the naive observer. But once the pathology is pointed out, the student is often amazed he was unable to see it before, and he can immediately recognize future examples.

67. Hart Crane, *The Bridge,* Horace Liveright, New York, 1930, p. 46.

68. C. G. Jung, "The Practical Use of Dream Analysis" (1934), *Dreams,* Bollingen Series XX, Princeton University Press, Princeton, N.J., 1973, p. 93.

69. There are actually two paintings, SOUVENIR and SOUVENIR 2.

70. Johns, "Sketchbook Notes," pp. 185–92.

71. The painting was done in Japan, and Johns had great difficulty finding a chair with sufficiently long legs to support the American model.

72. Rose, "Decoys and Doubles," p. 72.

73. John Cage, "26 Statements re Duchamp," *Art and Literature* (Lausanne), 3, Autumn–Winter 1964, p. 9.

74. Johns' sketchbook notes contain the following comment: "Simplification occurs not because one 'wants' it—but because one thing is not another thing (Leonardo's *Deluge* drawings). There is the business of approximation—what we hope is that anything meaning another thing will have a 'life' of its own, free from that other thing. The thing which 'means' has strengths (?) which are not dependent upon what is meant."

75. John Ashbery, "Art and Artists," *New York Herald Tribune* (European Edition), June 28, 1961.

76. *Idem,* "Paris Notes," *Art International* (Lugano), 6, Dec. 20, 1962, p. 51.

77. *Newsweek,* 61, Feb. 18, 1963, p. 65.

78. Dore Ashton, "Art," *Arts and Architecture,* 80, March 1963, p. 6.

79. Tillim, *op. cit.,* pp. 22, 25.

80. *Time,* 87, Jan. 14, 1965, p. 71.

81. The device of the imprint is also carried through with the circular paint can outline, from PASSAGE II (1966), through CORPSE AND MIRROR (1974) and later crosshatch paintings.

82. The exception is the stone for FIGURE 9, which cracked during the original black series printing, and had to be redrawn.

83. Lawrence Alloway, "Art," *The Nation,* 213, Nov. 22, 1971, p. 541.

84. This is literally true; at the bottom of the print the row of little Johnsian images represents etching-plate images used some years before, and reproduced here.

85. It has been frequently observed that to call these "crosshatch paintings" is both inaccurate—since the hatchmarks do not cross—and does injustice to an extremely varied body of work; but the paintings are generally known by that term, and for convenience it is used here.

86. *Dictionnaire abrégé du surréalisme,* quoted in André Breton, *Surrealism and Painting,* Icon Editions, Harper & Row, New York, 1972, p. 289.

87. Most critical discussion has related the painting to Pollock's. Johns has said, "Originally, I wanted to name the painting SCENT but was hesitant to do so because it would be related to [the Pollock]. Then I noticed that a Rauschenberg also had that title; so I decided to follow my original impulse and to use it."

88. "To conceal . . . [he] had resorted to the comprehensive and sagacious expedient of not attempting to conceal it at all." Poe's detective August Dupin, speaking of "The Purloined Letter" (1845), in Poe, *op. cit.,* p. 306.

89. *The National Geographic Magazine,* 143, May 1973, p. 668.

90. *Foirades/Fizzles,* Petersburg Press, New York (etchings printed by Atelier Crommelynck, Paris), 1976 (five texts by Samuel Beckett; thirty-three original etchings by Jasper Johns).

91. An untitled study for CICADA, made the previous year, in 1978, specifies several additional formal rules which the artist decided not to follow in the eventual image. From that study, it seems he originally intended the image to be called "Husk."

92. Nan Rosenthal and Ruth Fine, *The Drawings of Jasper Johns,* Thames and Hudson, London, 1990, p. 248.

93. Peter Fuller, "Jasper Johns Interviewed: Part II," *Art Monthly* (London), no. 19 (Sept. 1978), p. 7.

94. There is nothing speculative about the notion that the power of a work resides in its underlying composition. For example, Kenneth Clark observes that Leonardo's *Last Supper* has been ineptly restored many times since it was painted. "It is worth insisting on these changes because they prove that the dramatic effect of the Last Supper must depend entirely on the position and general movement of the figures, and not on the expression of the heads." (Kenneth Clark, *Leonardo da Vinci,* Penguin, Harmondsworth, England, 1959, p. 92.)

95. David Sylvester, "Interview," *Jasper Johns Drawings,* London, Arts Council of Great Britain, 1974, p. 14.

96. Cited in Mark Stevens, "Pessimist at Play," *New Republic,* Jan. 9, 1989, p. 26.

97. It is perhaps inevitable that a determined creator of oppositions, having made a painting entitled NO,

would eventually make one that said, however obliquely, Yes.

98. Paul Taylor, *op. cit.,* p. 123.

99. William Gass, "Johns," *New York Review of Books,* Feb. 2, 1989, p. 26.

100. Richard Francis, "Disclosures," *Art in America,* 72, Sept. 1984, pp. 199–200.

101. Carter Ratcliff, "Master of Abstraction: Jasper Johns Brings Clarity to Chaos," *Harper's Bazaar,* Oct. 1988, p. 236.

102. Robert Hughes, "The Venice Biennale Bounces Back," *Time,* July 25, 1988, p. 85.

103. Bruno Bettelheim, "Schizophrenic Art: A Case Study," *Scientific American,* April 1952, pp. 31–34. The picture in question was drawn late in the child's recovery. The patient called the picture "The Baby Drinking the Mother's Milk from the Breast," and as Bettelheim describes it, "This was a pictorial world that consisted only of the mother's breasts and just above them, what the nursing infant sees—mouth and eyes. As if to emphasize the primitive sensations, she put fingerprints all around the border" (p. 34).

104. Jill Johnston, "Tracking the Shadow," *Art in America,* Oct. 1987. For her response to the later, unidentified image, see Johnston, "Trafficking with X," *Art in America,* March 1991, pp. 103–10, 164–65.

105. Rosenthal and Fine, *op. cit.,* p. 278.

106. John Cage, "Jasper Johns: Stories and Ideas," in *Jasper Johns,* exhibition catalog, The Jewish Museum, New York, 1964, p. 1.

107. Rose, "Graphic Work of Jasper Johns, II," p. 74.

108. Sylvester, *op. cit.,* pp. 15–16.

109. Concerning self-imposed limits, designer Charles Eames used to tell about a study of creativity among architects, who were asked to make a design out of square tiles, from a great range of tiles at their disposal. Afterward, one architect proudly announced he had made his entire design from red, white, and blue tiles. Philip Johnson said his design was composed only of black and white. Eero Saarinen then announced he had made his design entirely from white tiles.

110. Taylor, *op. cit.,* p. 96.

111. One example is the Untitled 1988 drawing he made for an auction for St. Vincent's Hospital in New York; another is the Untitled 1983–84 drawing based on the Drainz advertisement. Rosenthal and Fine, *op. cit.,* p. 300.

3.

The Function of
THE OBSERVER

IN A CELEBRATED REMARK, Marcel Duchamp said, "It is the spectators who make the pictures." He meant by this that a work of art stands at a kind of midpoint between creator and viewer, and that each contributes to it. What the work of art means, how it is perceived, and literally *what it is* become a function not only of the artist's action but the viewer's response to it.

Jasper Johns shares this attitude. The participation of the viewer is implied in all his work, and it is made explicit in his TARGET (1960), where the spectator is invited to complete the image, and to sign his own name alongside the artist's. The piece shows many characteristics of Johns' work: it is self-contained (the artist provides all the materials for the interaction); simple (evoking childish play, coloring books); and literal in a way that undercuts its profound implications.

But the idea of participating in a work of art troubles many viewers, even critics. Lawrence Alloway said that "Johns has conceded to the spectator the right to determine the meaning of his works,"[1] as if there were an alternative. In fact there is none. An artist cannot fix his meanings absolutely, even if he wanted to do so; art functions in the region of indeterminate or ambiguous meanings. But modern art, particularly Johns' art, heightens this ambiguity, and plays upon our modern understanding of the observer's crucial role in determining the nature of reality.

The task of the spectator is to decide what he is looking at. We have some insight into how difficult this can be, in Leo Steinberg's reaction to Jasper Johns' first show in 1958:

> My own first reaction was normal. I disliked the show, and would gladly have thought it a bore. . . . I was angry at the artist, as if he had invited me to a meal, only to serve something uneatable. . . . I was irritated at some of my friends for pretending to like it—but with an uneasy suspicion that perhaps they did like it, so that I was really mad at myself for being so dull, and at the whole situation for showing me up.[2]

Steinberg summarized his reaction as "bewildered alarm." He expressed anxiety, uneasiness, the feeling of uncertainty about where he stands:

> I am challenged to estimate the aesthetic value of, say, a drawer stuck into a canvas. But nothing I've ever seen can teach me how this is to be done. I am alone with this thing, and it is up to me to evaluate it in the absence of available standards.[3]

Thirty-five years ago, many observers were unsettled by Johns' flags, numbers, and targets. Alfred Barr would not buy the FLAG (1955) for the Museum of Modern Art, fearing patriotic repercussions; and TARGET WITH PLASTER CASTS (1955) was turned down by both the Jewish Museum and the Modern, because the casts included genitalia.

But Steinberg was not reacting with outraged patriotism or modesty; his response was more fundamental than that. He was looking at a group of paintings which did not conform to his ideas of what a painting is, or what it should

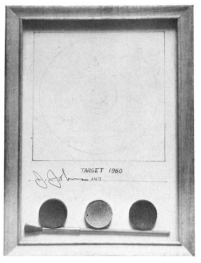

TARGET. 1960. Pencil on board with brush and watercolor disks, 17.1 x 11.8 cm (6¾ x 4⅝″). Private collection

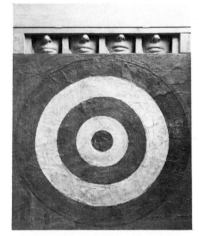

TARGET WITH FOUR FACES. 1955. Encaustic and collage on canvas with objects, 75.5 x 66 cm (29¾ x 26″). The Museum of Modern Art, New York. Gift of Mr. and Mrs. Robert Scull

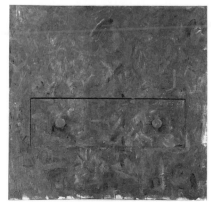

DRAWER. 1957. See Plate 14

83

be. They could not be fitted into any mental category he possessed. Steinberg's sense of bewildered alarm was modified with familiarity and later thought. But one aspect of the observer's response to Johns' work remains: "I am alone with this thing, and it is up to me to evaluate it." A person looking at Johns' work often feels *alone* in an odd way. This may in part reflect something of Johns' own personality, but it is more certainly a modern dilemma of epistemology, which Johns re-creates—the dilemma of the observer looking out at the world and trying to make sense of it.

For more than three centuries, "sense" in the Western world has increasingly meant scientific sense. Since the time of Galileo, we have come to believe in an objective, independently verifiable reality, to be investigated, measured, and controlled through science.

The fundamental feature of science was that its method eliminated the prejudices of the observer. Galileo dropped two weights and found they landed together; so could anyone else, and obtain the same result. A scientific experiment was not a matter of opinion. It was more tangible than that. And while there were disputes, they were not like theological disputes in the Middle Ages. Scientific disputes could be resolved.

This new power of the objective, scientific observer was intoxicating; the limitations of science became evident only in this century. Einstein's theory of special relativity, and the rise of quantum physics from 1900 to 1930, made the place of the observer much less certain. As John Wheeler summarized it:

> Nothing is more important about the quantum principle than this, that it destroys the concept of the world as "sitting out there," with the observer safely separated from it by a 20-centimeter slab of plate glass. Even to observe so minuscule an object as an electron, he must shatter the glass. He must reach in. . . . The universe will never afterwards be the same. To describe what has happened, one has to cross out that old word "observer" and put in its place the new word "participator." In some strange sense the universe is a participatory universe.[4]

Thus we find the idea that "the spectator makes the picture" raised in a fundamental context. Is external reality an illusion? Many physicists are no longer sure, and have retreated to the earlier notion that our conceptions of nature are not to be confused with nature itself;[5] that the map is not the territory; that any representation of reality is, in the end, no more than a stand-in, a surrogate, a tool, a way of thinking.

Thus, twentieth-century science has produced a crisis of the observer—as he has been moved from an objective witness to a relative witness, as his knowledge is obtained only by interfering with the event he studies, so that observer and observed become inextricably linked.

"Artists," says Kenneth Clark, "have always responded instinctively to latent assumptions about the shape of the universe."[6]

Thus Renaissance painters, living in a newly scientific world, where exact mea-

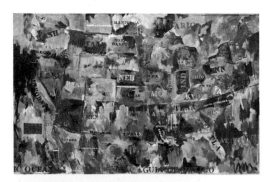

MAP. 1962. Encaustic and collage on canvas, 152.4 x 236.2 cm (60 x 93"). Collection Mr. and Mrs. Frederick R. Weisman, Beverly Hills, California

LAND'S END (detail). 1963. See Plate 100

Pablo Picasso. *Les Demoiselles d'Avignon*. 1907.
The Museum of Modern Art, New York.
Acquired through the Lillie P. Bliss Bequest

Georges Braque. *Man with a Guitar*. 1911.
The Museum of Modern Art, New York.
Acquired through the Lillie P. Bliss Bequest

surement was yielding powerful insights into reality, were naturally drawn to attempt "scientific" painting. One result was the innovation of linear perspective. Linear perspective could be described in a set of rules, or laws, for the representation of space and volume; it was geometric, mathematical, precise. It gave to painting a method that conformed to the intellectual principles of the day.

Arnold Hauser observes that "only since the Renaissance has painting been based on the assumption that the space in which things exist is an infinite, continuous and homogeneous element, and that we usually see things uniformly . . . with a single and motionless eye."[7]

Renaissance space turned the picture frame into a window through which one looked onto an imagined scene. The position of the observer was fixed, and remained so for the next four centuries. Genuine challenges did not appear until the latter nineteenth century, when Manet and Cézanne moved away from traditional fixed-point perspective. And a decisive break did not come until 1907, with Picasso's *Les Demoiselles d'Avignon,* two years after Einstein's special relativity theory. Apollinaire expressed the link between scientific advances and Cubism: "Today, the scientists do not confine themselves to the three dimensions of Euclidean geometry. Naturally and by intuition the painters were also led to the point where they concern themselves with new means of extension."[8]

Cubism's multiple perspectives displaced the observer from his comfortable, fixed position. It was no longer easy to enter the picture through the canvas window. Quite the contrary: the fact that a painting was only a representation of reality— a remnant of the artist's own complex vision—was all too obvious.

As the artist's own role gained importance, it was inevitable that someone would claim an ordinary object as a work of art, simply because he was an artist, and said it was. The problems for the observer caused by such an action are exemplified by Marcel Duchamp's Ready-mades.

But the primary thrust during the first half of the twentieth century was toward abstraction. In their search for purer self-expression, artists abandoned distracting elements, until finally representation itself—a recognizable image—

Marcel Duchamp. *In Advance of the Broken Arm.*
1915. Yale University Art Gallery, New Haven.
Gift of Katherine S. Dreier to the Collection
Société Anonyme

Marcel Duchamp. *Bottle Rack.*
1914. Collection Estate of
Man Ray, Paris

PAINTED BRONZE. 1960. See Plate 67

Jackson Pollock. *Scent.* 1955.
Private collection

SCENT. 1973–74. See Plate 161

was eliminated as unnecessary to the proper functioning of the artist. Standing before an Abstract Expressionist painting, the old objective Renaissance observer cannot function at all. In a real sense, the observer is no longer the audience, but the artist himself. As in physics, the observer and the observed have become inextricably linked. And, as in physics, this linkage produced a language of internal reference which outsiders often found obscure and alienating.

It is Jasper Johns' peculiar gift that he has been able to assimilate the advances of twentieth-century art, and shift the experience of the observer away from the painter and back to the audience. Not surprisingly, audiences have responded with pleasure, even though the dilemmas he presents them are often very great.

He accomplished this by reintroducing the recognizable image into modern art. But he did so in a particular way. Johns has repeatedly demonstrated the ability to insinuate himself into spaces where there does not, at first, seem to be room for play, and this has been true from his earliest paintings. In terms of art history, one could simplify his stance and say that he has slipped in between Duchamp and Pollock, between the found object and the highly personal abstraction.

In doing so, he often seemed to invert the attitudes of his predecessors. Thus Duchamp took a bottle rack and called it his own; Johns patiently built two ale cans in a complicated way, expending great effort on almost-reproducing these ordinary objects. Pollock's last painting, *Scent,* shows an abstraction born of spontaneity and freedom; Johns' image of the same title, while equally abstract, follows an elaborate plan which is mathematical in its precision—and ultimately the reverse of real spontaneity.

Of course, references to Pollock and Duchamp do not adequately describe either the intention, or the impact, of Johns' work. Although there is an interest in relating Johns' work to that of earlier painters—and Johns himself provokes such considerations, by building layers of historical reference into his pictures— there is a deeper question about Johns, and a more fundamentally interesting one. Ehrenzweig touches upon it when he speaks of the need for art to include "the participation of the unconscious."[9]

One could argue that Johns is an artist who has chosen, throughout his working life, to place himself explicitly at the juncture of abstraction and representation. His work always seems to oscillate between the thing and the representation of the thing. By doing this, he engages the most significant questions about art as a human activity.

The earliest Western art—the cave paintings of Spain and the Dordogne valley of France—is associated with anatomically modern man, beginning about thirty thousand years ago. The Cro-Magnon artists were hunters, and their drawings focus on animals and the activity of the hunt. We do not know why early men made these paintings, but based on studies of modern aborigines, most authorities ascribe a function of sympathetic magic to cave art—animals were represented to increase their number, or to invoke success in future hunts. If this is true, then visual art began as an attempt to influence future human activity in the natural world. To make a mark on a cave wall was to alter the outcome of events in time.

This implies a deep belief in the power of representation that has never really waned, even to the present day. We smile when superstitious natives refuse to let tourists take their picture, lest their souls be stolen; but on television, a woman sharpshooter declined to shoot out the eyes of photographs of her children;[10] and if we tear up the picture of a person who made us angry, we may later feel guilty, as if we have actually harmed the person. On some primitive level we all retain the idea, thousands of years old, that the image of a thing is tied to the thing itself, and that what we do to the image is done to the thing it represents.

Another aspect of representation, also very old, springs from the need to represent complex attributes of a subject in a simpler static image. To solve this problem, artists created pictorial conventions—agreed-upon procedures which stand for something that cannot otherwise be shown. The multi-legged running beast may be the first representational convention in Western art.

Altamira. The Painted Ceiling

Pictorial conventions are arbitrary. Their meanings must be assigned and learned. We tend to think of our vision as natural—we look at something, recognize it, and say what it is—but in fact, all perception requires prior learning. People with congenital cataracts, who are enabled by surgery to see for the first time as adults, cannot at first distinguish between a circle and a square. They literally cannot see any difference. Later they can detect the difference, but can't say what the difference is. Not until they learn concepts such as line, angle, and curve are they able to articulate what they see.

In complicated ways, what we see is related to what we have already seen. Memory can be thought of as a kind of stored perception, which we use to help interpret new events in our world. Perception is not the passive process it was imagined to be even a century ago. Perception has nothing to do with the eye as a camera; we do not "see" the image projected on the backs of our eyeballs. Instead, what we see is the result of an active, inquisitive search of our environment, and an active, intellectual process of assigning learned meanings to the information we gather. That we are not consciously aware of this continuous effort does not make it any less real.

Beneath our conscious awareness is an unconscious mind, childlike and literal, that implacably observes everything around us. Yet on the conscious level, we filter our input, taking what is useful to us and ignoring the rest. We find continuity in the world at the expense of contradictory information that we ignore—indeed, that we will often fight hard not to see. Thus there must always be a considerable tension in our perceptual apparatus that comes from the awareness, at some level, of what we are consciously ignoring. From time to time, that tension can be collapsed, and in a moment of surprise we may become aware of how much has been ignored.

In art, that tension may be collapsed through imagery which deals with ambiguous information. The best art always sets our eyes and our brains at war in some way which must be resolved. And ordinarily that resolution invokes the unconscious mind.

Jasper Johns involves the unconscious mind of the observer in his art by a variety of procedures, employing irony, paradox, self-reference, and ambiguity in his imagery.

René Magritte. *The Promenades of Euclid*
(Les Promenades d'Euclide). 1955.
The Minneapolis Institute of Arts

The unconscious participates whenever there is ambiguous input. The phrase *nudisplays* can be heard as "new displays" or "nudist plays," depending only upon the predisposition of the listener. It is not a function of the auditory signal but rather of the receiving equipment.

Nudisplays is ambiguous only because it lacks a context. Placed in a sentence, it admits no multiple meanings: "I saw the *nudisplays* in the window of Tiffany's." The surrounding words provide a context, and eliminate ambiguity.

There has been a good deal of experimental work on context and perception. Psychologist George Miller asked subjects to listen to a string of words, such as *socks, brought, some, wet, who*. Played against a background of static noise, subjects could identify the words correctly only 50 percent of the time. However, when the words were rearranged as *who, brought, some, wet, socks*, identification improved dramatically.

Context improves perception by invoking expectations that sharpen our focus. Having heard *who brought some* we do not expect to hear a verb, for instance. We expect an adjective, adverb, or noun. We are able to react more quickly to what comes next.

In other cases we fill in gap where something is missing (as a word is missing in this sentence) because we expect the word to be there. We may not even be aware that we have filled something in. A certain kind of art plays on our desire to fill in, as in Magritte's *The Promenades of Euclid* (1955). One can compare this to Johns' FLAGS (1965), or to his more subtly proposed comparison in THE DUTCH WIVES. More abstractly, the title alone may provoke an attempt to fill in, as Johns' BETWEEN THE CLOCK AND THE BED may lead viewers to locate Munch's original composition within Johns' crosshatch composition. (Certainly, one would look at this painting very differently if it had a different title.)

Context is a powerful tool for directing our comprehension, by allowing us to anticipate what is to come. One way to break it is by repetition. In *Krapp's Last Tape*, Samuel Beckett repeats the word *spool* until context vanishes, and the naked syllable takes on multiple, conflicting associations. The audience usually laughs. (Mark Twain said that almost anything becomes funny if it is repeated

THE DUTCH WIVES. 1975. See Plate 167

TWO FLAGS. 1960. See Plate 54

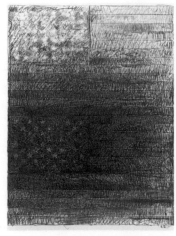

TWO FLAGS. 1980. See Plate 184

often enough, and humor always derives from the overlap of multiple simultaneous contexts.)

Johns employs repetition for other effects. Sometimes he seems to follow Cage's dictum that if something is boring done once, do it twice; at other times his repeated images are intended to be compared with one another. In either case, context is changed by repetition. Johns makes the image oscillate between representation and abstraction, between fixed meaning and floating meaning. And in doing so he allows the unconscious mind freedom to play. Thus the flag, the familiar image, becomes unfamiliar in a way that re-creates childish awe, the vision of a naive observer. We look at it with the open curiosity of someone who has never seen a flag before not because we haven't, but because it is "out of place" in a new setting, and because it is treated in a new way.

By breaking their context, Johns' images often assume a paradoxical aspect. Here is what some children were told about NUMBERS IN COLOR (1958–59):

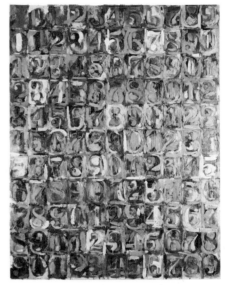

NUMBERS IN COLOR. 1958–59. See Plate 26

> You are probably wondering why Jasper Johns painted a picture of numbers. He could have used anything like a flower or something else. He could have made a landscape. But he used numbers. He apparently likes the pattern they can make. He must think them important in their own way. Of course numbers are important to us. We use them to telephone. We use them in the bank. We have to know arithmetic. In the picture, the numbers have nothing to do with telephoning. They have nothing to do with banking or arithmetic. The numbers in the picture are part of a design. They have become something new. They are just shapes and colors repeated and repeated.[11]

In addition, a critic could point out the competition between elements and overall construction, between the units and the grid in which they are imprisoned;[12] further, the competition between the brushstrokes and the numerals defined by the strokes. There is, in nearly all Johns' work, such a competition between structure and imagery, between technique and subject, between the whole and its parts.

But the numbers are, after all, painted abstractions. Arthur Koestler:

> Twentieth-century European regards with justified misgivings the "reduction" of the world around him, of his experiences and emotions, into a set of abstract formulae, deprived of colour, warmth, meaning and value. To the Pythagoreans, on the contrary, the mathematization of experience meant not an impoverishment, but an enrichment. Numbers were sacred to them as the purest of ideas, dis-embodied and ethereal. . . . Numbers are eternal while everything else is perishable; they are of the nature not of matter, but of mind.[13]

0 THROUGH 9. 1961. Charcoal and pastel on paper, 137.2 x 114.3 cm (54 x 45″). Private collection

Koestler's remarks focus attention on another paradox—the idea of representing what is already an abstraction. A flag is an abstraction, though most people think of it as a piece of multi-colored cloth. But numbers exist only as intellectual constructs, and to give them form in a painting is to challenge immediately our ideas of representation and abstraction.

With his targets, Johns went deeper into ambiguous, psychically rich juxtapositions. In TARGET WITH FOUR FACES, he combines one target and four cut-off

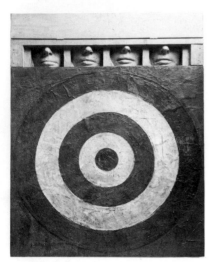

Target with Four Faces. 1955. Encaustic and collage on canvas with objects, 75.5 x 66 cm (29¾ x 26"). The Museum of Modern Art, New York. Gift of Mr. and Mrs. Robert Scull

faces. Although there is no obvious link between these two elements, the viewer is forced to make a connection. Several gifted observers have recorded their attempts.

Leo Steinberg:

Could any meaning be wrung from it? I thought how the human face in this picture seemed desecrated, being brutally thingified—and not in any acceptable spirit of social protest, but gratuitously, at random. At one point, I wanted the picture to give me a sickening suggestion of human sacrifice, of heads pickled or mounted as trophies. Then, I hoped, the whole thing would come to seem hypnotic and repellent, like a primitive sign of power. But when I looked again, all this romance disappeared. These faces—four of the same—were gathered there for no triumph; they were chopped up, cut away just under the eyes, but with no suggestion of cruelty, merely to make them fit into their boxes; and they were stacked on that upper shelf as a standard commodity. . . . I became aware of an uncanny inversion of values. With mindless inhumanity or indifference, the organic and the inorganic had been leveled . . . [a]s if the values that would make a face seem more precious or eloquent had ceased to exist.[14]

David Sylvester:

We speak of a target as a "face"; this is a conventionalized face surmounted by real faces. But are these "real" faces so very much more like faces in reality than the targets are? . . . The plaster faces have no more identity than masked faces. . . . If the target is there to be shot at, maybe the casts are there to be shot at: their absent eyes give them the look of men blindfolded before a firing squad.[15]

Time magazine:

. . . a Johns target, messily painted in red, blue and yellow atop a layer of old newspapers pasted to canvas. Attached to the upper edge of the canvas was a boxlike arrangement containing the lower parts of four faces, done in tinted plaster. The critics have dutifully produced a jargon suitable for such works.[16]

Leo Steinberg, on Target with Plaster Casts:

Apparently the artist wanted to know (or so he says) whether he could use life-cast fragments of body and remain as indifferent to reading their message as he was to the linage in the newspaper fragments pasted on the canvas below. Could our habit of sentimentalizing the human, even when obviously duplicated in painted plaster—could this pathetic instinct in us be deadened at sight so as to free alternative attitudes? He was tracking a dangerous possibility to its limits; and I think he miscalculated. Not that he failed to make a picture that works; but the attitude of detachment required to make it work on his stated terms is too special, too rare, and too pitilessly matter-of-fact to acquit the work of morbidity.[17]

The strength and variety of these comments remind us of the power of ambi-

guity, its evocative aspects. The targets have no single meaning, and what we know of the artist's own thinking is no help to us. (Artists are not usually much help; Picasso always said, "It is forbidden to question the pilot.") But the undercurrent of frustration was, if anything, heightened when critics attempted to deal with the paintings that followed.

Max Kozloff:

The condition of closure, denial, and concealment runs like a *leitmotiv* through this entire gamut of paintings, evoking, as it does, a low-pressure frustration which analysis almost cheapens. After all, the drawer cannot be opened; the canvas will not pry off; nor will the shade roll up, or the envelope unfold. With almost diabolical intent, the artist glues or immolates objects whose everyday function demands some kind of human operation.[18]

Barbara Rose:

The frustration of expectations created by the disruption of normal cause and effect relationships parallels a similar frustration produced by the knowledge that Johns's apparently useful objects are functionless and inoperative. The newspapers and books can't be read; the piano can't be played; the misshapen cutlery and bent hangers can't be used; the drawers don't open; the traffic lights signal nothing; the canvases can't be painted on. This collection of functional objects deprived of their normal functioning constitutes a depressing catalog of frustrations.[19]

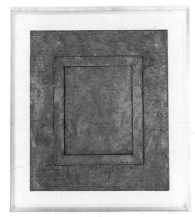

CANVAS. 1956. See Plate 21

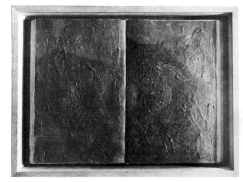

BOOK. 1957. See Plate 17

This sense of frustration occurs in the beholder, not necessarily in the artist. Johns gives us a canvas with an inset drawer, implying a space behind the picture plane, but it is we, as observers, who want to open the drawer. Paradoxically, the reason we want to open the drawer is to demonstrate what we already know— that there is nothing behind the canvas plane. Johns has suggested that there is, as Renaissance perspective suggested, a space behind the picture frame. But nobody has the urge to step into a Raphael or a Rembrandt; Johns has used other means to evoke space behind the picture, and this time, we accept the idea, at least enough to feel frustrated. One suspects it is Johns' literal treatment that accounts for our literal frustration.

But beyond this, we can observe that we are again confronted by a fundamental conflict between what the eye sees and what the mind knows, a feature of the paintings which is less ambiguous than paradoxical. These paradoxes are even more prominent in later work that employs labels.

The label first emerged as a motif in FALSE START. In its schematic quality, that painting suggests a useful abstraction, a map of some psychic territory of the mind. It is perhaps not surprising that an actual MAP of the United States followed two years later, in 1961. Viewing this painting, one senses contradictions piled upon one another—the use of colors, the naming of states, and the space of the painting employed to evoke, without suggestion, a geographical space of other dimensions.

At the same time, a paradox underlies any map. Lewis Carroll:

"There's another thing we've learned from your Nation," said Mein Herr,

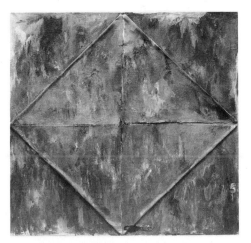

DISAPPEARANCE II. 1961. Encaustic and collage on canvas, 101.6 x 101.6 cm (40 x 40"). Private collection

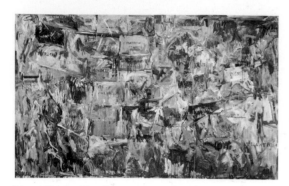

Map. 1961. See Plate 74

"map-making. But we've carried it much further than you. What do you consider the *largest* map that would be really useful?"

"About six inches to the mile."

"Only six *inches!*" exclaimed Mein Herr. "We very soon got to *six yards* to the mile. Then we tried a *hundred* yards to the mile. And then came the grandest idea of all! We actually made a map of the country, on the scale of *a mile to the mile!*"

"Have you used it much?" I enquired.

"It has never been spread out, yet," said Mein Herr: "the farmers objected: they said it would cover the whole country, and shut out the sunlight! So we now use the country itself, as its own map, and I assure you it does nearly as well."[20]

The map reminds us that representation is not a substitute so much as a useful tool. A map exists because it has certain advantages over the reality it stands for.[21] The idea of scale is important here. Kozloff notes:

> Scale becomes a very entertaining element. With one movement of the wrist [Johns] can slide from Oklahoma through Kansas into Missouri. And with merely a few strokes, he obliterates most of California, Arizona, Utah, and all of Nevada.[22]

The maps also focus on labels—the verbal abstraction, the linguistic convention. In these paintings, one feels a competition between the language of the painter and spoken or written language. The competition appears literally, as brushstrokes obliterate labels and vice versa; and it is felt as we look, and try to make sense of what we see. For just as casts of body parts exert an almost irreducible power, so too do words carry an irreducible impact—and an impact we are reluctant to give up. As anthropologist Edmund Carpenter says, "Any word is far more than just a label, a decal, applied or removed at will. It contains meanings & associations & values which help give the thing its identity."[23]

Zone. 1962. See Plate 101

One might think of the paintings that follow, such as Out the Window and Zone, as maps in another sense. But here we note a tentative, almost hypothetical quality to these paintings. In contrast to the flat literalness of the underlying imagery of earlier flags, targets, and maps, Johns' new paintings seem to suggest other ways of thinking, other possibilities. If they are maps, they chart an uncertain territory; the reality they represent is doubtful and mutable.

In fact, there is an implied attitude toward reality reminiscent of the attitude of the Wintu, as reported by Dorothy Lee:

> Outside man's experience . . . reality is unbounded, undifferentiated, timeless. Man believes it but does not know it. . . . Within his experience, the reality assumes temporality and limits. As it impinges upon his consciousness he imposes temporary shape upon it. Out of the undifferentiated qualities and essences of the given reality, he individuates and particularizes, impressing himself diffidently and transiently, performing acts of will with circumspection. . . . The Wintu actualizes a given design, endowing it with temporality and form through his experience. But he neither creates nor changes; the design remains immutable.[24]

Johns explicitly has expressed a similar attitude toward reality.

Time does not pass
Words pass.
 —Jasper Johns

It is believed by most that time passes; in actual fact, it stays where it is.
 —Dogen, a Zen Master

Things slip away from the intentions that have located them. Abuses and unexpected uses are found.
 —Jasper Johns

"I am thinking," says Zarian, "how nothing is ever solved finally. In every age, from every angle, we are facing the same set of natural phenomena, moonlight, death, religion, laughter, fear. We make idolatrous attempts to enclose them in a conceptual frame. And all the time they change under our very noses."[25]
 —Lawrence Durrell

SLOW FIELD. 1962. See Plate 104

The sense of elusive reality seems particularly important in two subsequent Johns paintings—SLOW FIELD (1962) and FIELD PAINTING (1963–64). The latter can be described in reference to a color field, a magnetic field, an electric field, a field of view, mirror images, movement. Johns himself thought of an agricultural field, in which a plow turned up a symmetrical furrow of letters. Here the letters are hinged, and movable. In earlier paintings, Johns was interested in having the observer move in relation to the picture; so why couldn't the elements of the painting move as well? Here they can—a relativistic situation in which the viewer's position and the painting can both change. The participation of the observer is directly implied—he can alter the shape of the work, with a touch of his hand.

At the same time, Johns' field paintings are intimately concerned with the painter's craft; paintbrushes, solder, and mixing cans litter the field, sticking obstinately to the creation already made, as if they can't be gotten rid of.

FIELD PAINTING. 1963–64. See Plate 111

This draws our attention to certain other ideas about representation which interested Johns during this period. Increasingly, he tended to leave behind a literal mark which suggested how the picture had been made. From the wooden device in DEVICE CIRCLE (1959), through the handprints in DIVER and LAND'S END, until, finally, the device that scrapes the arc in PERISCOPE (HART CRANE) becomes the artist's arm—we are never allowed to slip into the illusion that the painting is other than a man-made thing, an object in its own right, as well as a representation of something else.

One could argue that the devices attached to these paintings function less to explain than to reinforce doubt. Often we feel the devices probably did not make the paintings as they seem to have done; a close inspection of the scraped arc in PERISCOPE (HART CRANE) leaves us unsure that it was created by the arm we are shown. If the picture wasn't made that way—if the illusion is so obviously an illusion—then we are reminded that the painting itself stands in even more doubtful relationship to whatever it can be said to "represent."

FIELD PAINTING (detail)

PERISCOPE (HART CRANE) (detail). 1963. See Plate 105

DEVICE. 1961–62. See Plate 91

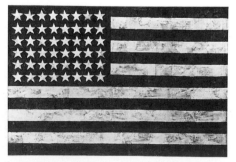

FLAG. 1955. See Plate 1

Alan Solomon:

It must be understood . . . that his pictures, before anything else, have to do with the avoidance of specific meanings, with the necessity for keeping the associational and even the physical meaning of the image ambiguous and unfixed. This attitude should not be regarded as a denial of responsibility, but rather as a positive affirmation of the need for questioning established values. . . . Despite the complexity and the ambiguity of the statement made in his work, Johns comes to his position in a very direct and uncomplicated way: he questions everything. . . . His work may be regarded as a series of rhetorical questions, unanswerable questions which keep us constantly off-balance.[26]

We have already observed that the paintings from 1961–64 convey a sense of cumulative thought. Looking at the three-paneled RED YELLOW BLUE "flag" of the pictures from the early sixties, one feels that the increasing subtlety of transformation reflects the logical way that Johns' own thinking proceeded. Indeed, Max Kozloff observed that to review Johns' work was not so much to be exposed to a personality as it was to receive an introduction to his way of thought.[27]

Johns' system of thought—the attitudes which lead to work, and to the perception of limitations which are overcome—is striking in its formality. Paul Dirac noted that advances in physics "usually consist in overcoming a prejudice. We have had a prejudice from time immemorial, something which we have accepted without question, as it seems so obvious. And then the physicist finds that he has to question it, he has to replace his prejudice by something more precise, and leading to some entirely new conception of nature."[28]

Similarly, Johns' methods often have been taken to imply a reluctance to move forward. Many observers have noted that Johns seems to work patiently on a set of ideas until they become increasingly convoluted and difficult, only to escape into new freedom and fresh consideration. The later works of any period have often been taken to suggest desperation, entrapment, or exhaustion on the artist's part. That was a common view in 1964, after several years of these uncertain maps; it was again the view in 1979, when, after several years, the crosshatch paintings appeared labored and too formal; and it is a view sometimes expressed about Johns' newest work, which is thought by some to belabor the now-exhausted potential of his wall-paintings.

In each instance, the progression of the work is presumed to reflect something about how the artist is feeling, not how he is thinking. Unappreciated is the possibility that these periodic "crises" in Johns' work may be the inevitable consequence of his rigorous methods. For it is demonstrable that any developing logical system will alternate between periods where everything seems comfortable and new ideas are smoothly integrated, and periods where nothing makes sense, where absurdities pile up, and where all efforts to resolve the problems only seem to make them worse, until finally there is some new breakthrough, some new sense of order at a higher level. That has been the history of physics and of mathematics. And it may explain much of Johns' working history, as well.

In any case, it is worth observing that viewed in ten-year intervals, Johns' work demonstrates clearly that although one painting may lead to the next, his major shifts cannot really be said to be implied by their starting points. It is one of the many paradoxes of Johns' work that his deliberate, logical working procedures should have led him to such surprising outcomes—for example, the crosshatch paintings.

EDDINGSVILLE. 1965. See Plate 120

The initial critical response to the crosshatch paintings was dismay: Jasper Johns, the painter who had vanquished Abstract Expressionism, was revealed to be an abstract painter after all. But as his work continued, observers noted the formal structure that underlay the compositions, and the metaphorical and allusive ends to which they were put. Thus, a new paradox arose: Johns had created abstract images that were arguably not abstract at all. He had once again found room to play, in an ambiguous area that had not previously been suspected to exist.

Nan Rosenthal and Ruth Fine:

It is a central feature of the crosshatch works to address both the eye and the mind: the eye with an often dizzying array of lush marks on the surface, the mind with the system that establishes the patterns in which the marks are laid down.[29]

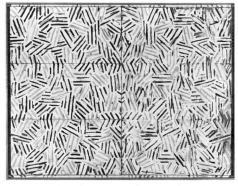

CORPSE AND MIRROR II. 1974–75. See Plate 163

Mark Rosenthal:

With the crosshatchings, Johns has placed himself within the primary tradition of modernism—abstraction—and its concern for the physically literal mark. . . . Johns may employ several systems to arrive at the overall composition of a crosshatch painting and each is plotted in advance. . . . In effect, his . . . nonobjective art bears a likeness to events and appearances in the world. . . . One comes to the conclusion that in Johns's crosshatch paintings, as in life itself, processes and systems almost always underlie appearances.[30]

Robert Hughes:

His diagonal cross-hatchings are both subtle and banal, for Johns' scrutiny flickers in a perplexing, teasing way between simple pattern recognition and active, probing attention.[31]

William Gass favorably compared the crosshatch paintings to the targets of the fifties, but nevertheless expressed some reservations:

Usuyuki is a relatively uncluttered, "unclever" painting, profound in what it does not have to say; however elsewhere, in Johns's work, profundity is alleged, but not as readily reached. His symbols sometimes get a bit nervous and fussy. There is a lot of tugging at the observer's sleeve.[32]

But for the most part, the crosshatch images were received with pleasure by critics and audiences alike. There is an unmistakable sense of play in the images, and a strong sense of teasing, even seduction, of hidden secrets and formal plans, and if the artist is tugging at your sleeve, it is perhaps to lead you astray. In

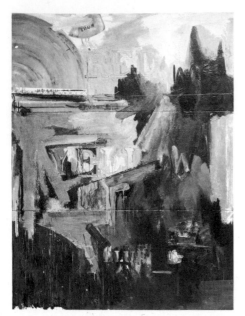

PASSAGE. 1962. See Plate 99

fact, taken as a whole, one could argue Johns' new paintings were more accessible than the work that preceded them; it is ironic that these entirely abstract images should often seem so much more active in soliciting our attention than the implacable targets and flags of Johns' earlier career.

Johns' much-discussed sense of irony takes many forms—including the most literal "form," the imprint of an iron in the wax surface of a painting. This was first seen in PASSAGE (1962), where it may have stood as a response to Duchamp's idea to "use a Rembrandt as an ironing board." It appeared again in the cross-hatch painting WEEPING WOMEN (1975), where its female connotations, breasts and laundresses, were intermingled with the sense of the artist's stamp—a kind of iron-ic handprint—a trace of his work, left on the worked encaustic surface. With a title that derives from a Picasso painting, WEEPING WOMEN invites us to search through past images from art history in an attempt to locate meanings; but the panels of THE DUTCH WIVES, painted the same year, provoke a more immediate search for the differences between the original and the surrogate.

These two sources of meaning, the historical referents and the compositional referents, were carried to new levels in the wall paintings of the early 1980s, such as PERILOUS NIGHT. Mark Rosenthal observes:

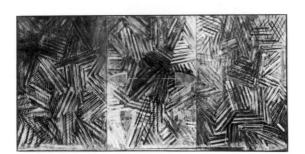

WEEPING WOMEN. 1975. See Plate 168

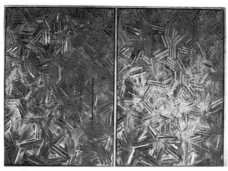

THE DUTCH WIVES. 1975. See Plate 167

PERILOUS NIGHT. 1982. See Plate 191

Pablo Picasso. *Weeping Woman*. 1937. Oil on canvas, 59.7 x 49.5 cm (23½ x 19½"). Penrose Collection, London

Perilous Night is an altogether moody composition possessing the air of fragmented dreams. Yet notwithstanding its disjunctive character, the painting [is] organized into diptych compositions. With this arrangement, Johns encourages the viewer to begin making relationships and distinctions.[33]

So far, his description could equally fit THE DUTCH WIVES, and in fact Rosenthal himself soon proposes a formal comparison to the earlier corpse and mirror structures. But he goes on to specify for PERILOUS NIGHT the "ambiguous, unexplained sections and the conflicting versions of reality, either painted, cast or found." Rosenthal considers the three arms to symbolize the Three Ages of Man or even the Trinity; the painted spots on the limbs to echo arm wounds; the handkerchief to be quoted from Picasso's *Weeping Woman*; and that this imagery, alongside the fallen soldiers of the Resurrection panel, suggests that "Johns documents appearances following a death—wounded arms hanging as if hunks of meat and a handkerchief used in mourning."

Rosenthal is one of the few observers to attempt a detailed analysis of the imagery. He concludes Johns has created "an endlessly contemplative image . . . another of Johns's attempts to distinguish between reality and paradox, whereupon he resigns himself to the permanent state of confusion and doubt these concepts inspire in him."

Other observers have tended to admire the wall paintings from a distance, so to speak, recognizing that Johns' procedures now pile up so many contradictions, conflicting references, and doubtful distinctions within a single canvas that meaning cannot any longer be determined, except in the most general terms. And perhaps not even then:

John Russell:

Racing Thoughts is a classic of complication. Fundamentally, it belongs to the great 20th-century tradition of the artist's interior. Humdrum elements from everyday life are set side by side with works of art by other artists. Photographs of people who matter to the artist and allusions of a more esoteric kind are magically commingled. . . . As Johns is one of the great recorders of panic and loss in contemporary art, we have no trouble with a bilingual warning (Watch Out! Falling Ice! in French and German) against the possible collapse of a glacier, which bulks large on the right of the canvas. . . . I suspect that *Racing Thoughts* is about the ambitions of art, about a career in art and about the loneliness of making art.[34]

Barbara Rose:

Johns's *Racing Thoughts* is a meditation. The subject seems to be a series of free associations on that which has disappeared or is disappearing: the dashing youth of his good friend and dealer Leo Castelli; allusions to past art and Old Masters. The curious introduction of profiles of Queen Elizabeth and Prince Philip of England . . . may refer to the passing of the social class they represent, with its monarchy and collapsing empire. In this sense, the painting is a meditation on history—on the replacement of the old order by a new age. . . . Perhaps Johns is saying that we live in a dangerous time, in which the old order is crumbling, yet there may be resurrection.[35]

Mark Rosenthal:

Doubleness of identity, appearance and meaning underlies virtually every object or image in *Racing Thoughts*. . . . The painting is a kind of witty, Cubist portrait of a male-female personage, with the jigsaw puzzle as a model of the fragmentation that is employed. . . . Johns . suggests that interpreting existence is an altogether subjective activity.[36]

Richard Francis:

Deciphering the personal revelations Johns offers us . . . is no easy task . . . for he has hardly relinquished his interest in formal complexities, and on repeated occasions makes use of Cubist notions of space and picture plane to organize his canvases. . . . In *Racing Thoughts* . . . each element adds clues to the build-up of a bewilderingly complex picture (we must constantly ask what

RACING THOUGHTS. 1983. See Plate 199

UNTITLED. 1986. See Plate 217

is on top of what surface) and thence to the extravagant topography of the artist's imagination.[37]

For the entire group of paintings, a cinematic or dreamlike quality was noted by many critics, including Robert Hughes:

> Sometimes one is excluded; it is like eavesdropping on a man who, half asleep at 4 in the morning, combines and recombines the obsessive contents of his semiconscious mind, muttering and sometimes cursing. But this is the play of a great artist.[38]

Many critics seem to have agreed with David Carrier that "it is hard to assemble the implied meanings of Johns' works. . . . Ultimately the potential meanings cancel each other out, leaving us no further than we were at the start."[39] This difficulty was often seen as a virtue: "It seems unlikely anyone will (or should) ever crack Johns' sibylline code. Given the endless possibilities in this endlessly changing body of work, with all its attendant pleasures, who would really want to?"[40] Or Mark Stevens:

> Nothing stops play faster than the tyranny of explanation. Around a Johns painting, people too often spend their time looking for keys, as if the paintings were merely puzzles in search of a solution. They are more like solutions in search of a puzzle.[41]

Not every critic was content to admire pictures about which little could be said with certainty; the fact that every statement could be cast into doubt by other aspects of the same image soon began to lose its fascination. It may be that critical frustration with Johns' elegant but contradictory canvases was partly responsible for the growing interest, during the latter 1980s, in the embedded imagery in Johns' paintings—an interest which Johns himself felt was irrelevant to the work he was doing, and which eventually he would attempt to divert.

THE SEASONS (SUMMER). 1987. Etching and aquatint, edition 73, 66.4 x 48.6 cm (26⅛ x 19⅛"). Published by ULAE

The explicit formal structure of THE SEASONS and its catalog of familiar Johnsian objects provided a more accessible context for critical discussion; Johns himself spoke freely about the paintings, and how they had come about. There was a frequent tendency to see the works as autobiographical in some way, or at least "as a complex allegory of the artist's life."[42]

Characteristically, Johns denied this. He has said, "There is an aspect to most painting—I don't know how it happens—but somehow it conveys a suggestiveness about the person who made the work. Maybe this is true of mathematics too, but I don't think it is in that same way. It may have to do with anything that is done by hand."

It was in this series of paintings that more than one observer came to realize the irony behind the fact that if the shadow on the wall was really Johns' own— as he said it was—then he could not have traced it himself. Thus the first life-sized appearance of the artist in his own work had been accomplished through a line that Johns himself did not draw. It makes the shadow oddly unsettling; for Johns to place this tracing in the painting is to raise a question about what has been done—a question that nearly any observer will instinctively recognize. A

STUDY FOR FALL. 1986. Pencil on paper, 51.4 x 72.7 cm (20¹⁄₁₆ x 28⅝"). Collection Janie C. Lee

98

viewer who knows nothing of Duchamp, or Picasso, or embedded images and Ohr cups will know, without being told, that the shadow is ambiguous. We are all accustomed to the projection of our body's shadow in space; we have all as children traced our hands and feet. Johns' treatment of his shadow thus re-creates a startlingly simple dilemma.

Johns has said, "My thinking is dependent on real things. . . . I'm not willing to accept the representation of a thing as being the real thing, and I am frequently unwilling to work with the representation of a thing as . . . standing for the real thing. I like what I see to be real, or my idea of what is real.[43]

In the end, his highly complex concerns about hidden images taken from sixteenth-century altarpieces stand side-by-side with this almost childishly simple paradox: an artist who appears to have drawn his own shadow cannot in fact have done so.

Ventriloquist. 1983. See Plate 197

After nearly forty years, the determinative position of the observer in Johns' art—once so controversial in the earliest responses to his work—has been accepted, and even presumed. William Gass:

Johns is aware that before one of his paintings completes its passage from his atelier to a commercial gallery . . . critics and commentators will . . . complete the conceptual bridge the work requests by educating an otherwise uninformed eye: glossing the imagery, explaining techniques, interpreting themes, linking watercolors, prints and canvases, calling upon the appropriate traditions.[44]

Untitled. 1983–84. Ink on plastic, 66.4 x 87.6 cm (26⅛ x 34¼"). Collection the artist

But ironically, if the early works were seen as perplexing because they were deprived of associations, the later works often seem problematical because they evoke so many associations. And thus, paradoxically, viewers sometimes express a wish just to look at the paintings in an ordinary way—"as you would look at a radiator," as Johns himself once put it. Now that these complex associations are discussed and perceived as a significant feature of the work, there is a countervailing wish to escape all these associations, and deal with Johns more directly. Mark Stevens:

The Critic Sees. 1962. Pencil and collage on paper, 26.7 x 36.2 cm (10½ x 14¼"). Collection Leo Castelli, New York

The most difficult and intelligent response to Johns' art is to relax and allow the mind's eye to wander. . . . It is the playfulness of Johns that often needs to be regained amid all the saluting and earnest interpretation. . . . The art of looking at Johns does not consist in making a detailed list of explanations. It lies in the play of meaning. . . . The game is epistemological, and the playing never stops. It seems both a pleasure and a life sentence.[45]

William Gass expressed a similar feeling:

Much of the time, I, at least, wanted just to look . . . and to have my mind blown by great gusts from the lungs as the breath left. The formal still bears the brunt and carries the load [but] still, it was worthwhile remembering . . . while you make your way to look at the many fine signs, Borgesian games, and aesthetic reminiscences in this notable show that there was also hung on these walls simply a lot of great paint.[46]

Untitled. 1991. Oil on canvas, 152.4 x 101.6 cm (60 x 40"). Collection the artist

LIGHT BULB. 1958. See Plate 29

WINTER. 1986. Charcoal on paper,
106.7 x 75.6 cm (42 x 29¾").
Collection Robert and Jane Meyerhoff,
Phoenix, Maryland

CELINE (detail). 1978. See Plate 176

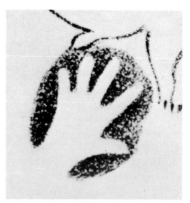

Paleolithic hand. c. 15,000 B.C.
Pech-Merle, France

If the observer, no longer preoccupied with formal connections and art histori-cal associations, falls silent and "simply" looks at Johns' art, it may mean that communication has moved to another level. Psychiatrist Milton Erickson, who devoted his life to a study of the unconscious, concluded that the conscious and unconscious minds were entirely separate systems of mental activity. In what could serve very well as a description of Johns' art, Erickson said:

> Dreams, puns, elisions, plays on words and similar tricks that we ordinarily think of as frivolous, all play a surprising and somewhat disconcerting role in the communication of important and serious feelings. . . . It is ever a source of fresh amazement when the unconscious processes express weighty and trou-blesome problems in a shorthand which has in it an element of levity.[47]

For the viewer, a shift away from conscious attention has its advantages, as Erickson observes:

> Underneath the diversified nature of the consciously organized aspects of personality, the unconscious talks in a language which has remarkable unifor-mity . . . the unconscious of one individual is better equipped to understand the unconscious of another than the conscious aspects of the personality of either.[48]

And finally, Erickson directs our attention to the unblinking, child-like quali-ties of unconscious processes:

> How many of us really appreciate the childishness of the unconscious mind? Because the unconscious mind is decidedly simple, unaffected, straightfor-ward and honest. It hasn't got all of this facade, this veneer of what we call adult culture. It's rather simple, rather childish. . . . It is direct and free.[49]

Throughout his work, Johns has always evinced a remarkable ability to re-create a naive perception—in the best sense of the word. This is the perception of the child, who sees an object and cannot make sense of it, since sense means, ultimately, adult sense—category formation, linguistic labels, intellectual con-structs—which eventually become so closely linked that they are attributes of the thing itself. The competition between fresh seeing and adult familiarity appears throughout Johns' work, which is at the same time neither childish nor sophisticated, but both at once.

It is here, finally, that his strength lies. What is truly familiar is not looked at; what is truly new is similarly meaningless. During the eighteenth century, ships' captains liked to invite naive Indians aboard their ships and then fire cannons to startle them, but the Indians didn't blink: the loud sound had no meaning to them.

Jasper Johns has always moved with assurance along that fine path between what is new and what is known, what is said and what is seen. He sees things with an innocent eye, but re-creates them with the full, overpowering awareness of the adult intellect—and a highly developed artistic skill. By doing so, he evokes the oscillation that exists between a representation and the abstract qualities of that representation. The form his work takes is a peculiarly modern, twentieth-century form. But its power is as old as Paleolithic cave art.

NOTES

1. Lawrence Alloway, "Jasper Johns and Robert Rauschenberg," *American Pop Art*, Collier Books and the Whitney Museum of American Art, New York, 1974, p. 66.

2. Leo Steinberg, "Contemporary Art and the Plight of Its Public" (1962), *Other Criteria: Confrontations with Twentieth-Century Art*, Oxford University Press, New York, 1972, p. 12.

3. *Ibid.*, p. 15.

4. John A. Wheeler, "From Relativity to Mutability," in *The Physicist's Conception of Nature*, ed. Jagdish Mehra, Reidel, Dordrecht and Boston, 1973, p. 244.

5. Or nature "exposed to our method of questioning," as Werner Heisenberg put it.

6. Kenneth Clark, *Civilization*, Harper & Row, New York, 1969, p. 345. He goes on to say: "The incomprehensibility of our new cosmos seems to me, ultimately, to be the reason for the chaos of modern art."

7. Arnold Hauser, *The Social History of Art*, Knopf, New York, 1951, vol. I, p. 334.

8. Guillaume Apollinaire, *Meditations esthetiques—Les Peintres cubistes*, eds. L. C. Breunig and J.-Cl. Chevalier, Hermann, Paris, 1965, pp. 51–52.

9. Anton Ehrenzweig, *The Hidden Order of Art*, University of California Press, Berkeley, 1967, p. 62.

10. Edmund Carpenter, *Oh, What a Blow That Phantom Gave Me!*, Holt, Rinehart & Winston, New York, 1973, p. 17.

11. Charlotte Buel Johnson, "Numbers in Color," *School Arts*, 62, Nov. 1962, p. 35.

12. Amy Goldin, "Patterns, Grids, and Painting," *Artforum*, 14, Sept. 1975, pp. 50–54.

13. Arthur Koestler, *The Sleepwalkers*, Macmillan, New York, 1959, p. 28.

14. Steinberg, *op. cit.*, pp. 12–13.

15. David Sylvester, "Jasper Johns at the Whitechapel," unpublished talk on the *BBC Third Progamme*, transmitted Dec. 12, 1964; cited in Max Kozloff, *Jasper Johns*, Abrams, New York, 1969, p. 14.

16. *Time*, 73, May 4, 1959, p. 58.

17. Leo Steinberg, "Jasper Johns: The First Seven Years of His Art" (1962), *Other Criteria: Confrontations with Twentieth-Century Art*, Oxford University Press, New York, 1972, p. 37.

18. Kozloff, *op. cit.*, p. 21.

19. Barbara Rose, "The Graphic Work of Jasper Johns, Part II," *Artforum*, 9, Sept. 1970, p. 66.

20. Lewis Carroll, *Sylvie and Bruno Concluded* (1893), *The Complete Works of Lewis Carroll*, Modern Library, New York, 1936, pp. 616–17.

21. We are so accustomed to manipulating symbolic material, we inevitably come to think of symbols as reality itself. (When the first photographs of the earth from space were seen, it was surprising to find that national boundaries were not demarcated, and that different states were not different colors. We knew it, of course, but we had forgotten.)

22. Kozloff, *op. cit.*, p. 28.

23. Carpenter, *op. cit.*, p. 18.

24. Dorothy Lee, "Linguistic Reflection of Wintu Thought" (1944), *Explorations in Communication*, eds. E. Carpenter and M. McLuhan, Beacon Press, Boston, 1960, p. 12.

25. Dogen cited in Fritjof Capra, *The Tao of Physics*, Shambhala Publications, Berkeley, Cal., 1975, p. 186. Zarian in Lawrence Durrell, *Prospero's Cell, and Reflections on a Marine Venus*, E.P. Dutton, New York, 1960, p. 105.

26. Solomon, "Jasper Johns," in *Jasper Johns: Paintings, Drawings and Sculpture, 1954–1964*, Whitechapel Gallery, London, p. 8.

27. Kozloff, *op. cit.*, p. 28.

28. Paul A. M. Dirac, "Development of the Physicist's Conception of Nature," in Mehra, *op. cit.*, p. 1.

29. Nan Rosenthal and Ruth Fine, *The Drawings of Jasper Johns*, Thames and Hudson, London, 1990, p. 226.

30. Mark Rosenthal, *Jasper Johns Work Since 1974*, Thames and Hudson, London, 1988, pp. 14–16.

31. Robert Hughes, "The Venice Biennale Bounces Back," *Time*, July 25, 1988, p. 85.

32. William Gass, "Johns," *New York Review of Books*, Feb. 2, 1989, p. 27.

33. Rosenthal, *op. cit.*, p. 65.

34. John Russell, "Jasper Johns Show Is Painter at His Best," *New York Times*, Feb. 3, 1984, III, 22:5.

35. Barbara Rose, "Bathus and Johns," *Vogue*, Feb. 1984, p. 418.

36. Rosenthal, *op. cit.*, p. 86.

37. Richard Francis, "Disclosures," *Art in America*, Sept. 1984, p. 202.

38. Hughes, *op. cit.*, p. 85.

39. David Carrier, "Jasper Johns at the Museum of Modern Art," *Burlington Magazine*, Jan. 1989, pp. 66–67.

40. Barbara Knowles Debs, "On the Permanence of Change," *Print Collector's Newsletter*, 17, 4, Sept.–Oct. 1986, p. 123.

41. Mark Stevens, "Pessimist at Play," *New Republic*, Jan. 9 and 16, 1989, p. 26.

42. Roberta Bernstein, "Jasper Johns's *The Seasons:* Record of Time," catalog, Brooke Alexander Editions, 1991, p. 9.

43. Sylvester, *op. cit.*, p. 14.

44. Gass, *op. cit.*, p. 27.

45. Mark Stevens, "The Seducer of Certainty," *New Republic*, July 30, 1990, p. 28.

46. Gass, *op. cit.*, p. 27.

47. Cited in Ronald A. Havens, *The Wisdom of Milton H. Erickson*, Irvington Publishers, New York, 1985, p. 63.

48. Havens, *op. cit.*, p. 82.

49. *Ibid.*, p. 79.

PLATES

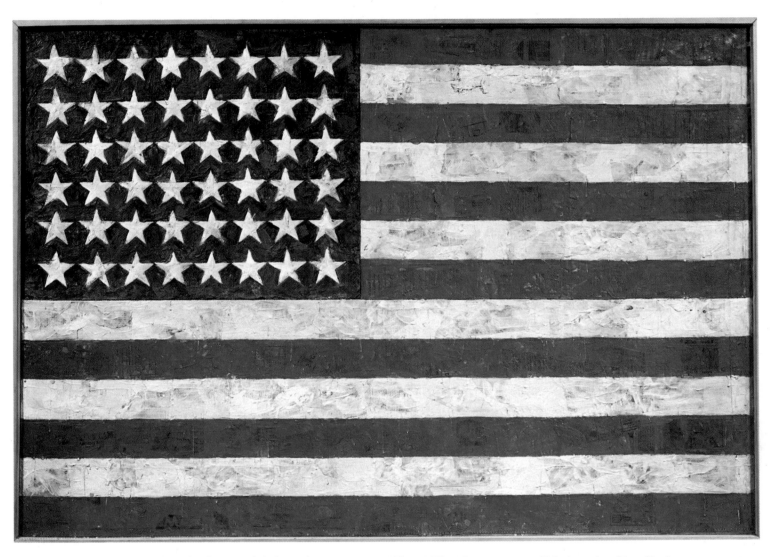

1. FLAG. 1955. Encaustic, oil, and collage on fabric, 107.3 x 154 cm (42¼ x 60⅝″). The Museum of Modern Art, New York. Gift of Philip Johnson in honor of Alfred Barr

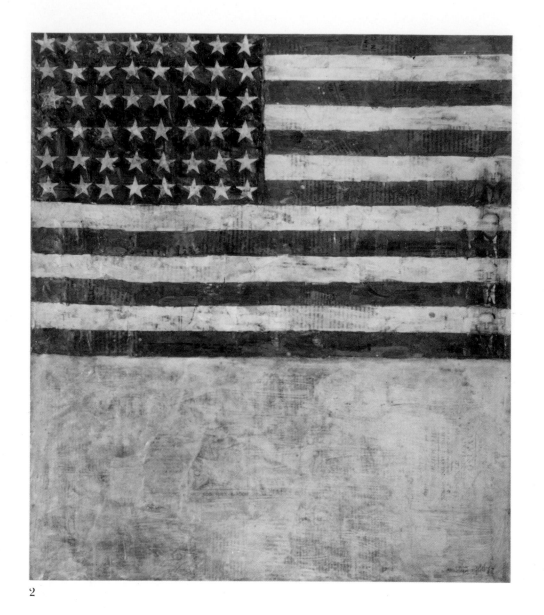

2

2. FLAG ABOVE WHITE WITH COLLAGE.
1955. Encaustic and collage on canvas,
57.2 x 48.9 cm (22½ x 19¼").
Collection the artist

3. FIGURE 1. 1955.
Encaustic and collage on canvas,
43.8 x 34.9 cm (17¼ x 13¾").
Private collection, New York

4. FIGURE 5. 1955.
Encaustic and collage on canvas,
44.5 x 35.6 cm (17½ x 14").
Collection the artist

5. FIGURE 7. 1955.
Encaustic and collage on canvas,
44.5 x 35.6 cm (17½ x 14").
Collection Robert H. Halff and
Carl W. Johnson

6. FIGURE 2. 1956.
Encaustic and collage on canvas,
43.2 x 35.6 cm (17 x 14").
Private collection

3

4

5

6

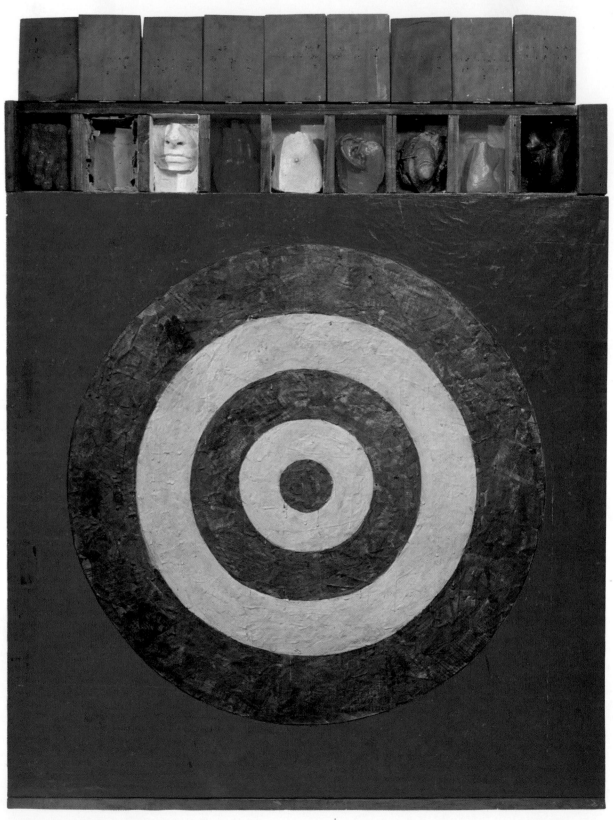

7. TARGET WITH PLASTER CASTS. 1955. Encaustic and collage on canvas with objects, 129.5 x 111.8 cm (51 x 44").
Collection Mr. and Mrs. Leo Castelli

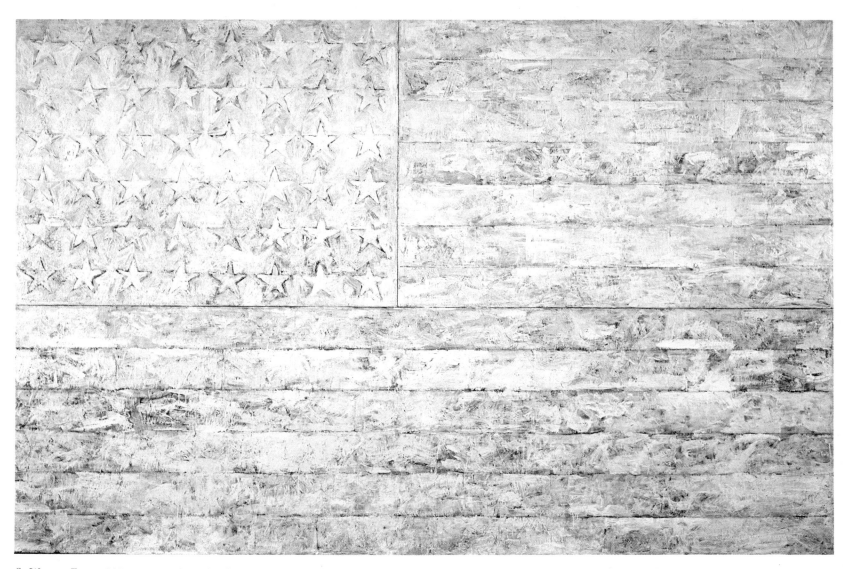

8. WHITE FLAG. 1955. Encaustic and collage on canvas, 198.9 x 306.7 cm (78⁵/₁₆ x 120¾"). Collection the artist

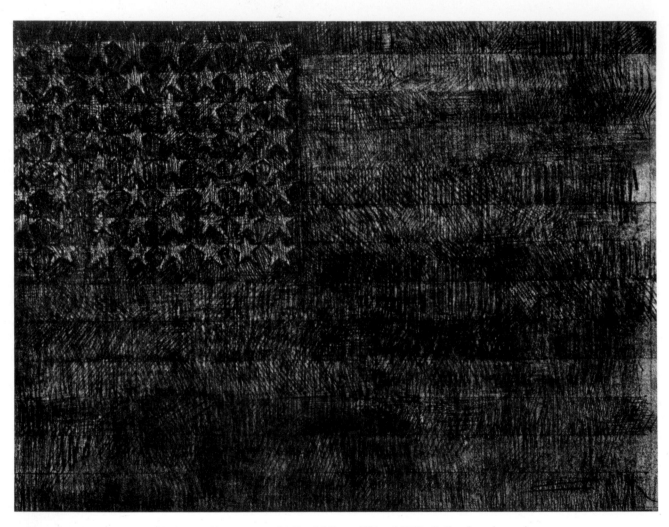

9. FLAG (WITH 64 STARS). 1955. Pencil on paper, 21.5 x 25.7 cm (8½ x 10⅛"). Collection the artist

10. TARGET WITH FOUR FACES. 1955.
Pencil on paper,
21.5 x 18.4 cm (8½ x 7¼″).
Collection the artist

11. TARGET. 1955.
Pencil on paper,
24.2 x 19.1 cm (9½ x 7½″).
Collection Jean-Cristophe Castelli

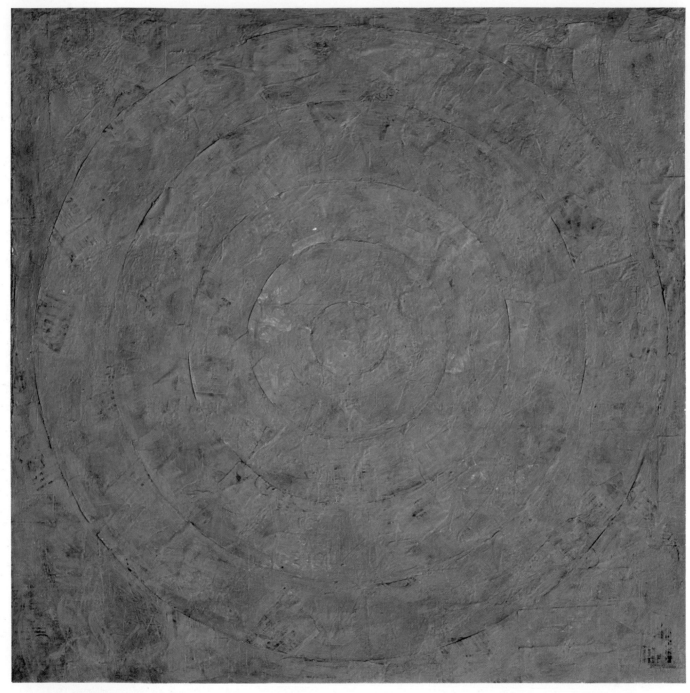

12. GREEN TARGET. 1955. Encaustic and collage on canvas, 152.4 x 152.4 cm (60 x 60″). The Museum of Modern Art, New York. Richard S. Zeisler Fund, 1958

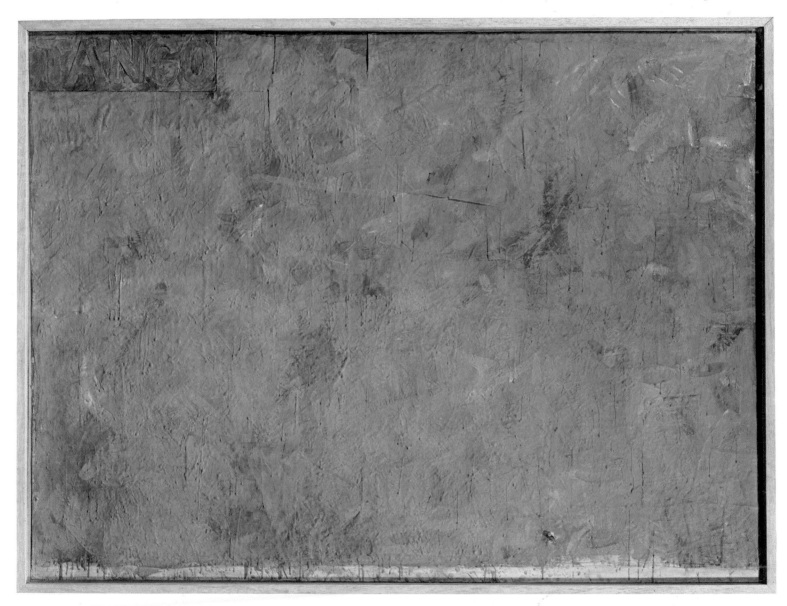

13. TANGO. 1955. Encaustic and collage on canvas with objects, 109.2 x 144.5 cm (43 x 56⅞″). Collection Ludwig, Aachen

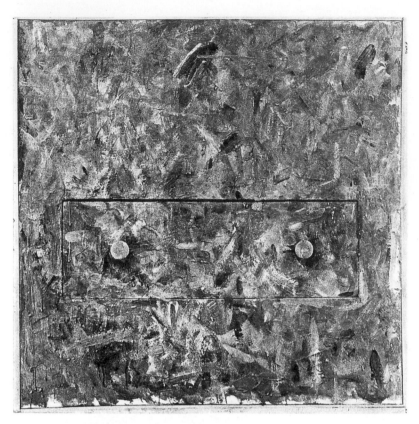

14. DRAWER. 1957. Encaustic on canvas with objects, 77.5 x 77.5 cm
(30½ x 30½″). Brandeis University Art Collection, Rose Art Museum.
Gevirtz-Mnuchin Purchase Fund

15. THE. 1957.
Encaustic on canvas,
61 x 50.8 cm (24 x 20″).
Collection Mildred and Herbert Lee

16. NEWSPAPER. 1957. Encaustic and collage on canvas, 68.6 x 88.3 cm (27 x 34¾″).
Collection Mildred S. Lee

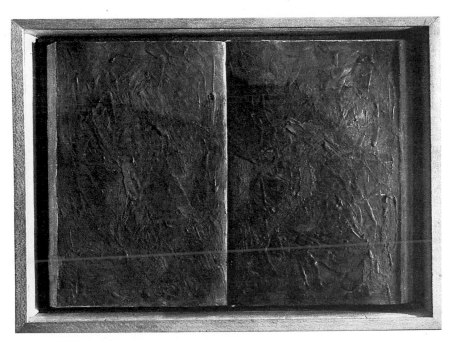

17. BOOK. 1957. Encaustic with objects, 24 x 32.7 cm (9½ x 12⅞″).
The Margulies Family Collection, Miami

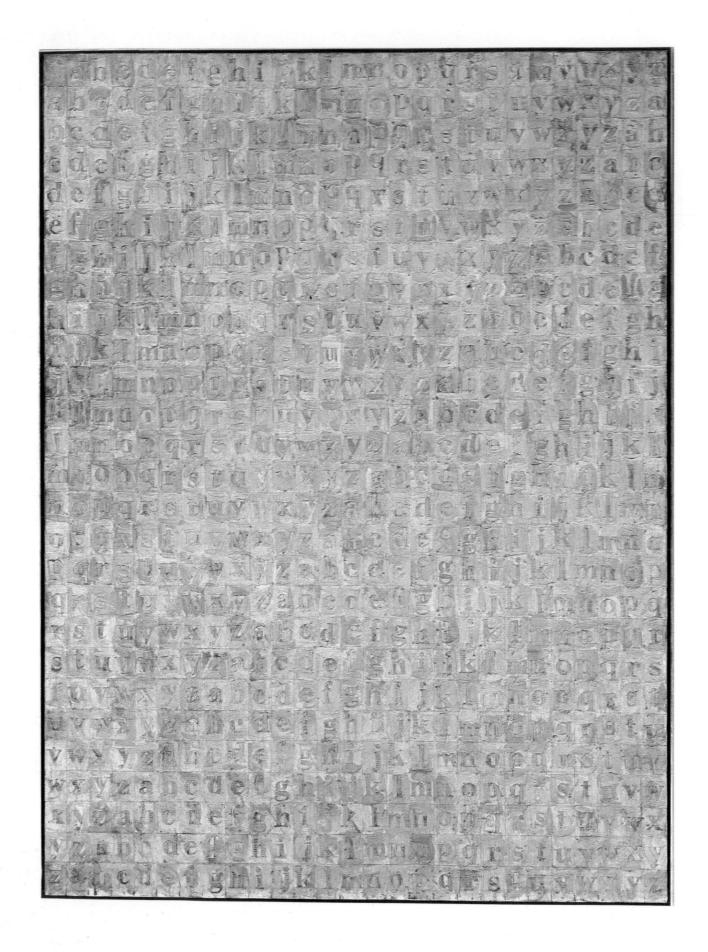

19. FLAG. 1957. Pencil on paper, 27.6 x 38.9 cm (10⅞ x 15⁵/₁₆″). Collection the artist

18. GRAY ALPHABETS. 1956.
Encaustic and collage on canvas,
167.6 x 124.5 cm (66 x 49″).
The Menil Collection, Houston

20. ALPHABETS. 1957.
Pencil and collage on paper,
36.9 x 26.7 cm (14½ x 10½″).
Collection Robert Rosenblum, New York

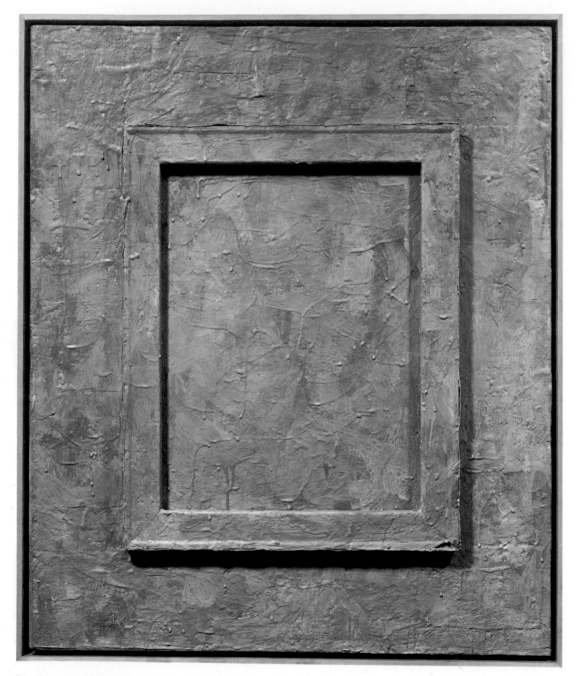

21. CANVAS. 1956. Encaustic and collage on canvas with objects, 76.2 x 63.5 cm (30 x 25″).
Collection the artist

22. FLAG ON ORANGE FIELD. 1957.
Encaustic on canvas,
167.6 x 124.5 cm (66 x 49″).
Museum Ludwig, Cologne

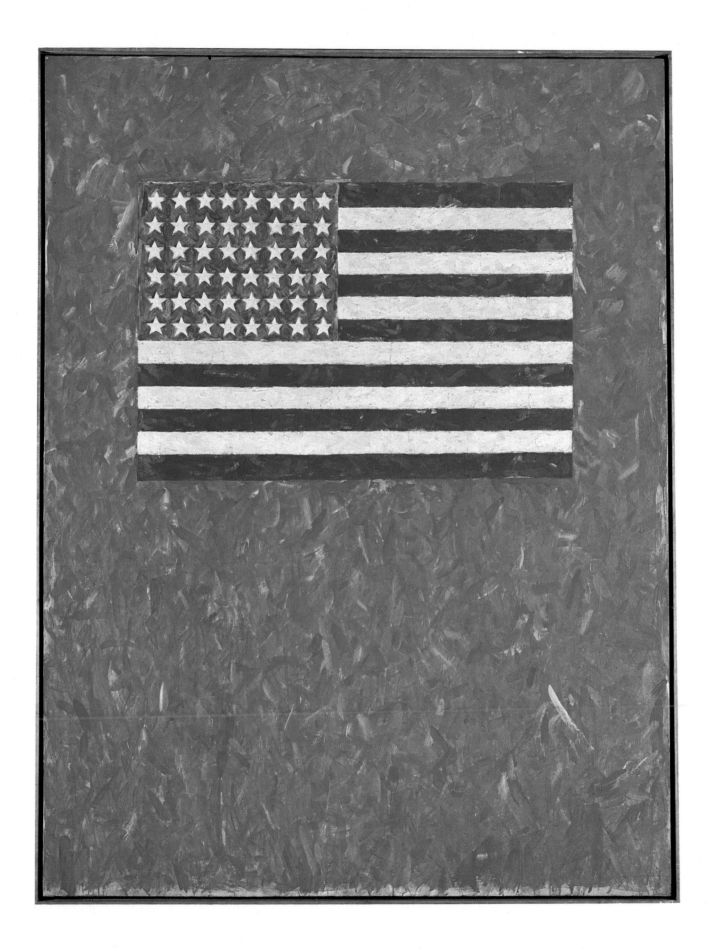

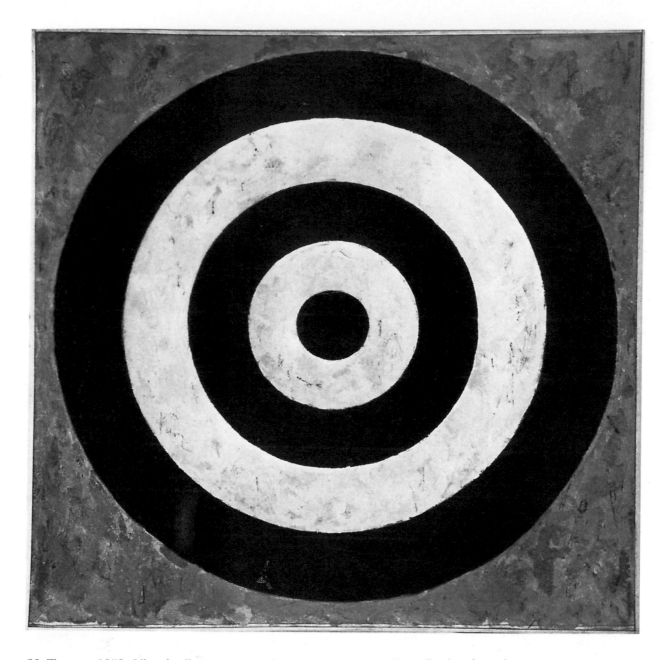

23. Target. 1958. Oil and collage on canvas, 91.4 x 91.4 cm (36 x 36″). Collection the artist

24. White Numbers. 1958.
Encaustic on canvas,
170.2 x 125.8 cm (67 x 49½″).
Museum Ludwig, Cologne

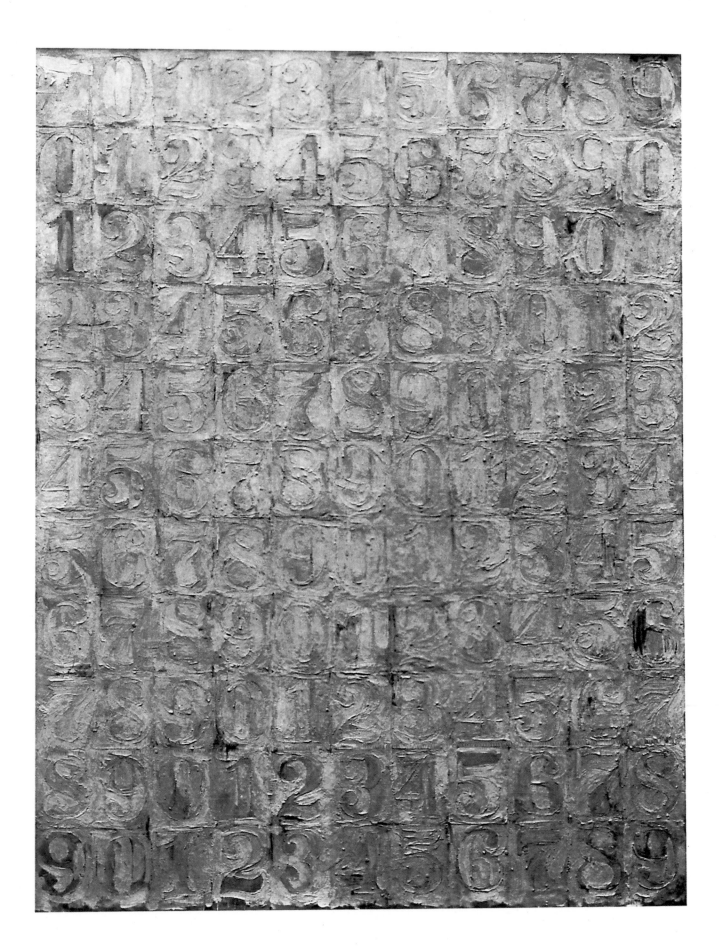

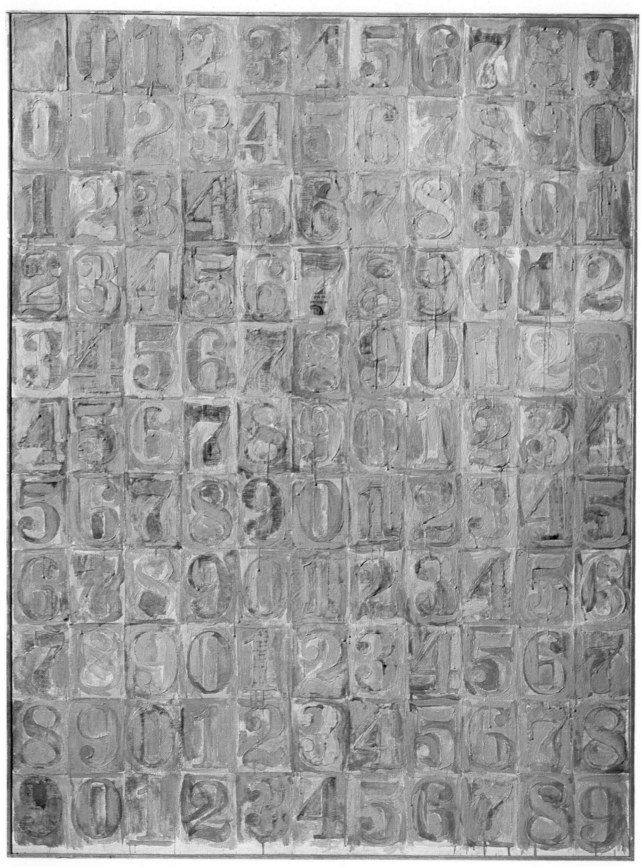

25. GRAY NUMBERS. 1958. Encaustic and collage on canvas, 170.2 x 125.8 cm (67 x 49½").
Collection Kimiko and John Powers, Colorado

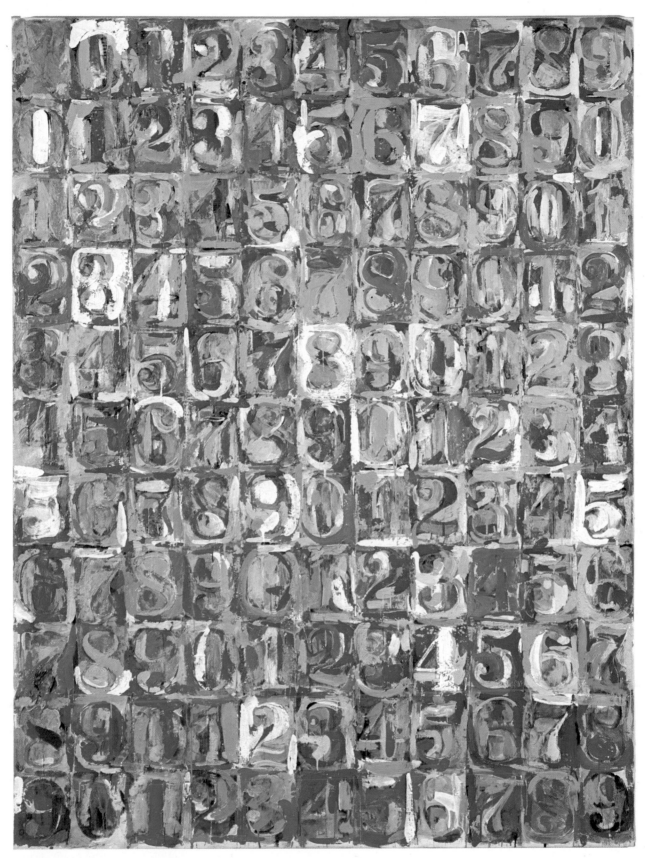

26. NUMBERS IN COLOR. 1958–59. Encaustic and collage on canvas, 170.2 x 125.8 cm (67 x 49½″).
Albright–Knox Art Gallery, Buffalo, N.Y. Gift of Seymour H. Knox

27

28

27. LIGHT BULB I. 1958.
Sculp-metal,
11.5 x 17.1 x 11.5 cm (4½ x 6¾ x 4½″).
Collection Dr. and Mrs. Jack M. Farris

28. LIGHT BULB II. 1958.
Sculp-metal,
7.9 x 20.3 x 12.7 cm (3⅛ x 8 x 5″).
Collection the artist

29. LIGHT BULB. 1958.
Pencil and graphite wash on paper,
16.5 x 22.2 cm (6½ x 8¾″).
Private collection

30. FLASHLIGHT I. 1958.
Sculp-metal over flashlight and wood,
13.3 x 23.2 x 9.8 cm (5¼ x 9⅛ x 3⅞″).
Private collection, New York

31. FLASHLIGHT II. 1958.
Papier-mâché and glass,
7.6 x 22.2 x 10.2 cm (3 x 8¾ x 4″).
Collection Robert Rauschenberg

29

30

31

32. FLASHLIGHT III. 1958. Plaster and glass, 13.3 x 9.5 x 20.9 cm (5¼ x 3¾ x 8¼″). Collection the artist

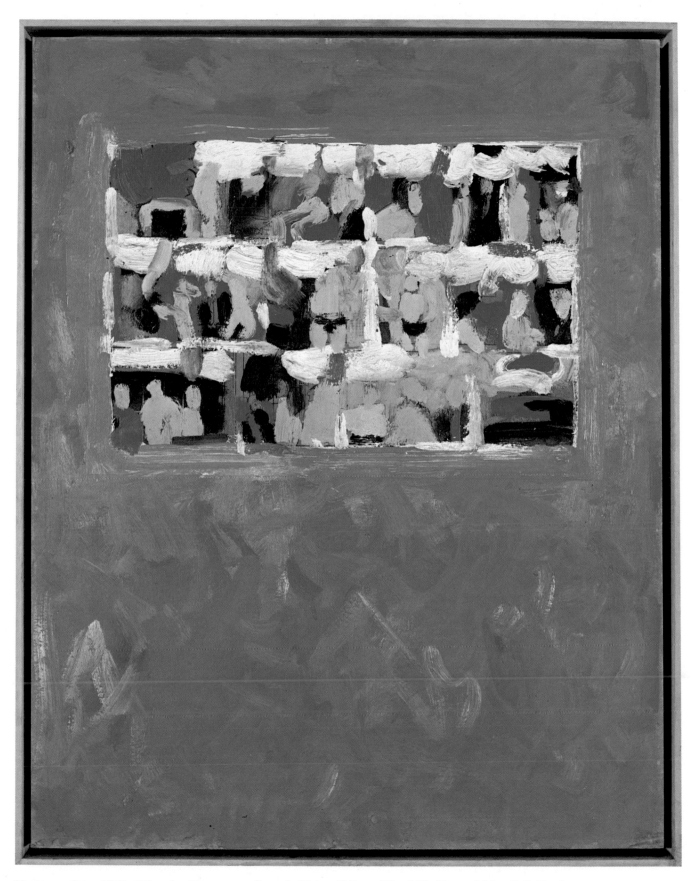

33. ALLEY OOP. 1958. Oil and collage on cardboard, 58.4 x 45.7 cm (23 x 18″). Mr. and Mrs. S. I. Newhouse

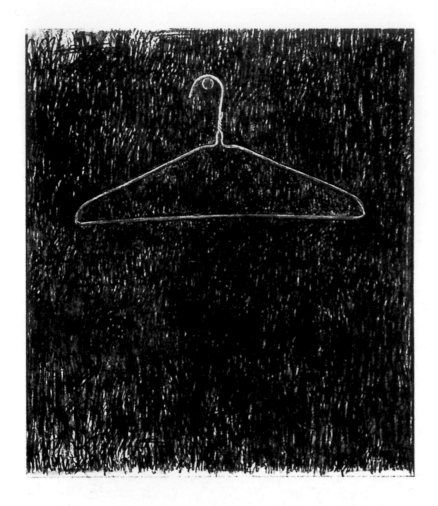

34. COAT HANGER. 1958.
Crayon on paper,
62.3 x 54.9 cm (24½ x 21⅝").
Collection Mr. and Mrs. William Easton

35. HOOK. 1958.
Crayon on paper,
43.2 x 52.7 cm (17 x 20¾").
Private collection, New York

36. GRAY RECTANGLES. 1957. Encaustic on canvas, 152.4 x 152.4 cm (60 x 60″). From the collection of Mr. & Mrs. Barney Ebsworth

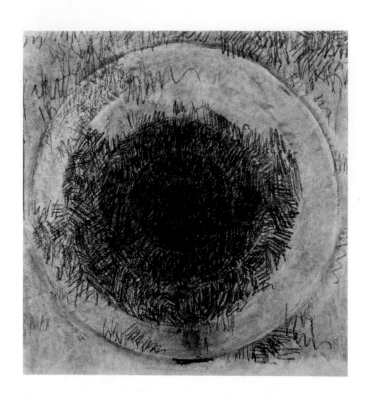

37. BROKEN TARGET. 1958.
Crayon on paper,
39.3 x 38.1 cm (15½ x 15″).
Collection Mr. and Mrs. Ben Heller

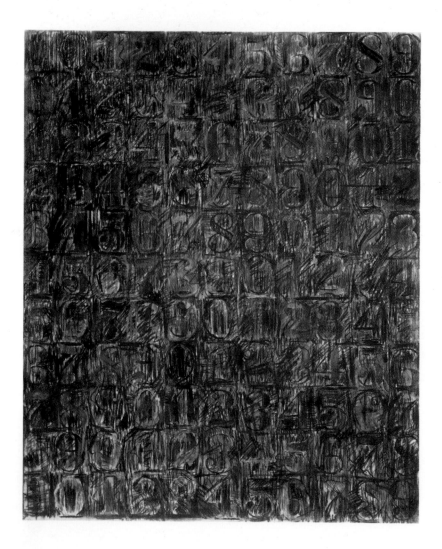

38. BLACK NUMBERS. 1958.
Crayon on paper,
77.5 x 61 cm (30½ x 24″).
Ohara Museum of Art,
Kurashiki, Japan

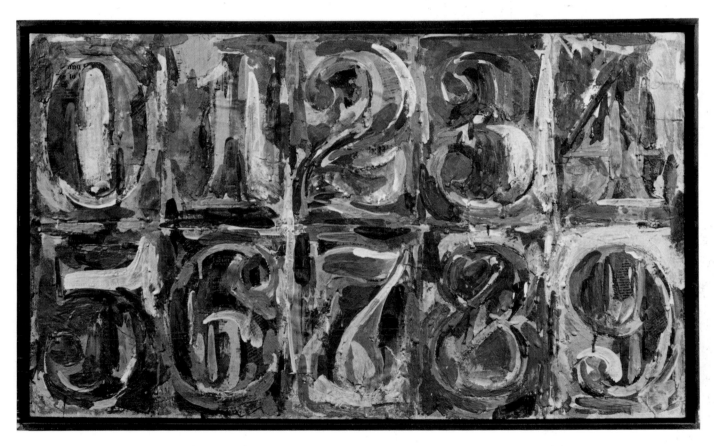

39. 0−9. 1959. Encaustic and collage on canvas, 51.1 x 88.9 cm (20⅛ x 35″). Collection Ludwig, Aachen

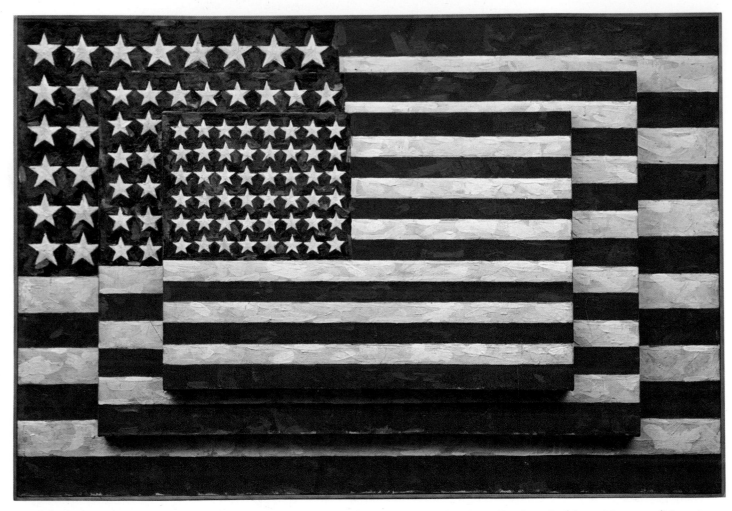

40. Three Flags. 1958. Encaustic on canvas, 78.4 x 115.6 x 12.7 cm (30⅞ x 45½ x 5″). Collection of Whitney Museum of American Art. 50th Anniversary Gift of the Gilman Foundation, Inc., The Lauder Foundation, A. Alfred Taubman, an anonymous donor, and purchase. 80.32

41. Tennyson. 1958.
Encaustic and collage on canvas,
186.7 x 122.5 cm (73½ x 48¼″).
Des Moines Art Center.
Coffin Fine Arts Trust Fund, 1971

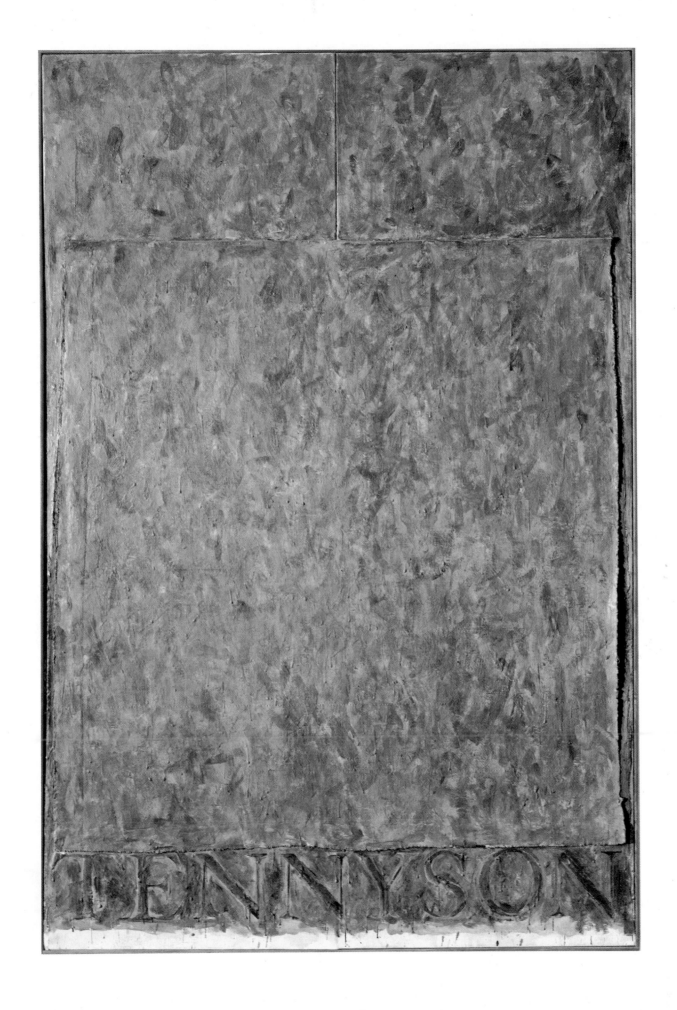

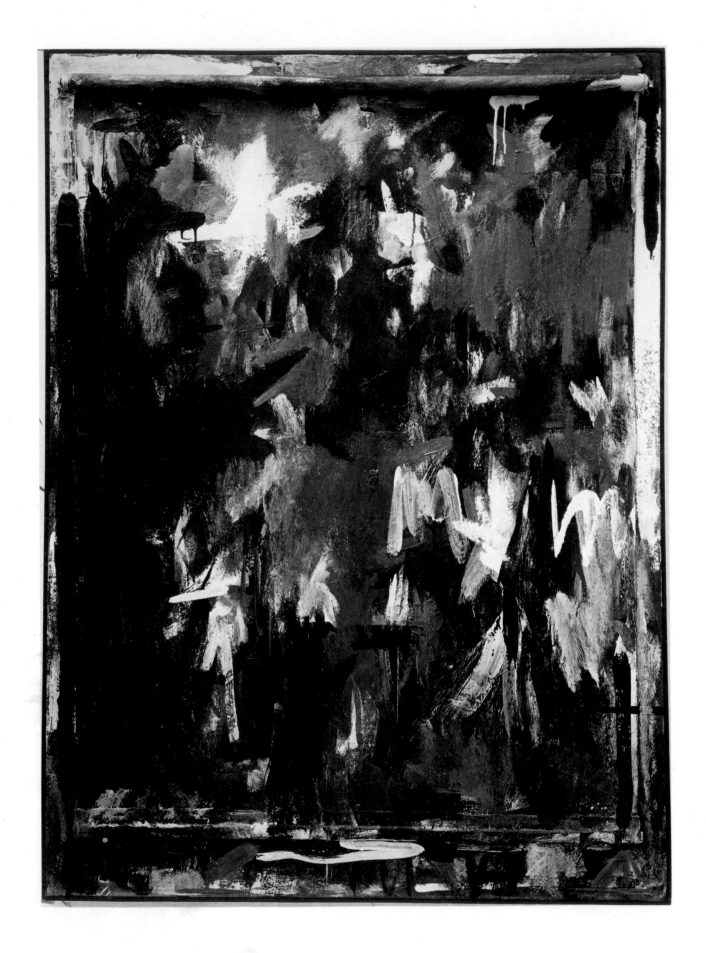

43. THREE FLAGS. 1959. Pencil on paper, 36.9 x 50.8 cm (14½ x 20″).
The Victoria and Albert Museum, London

42. SHADE. 1959.
Encaustic on canvas with objects,
132.1 x 99.1 cm (52 x 39″).
Collection Ludwig, Aachen

44. THREE FLAGS. 1960. Pencil on paper, 28.5 x 41.9 cm (11¼ x 16½″).
Collection Hannelore B. Schulhof

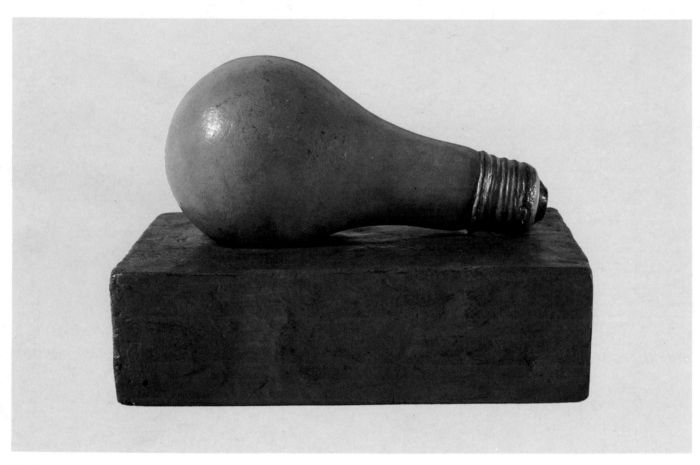

45. LIGHT BULB. 1960. Painted bronze, 10.8 x 15.2 x 10.2 cm (4¼ x 6 x 4″). One of four casts.
Unlike the other casts, this one has been painted. Collection the artist

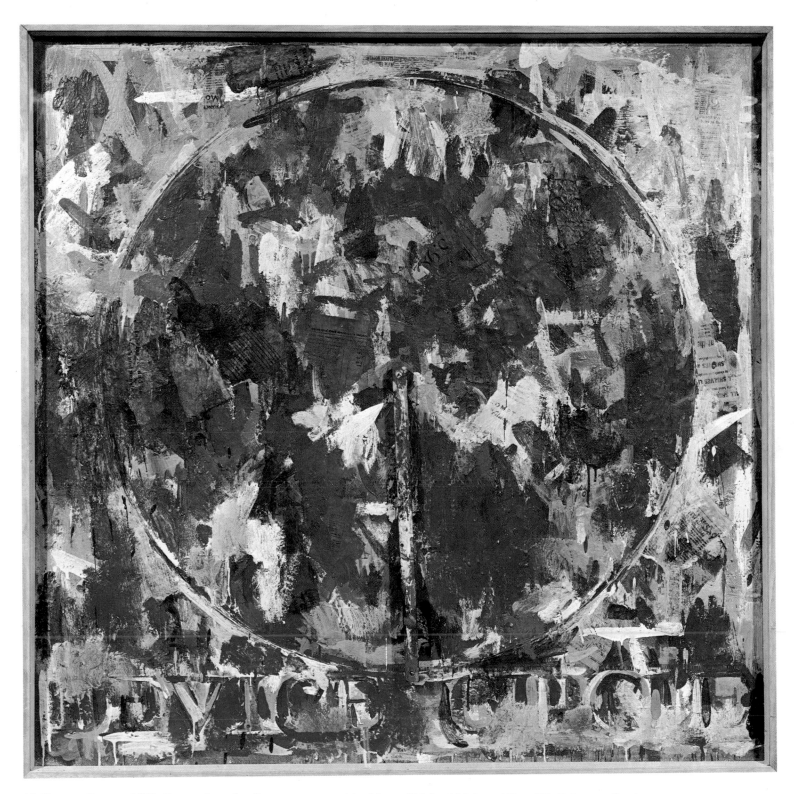

46. DEVICE CIRCLE. 1959. Encaustic and collage on canvas with objects, 101.6 x 101.6 cm (40 x 40″). Private collection

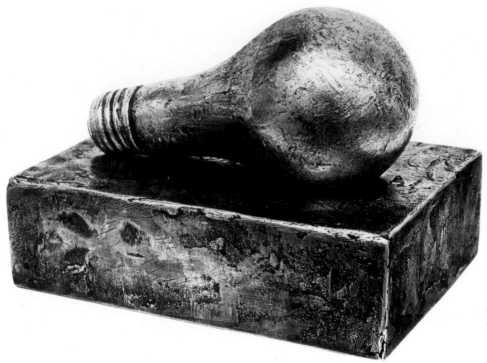

47. Light Bulb. 1960.
Bronze,
10.8 x 15.2 x 10.2 cm (4¼ x 6 x 4″).
One of four casts.
Collection Irving Blum

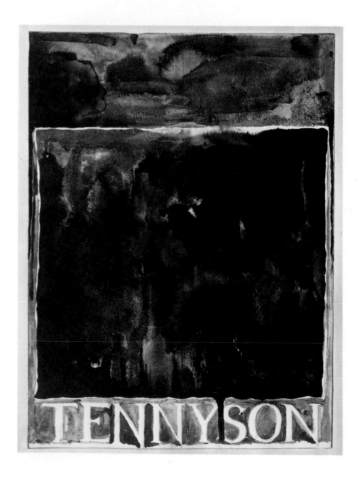

48. Tennyson. 1958.
Ink on paper,
37.8 x 25.1 cm (14⅞ x 9⅞″).
Collection the artist

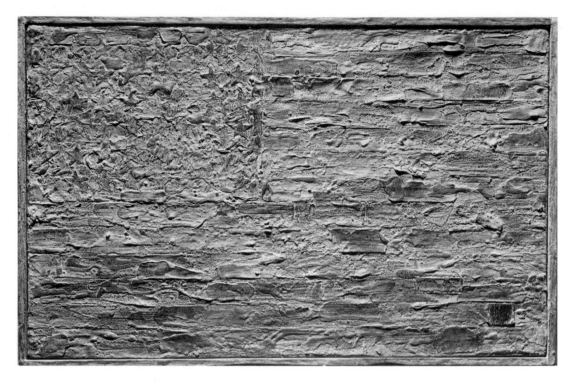

49. FLAG. 1960. Sculp-metal and collage on canvas, 31.8 x 48.3 cm (12½ x 19″).
Collection Robert Rauschenberg

50. FLAG. 1960. Bronze, 31.1 x 47.6 cm (12¼ x 18¾″). One of four casts. Collection the artist

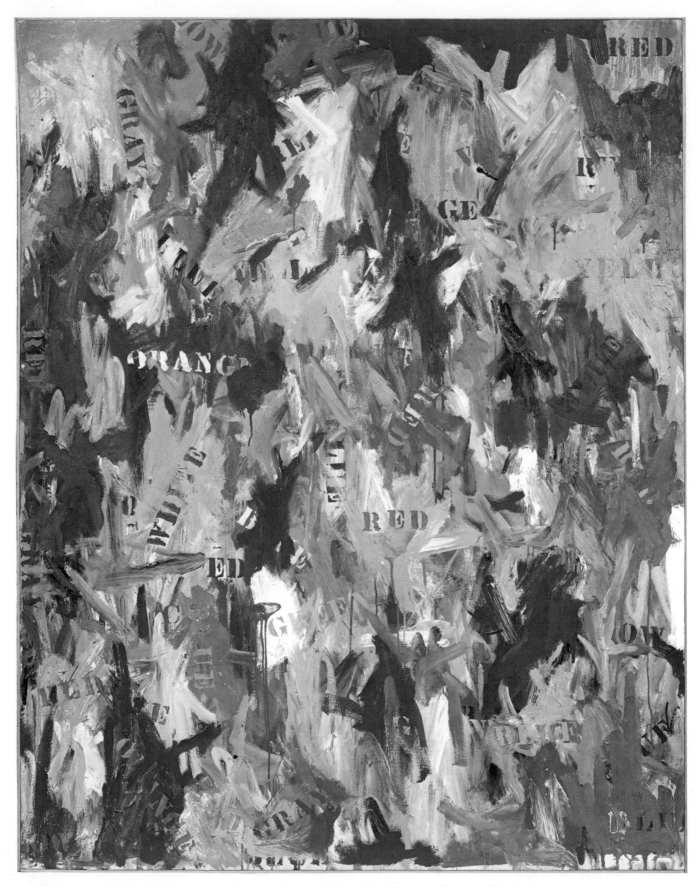

51. FALSE START. 1959. Oil on canvas, 170.8 x 137.2 cm (67¼ x 54″). Private collection, New York

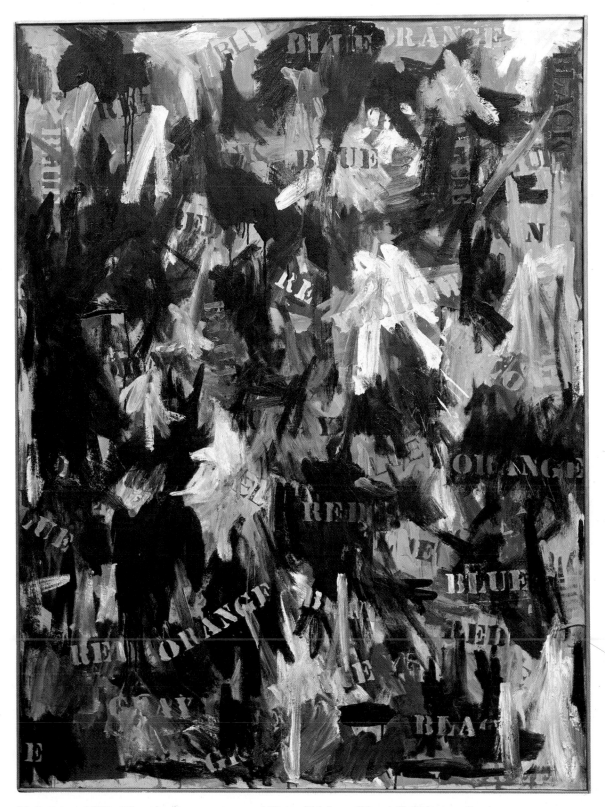

52. JUBILEE. 1959. Oil and collage on canvas, 152.4 x 111.8 cm (60 x 44″). Private collection

54. TWO FLAGS. 1960. Pencil and graphite wash on paper,
68.6 x 52.1 cm (27 x 20½"). Collection the artist

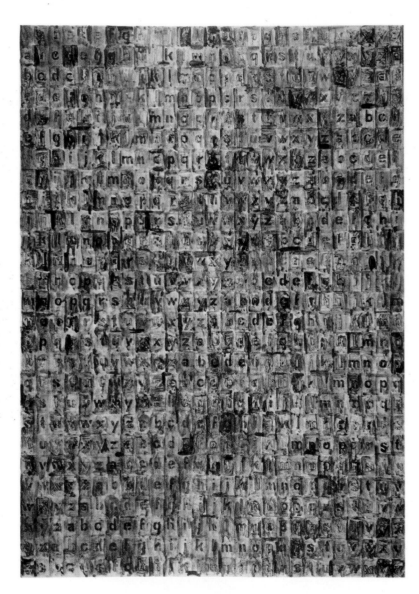

53. GRAY ALPHABETS. 1960. Pencil and graphite wash on paper,
85.1 x 60.6 cm (33½ x 23⅞"). Collection Mrs. Leo Castelli, New York

55. TEN NUMBERS. 1960. Charcoal on paper, each 24.1 x 19.1 cm (9½ x 7½"). Collection the artist

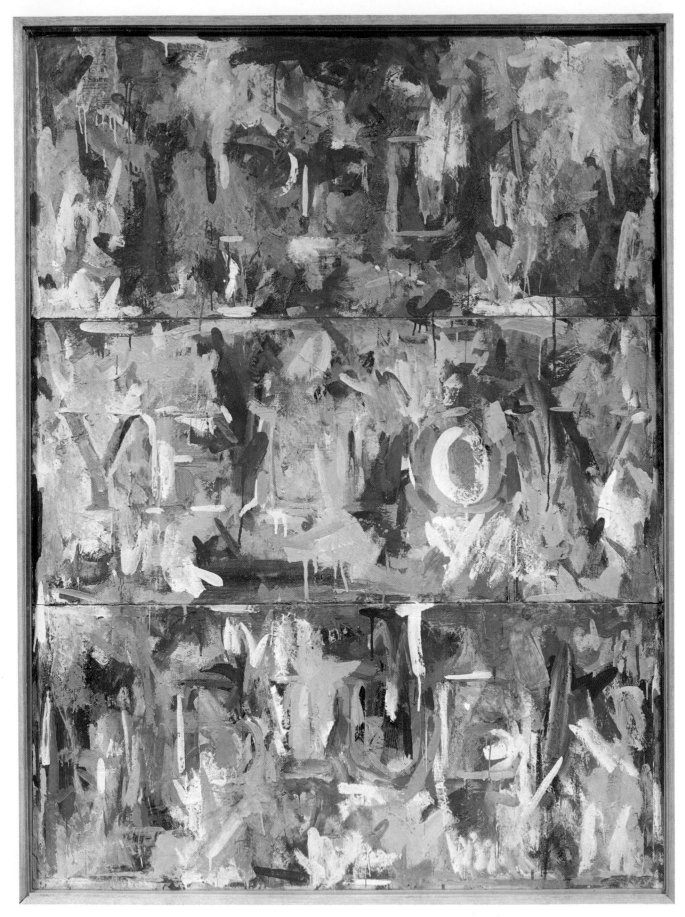

56. OUT THE WINDOW. 1959. Encaustic and collage on canvas, 139.7 x 101.6 cm (55 x 40″). Private collection, New York

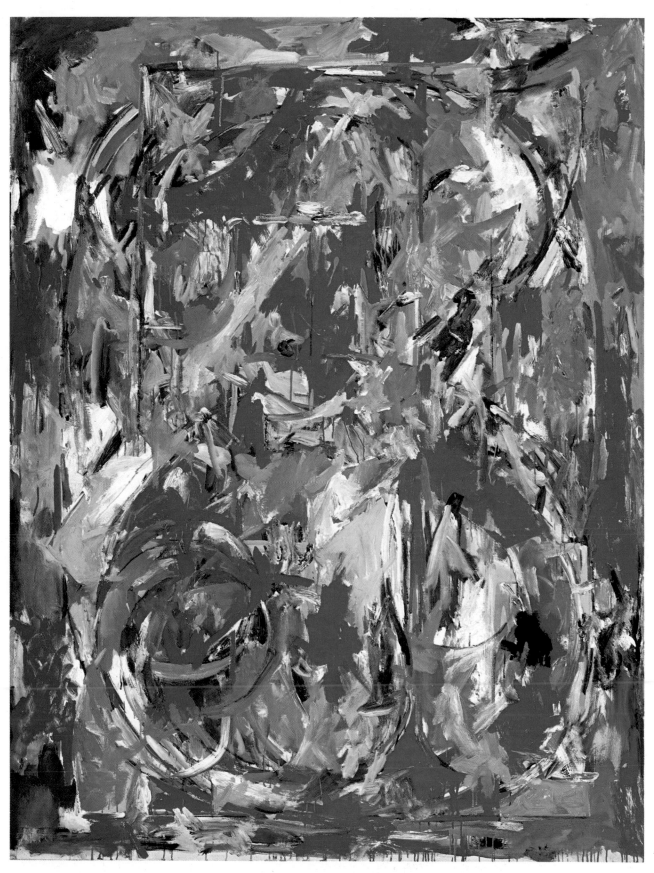

57. 0 THROUGH 9. 1960. Oil on canvas, 182.9 x 137.2 cm (72 x 54″). Private collection

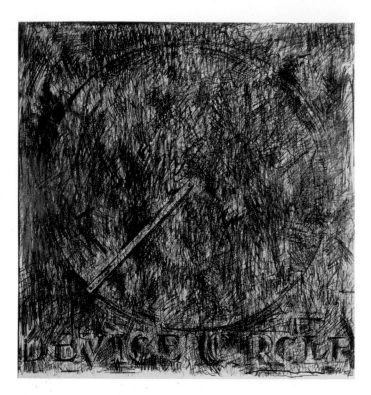

58. DEVICE CIRCLE. 1960. Pencil on paper, 38.4 x 38.4 cm
(15⅛ x 15⅛″). Private collection

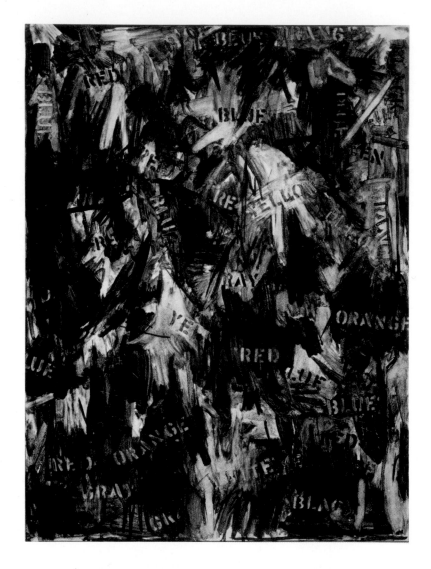

59. JUBILEE. 1960. Graphite wash on paper, 71.1 x 53.3 cm
(28 x 21″). The Museum of Modern Art, New York.
Extended loan from the Lester and Joan Avnet Collection

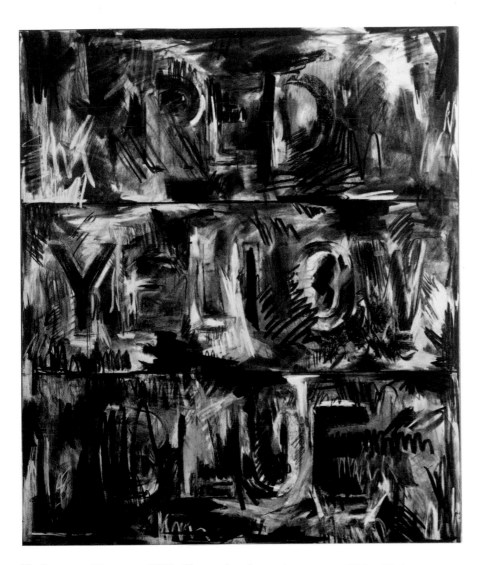

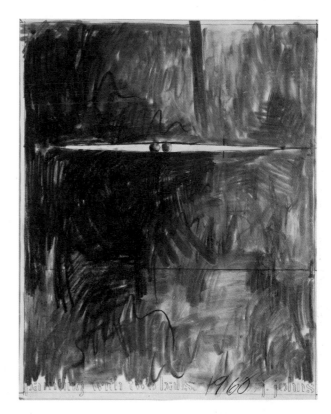

61. PAINTING WITH TWO BALLS. 1960. Charcoal, pastel, and pencil on paper, 49.6 x 38.7 cm (19½ x 15¼"). Collection Hirshhorn Museum and Sculpture Garden, Smithsonian Institution, Gift of Joseph H. Hirshhorn, 1966

60. OUT THE WINDOW. 1960. Charcoal and pastel on paper, 87.7 x 72.4 cm (34½ x 28½"). Collection David Whitney

62. THE CRITIC SMILES. 1959. Sculp-metal, 4.1 x 19.7 x 3.8 cm (1⅝ x 7¾ x 1½″). Collection the artist

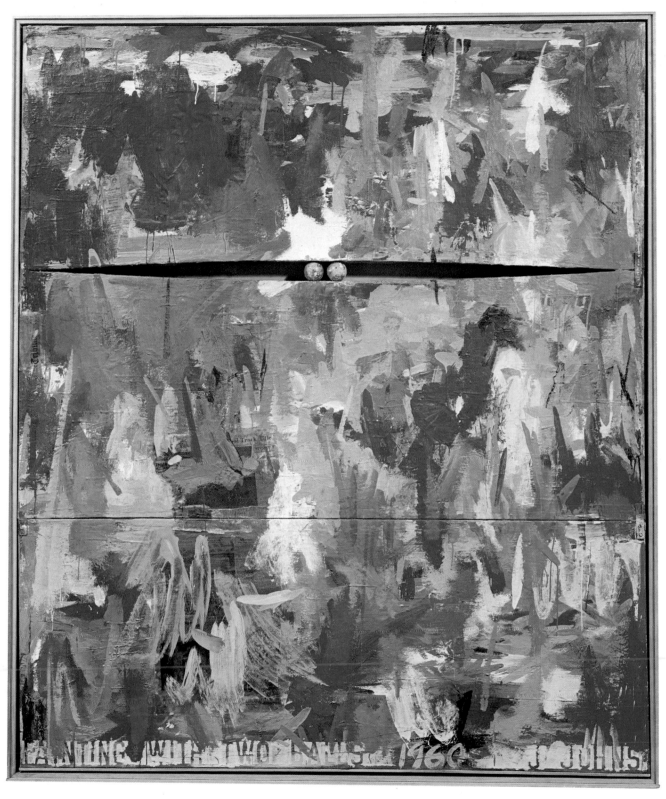

63. PAINTING WITH TWO BALLS. 1960. Encaustic and collage on canvas with objects, 165.1 x 137.2 cm (65 x 54″). Collection the artist

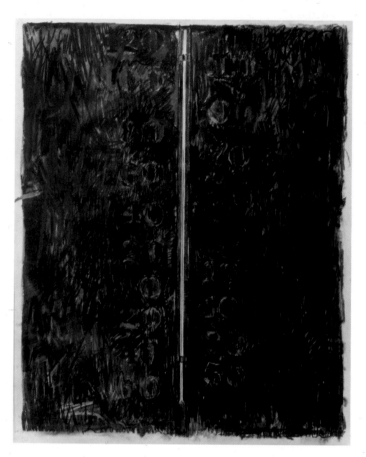

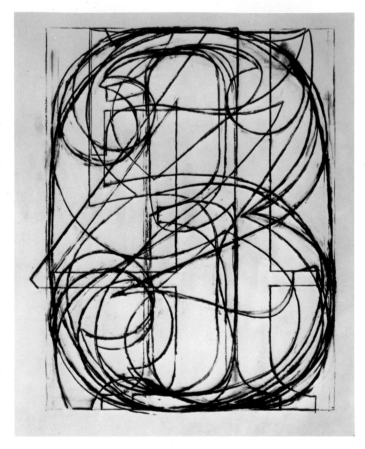

64. THERMOMETER. 1960. Charcoal and pastel on paper,
56.5 x 41.9 cm (22¼ x 16½″). Collection the artist

65. 0 THROUGH 9. 1960. Charcoal on paper, 73.7 x 58.4 cm
(29 x 23″). Collection the artist

66. HIGHWAY. 1959.
Encaustic and collage on canvas
190.5 x 154.9 cm (75 x 61″).
Private collection

67. PAINTED BRONZE. 1960. Painted bronze, 14 x 20.3 x 12.1 cm (5½ x 8 x 4¾″).
Kunstmuseum Basel, Collection Ludwig

68. PAINTED BRONZE. 1960.
Painted bronze,
34.3 x 20.3 cm diameter (13½ x 8″ diameter).
Collection the artist

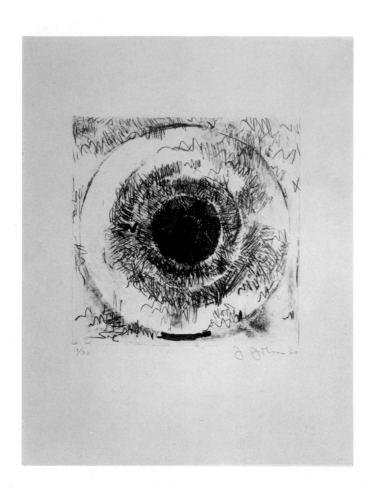

69. TARGET. 1960.
Lithograph,
57.2 x 44.5 cm (22½ x 17½″).
Edition of 30.
Published by Universal Limited
Art Editions

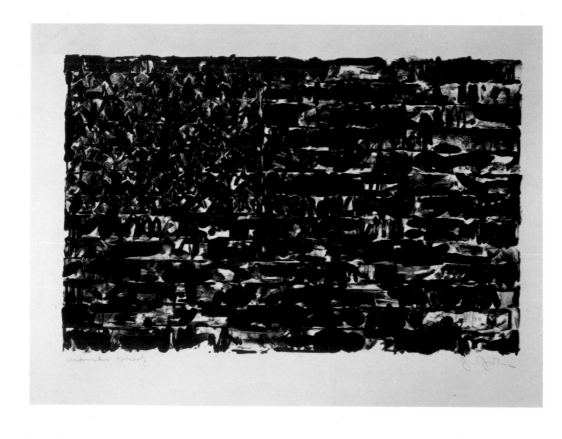

70. FLAG I. 1960.
Lithograph,
55.9 x 76.2 cm (22 x 30″).
Edition of 23.
Published by Universal Limited
Art Editions

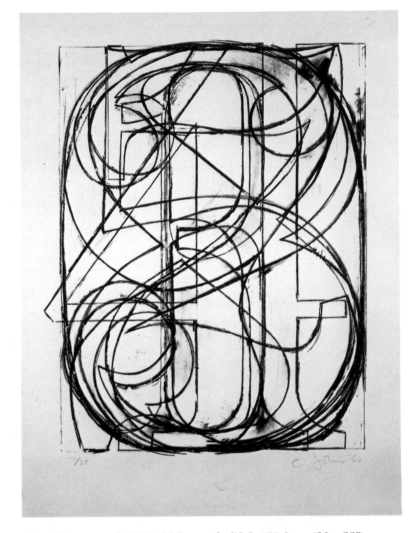

71. COAT HANGER I. 1960. Lithograph, 91.4 x 67.9 cm (36 x 26¾").
Edition of 35. Published by Universal Limited Art Editions

72. 0 THROUGH 9. 1960. Lithograph, 76.2 x 55.9 cm (30 x 22").
Edition of 35. Published by Universal Limited Art Editions

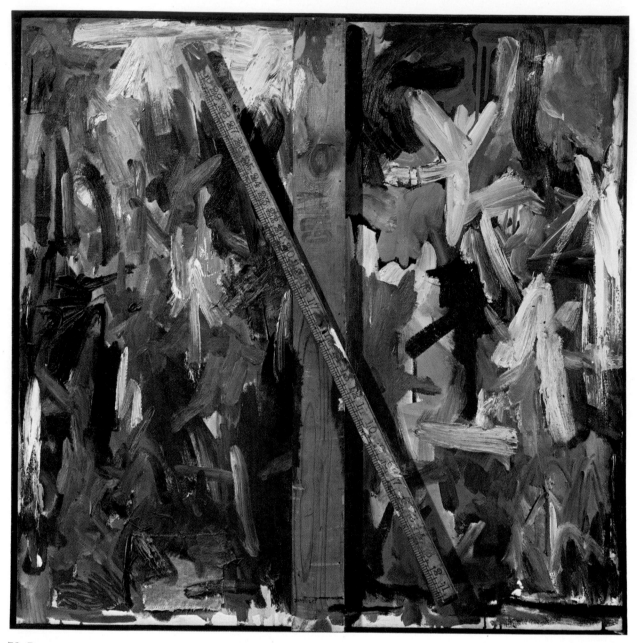

73. PAINTING WITH RULER AND "GRAY." 1960. Oil and collage on canvas with objects, 81.3 x 81.3 cm (32 x 32″).
Collection of Fredrick Weisman Company, Los Angeles

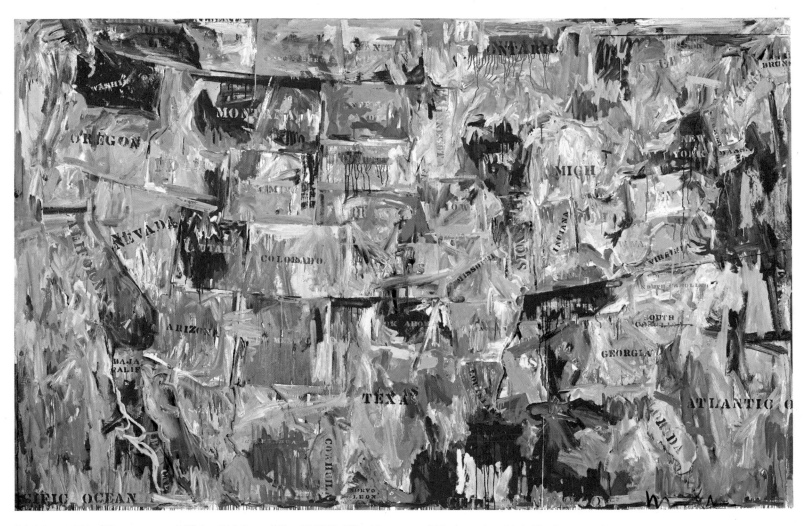

74. Map. 1961. Oil on canvas, 198.1 x 312.7 cm (78 x 123⅛″). The Museum of Modern Art, New York.
Gift of Mr. and Mrs. Robert C. Scull, 1963

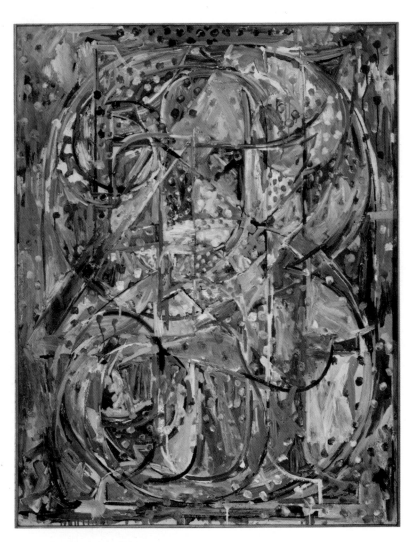

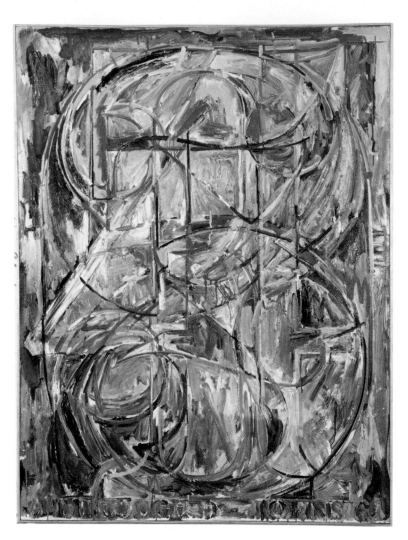

75. 0 THROUGH 9. 1961. Oil on canvas, 137.2 x 104.8 cm
(54 x 41¼"). Hirshhorn Museum and Sculpture Garden,
Smithsonian Institution, Washington, D.C.

76. 0 THROUGH 9. 1961. Oil on canvas, 137.2 x 104.8 cm
(54 x 41¼"). Private collection

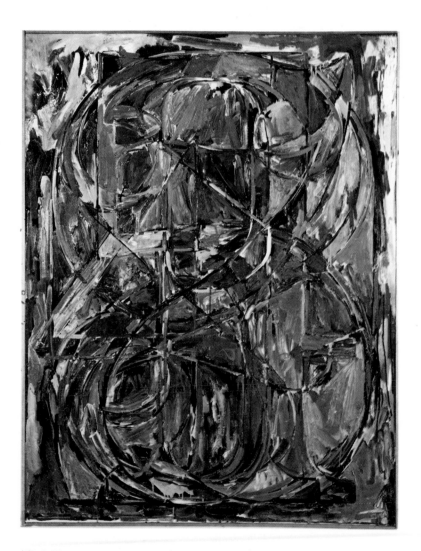

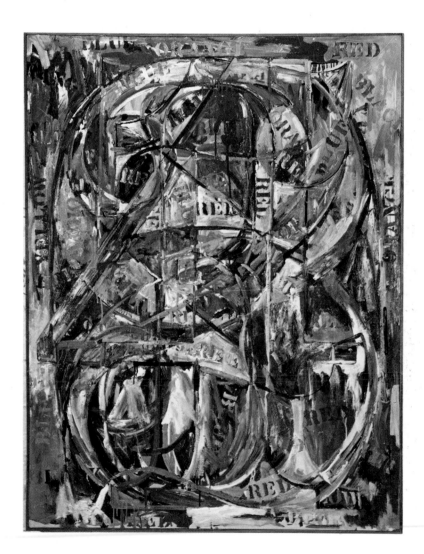

77. 0 THROUGH 9. 1961. Oil on canvas, 137.2 x 104.8 cm
(54 x 41¼″). Private collection

78. 0 THROUGH 9. 1961. Oil on canvas, 137.2 x 104.8 cm
(54 x 41¼″). Private collection

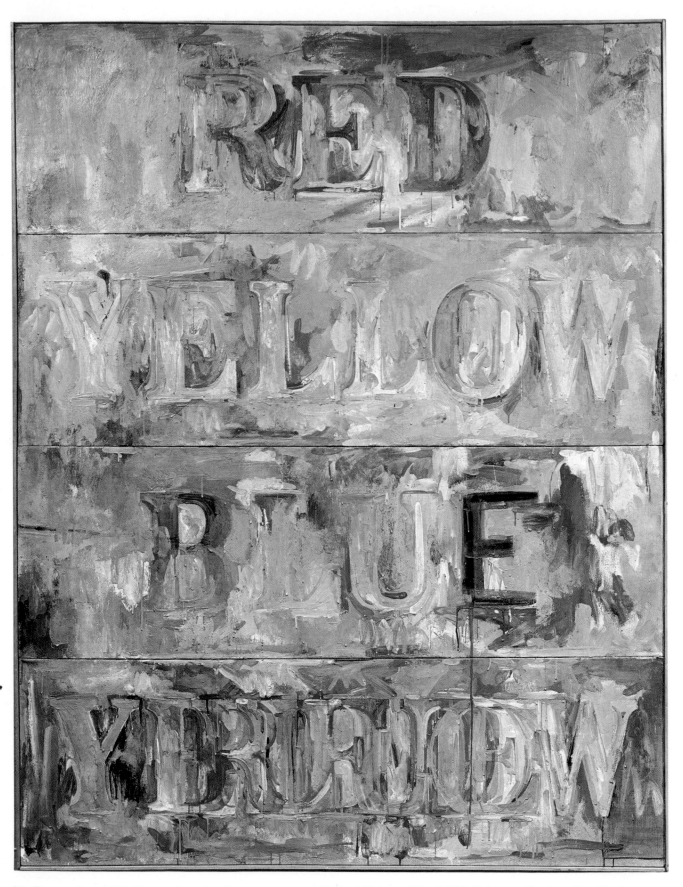

79. BY THE SEA. 1961. Encaustic and collage on canvas, 182.9 x 138.5 cm (72 x 54½″). Private collection, New York

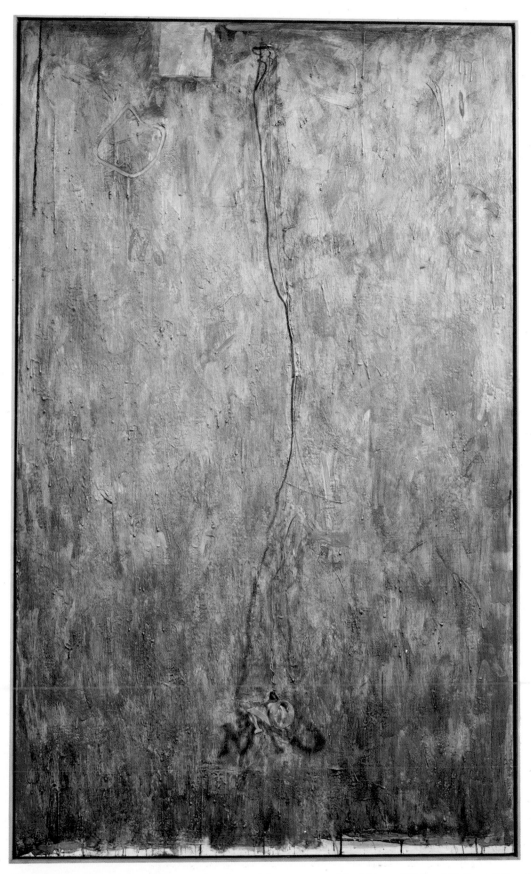

80. No. 1961. Encaustic, collage, and sculp-metal on canvas with objects, 172.7 x 101.6 cm (68 x 40″).
Collection the artist

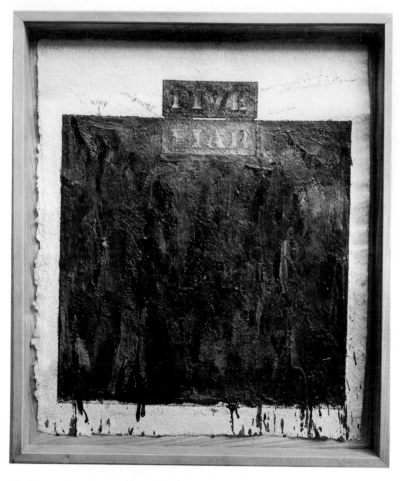

81. LIAR. 1961. Encaustic, pencil, and sculp-metal on paper,
53.9 x 43.2 cm (21¼ x 17″). Collection Tony and Gail Ganz

82. DISAPPEARANCE II. 1962.
Ink on plastic,
45.7 x 45.7 cm (18 x 18″).
Collection The Honorable and
Mrs. Gilbert Hahn, Jr.

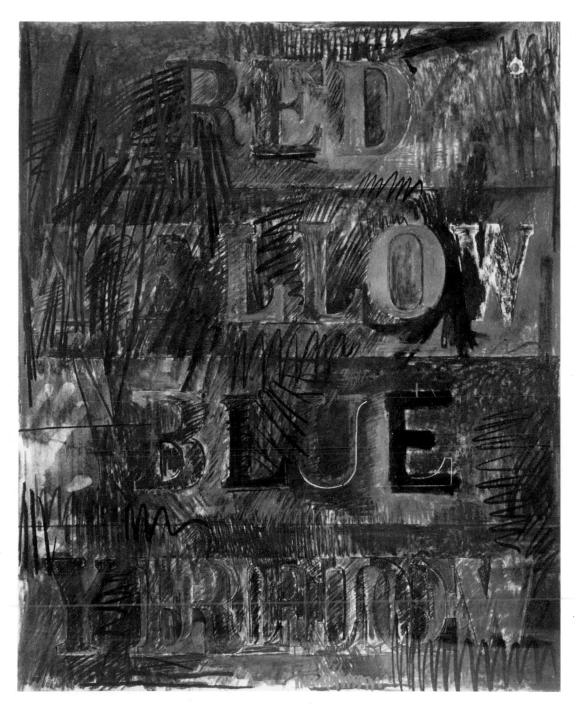

83. FOLLY BEACH. 1962. Charcoal and pastel on paper, 90.2 x 73.7 cm (35½ x 29″).
Anonymous collection

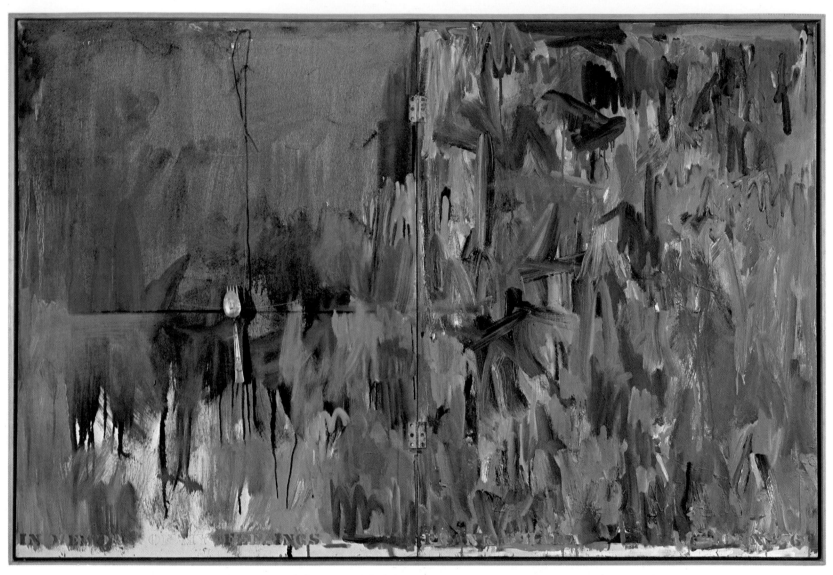

84. IN MEMORY OF MY FEELINGS—FRANK O'HARA. 1961. Oil on canvas with objects, 101.6 x 152.4 cm (40 x 60″).
Stefan T. Edlis Collection

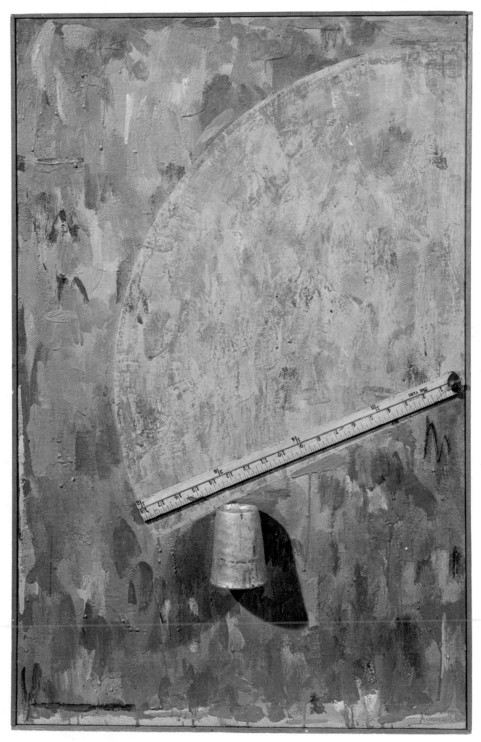

85. GOOD TIME CHARLEY. 1961. Encaustic on canvas with objects,
96.5 x 61 cm (38 x 24"). Private collection

86. STUDY FOR SKIN I. 1962. Charcoal on paper, 55.9 x 86.4 cm (22 x 34″). Collection the artist

87. STUDY FOR SKIN II. 1962. Charcoal on paper, 55.9 x 86.4 cm (22 x 34″). Collection the artist

88. STUDY FOR SKIN III. 1962. Charcoal on paper, 55.9 x 86.4 cm (22 x 34″). Collection the artist

89. STUDY FOR SKIN IV. 1962. Charcoal on paper, 55.9 x 86.4 cm (22 x 34″). Collection the artist

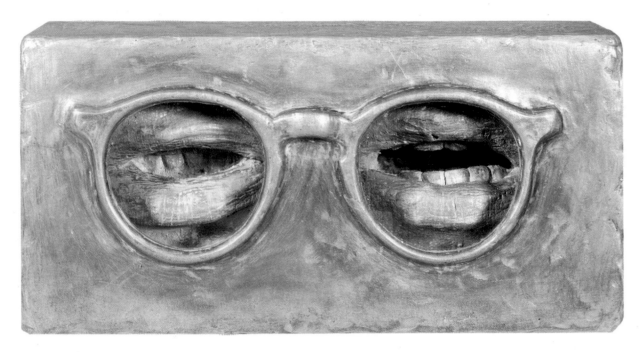

90. THE CRITIC SEES. 1961. Sculp-metal over plaster with glass, 8.2 x 15.8 x 5.4 cm (3¼ x 6¼ x 2⅛").
Private collection, New York

91. DEVICE. 1961–62. Oil on canvas with objects,
182.9 x 122.5 cm (72 x 48¼"). Dallas Museum of Fine Arts.
Acquired in honor of Mrs. Eugene McDermott.
Dallas Art Museum League, Mr. and Mrs. George V. Charlton,
Mr. and Mrs. James B. Francis, Dr. and Mrs. Ralph Greenlee, Jr.,
Mr. and Mrs. James H. W. Jacks, Mr. and Mrs. Irvin L. Levy,
Mrs. John W. O'Boyle, Dr. Joanne Stroud

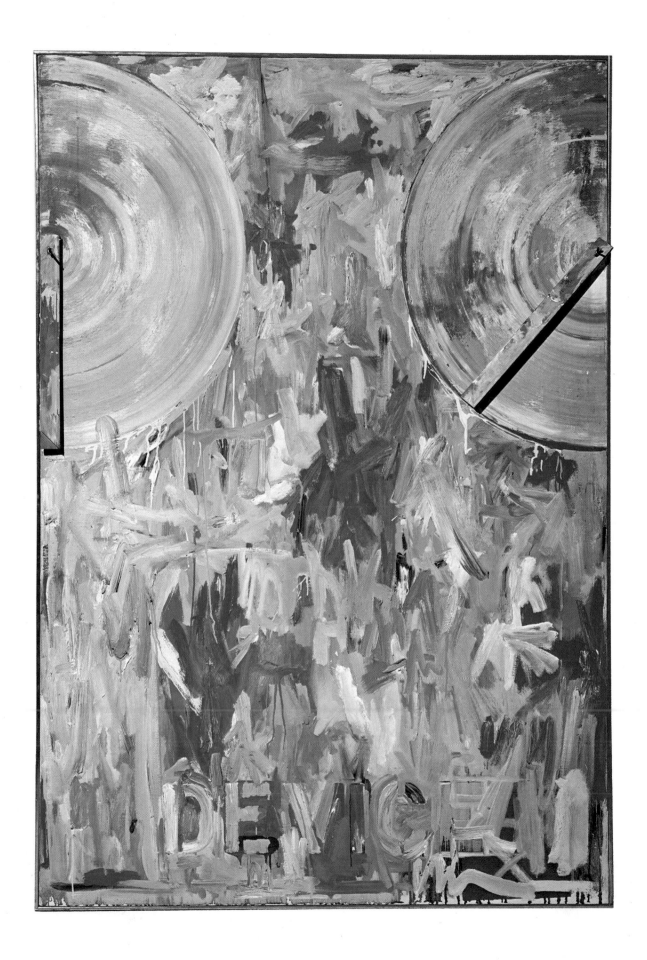

92

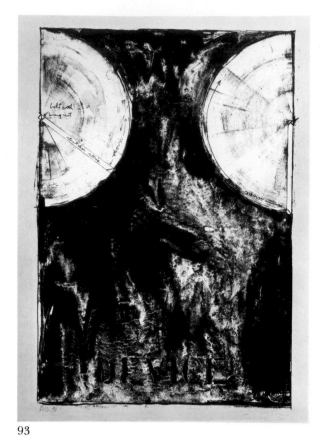

93

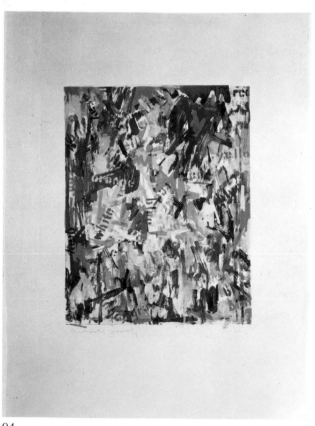

94

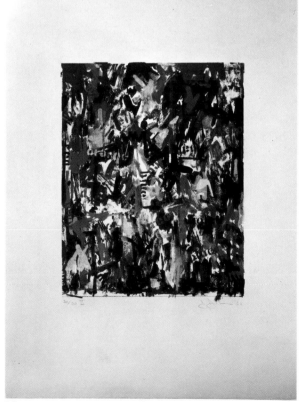

95

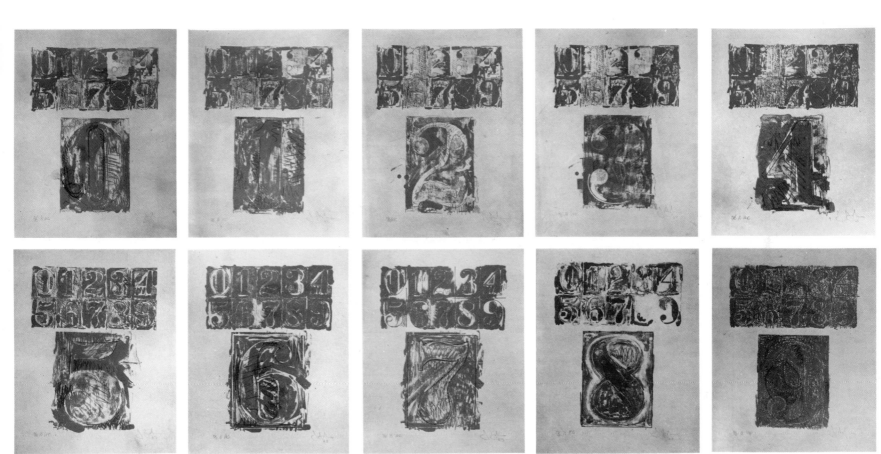

92. PAINTING WITH TWO BALLS I. 1962.
Lithograph,
67.3 x 52.1 cm (26½ x 20½").
Edition of 39.
Published by Universal Limited Art Editions

93. DEVICE. 1962.
Lithograph,
80 x 57.8 cm (31½ x 22¾").
Edition of 6.
Published by Universal Limited Art Editions

94. FALSE START I. 1962.
Lithograph,
75.6 x 56.5 cm (29¾ x 22¼").
Edition of 38.
Published by Universal Limited Art Editions

95. FALSE START II. 1962.
Lithograph,
78.7 x 57.2 cm (31 x 22½").
Edition of 30.
Published by Universal Limited Art Editions

96. 0–9. 1960–63.
Ten lithographs from the portfolio
0–9 (B/C, 1/1, H.C.),
each 52.1 x 40 cm (20½ x 15¾").
Published by Universal Limited Art Editions.
Collection Mr. and Mrs. Leo Castelli

97. 4 THE NEWS. 1962.
Encaustic and collage on canvas with objects,
165.1 x 127.6 cm (65 x 50¼″).
Collection Kunstsammlung
Nordrhein-Westfalen, Dusseldorf

98. FOOL'S HOUSE. 1962.
Oil on canvas with objects,
182.9 x 91.4 cm (72 x 36″).
Collection Mr. Jean Christophe Castelli

99. PASSAGE. 1962. Encaustic and collage on canvas with objects, 137.2 x 101.6 cm (54 x 40″).
Museum Ludwig, Cologne

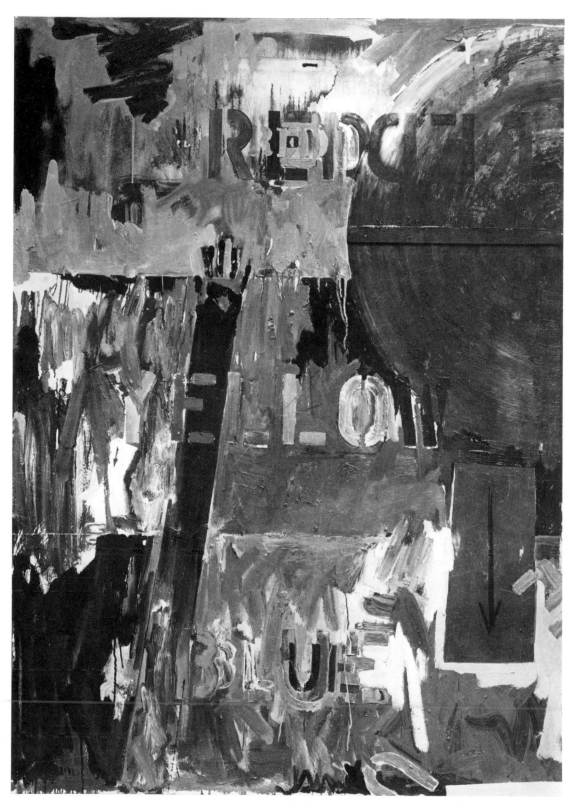

100. LAND'S END. 1963. Oil on canvas with objects, 170.2 x 121.9 cm (67 x 48″).
San Francisco Museum of Modern Art

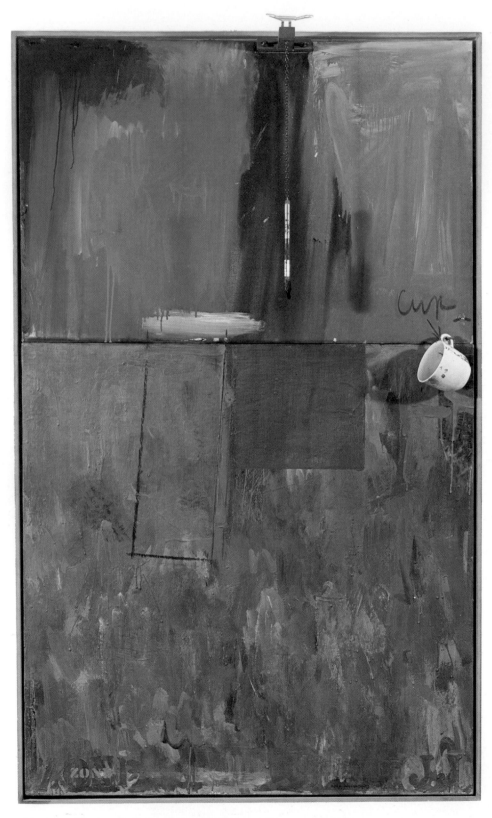

101. ZONE. 1962. Oil, encaustic, and collage on canvas with objects,
153 x 91.5 cm (60 x 36″). Kunsthaus Zürich

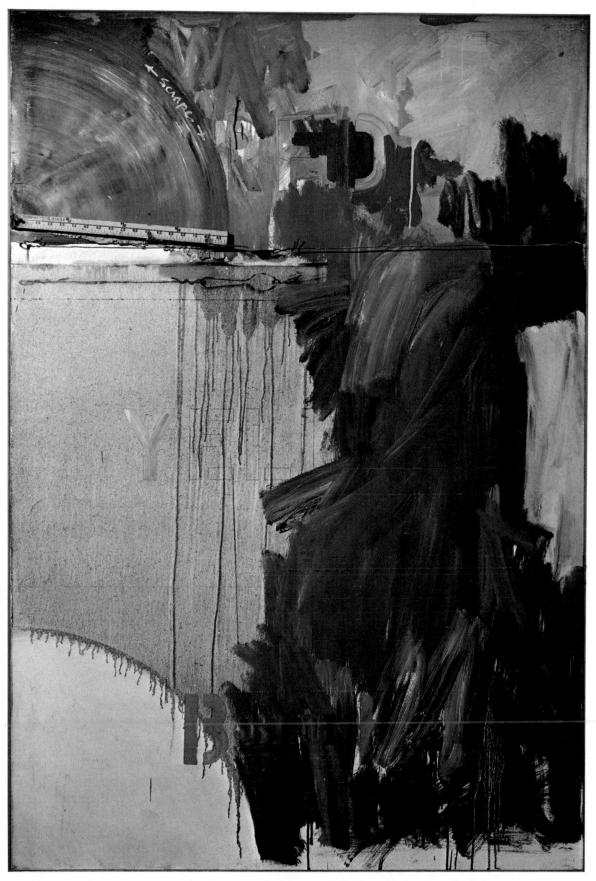

102. OUT THE WINDOW NUMBER 2. 1962. Oil on canvas with objects, 182.9 x 121.9 cm (72 x 48″).
Collection the artist

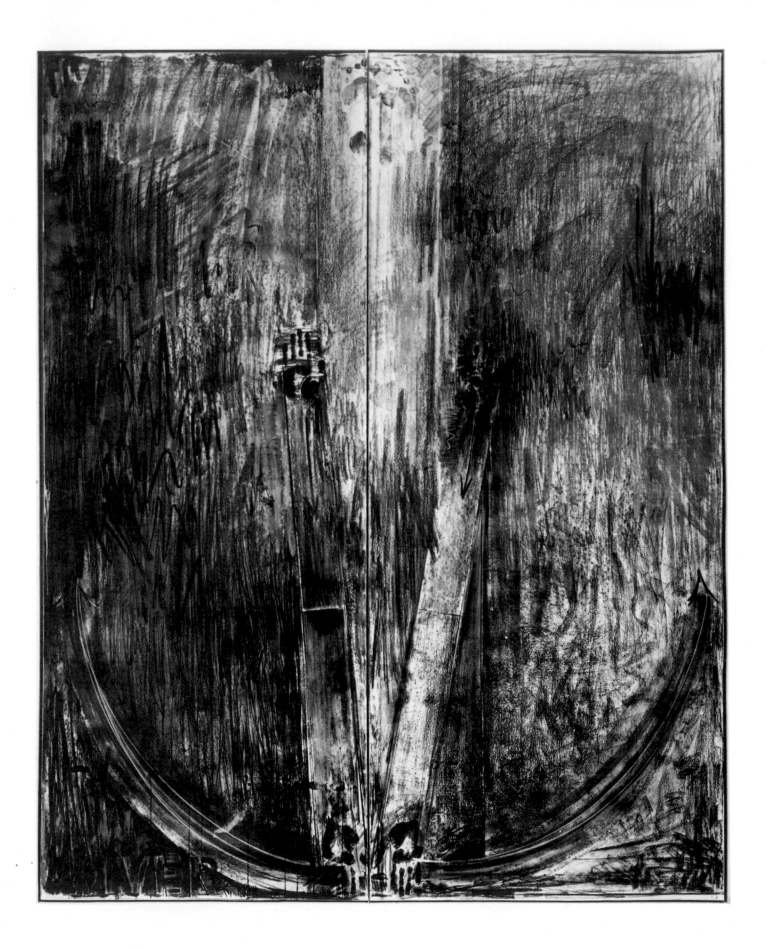

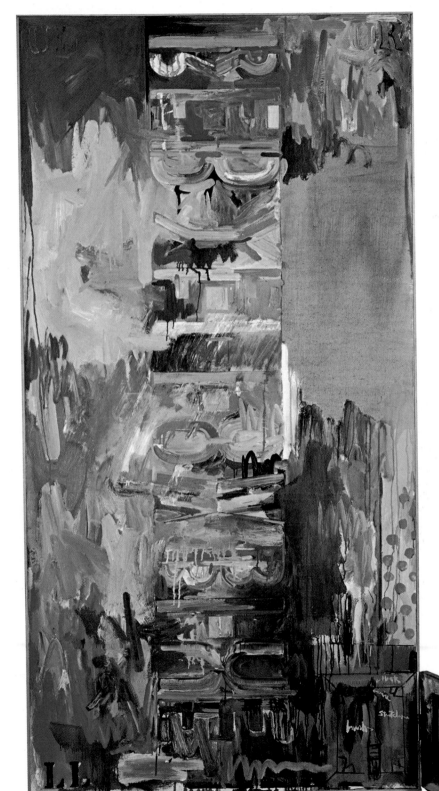

103. DIVER. 1963.
Charcoal and pastel on paper,
219.7 x 180.3 cm (86½ x 71″).
Collection Mr. and Mrs. Victor W. Ganz

104. SLOW FIELD. 1962.
Oil on canvas with objects,
182.9 x 91.4 cm (72 x 36″).
Moderna Museet, Stockholm

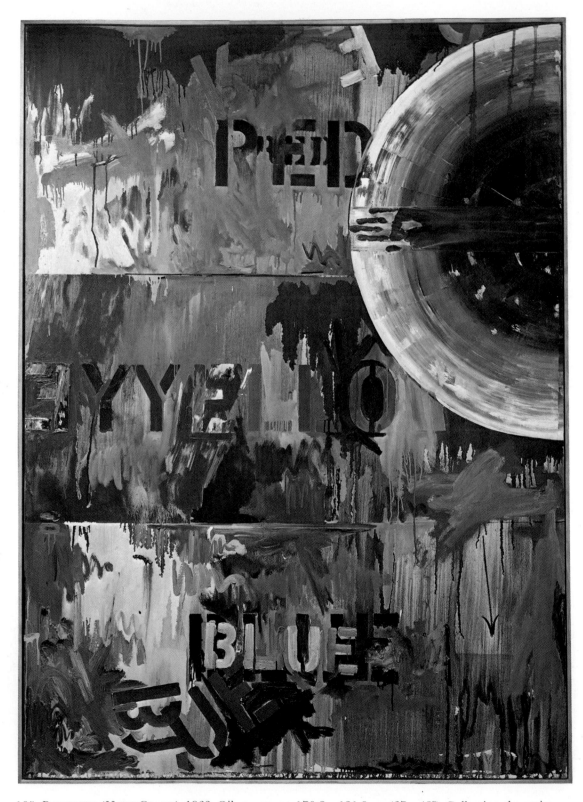

105. Periscope (Hart Crane). 1963. Oil on canvas, 170.2 x 121.9 cm (67 x 48″). Collection the artist

106. DIVER. 1962.
Oil on canvas with objects,
228.6 x 431.8 cm (90 x 170″).
Collection Norman and Irma Bramen

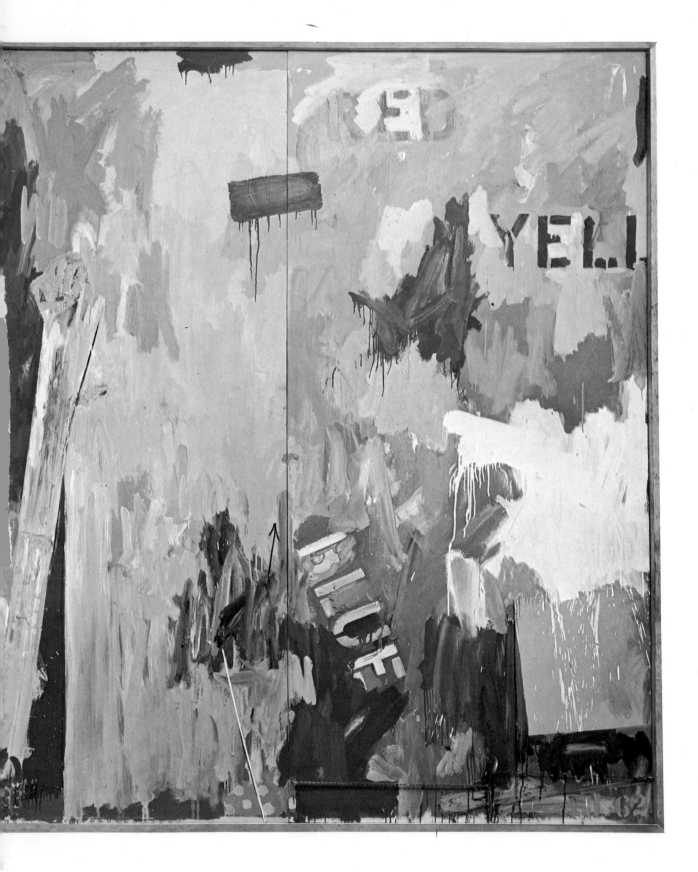

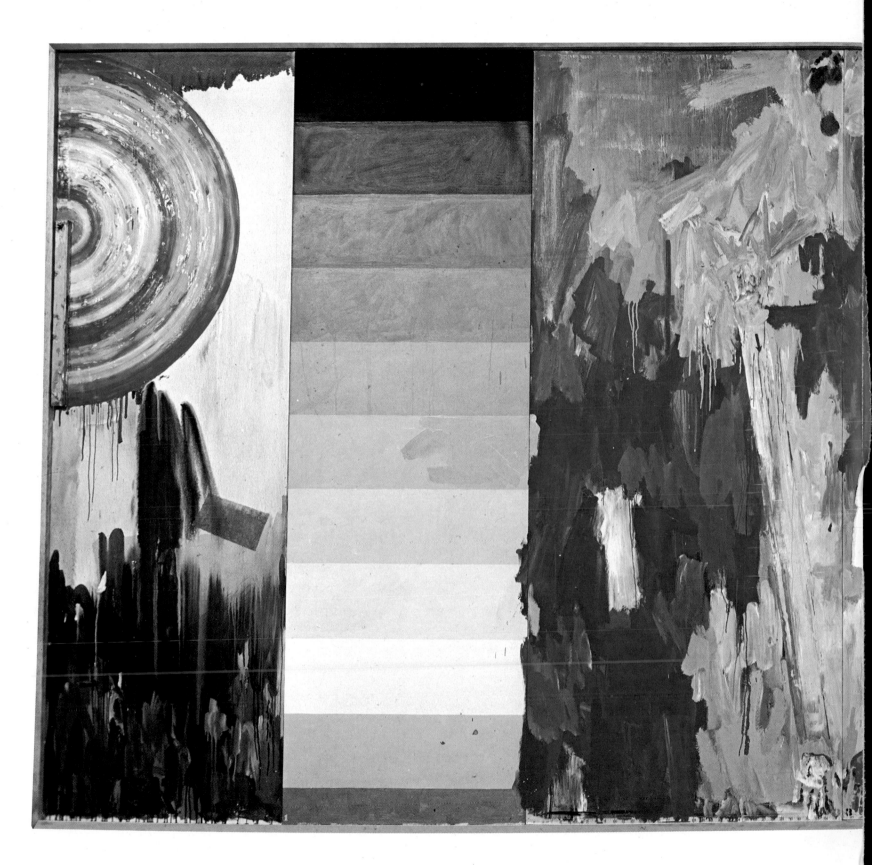

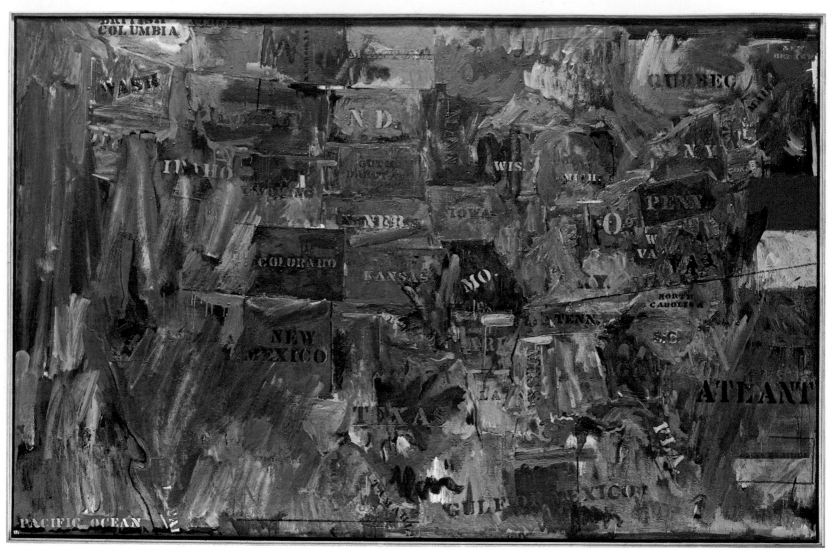

107. Map. 1963. Encaustic and collage on canvas, 152.4 x 236.2 cm (60 x 93″). Private collection, New York

108. UNTITLED. 1963. Charcoal, collage,
and paint on paper, 108 x 76.2 cm (42½ x 30″).
Collection Victoria Ganz DeFelice

109. HATTERAS. 1963. Lithograph, 104.7 x 75 cm
(41¼ x 29½″). Edition of 30. Published by Universal Limited
Art Editions

110. SKIN WITH O'HARA POEM.
1963–65. Lithograph,
55.9 x 86.4 cm (22 x 34″).
Edition of 30. Published by
Universal Limited Art Editions

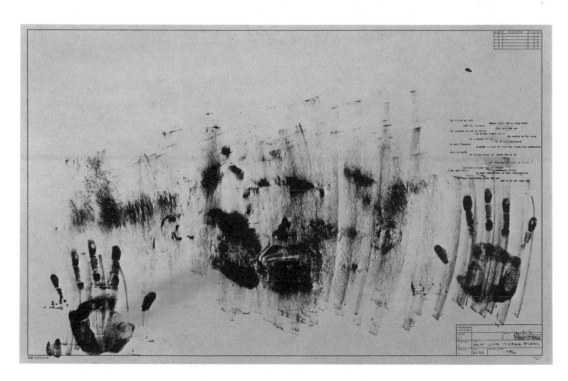

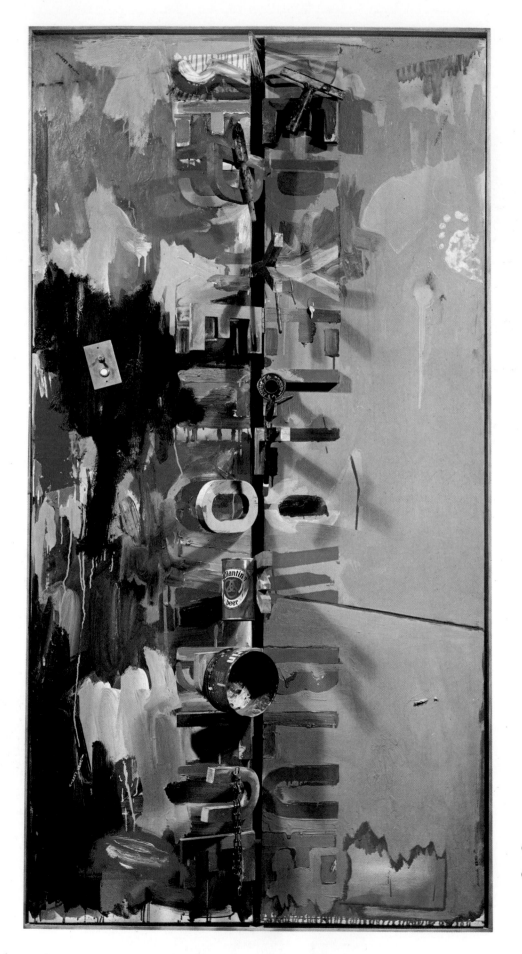

111. FIELD PAINTING. 1963–64.
Oil on canvas, with objects,
182.9 x 93.3 cm (72 x 36¾″).
Collection the artist

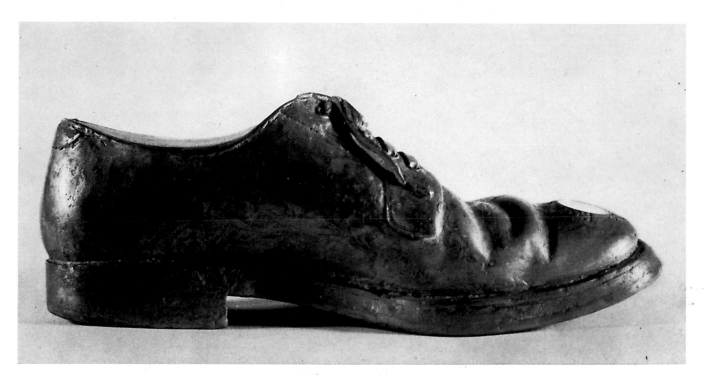

112. HIGH SCHOOL DAYS. 1964. Sculp-metal over plaster with mirror, 10.8 x 30.5 x 11.5 cm (4¼ x 12 x 4½″).
Collection the artist

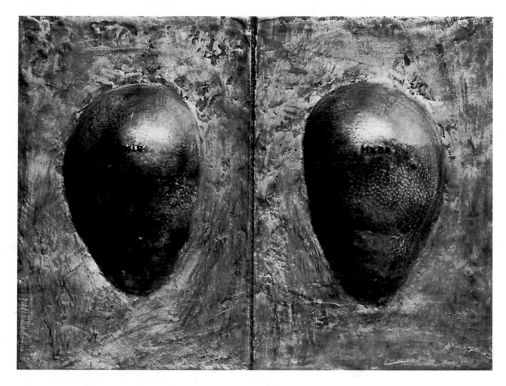

113. SUBWAY. 1965. Sculp-metal over plaster and wood, 19.4 x 25.1 x 7.6 cm
(7⅜ x 9⅞ x 3″). Collection the artist

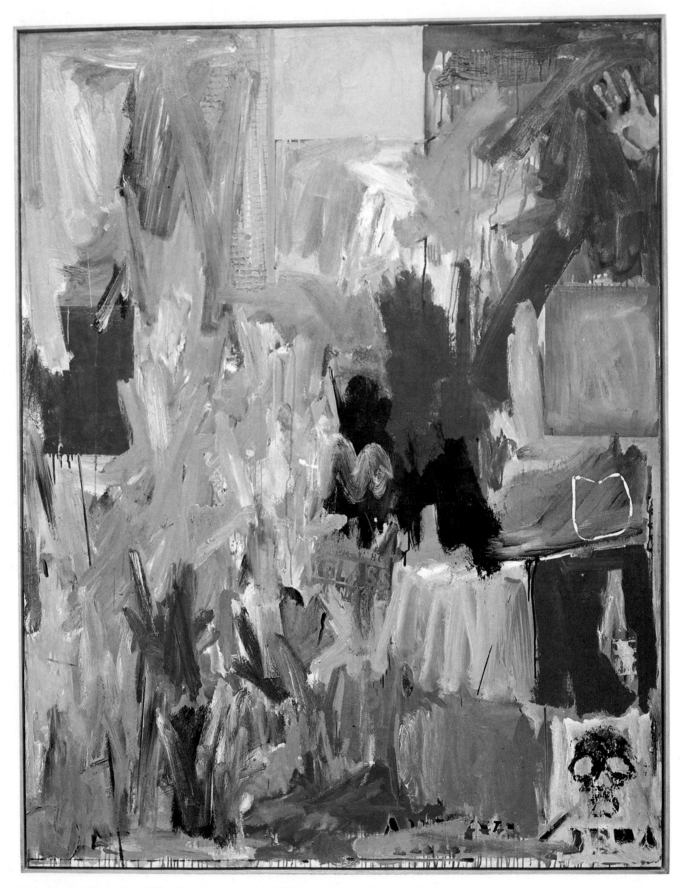

114. ARRIVE/DEPART. 1963–64. Oil on canvas, 172.7 x 130.8 cm (68 x 51½″). Private collection, Munich

115. ACCORDING TO WHAT. 1964.
Oil on canvas with objects,
223.5 x 487.7 cm (88 x 192″).
Mr. and Mrs. S. I. Newhouse

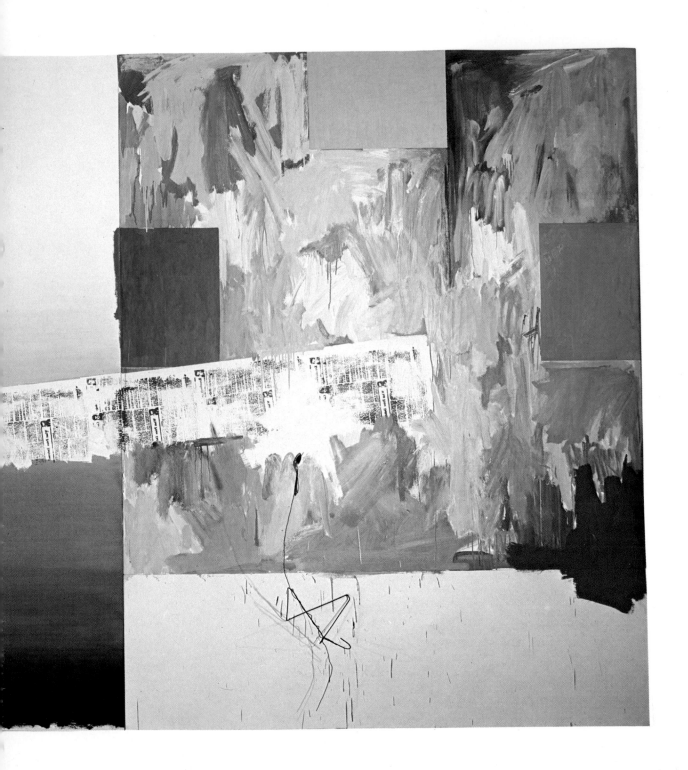

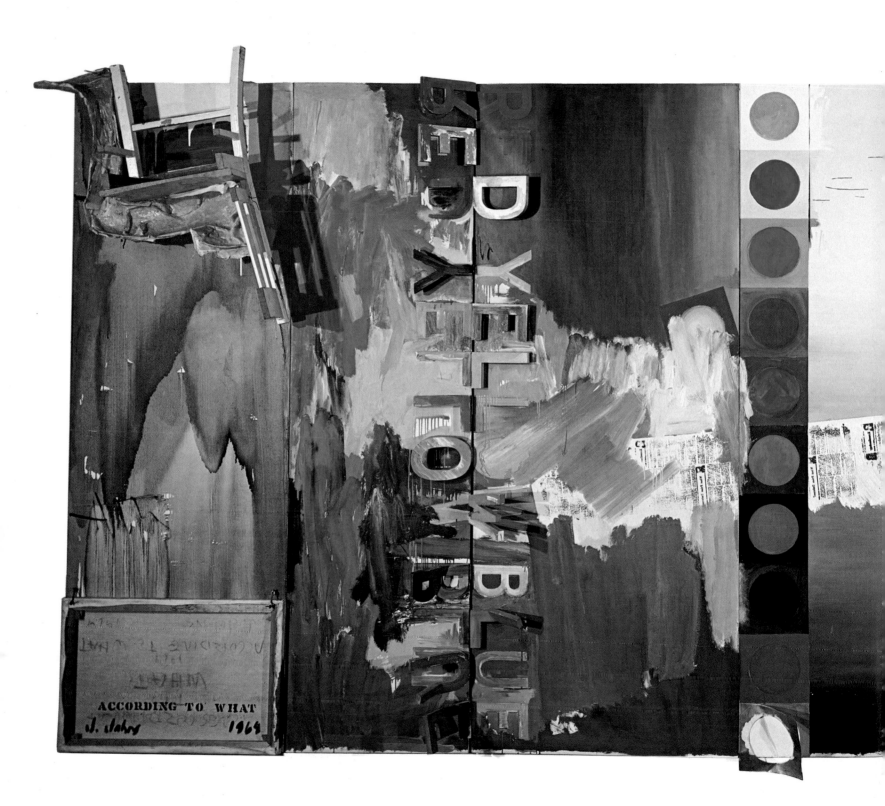

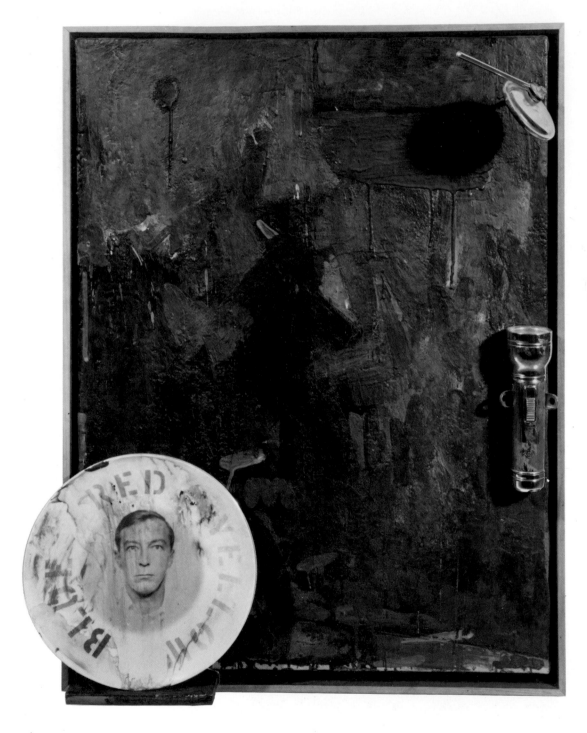

116. Souvenir. 1964. Encaustic on canvas with objects,
73 x 53.3 cm (28¾ x 21″). Collection the artist

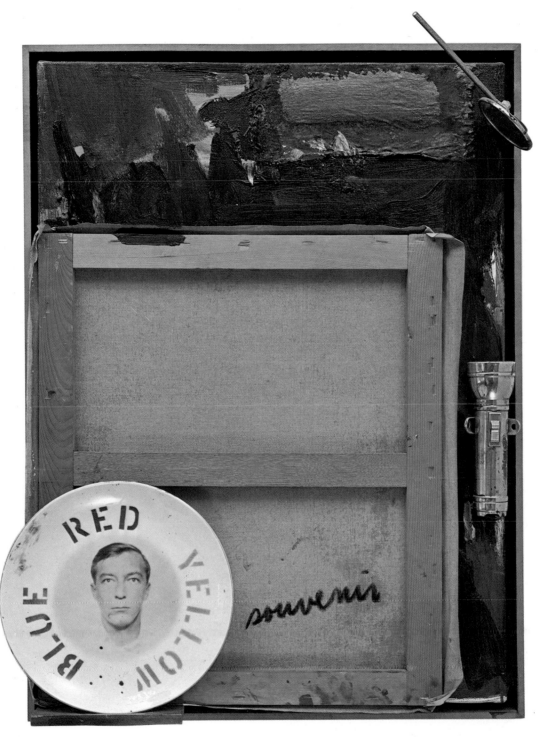

117. SOUVENIR 2. 1964. Oil and collage on canvas with objects, 73 x 53.3 cm
(28¾ x 21″). Collection Mr. and Mrs. Victor W. Ganz

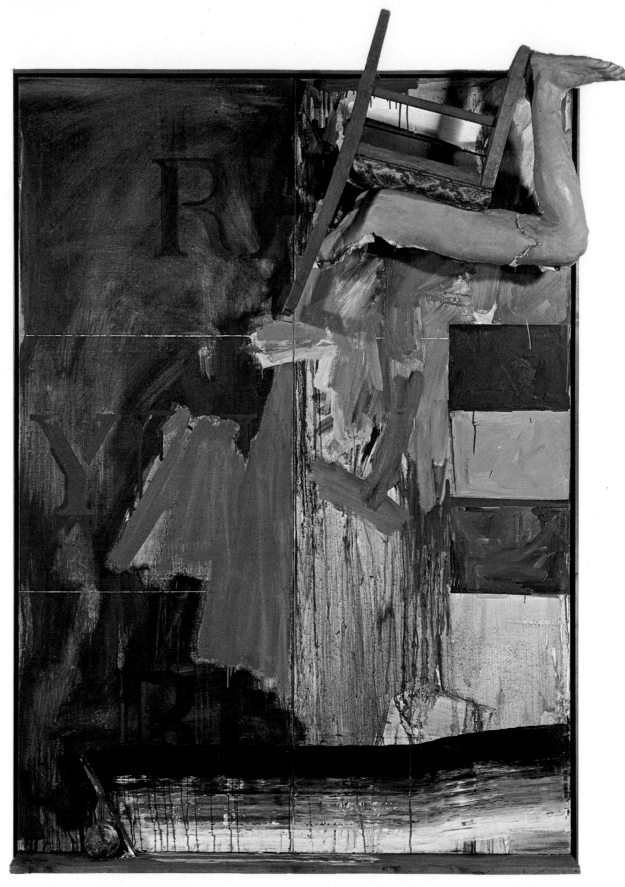

118. WATCHMAN. 1964. Oil on canvas with objects, 215.9 x 153 cm (85 x 60¼″).
Collection Mr. Hiroshi Teshigahara, Tokyo

119. STUDIO. 1964.
Oil on canvas with objects,
224.8 x 369.6 cm (88½ x 145½").
Collection of Whitney Museum of American Art.
Purchase, with partial funding from the
Friends of the Whitney Museum
of American Art. 66.1

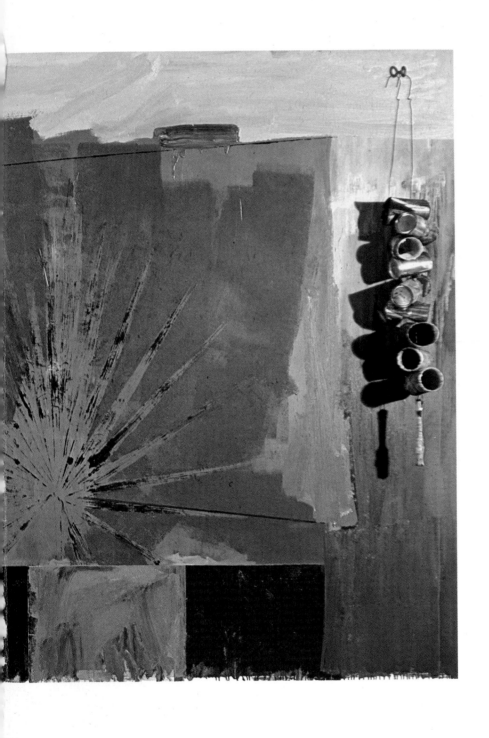

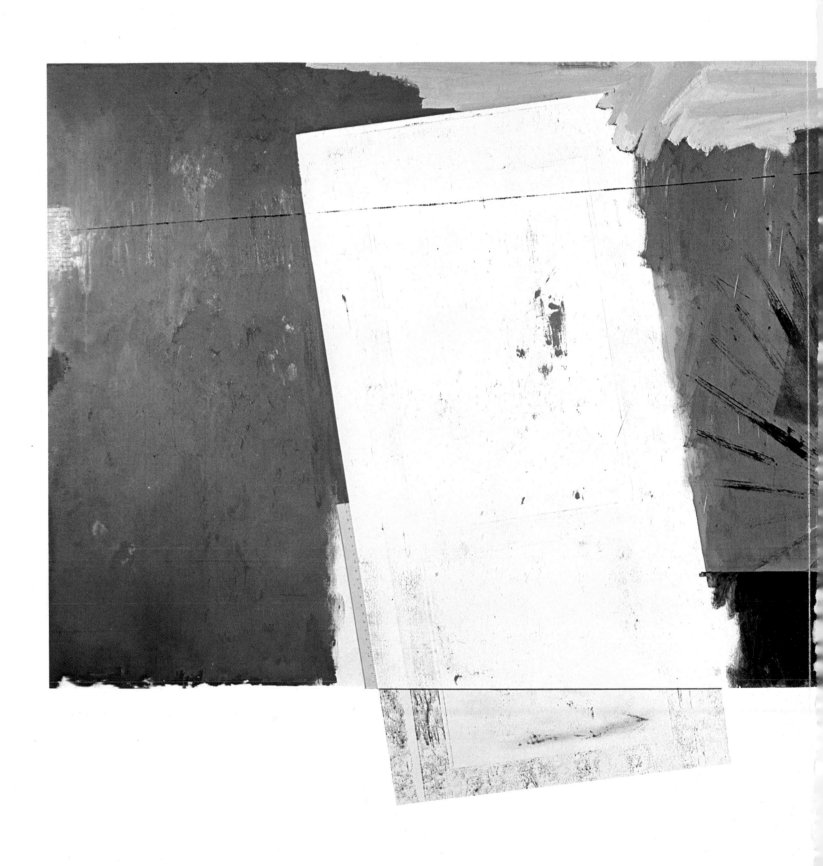

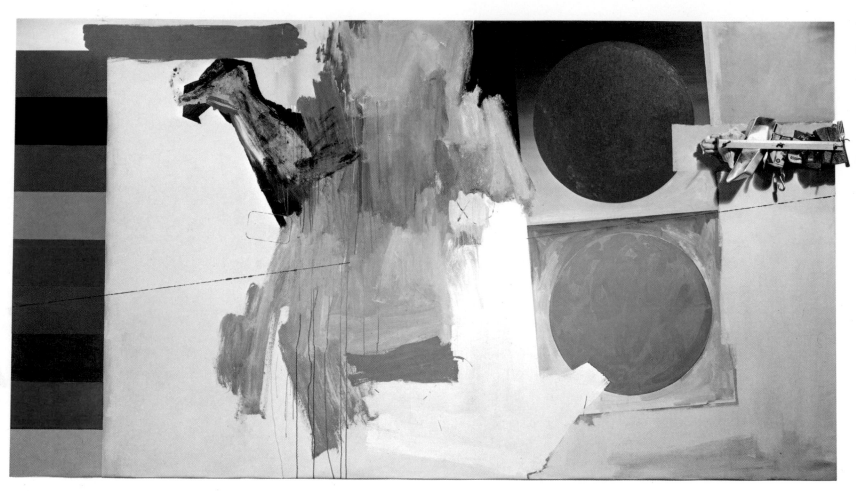

120. EDDINGSVILLE. 1965. Oil on canvas with objects, 172.7 x 311.2 cm (68 x 122½"). Museum Ludwig, Cologne

122. ALE CANS. 1964. Lithograph,
57.2 x 44.5 cm (22½ x 17½″).
Edition of 31. Published by
Universal Limited Art Editions

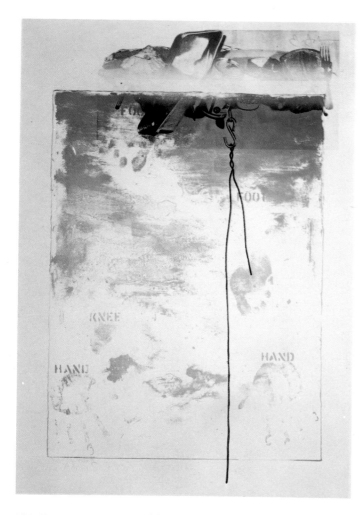

121. PINION. 1963 – 66. Lithograph, 101.6 x 71.1 cm
(40 x 28″). Edition of 36. Published by Universal Limited
Art Editions

123. TWO MAPS I. 1965–66.
Lithograph, 83.8 x 67.3 cm (33 x 26½″).
Edition of 30. Published by
Universal Limited Art Editions

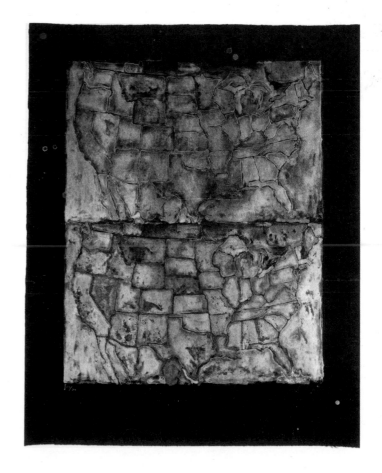

124. PASSAGE II. 1966.
Oil on canvas with objects,
151.8 x 158.8 cm (59¾ x 62½″).
Teheran Museum of Contemporary Art

125 Untitled 1964–65
Oil on canvas with objects,
182.9 x 426.7 cm (72 x 168″).
Stedelijk Museum, Amsterdam

126. WATCHMAN. 1966. Graphite wash, metallic powder, pencil, and pastel on paper, 97.1 x 67.3 cm (38¼ x 26½″). Collection, The Museum of Modern Art, New York. Gift of Mrs. Victor W. Ganz in memory of Victor W. Ganz

127. WATCHMAN. 1967. Lithograph, 91.4 x 61 cm (36 x 24″). Edition of 40. Published by Universal Limited Art Editions

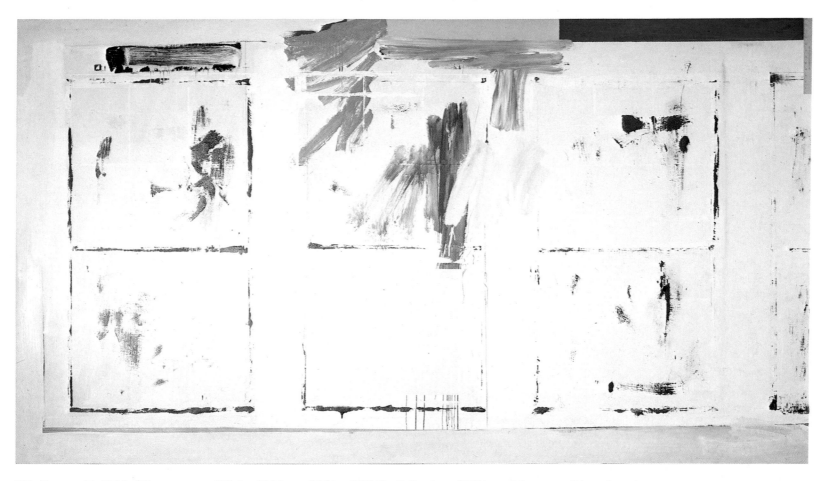

128. STUDIO II. 1966. Oil on canvas, 178.8 x 318.1 cm (70⅜ x 125¼″). Collection of Whitney Museum of American Art. Gift of the family of Victor W. Ganz in his memory. 92.4

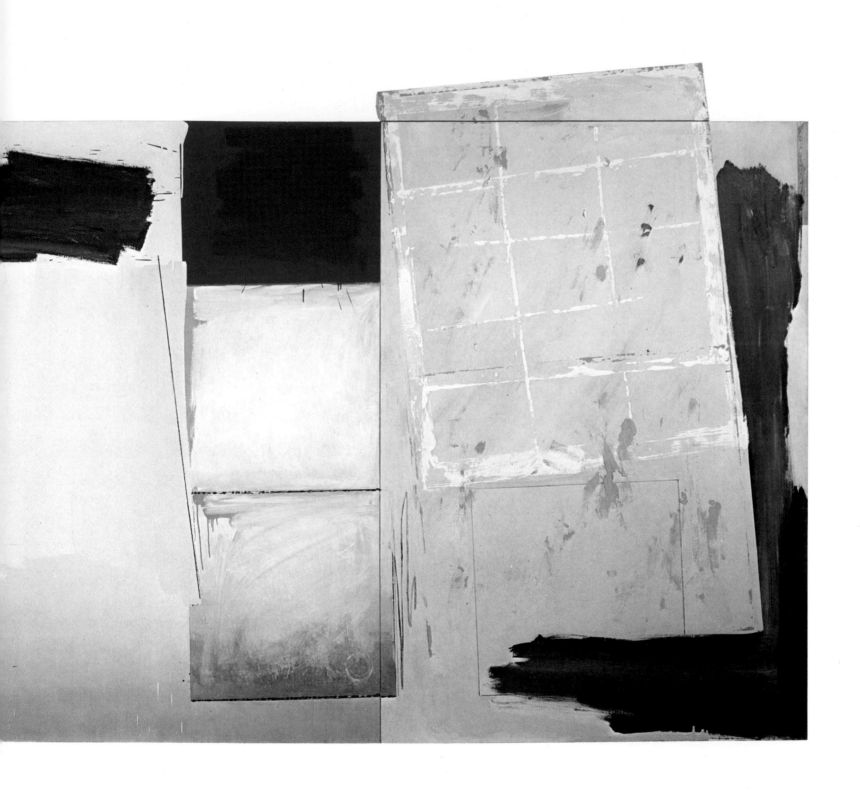

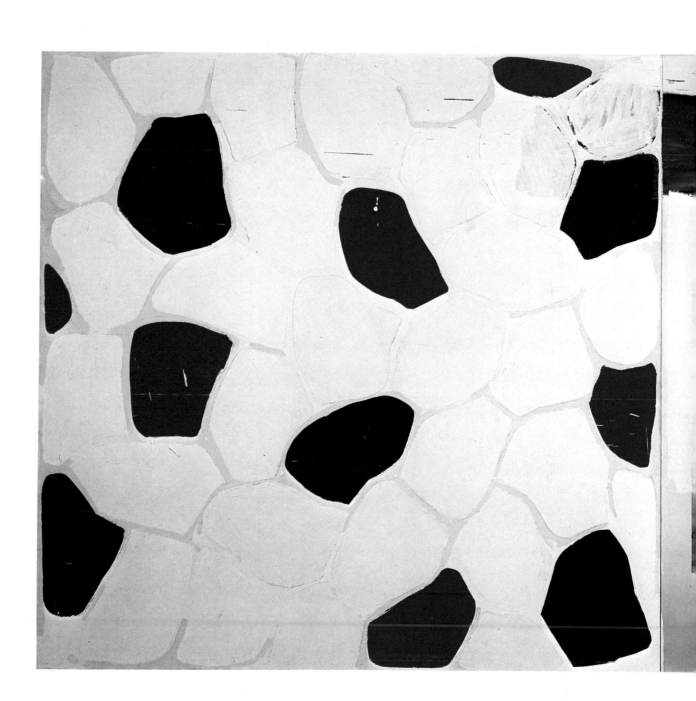

129. HARLEM LIGHT. 1967.
Oil and collage on canvas,
198.1 x 436.9 cm (78 x 172″).
Collection David Whitney

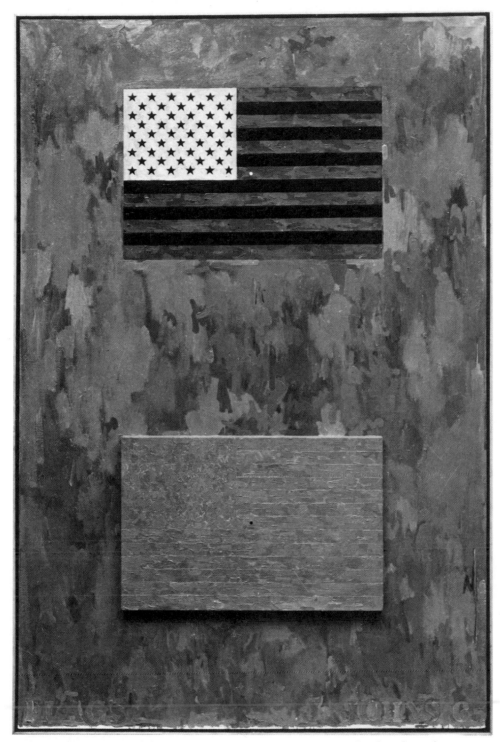

130. FLAGS. 1965. Oil on canvas, 182.9 x 121.9 cm (72 x 48″). Collection the artist

131. SCREEN PIECE. 1967. Oil on canvas, 182.9 x 127 cm (72 x 50″). Private collection

132. SCREEN PIECE 2. 1968. Oil on canvas, 182.9 x 127 cm (72 x 50″). Collection Mr. and Mrs. Richard Lane

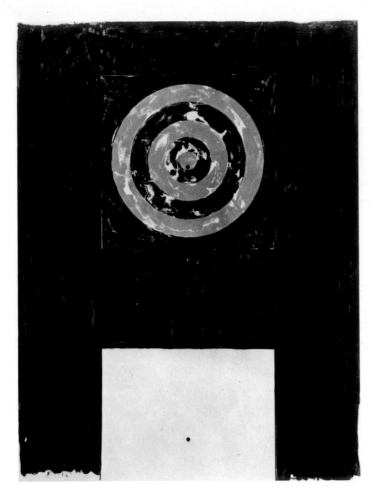

133. TARGETS. 1967–68. Lithograph, 86.4 x 64.8 cm (34 x 25½″). Edition of 42. Published by Universal Limited Art Editions

134. EVIAN. 1968. Graphite, gouache, and pastel on paper, 76.2 x 53.9 cm (30 x 21¼″). Collection David Whitney

135. 1ST ETCHINGS. 1967–68. Six etchings from the portfolio 1ST ETCHINGS,
each 63.5 x 50.8 cm (25 x 20″). Edition of 26. Published by Universal Limited Art Editions

136. WALL PIECE. 1968. Oil and collage on canvas, 182.9 x 280 cm (72 x 110¼″). Collection the artist

137. WALL PIECE. 1969. Pencil, graphite, pastel, watercolor, and collage on paper, 69.9 x 101.6 cm (27½ x 40″). Collection the artist

138. WALL PIECE. 1969. Ink on plastic, 68.6 x 94 cm (27 x 37″).
Collection Mrs. Victor W. Ganz

139. FIGURES IN COLOR. 1969.
Ten lithographs, each 98.5 x 78.7 cm (38 x 31″).
Edition of 40. Published by Gemini G.E.L.,
Los Angeles, California

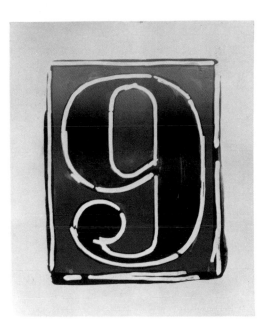

140

140. ENGLISH LIGHT BULB. 1968–70.
Sculp-metal, wire, and polyvinyl chloride,
dimensions variable—length of base 12.4 cm (4⅞″).
Collection Mark Lancaster

141. HIGH SCHOOL DAYS. 1969.
Lead relief with mirror,
58.4 x 43.2 cm (23 x 17″).
Edition of 60. Published by Gemini G.E.L.,
Los Angeles, California

142. BREAD. 1969.
Lead relief with paper and paint,
58.4 x 43.2 cm (23 x 17″).
Edition of 60. Published by Gemini G.E.L.,
Los Angeles, California

143. THE CRITIC SMILES. 1969.
Lead relief with gold and tin,
58.4 x 43.2 cm (23 x 17″).
Edition of 60. Published by Gemini G.E.L.,
Los Angeles, California

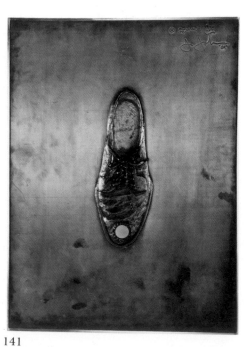

141

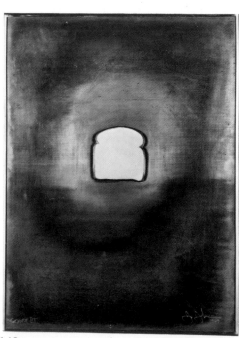

142

143

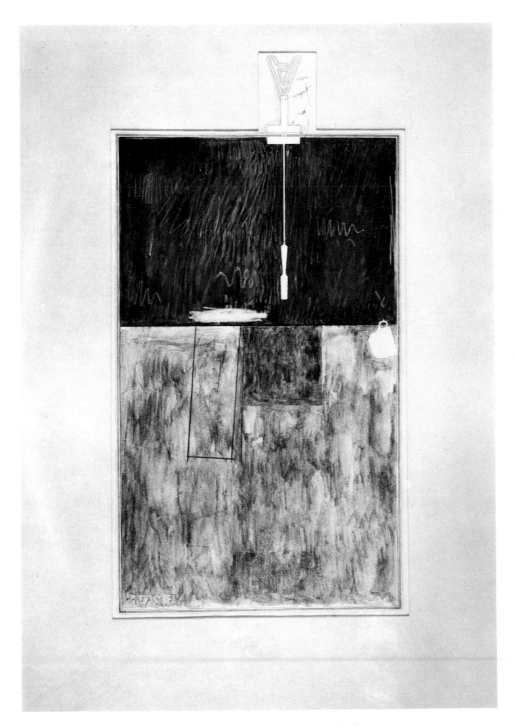

144. ZONE. 1969. Graphite, chalk, and gouache on paper, 83.2 x 44 cm (32¾ x 17⁵/₁₆″).
Collection the artist

145. DECOY II. 1971–73. Lithograph, 104.1 x 73.7 cm (41 x 29″).
Edition of 31. Published by Universal Limited Art Editions

146. DECOY. 1971.
Oil on canvas with object,
182.9 x 127 cm (72 x 50″).
Collection Mrs. Victor W. Ganz

147. VOICE 2. 1971.
Oil and collage on canvas,
three panels, each 182.9 x 127 cm (72 x 50″).
Kunstmuseum Basel

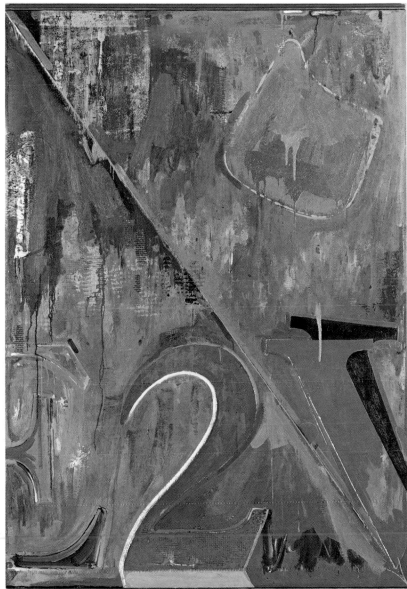

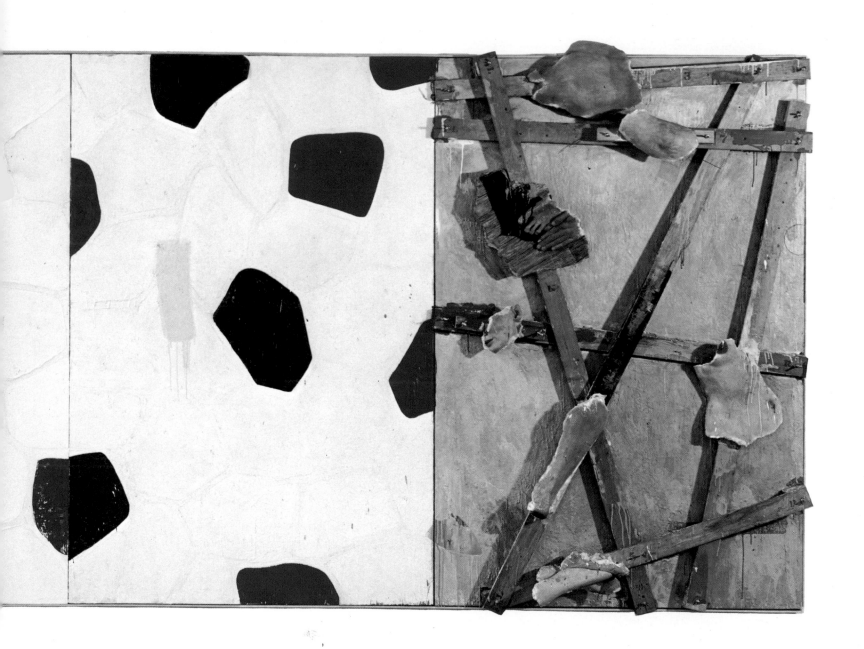

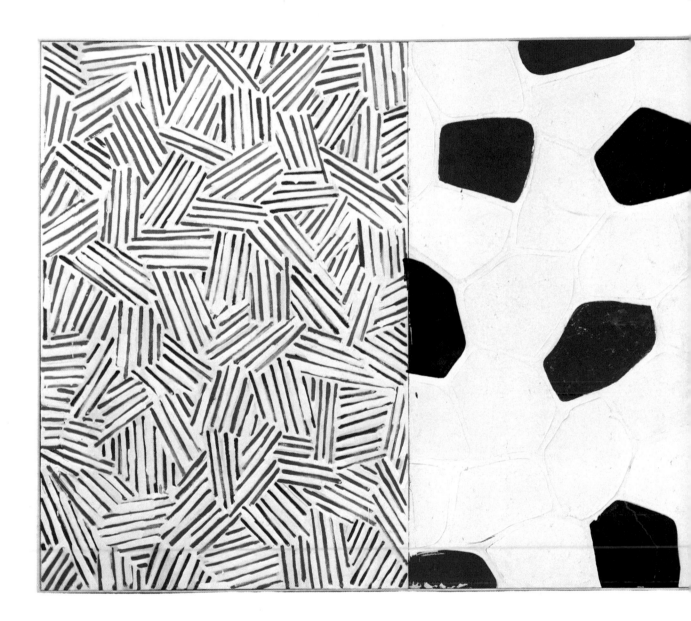

148. UNTITLED. 1972.
Oil, encaustic, and collage on canvas
with objects,
182.9 x 487.7 cm (72 x 192″).
Museum Ludwig, Cologne

149. SKIN I. 1973. Charcoal on paper, 64.8 x 102.2 cm (25½ x 40¼").
Collection the artist

150. SKIN II. 1973. Charcoal on paper, 64.8 x 102.2 cm (25½ x 40¼").
Collection the artist

151. UNTITLED. 1973.
Oil and pencil on paper,
104.7 x 75 cm (41¼ x 29½").
Collection David Whitney

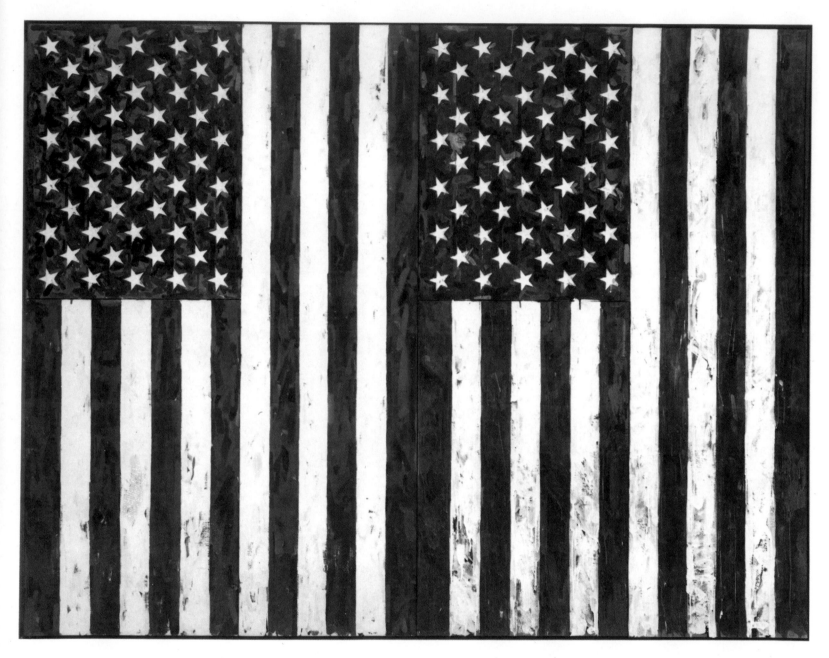

152. TWO FLAGS. 1973. Oil and encaustic on canvas, 145.9 x 176.7 cm (57⁷⁄₁₆ x 69⁹⁄₁₆″). Private collection

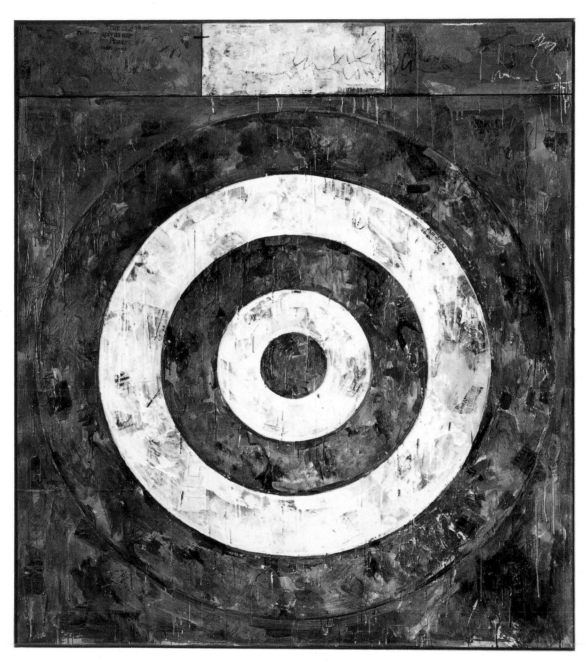

153. TARGET. 1974. Encaustic and collage on canvas, 155.5 x 135.5 cm (61¼ x 53¼").
The Seibu Museum of Art, Tokyo

154

155

156

157

158

159

160

154. FACE. 1974. Lithograph,
78.1 x 57.8 cm (30¾ x 22¾").
Edition of 49. Published by Gemini G.E.L.,
Los Angeles, California

155. HANDFOOTSOCKFLOOR. 1974. Lithograph,
78.1 x 57.8 cm (30¾ x 22¾").
Edition of 48. Published by Gemini G.E.L.,
Los Angeles, California

156. BUTTOCKS. 1974. Lithograph,
78.1 x 57.8 cm (30¾ x 22¾").
Edition of 49. Published by Gemini G.E.L.,
Los Angeles, California

157. TORSO. 1974. Lithograph,
78.1 x 57.8 cm (30¾ x 22¾").
Edition of 50. Published by Gemini G.E.L.,
Los Angeles, California

158. FEET. 1974. Lithograph,
78.1 x 57.8 cm (30¾ x 22¾").
Edition of 47. Published by Gemini G.E.L.,
Los Angeles, California

159. LEG. 1974. Lithograph,
78.1 x 57.8 cm (30¾ x 22¾").
Edition of 50. Published by Gemini G.E.L.,
Los Angeles, California

160. KNEE. 1974. Lithograph,
78.1 x 57.8 cm (30¾ x 22¾").
Edition of 47. Published by Gemini G.E.L.,
Los Angeles, California

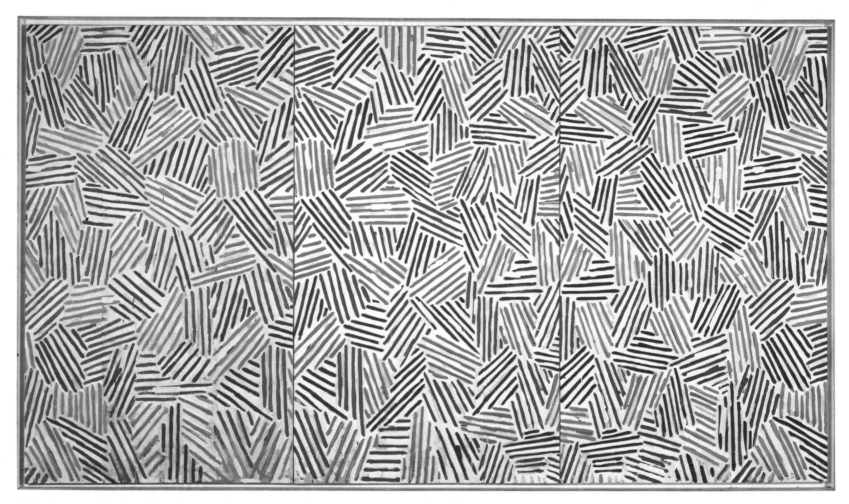

161. Scent. 1973–74. Oil and encaustic on canvas, 182.9 x 320.6 cm (72 x 126¼″). Collection Ludwig, Aachen

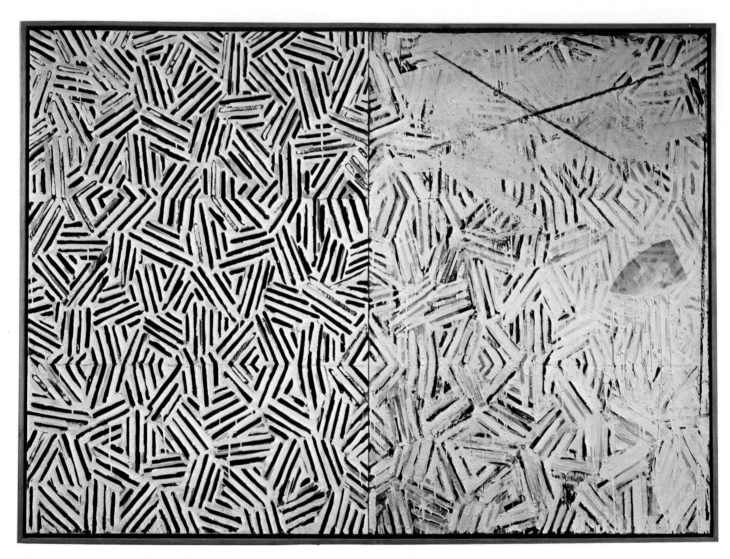

162. CORPSE AND MIRROR. 1974. Oil, encaustic, and collage on canvas, 127 x 173 cm (50 x 68⅛″).
Collection Mrs. Victor W. Ganz

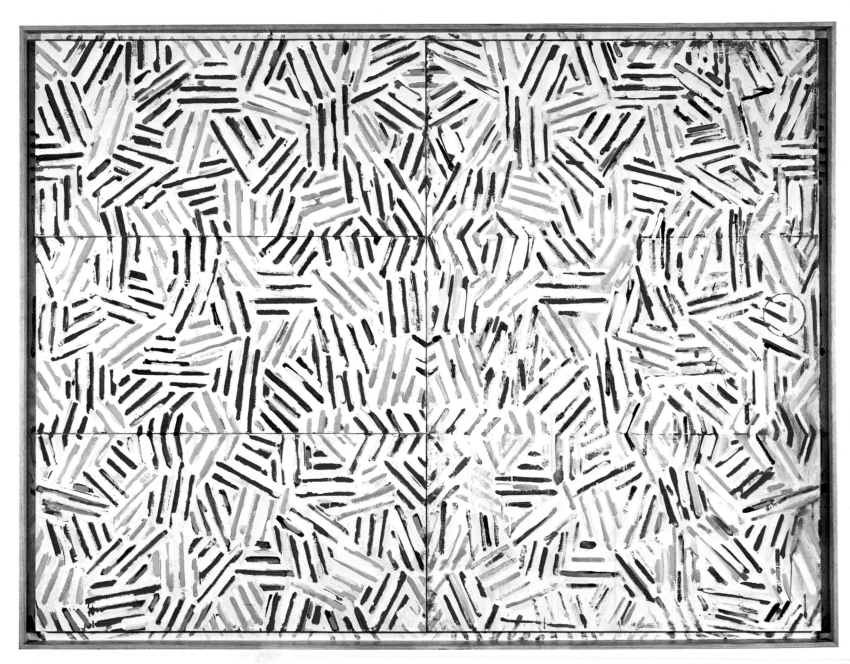

163. Corpse and Mirror II. 1974–75. Oil on canvas with painted frame, 146.4 x 191.1 cm (57⅝ x 75¼″). Collection the artist

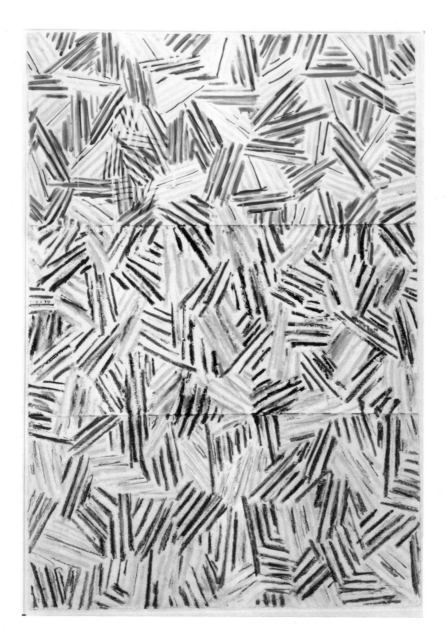

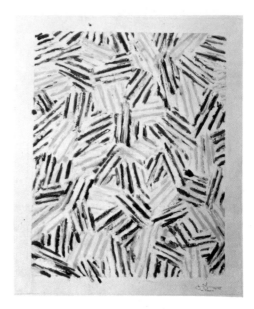

165. UNTITLED. 1974–75. Watercolor and Paintstik on paper, 62.9 x 51.4 cm (24¾ x 20¼″). Collection Janie C. Lee

164. CORPSE. 1974–75. Ink, Paintstik, and pastel on paper, 108 x 72.4 cm (42½ x 28½″). Collection David Whitney

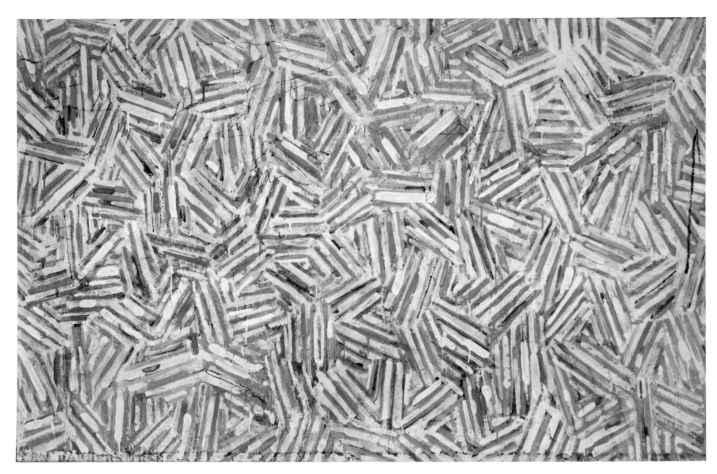

166. THE BARBER'S TREE. 1975. Encaustic and collage on canvas, 87 x 137.8 cm (34¼ x 54¼"). Collection Ludwig, Aachen

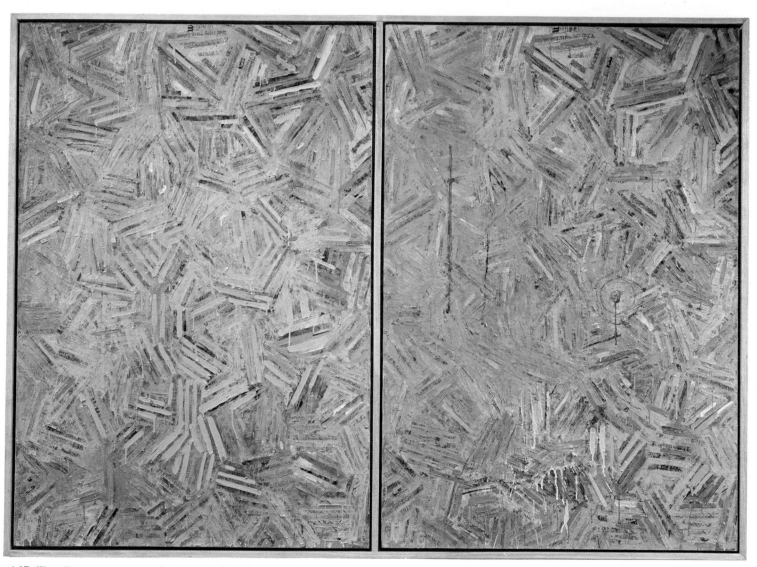

167. THE DUTCH WIVES. 1975. Encaustic and collage on canvas, 131.4 x 180.3 cm (51¾ x 71″). Collection the artist

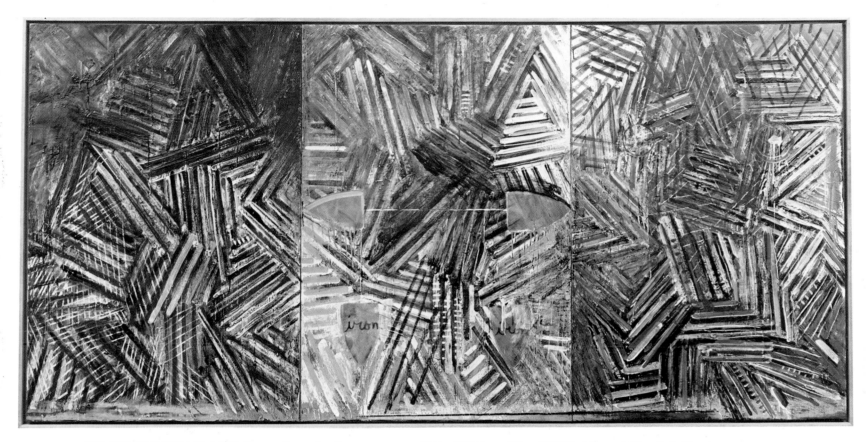

168. WEEPING WOMEN. 1975. Encaustic and collage on canvas, 127 x 259.7 cm (50 x 102¼″). Mr. and Mrs. S. I. Newhouse

 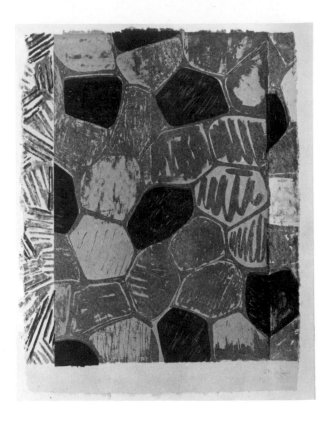

169. FOUR PANELS from UNTITLED 1972. (1975). Lithograph, Four panels, each 104.1 x 81.3 cm (41 x 32″). Edition of 20. Published by Gemini G.E.L., Los Angeles, California

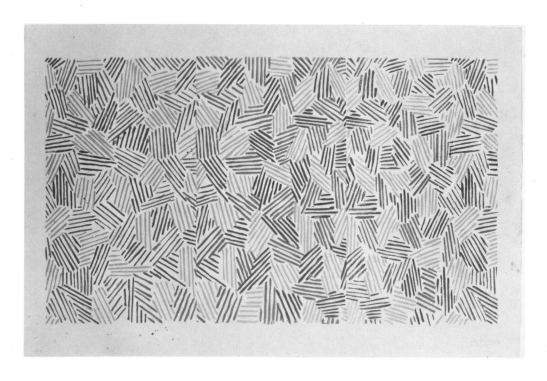

170. SCENT. 1975 – 76.
Lithograph, linocut, and woodcut,
79.3 x 119.4 cm (31¼ x 47″).
Edition of 42. Published by
Universal Limited Art Editions

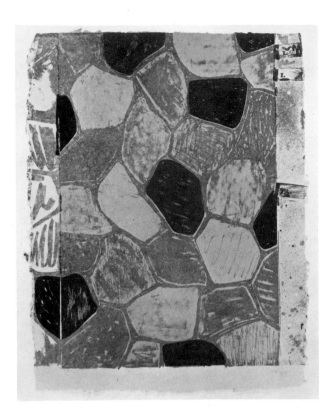

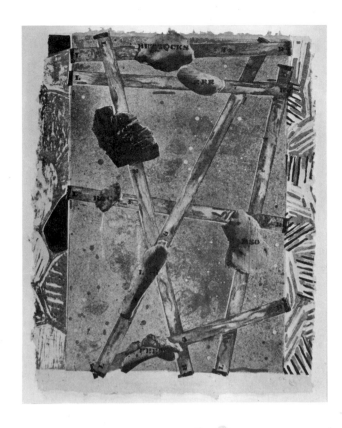

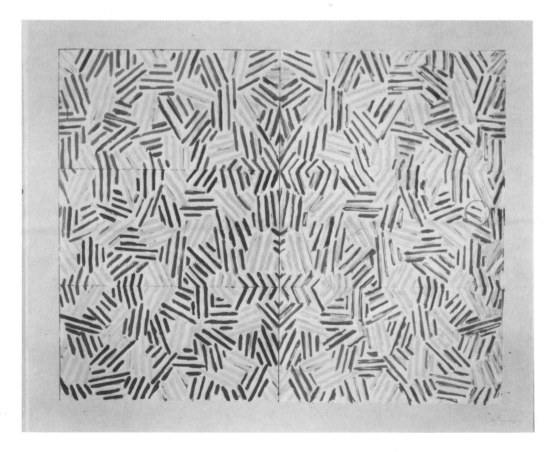

171. Corpse and Mirror. 1976.
Silkscreen,
109.2 x 135.2 cm (43 x 53¼″).
Edition of 65. Published by
Simca Print Artists, Inc.

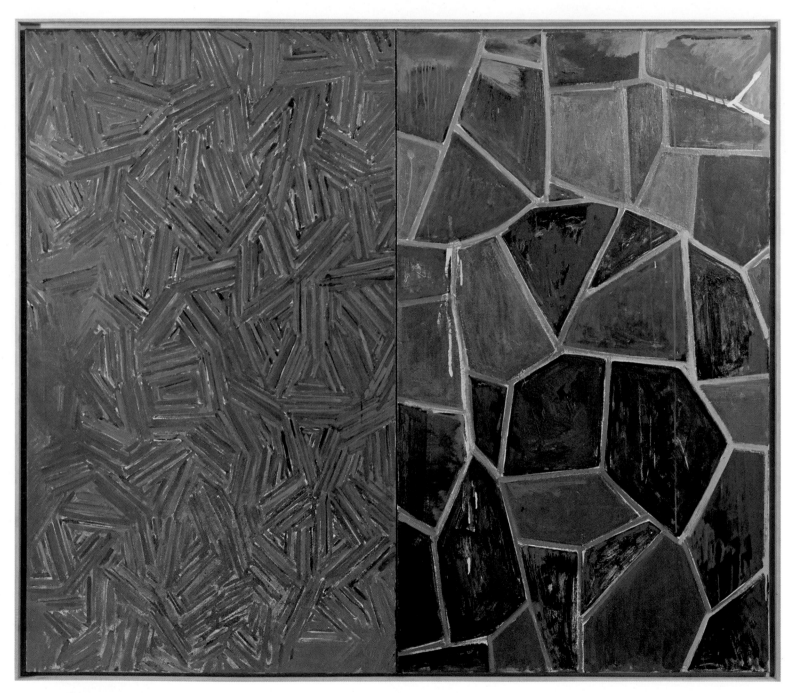

172. END PAPER. 1976. Oil on canvas, 152.4 x 176.6 cm (60 x 69½″). Collection Philip Johnson

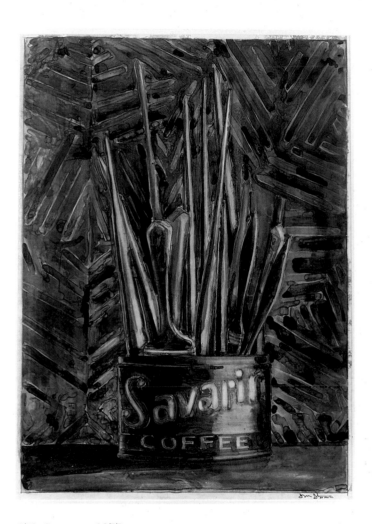

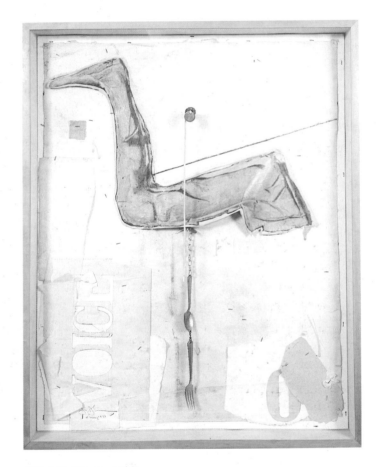

173. SAVARIN. 1977.
Brush, pen, and ink on plastic sheet,
96.8 x 67 cm (38⅛ x 26⅜").
Collection, The Museum of Modern Art, New York.
Gift of the Lauder Foundation

174. UNTITLED. 1977.
Collage with objects, various papers,
graphite pencil, and clear acrylic,
Box: 109.8 x 86.7 x 9.7 cm (43¼ x 34⅛ x 3¹³⁄₁₆").
Collection the artist

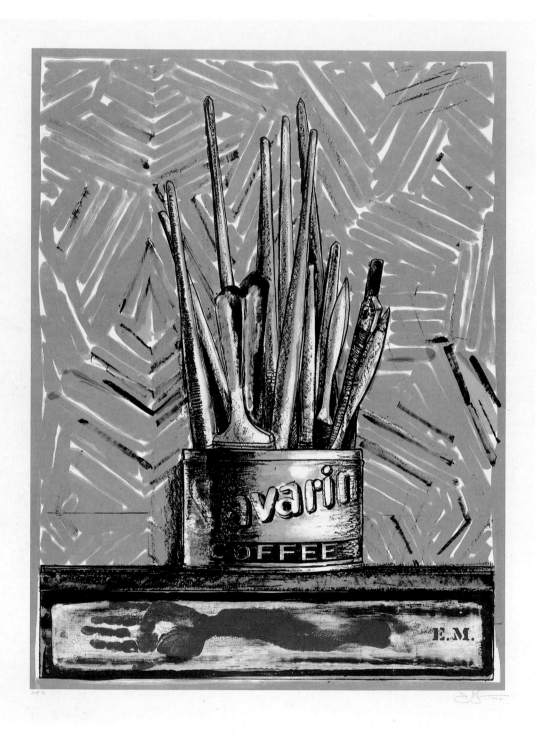

175. SAVARIN. 1977–81. Lithograph, 127 x 96.5 cm (50 x 38″).
Courtesy Universal Limited Art Editions

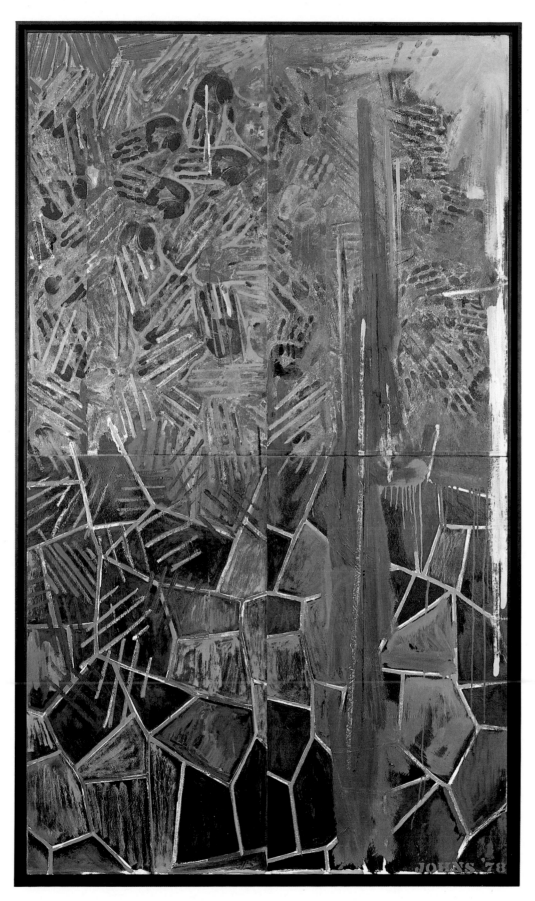

176. CELINE. 1978. Oil on canvas (2 panels), 217.5 x 123.8 cm (85⅝ x 48¾").
Oeffentliche Kunstsammlung, Kunstmuseum Basel

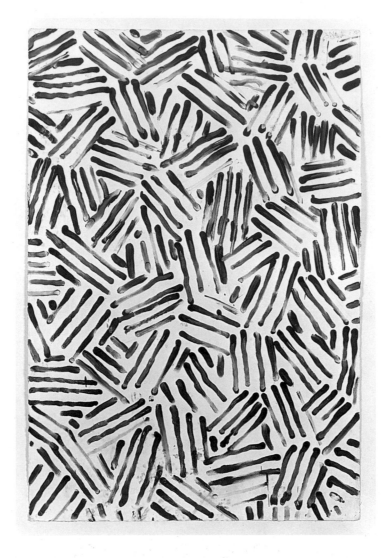

177. UNTITLED. 1978.
Acrylic on paper,
111.1 x 73.7 cm (43¾ x 29″).
Collection the artist

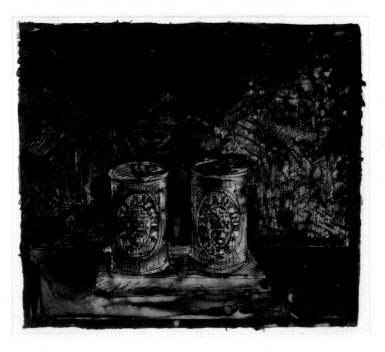

178. ALE CANS. 1978.
Ink on plastic,
35.9 x 40.6 cm (14⅛ x 16″).
Collection the artist

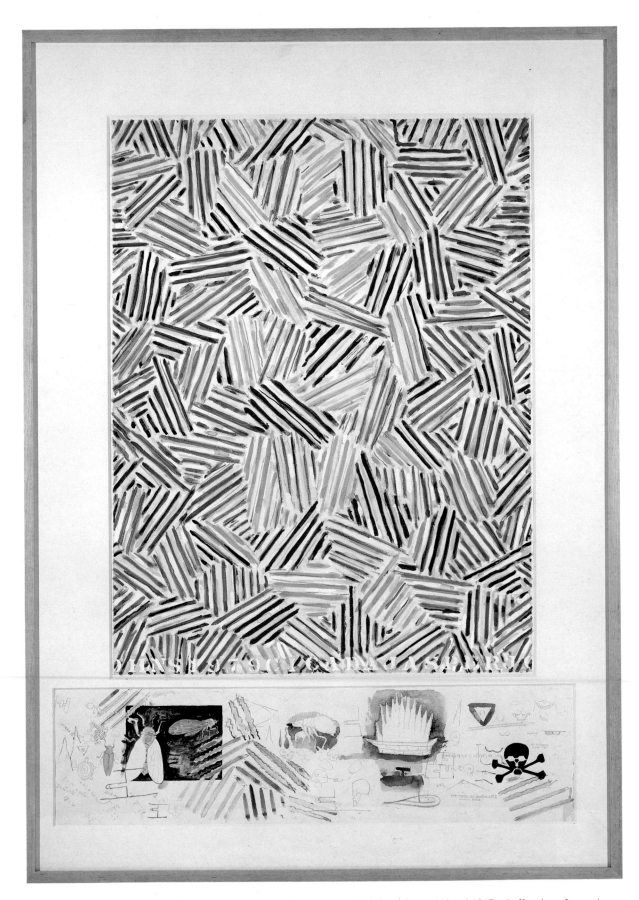

179. Cicada. 1979. Watercolor, crayon, and pencil on paper, 109.2 x 73 cm (43 x 28¾″). Collection the artist

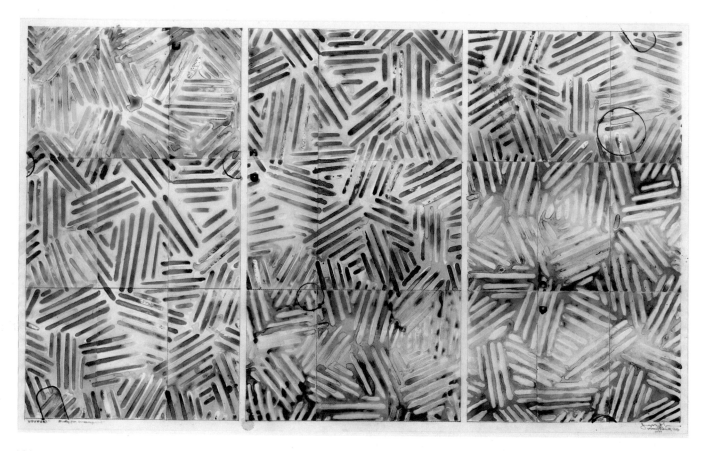

180. USUYUKI (study for screenprint). 1979. Ink on plastic, 73 x 120 cm (28¾ x 47¼″).
Collection Mr. Robert K. Hoffman, Dallas, Texas

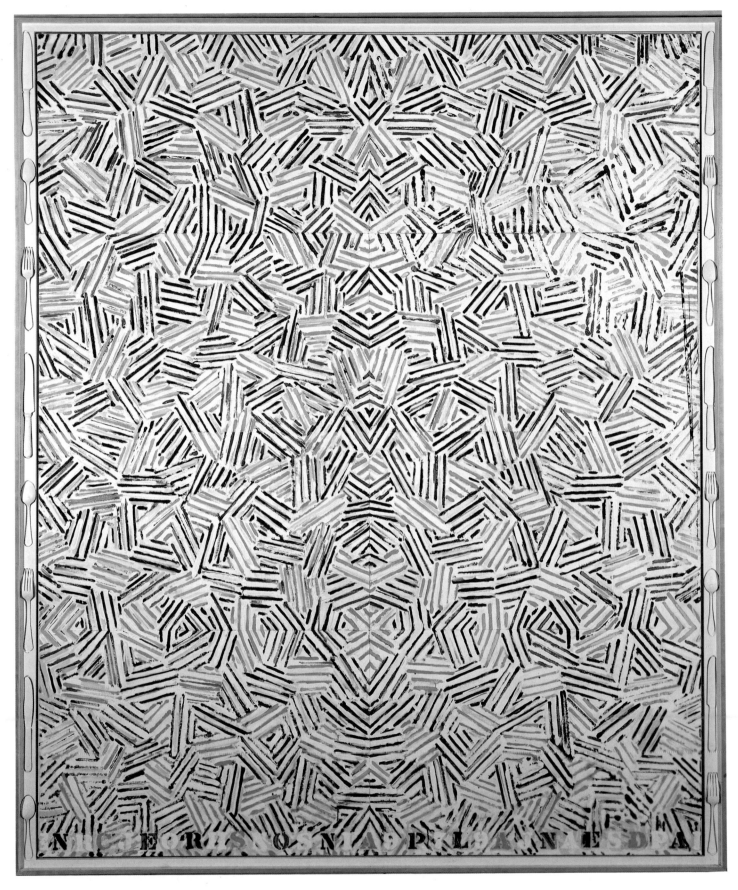

181. DANCERS ON A PLANE. 1979. Oil on canvas with objects, 198.1 x 162.6 cm (78 x 64″). Collection the artist

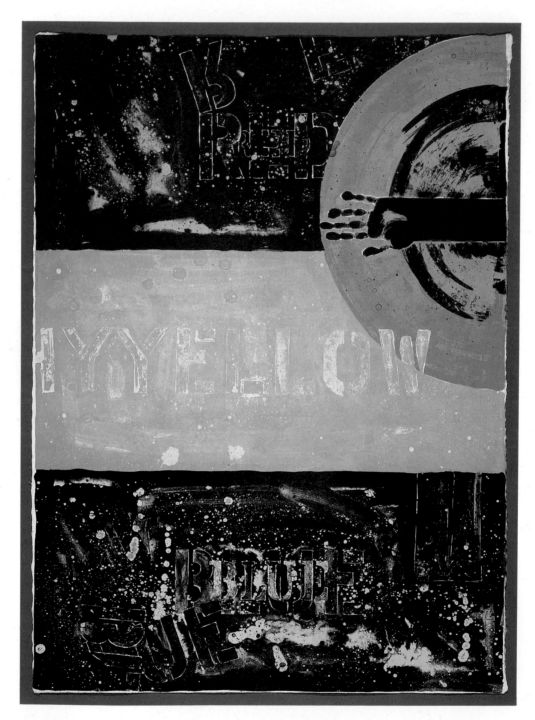

182. Periscope I. 1979. Lithograph, 127 x 91.4 cm (50 x 36″). Courtesy Gemini G.E.L.

183. Dancers on a Plane. 1980. Oil on canvas with painted bronze frame,
199.1 x 161.9 cm (78⅜ x 63¾″ [with frame]). Tate Gallery, London

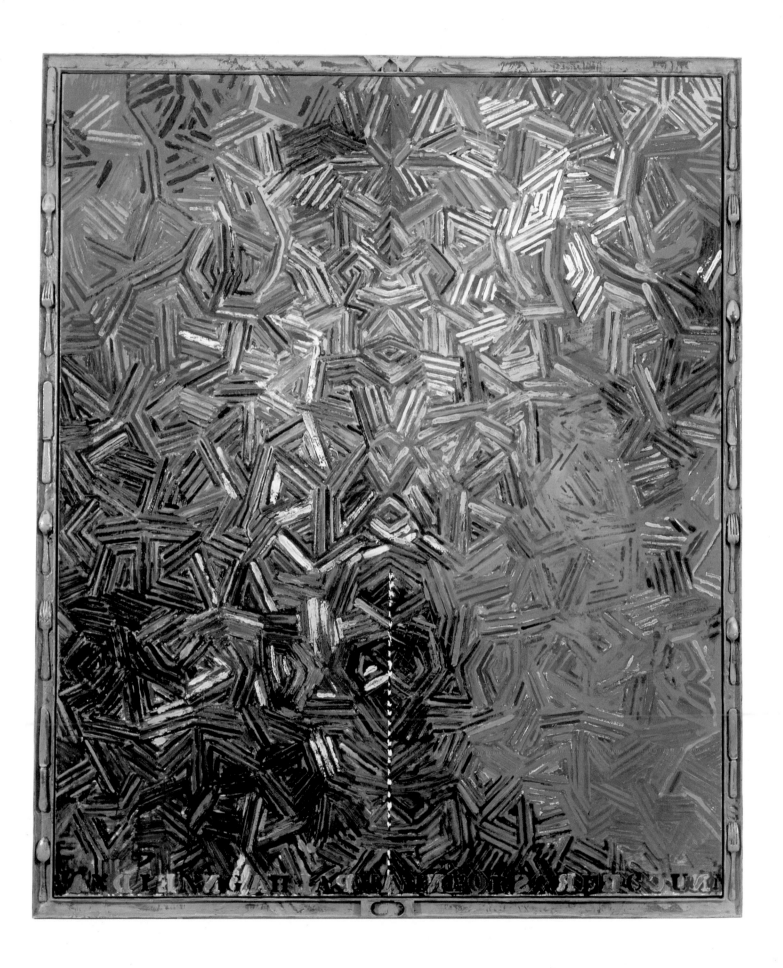

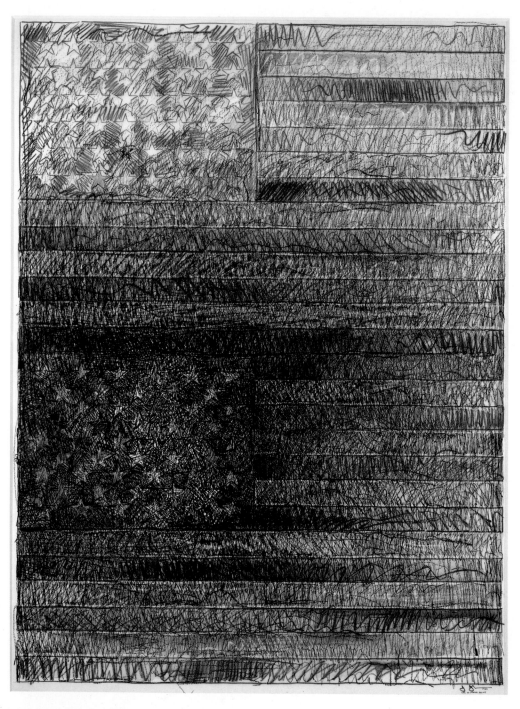

184. Two Flags. 1980. Ink and crayon on plastic, 102.9 x 74.3 cm (40½ x 29¼″).
Collection Peter and Irene Ludwig, Aachen

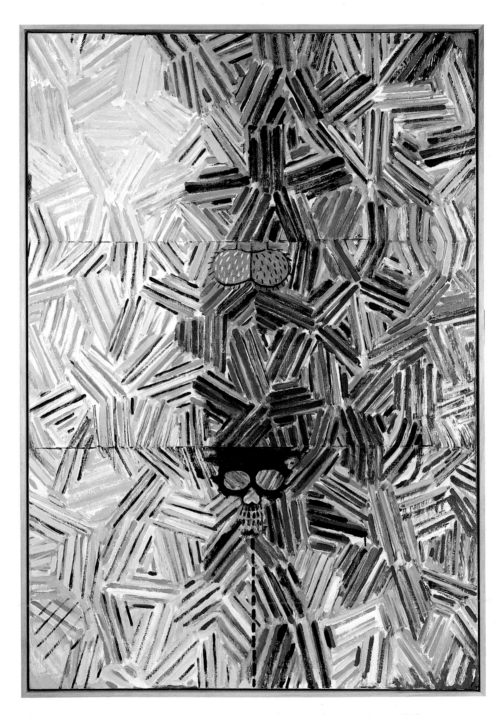

185. TANTRIC DETAIL I. 1980. Oil on canvas, 127.3 x 86.7 cm (50⅛ x 34⅛″).
Collection the artist

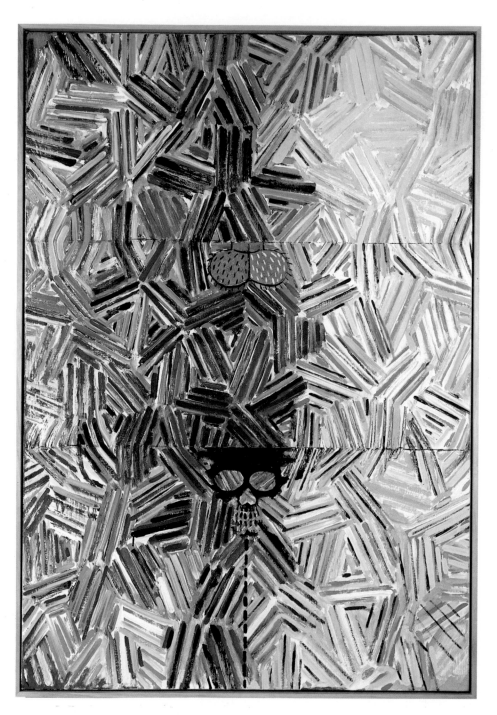

186. TANTRIC DETAIL II. 1981. Oil on canvas, 127 x 86.4 cm (50 x 34″).
Collection the artist

187. TANTRIC DETAIL III. 1981. Oil on canvas, 127 x 86.4 cm (50 x 34″).
Collection the artist

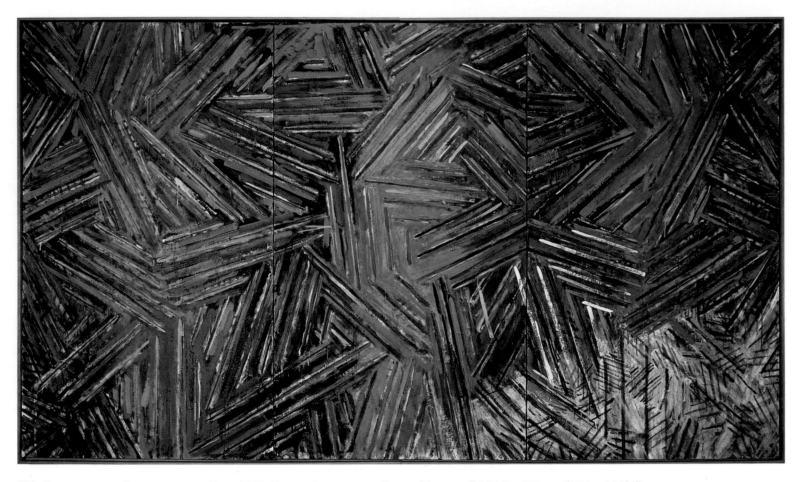

188. BETWEEN THE CLOCK AND THE BED. 1981. Encaustic on canvas (3 panels), overall 183.2 x 321 cm (72⅛ x 126⅜″).
Collection, The Museum of Modern Art, New York. Gift of Agnes Gund

189. DANCERS ON A PLANE. 1982. Graphite wash on paper, 89.5 x 68.6 cm (35¼ x 27″).
Collection the artist

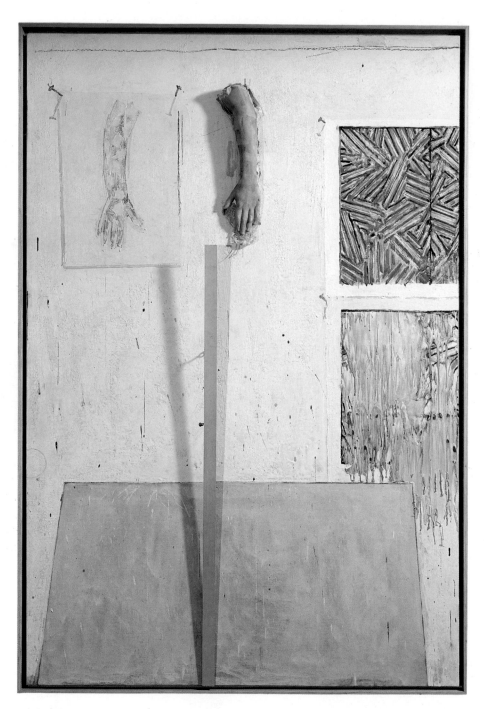

190. In the Studio. 1982. Encaustic and collage on canvas with objects, 182.9 x 121.9 cm (72 x 48″). Collection the artist

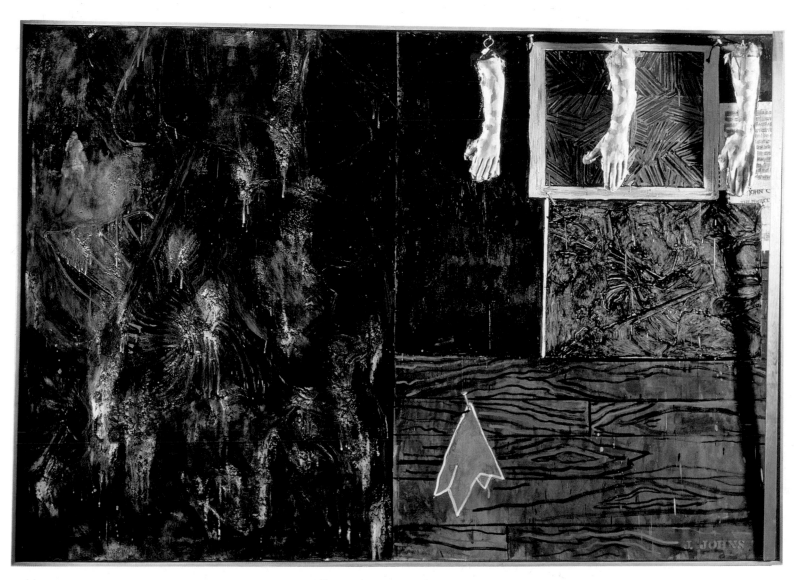

191. PERILOUS NIGHT. 1982. Encaustic on canvas with objects, 170.9 x 243.8 x 12.7 cm (67 x 96 x 5″).
Collection Robert and Jane Meyerhoff, Phoenix, Maryland

192. BETWEEN THE CLOCK AND THE BED. 1982. Ink on plastic,
47 x 79.4 cm (18½ x 31¼"). Collection Aldo Crommelynck

193. VOICE 2. 1982. Ink on plastic, three panels,
each 89.2 x 60.6 cm (35⅛ x 23⅞"). Collection the artist

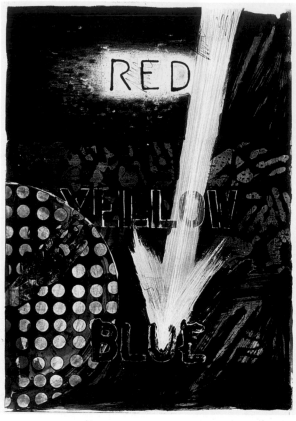

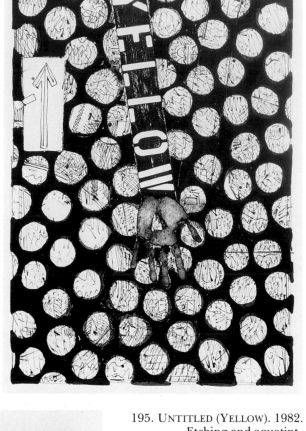

194. UNTITLED (RED). 1982.
Etching and aquatint,
87 x 62 cm (34¼ x 24⅜″).
Courtesy Petersburg Press, Inc.

195. UNTITLED (YELLOW). 1982.
Etching and aquatint,
87 x 62 cm (34¼ x 24⅜″).
Courtesy Petersburg Press, Inc.

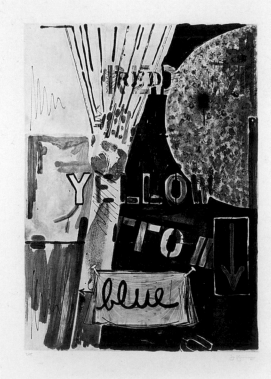

196. UNTITLED (BLUE). 1982.
Etching and aquatint,
87 x 62 cm (34¼ x 24⅜″).
Courtesy Petersburg Press, Inc.

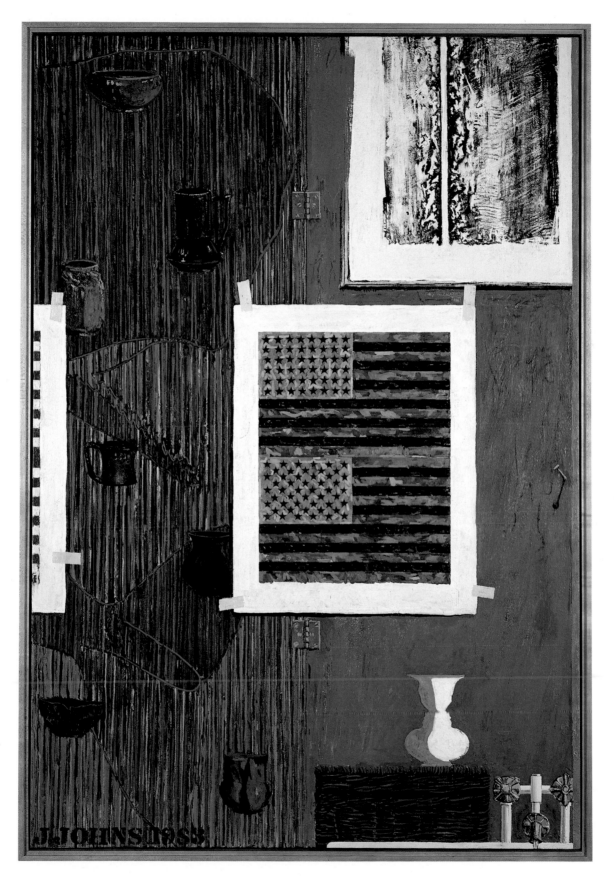

197. VENTRILOQUIST
1983. Encaustic on
canvas, 190.5 x 127 c
(75 x 50″). The Muse
of Fine Arts, Housto
Purchase: Agnes
Cullen Endowment
Fund

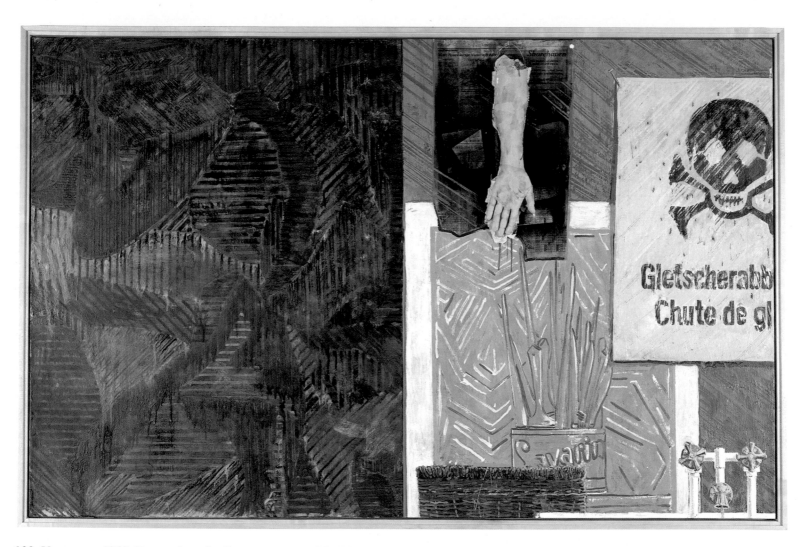

198. UNTITLED. 1983. Encaustic and collage on canvas with objects, 122.2 x 190.8 cm (48⅛ x 75⅛″). Private collection

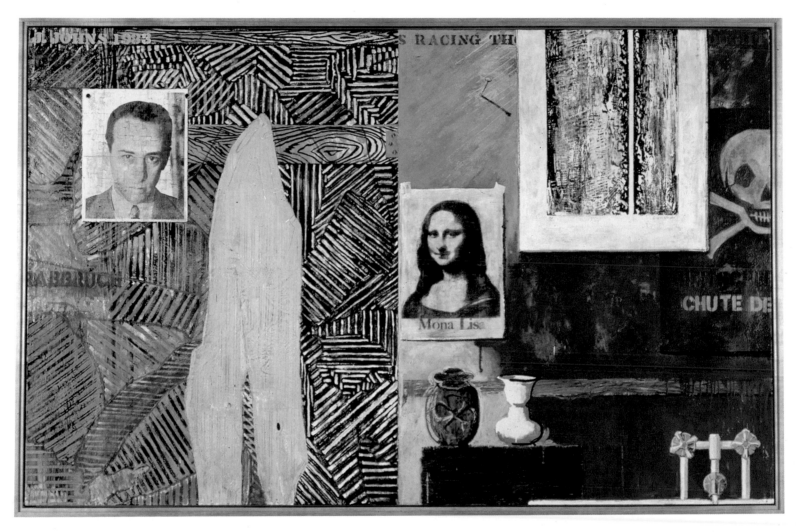

199. RACING THOUGHTS. 1983. Encaustic and collage on canvas, 121.9 x 190.8 cm (48 x 75⅛").
Collection of Whitney Museum of American Art. Purchase with funds from the Burroughs Wellcome Purchase Fund; Leo Castelli;
the Wilfred P. and Rose J. Cohen Purchase Fund; the Julia B. Engel Purchase Fund; the Equitable Life Assurance Society of
the United States Purchase Fund; the Sondra and Charles Gilman, Jr. Foundation, Inc.; S. Sidney Kahan; The Lauder Foundation,
Leonard and Evelyn Lauder Fund; the Sara Roby Foundation; and the Painting and Sculpture Committee. 84.6

200. UNTITLED. 1983. Charcoal and chalk on paper, 83.8 x 114.9 cm (33 x 45¼").
Collection the artist

201. UNTITLED. 1983. Monotype, 96.2 x 245.4 cm (37⅞ x 96⅝"). Courtesy Universal Limited Art Editions

202. UNTITLED. 1983–84.
Ink on plastic,
59.4 x 87 cm (23⅜ x 34¼″).
Mrs. John Hilson

203. UNTITLED. 1983–84. Watercolor, charcoal, and crayon on paper (two pieces joined), 114.3 x 167 cm (45 x 65¾″).
Private collection

204. UNTITLED.
1984. Oil on canvas,
190.5 x 127 cm
(75 x 50″).
Private collection

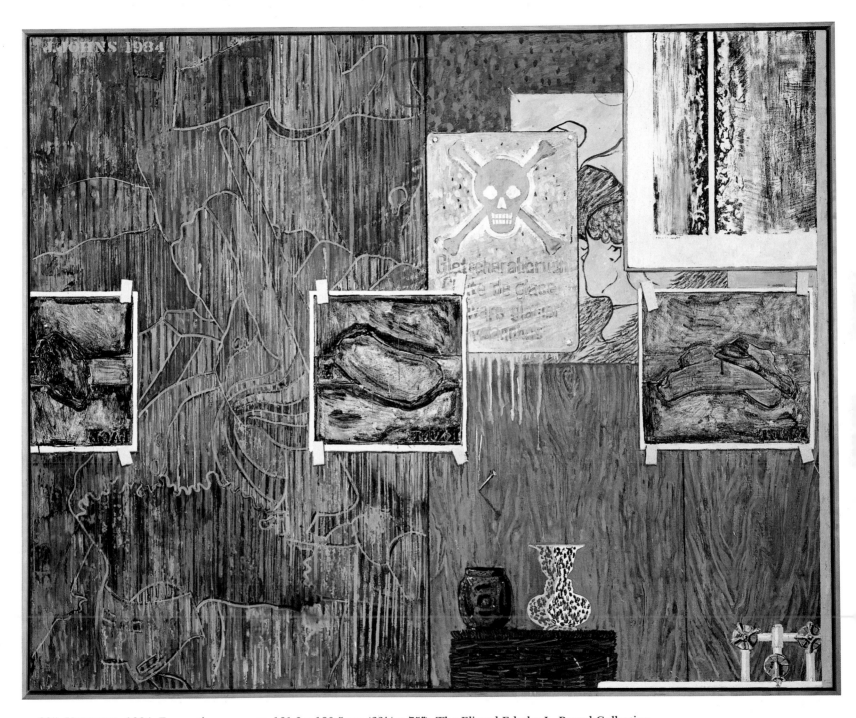

205. Untitled. 1984. Encaustic on canvas, 161.3 x 190.5 cm (63½ x 75″). The Eli and Edythe L. Broad Collection

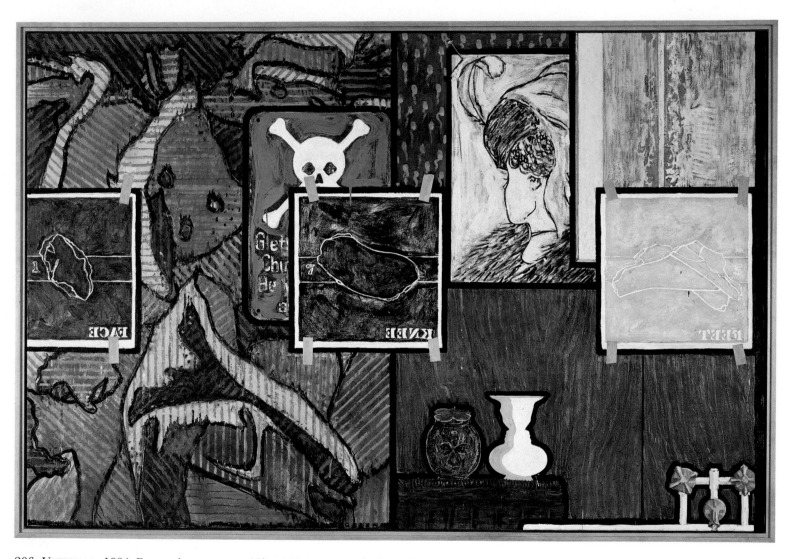

206. UNTITLED. 1984. Encaustic on canvas, 127 x 190.5 cm (50 x 75″). Collection the artist

207. VENTRILOQUIST. 1984. Ink on plastic,
85.1 x 57.8 cm (33½ x 22¾″). Collection the artist

208. UNTITLED. 1984. Charcoal and oil pastel on paper,
103.5 x 73 cm (40¾ x 28¾″). Collection Jean-Christophe Castelli

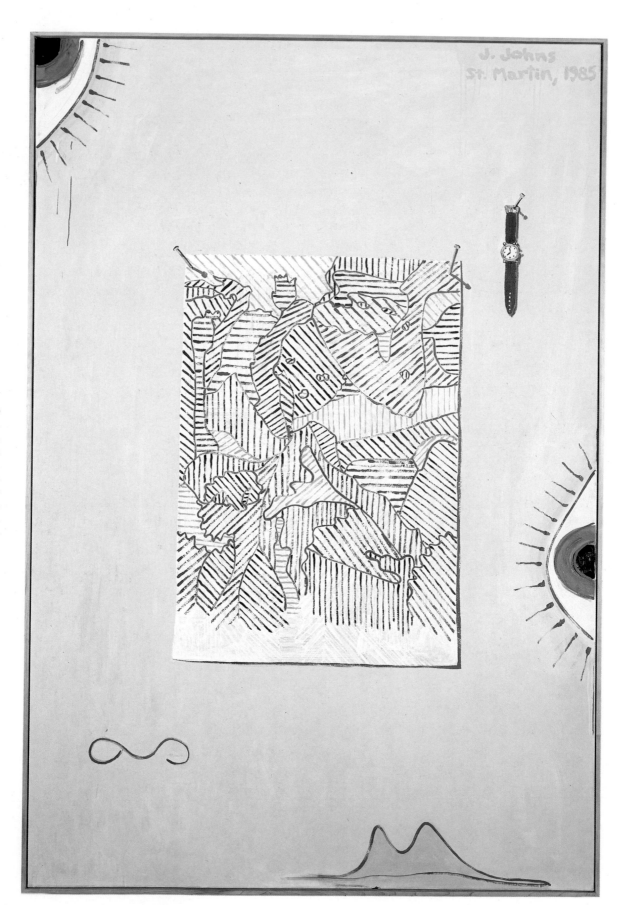

209. UNTITLED
(A DREAM). 1985.
Oil on canvas,
190.5 x 127 cm
(75 x 50″).
Collection
Robert and Jane
Meyerhoff,
Phoenix,
Maryland

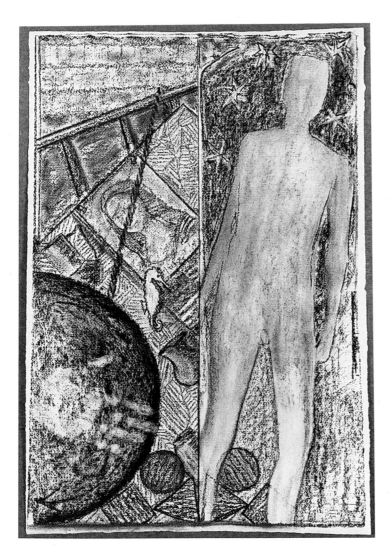

210. SUMMER. 1985. Charcoal on paper,
77.2 x 51.6 cm (30⅜ x 20⅜″). Collection the artist

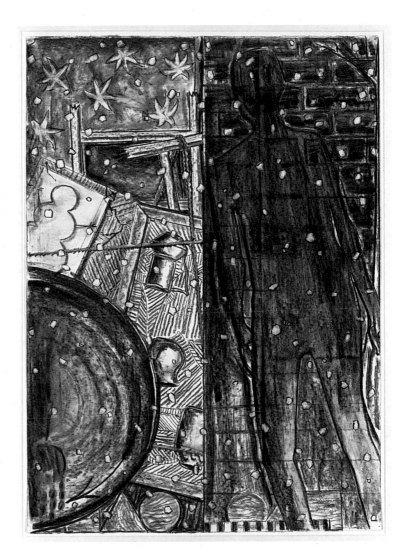

211. WINTER. 1986. Charcoal on paper,
106.7 x 75.6 cm (42 x 29¾″). Collection Jean-Christophe Castelli

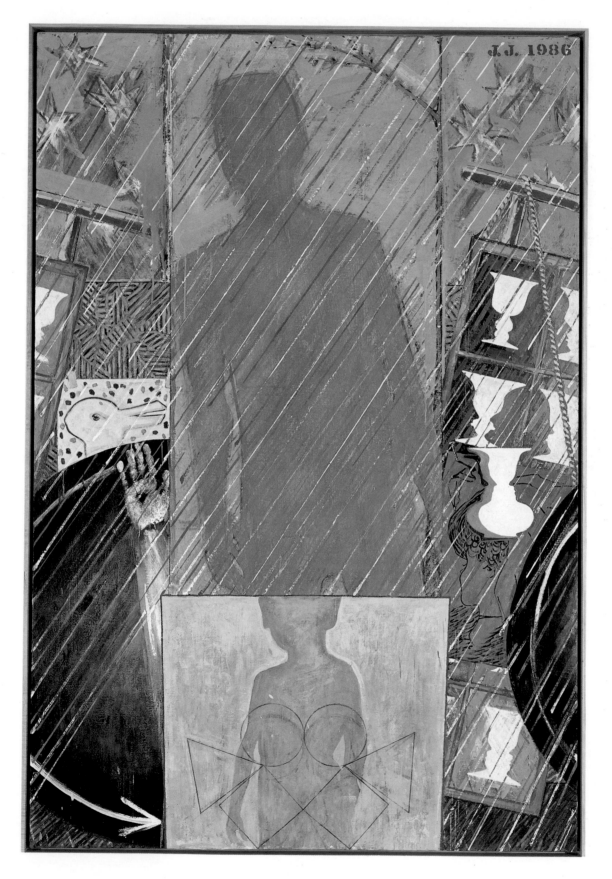

212. SPRING. 1986.
Encaustic on canvas,
190.5 x 127 cm
(75 x 50″).
Private collection

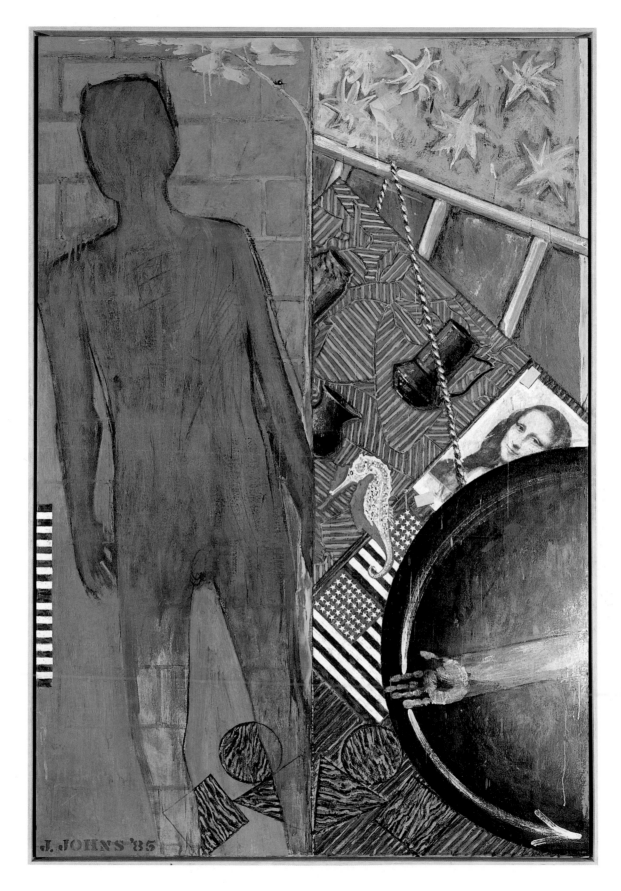

213. SUMMER. 1985.
Encaustic on canvas,
190.5 x 127 cm
(75 x 50″).
Collection Philip
Johnson

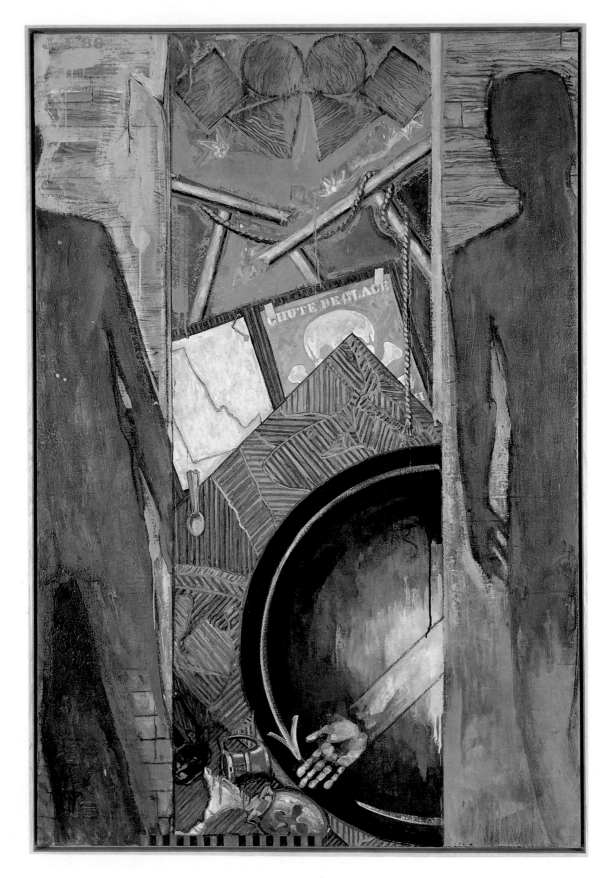

214. FALL. 1986.
Encaustic on canvas,
190.5 x 127 cm
(75 x 50″).
Collection the artist

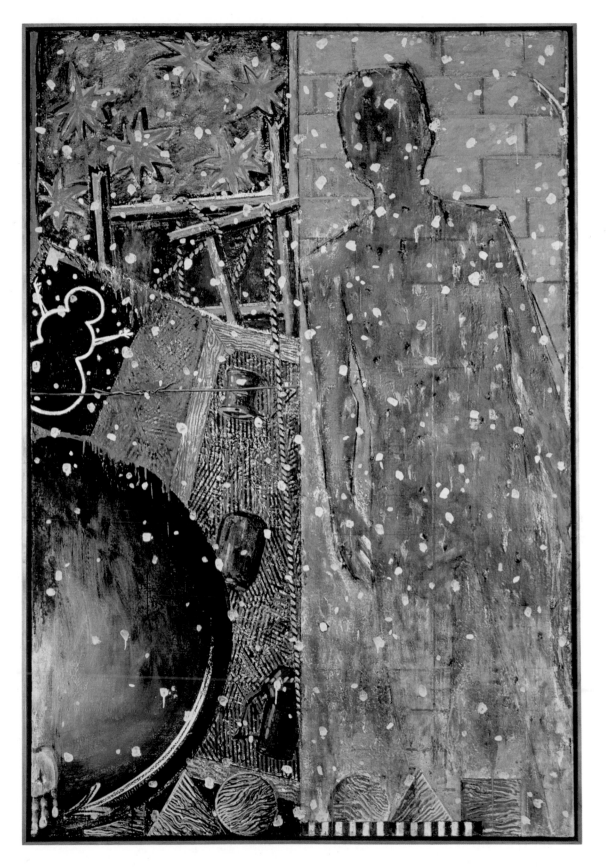

215. WINTER. 1986.
Encaustic on canvas,
190.5 x 127 cm
(75 x 50″).
Collection of Asher
B. Edelman

216. UNTITLED. 1986. Charcoal and chalk on paper,
75.6 x 106.7 cm (29¾ x 42″). Private collection, New York

217. UNTITLED. 1986. Watercolor and pencil on paper,
62.5 x 90.2 cm (24⅝ x 35½″). Collection the artist

218. UNTITLED. 1986. Charcoal on paper, 101.6 x 210.8 cm (40 x 83″). Collection Douglas S. Cramer

219. VENTRILOQUIST II. 1986. Lithograph, 104.8 x 73.7 cm
(41¼ x 29″). Courtesy Universal Limited Art Editions

220. Untitled. 1987. Encaustic and collage on canvas, 127 x 190.5 cm (50 x 75"). Collection Robert and Jane Meyerhoff, Phoenix, Maryland

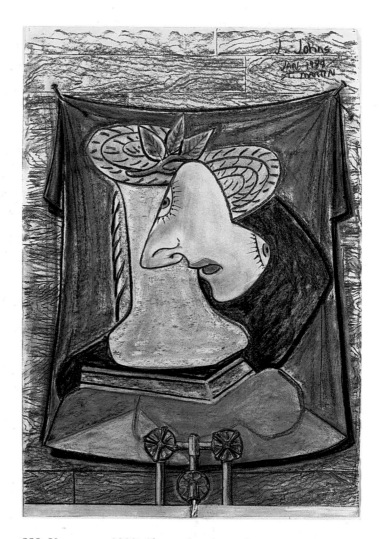

221. A SOUVENIR FOR ANDREW MONK. 1987. Pastel, charcoal, graphite, and collage on paper, 106.7 x 71.1 cm (42 x 28″). Collection Andrew Monk

222. UNTITLED. 1988. Charcoal and pastel on paper, 97.2 x 67.9 cm (38¼ x 26¾″). Collection the artist

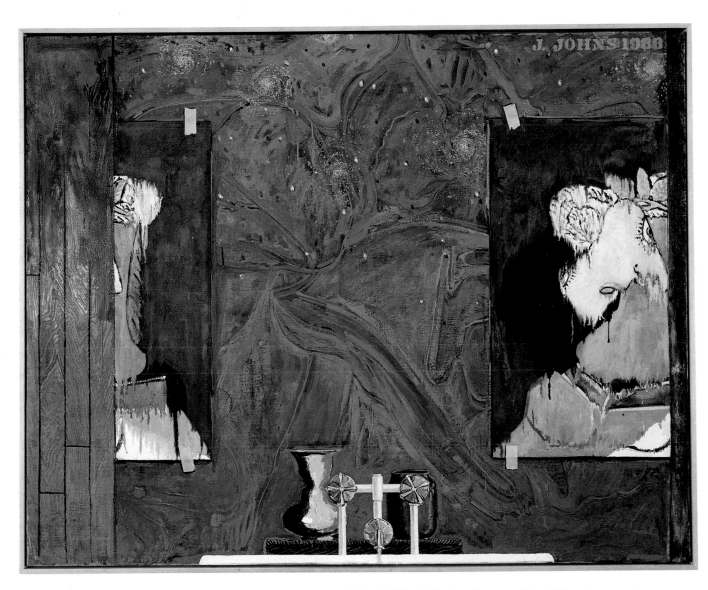

223. UNTITLED. 1988. Encaustic on canvas, 122.6 x 153 cm (48¼ x 60¼") Collection Anne and Joel Ehrenkranz

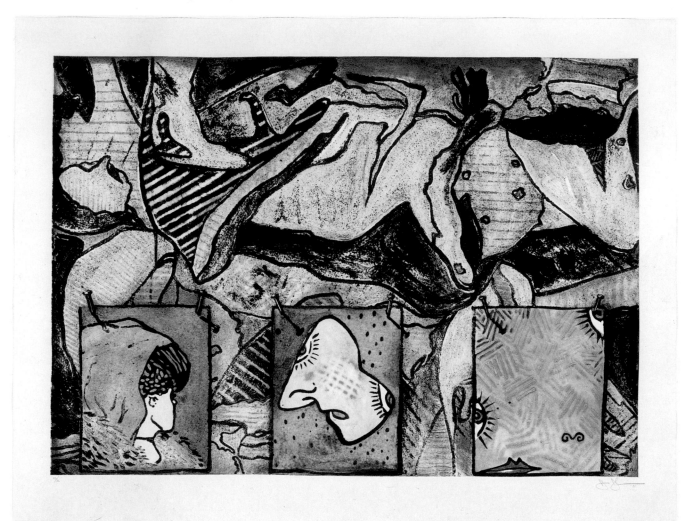

224. UNTITLED. 1988. Carborundum, 90.5 x 119.4 cm (35⅝ x 47″). Courtesy Universal Limited Art Editions

225. TRACING. 1989. Ink on plastic, 92.1 x 78.7 cm (36¼ x 31″).
Collection Anne and Anthony d'Offay, London

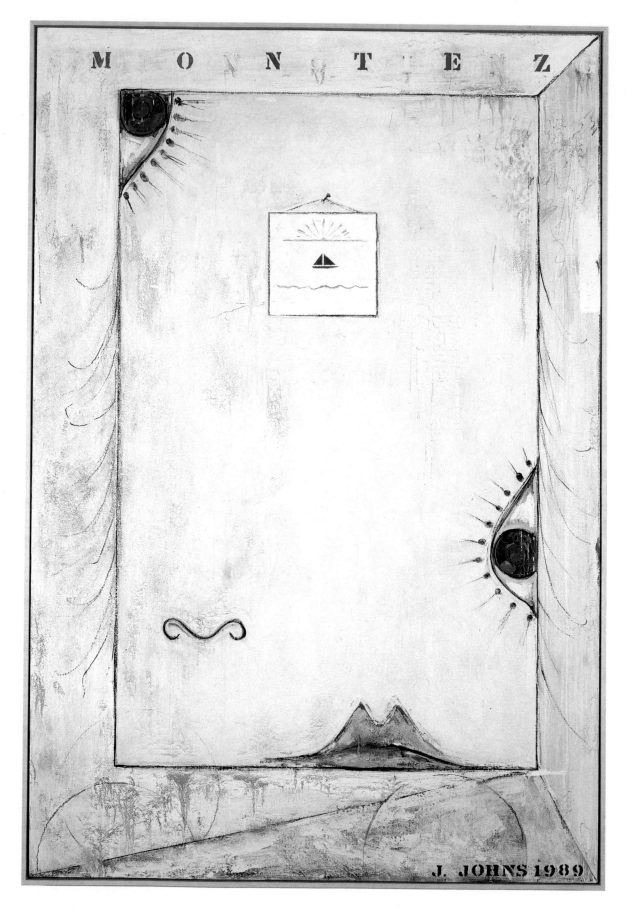

226. MONTEZ
SINGING. 1989.
Encaustic and
sand on canvas,
190.5 x 127 cm
(75 x 50″).
Collection Douglas
S. Cramer

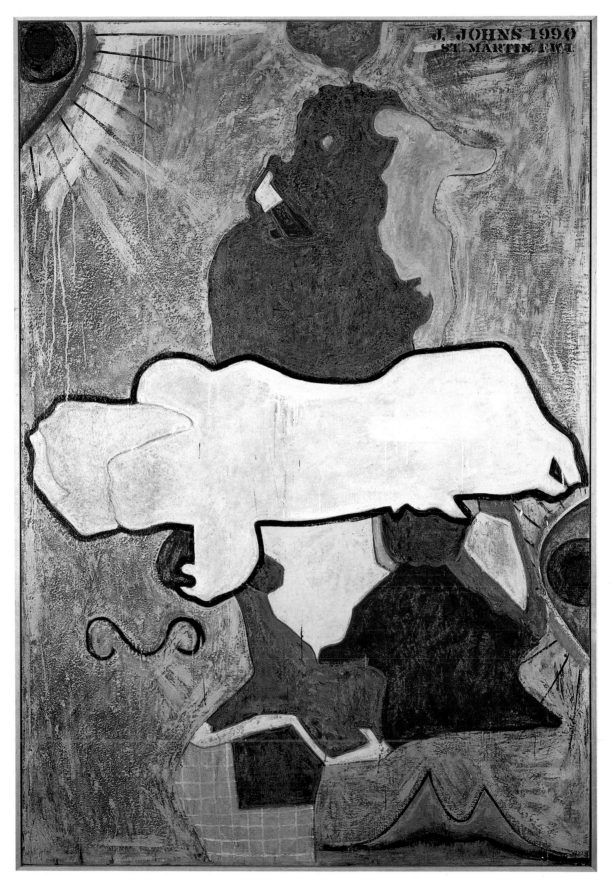

227. GREEN ANGEL. 1990. Encaustic and sand on canvas, 190.5 x 127 cm (75 x 50″). Collection Walker Art Center, Minneapolis. Gift of Judy and Ken Dayton, 1990

228. UNTITLED. 1990. Pastel and crayon on paper, 65.7 x 47 cm (25⅞ x 18½″). Courtesy Leo Castelli Gallery, New York

229. THE SEASONS. 1990. Intaglio, 127.6 x 113 cm (50¼ x 44½″). Courtesy Universal Limited Art Editions

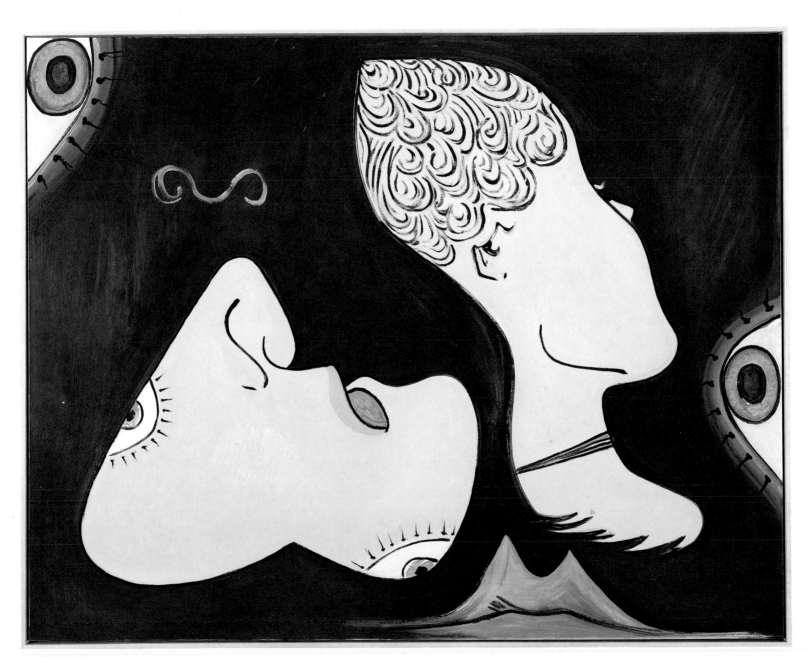

230. UNTITLED. 1991. Oil on canvas, 122.6 x 153 cm (48¼ x 60¼″). Collection Mr. and Mrs. S. I. Newhouse

231. GREEN ANGEL. 1991. Eight-color etching, 78.7 x 57.2 cm (31 x 22½″).
Courtesy Universal Limited Art Editions

Selected Bibliography

Alloway, Lawrence, "The Man Who Liked Cats: The Evolution of Jasper Johns," *Arts Magazine,* vol. 44, no. I, Sept.–Oct. 1969, pp. 40–43 (review of Max Kozloff, *Jasper Johns,* Abrams, New York, 1969).

———, "Jasper Johns and Robert Rauschenberg," *American Pop Art* (exhibition catalog), Collier Books and the Whitney Museum of American Art, New York, 1974, pp. 52–75.

Ashbery, John, "Brooms and Prisms," *Art News,* vol. 65, no. 1, Mar. 1966, pp. 58–59, 82–84.

Bernstein, Roberta (Introduction), and Robert Littman (Notes), *Jasper Johns' Decoy: The Print and the Painting* (exhibition catalog), The Emily Lowe Gallery, Hofstra University, Hempstead, N.Y., 1972, unpaginated.

———, "Johns and Beckett: Foirades/Fizzles," *The Print Collector's Newsletter,* vol. 7, no. 5, Nov.–Dec. 1976, pp. 141–45.

———, "Jasper Johns: Drawings 1954–1984," *The Print Collector's Newsletter,* vol. 16, May/June 1985, pp. 66–67.

———, "Jasper Johns's The Seasons: Record of Time," *Jasper Johns The Seasons* (exhibition catalog), Brooke Alexander Editions, New York, 1991.

Cage, John, "Jasper Johns: Stories and Ideas," *Jasper Johns* (exhibition catalog), The Jewish Museum, New York, 1964, pp. 21–26; reprinted in John Cage, *A Year from Monday: New Lectures and Writings,* Wesleyan University Press, Middletown, Conn., 1969, pp. 73–84.

Calas, Nicolas, and Elena Calas, "Jasper Johns: And/Or," *Icons and Images of the Sixties,* E. P. Dutton & Co., New York, 1971.

Castleman, Riva, *Jasper Johns Lithographs* (exhibition catalog), The Museum of Modern Art" New York, 1970.

———, *Jasper Johns: A Print Retrospective* (exhibition catalog), The Museum of Modern Art, New York, 1986.

Coplans, John, "Fragments According To Johns: An Interview with Jasper Johns," *The Print Collector's Newsletter,* vol. 3, no. 2, May–June 1972, pp. 29–32.

Cuno, James, "Voices and Mirrors/Echoes and Allusions, Jasper Johns's *Untitled,* 1972," in *Foirades/Fizzles: Echo and Allusion in the Art of Jasper Johns* (exhibition catalog), Wight Art Gallery, UCLA, Los Angeles, 1987, pp. 201–35.

Debs, Barbara Knowles, "On the Permanence of Change: Jasper Johns at the Modern," *The Print Collector's Newsletter,* vol. 17, no. 4, Sept.–Oct. 1986, pp. 117–23.

Field, Richard S., *Jasper Johns: Prints 1960–1970* (exhibition catalog), Philadelphia Museum of Art (in conjunction with Praeger, New York), 1970.

———, "Jasper Johns' Flags," *The Print Collector's Newsletter,* vol. 7, no. 3, July–Aug. 1976, pp. 69–77.

———, *Jasper Johns: Prints 1970–1977* (exhibition catalog), Wesleyan University, Middletown, Conn., 1978.

———, "The Making of Foirades/Fizzles," in *Foirades/Fizzles: Echo and Allusion in the Art of Jasper Johns* (exhibition catalog), Wight Art Gallery, UCLA, Los Angeles, 1987, pp. 99–127.

Francis, Richard, *Jasper Johns,* Abbeville, New York, 1984.

———, "Disclosures," *Art in America,* vol. 72, Sept. 1984, pp. 199–200.

———, "Introduction," in *Dancers On A Plane: Cage Cunningham Johns* (exhibition catalog), Anthony d'Offay Gallery, London, 1989, pp. 25–32.

Fried, Michael, "New York Letter," *Art International,* vol. 7, no. 2, Feb. 25, 1963, pp. 60–62.

Geelhaar, Christian, *Jasper Johns: Working Proofs* (exhibition catalog), Kunstmuseum Basel, Basel, 1979.

Geldzahler, Henry, "Numbers in Time: Two American Paintings," *The Metropolitan Museum of Art Bulletin,* vol. 23, no. 8, Apr. 1965, pp. 295–99.

Goldman, Judith, *Jasper Johns Prints: 1977–1981* (exhibition catalog), Thomas Segal Gallery, Boston, 1981.

Greenberg, Clement, "After Abstract Expressionism," *Art International,* vol. 6, no. 8, Oct. 25, 1962, pp. 24–32; revised and reprinted in Henry Geldzahler, *New York Painting and Sculpture: 1940–1970,* E. P. Dutton & Co., in association with The Metropolitan Museum of Art, New York, 1969, pp. 360–71.

Heller, Ben, "Jasper Johns," *School of New York: Some Younger Artists,* ed. B. H. Friedman, Grove Press, New York, 1959, pp. 30–35.

Hess, Thomas B., "On the Scent of Jasper Johns," *New York Magazine,* vol. 9, no. 6, Feb. 9, 1976, pp. 65–67.

Higginson, Peter, "Jasper's Non-Dilemma: A Wittgensteinian Approach," *New Lugano Review,* no. 10, 1976, pp. 53–60.

Hopkins, Henry, "Jasper Johns: Figures 0 to 9" (brochure) Gemini G.E.L., Los Angeles, 1968

Hopps, Walter, "An Interview with Jasper Johns," *Artforum* vol. 3, no. 6, Mar. 1965, pp. 32–36.

———, "Jasper Johns: Fragments—According To What," (brochure), Gemini G.E.L., Los Angeles, 1971.

Huber, Carlo, "Jasper Johns: Die Graphik," *Jasper Johns Graphik*, ed. Carlo Huber, Kornfeld und Klipstein, Bern, 1970.

Johns, Jasper [statement], *Sixteen Americans* (exhibition catalog), ed. Dorothy C. Miller, The Museum of Modern Art, New York, 1959, pp. 22–27; reprinted in Barbara Rose (ed.), *Readings in American Art Since 1900: A Documentary Survey*, Praeger, New York, 1968, pp. 165–66.

———, "Duchamp," *Scrap*, vol. 2, Dec. 23, 1960, p. 4 (review of *The Bride Stripped Bare By Her Bachelors, Even*, a typographic version by Richard Hamilton of Marcel Duchamp's *Green Box*, translated by George Heard Hamilton, *The Documents of Modern Art*, no. 14, Wittenborn, New York, 1960).

———, "Sketchbook Notes," *Art and Literature* (Lausanne), vol. 4, Spring 1965, pp. 185–92; reprinted in John Russell and Suzi Gablik, *Pop Art Redefined*, Thames and Hudson, London, 1969, pp. 84–85.

———, "Marcel Duchamp (1887–1968): An Appreciation," *Artforum*, vol. 7, no. 3 (Nov. 1968), p. 6; reprinted in Anne d'Harnoncourt and Kynaston McShine (eds.), Marcel Duchamp, The Museum of Modern Art, New York, 1973, pp. 203–4.

———, "Sketchbook Notes," *Juillard*, ed. [and publ.] Trevor Winkfield, Winter 1968–69, pp. 25–27.

———, "Sketchbook Notes," *Art Now: New York*, vol. I, no. 4, Apr. 1969.

———, "Thoughts on Duchamp," *Art in America*, vol. 57, no. 4, July–Aug. 1969, p. 31.

Johnson, Ellen H. "Jim Dine and Jasper Johns: Art about Art," *Art and Literature* (Lausanne), vol. 6, Autumn 1965, pp. 128–40; reprinted in Ellen H. Johnson, *Modern Art and the Object*, Harper and Row, New York, 1976, pp. 171–76.

Kaplan, Patricia, "On Jasper Johns' *According To What*," *Art Journal*, vol. 35, no. 3, Spring 1976, pp. 247–50.

Kozloff, Max, "Johns and Duchamp," *Art International*, vol. 3, no. 2, Mar. 1964, pp. 42–45.

———, *Jasper Johns*, Abrams, New York, 1969.

———, *Jasper Johns*, Abrams/Meridian Modern Artists, New York, 1974.

Krauss, Rosalind, "Jasper Johns," *Lugano Review II*, vol. 1, no. 2, 1965, pp. 84–114.

———, "Jasper Johns: The Functions of Irony," *October*, vol. 2, Summer 1976, pp. 91–99.

Masheck, Joseph, "Sit-in on Johns," *Studio International*, vol. 178, no. 916, pp. 193–95 (review of Max Kozloff, *Jasper Johns*, Abrams, New York, 1969).

———, "Jasper Johns Returns," *Art in America*, vol. 64, no. 2, Mar.–Apr. 1976, pp. 65–67.

Michelson, Annette, "The Imaginary Object: Recent Prints by Jasper Johns," *Artist's Proof*, vol. 8, 1968, pp. 44–49.

Perrone, Jeff, "Jasper Johns's New Paintings," *Artforum*, vol. 14, no. 8, Apr. 1976, pp. 48–51.

Porter, Fairfield, "The Education of Jasper Johns," *Art News*, vol. 62, no. 10, Feb. 1964, pp. 44, 61–62.

Raynor, Vivian, "Conversation with Jasper Johns," *Art News*, vol. 72, no. 3, Mar. 1973, pp. 20–22.

Rose, Barbara, "The Graphic Work of Jasper Johns: Part I," *Artforum*, vol. 8, no. 7, Mar. 1970, pp. 39–45.

———, "The Graphic Work of Jasper Johns: Part II," *Artforum*, vol. 8, no. 9, Sept. 1970, pp. 65–74.

———, "Decoys and Doubles: Jasper Johns and the Modernist Mind," *Arts Magazine*, vol. 50, no. 9, May 1976, pp. 68–73.

———, "To Know Jasper Johns," *Vogue*, vol. 167, Nov. 1977, pp. 280–85.

———, "Modern Classics: Johns and Balthus," *Vogue*, vol. 174, Feb. 1984, pp. 362–65, 417–18.

———, "Jasper Johns: The Seasons," *Vogue*, vol. 177, Jan. 1987, pp. 193–94, 199, 259–60.

Rosenberg, Harold, "'Jasper Johns: Things the Mind Already Knows," *Vogue*, vol. 143, no. 3, Feb. 1, 1964, pp. 175–77, 201–3; reprinted in Harold Rosenberg, *The Anxious Object: Art Today and Its Audience*, Collier Books, New York, 1973, pp. 176–84.

Rosenblum, Robert, "Jasper Johns," *Art International*, vol. 4, no. 7, Sept. 1960, pp. 74–77.

———, "Les Oeuvres Récentes de Jasper Johns," *XXe Siecle*, vol. 24, no. 18, Feb. 1962, supplement, unpaginated.

———, [Preface to Portfolio 0–9], Universal Limited Art Editions, West Islip, N.Y., 1963.

Rosenthal, Mark, *Jasper Johns Work Since 1974* (exhibition catalog), Philadelphia Museum of Art, Philadelphia, 1988.

———, "*Dancers on a Plane* and Other Strategems for Inclusion in the Work of Jasper Johns," in *Dancers On A Plane: Cage Cunningham Johns* (exhibition catalog), Anthony d'Offay Gallery, London, 1989, pp. 115–33.

Rosenthal, Nan, and Ruth Fine, *The Drawings of Jasper Johns* (exhibition catalog), National Gallery of Art, Washington, 1990.

Rubin, William, "Younger American Painters," *Art International*, vol. 4, no. 1, 1960, pp. 24–31.

Russell, John, "Jasper Johns and the Readymade Image," in *The Meanings of Modern Art*, vol. 11, The Museum of Modern Art, New York, 1975, pp. 15–23.

Shapiro, David, "Imago Mundi, *Art News*, vol. 70, no. 6, Oct. 1971, pp. 40–41, 66–68.

———, *Jasper Johns: Drawings 1954–1984*, Abrams, New York, 1984.

Solomon, Alan R., "Jasper Johns," *Jasper Johns* (exhibition catalog), The Jewish Museum, New York, 1964, pp. 5–19; reprinted in *Jasper Johns* (exhibition catalog), Whitechapel Gallery, London, 1964, pp. 4–25.

———, "Jasper Johns: Lead Reliefs" (brochure), Gemini G.E.L., Los Angeles, 1969.

Steinberg, Leo, "Contemporary Art and the Plight of Its Public," *Harper's Magazine,* vol. 224, no. 1342, Mar. 1962, pp. 31–39; reprinted in Leo Steinberg, *Other Criteria: Confrontations with Twentieth-Century Art,* Oxford University Press, New York, 1972.

———, "Jasper Johns," *Metro,* nos. 4/5, May 1962; enlarged and revised for Leo Steinberg, *Jasper Johns,* Wittenborn, New York, 1963; revised and expanded as "Jasper Johns: The First Seven Years of His Art," in Leo Steinberg, *Other Criteria: Confrontations with Twentieth-Century Art,* Oxford University Press, New York, 1972.

Swenson, G. R., "What is Pop Art? Part II [Interview with Jasper Johns, *i.a.*]," *Art News,* vol. 62, no. 10, Feb. 1964, pp. 40–43, 62–67; reprinted in John Russell and Suzi Gablik, *Pop Art Redefined,* Thames and Hudson, London, 1969, pp. 82–83.

Sylvester, David, "Interview," *Jasper Johns Drawings* (catalog of the exhibition organized by the Arts Council of Great Britain), London, 1974, pp. 7–19.

Taylor, Paul, "Jasper Johns," *Interview,* July 1990, p. 123.

Tillim, Sidney, "Ten Years of Jasper Johns," *Arts Magazine,* vol. 38, no. 7, Apr. 1964, pp. 22–26.

Yau, John, "Target Jasper Johns," *Artforum,* vol. 24 (Dec. 1985), pp. 80–84.

Index of Illustrated Works by Jasper Johns

Editor's note: Letters in parentheses following the title and date of each work indicate its medium: (d) = drawing; (p) = painting; (pr) = print; and (s) = sculpture. Included in the drawing category are ink drawings, watercolors, washes, and all works on paper or plastic; the painting category includes works incorporating collage or objects.

ACCORDING TO WHAT. 1964. (p), Plate 115; p. 51 left. *See also* FRAGMENT—ACCORDING TO WHAT—COAT HANGER AND SPOON

ALE CANS. 1964. (pr), Plate 122; p. 44 top; *See also* PAINTED BRONZE (Ale Cans); 1ST [FIRST] ETCHINGS

ALE CANS. 1978. (d), Plate 178

ALLEY OOP. 1958. (p), Plate 33; p. 35 bottom

ALPHABETS. 1957. (d), Plate 20

ALPHABETS, GRAY, *see* GRAY ALPHABETS

ANGEL, GREEN, *see* GREEN ANGEL

ARRIVE/DEPART. 1963–64. (p), Plate 114

A SOUVENIR FOR ANDREW MONK. 1987. (d), Plate 221

BARBER'S TREE, THE, *see* THE BARBER'S TREE

BETWEEN THE CLOCK AND THE BED. 1981. (d), p. 63, second from top

BETWEEN THE CLOCK AND THE BED. 1981. (p), Plate 188; p. 63, third from top

BETWEEN THE CLOCK AND THE BED. 1982. Plate 192

BOOK. 1957. (p), Plate 17; p. 91 middle

BLACK NUMBERS. 1958. (d), Plate 38

BREAD. 1969. (s) Plate 142

BROKEN TARGET. 1958. (d), Plate 37

BUTTOCKS. 1974. (pr), Plate 156

BY THE SEA. 1961. (p), Plate 79

CANVAS. 1956. (p), Plate 21; p. 91 top

CELINE. 1978. (p), Plate 176; p. 61 top right; detail: p. 100 bottom

CICADA. 1979. (d), Plate 179; p. 61 middle right; detail: p. 61 bottom right

COAT HANGER. 1958. (d), Plate 34; p. 45 above

COAT HANGER. 1959. (p), p. 45 below

COAT HANGER. 1960. (pr), Plate 71

CONSTRUCTION WITH TOY PIANO. 1954. (p), p. 29 below

CORPSE. 1974–75. (d), Plate 164

CORPSE AND MIRROR. 1974. (p), Plate 162; p. 58 above

CORPSE AND MIRROR II. 1974–75. (p), Plate 163; p. 95 below

CORPSE AND MIRROR. 1976. (pr), Plate 171

CRITIC SEES, THE, *see* THE CRITIC SEES

CRITIC SMILES, THE, *see* THE CRITIC SMILES

DANCERS ON A PLANE. 1979. (p), Plate 181; p. 62 top

DANCERS ON A PLANE. 1980. (p), Plate 183

DANCERS ON A PLANE. 1982. (d), Plate 189

DECOY. 1971. (p), Plate 146

DECOY. 1971. (pr), p. 57 above

DECOY II. 1971–73. (pr), Plate 145

DEVICE. 1961–62. (p), Plate 91; p. 94 middle

DEVICE. 1962. (pr), Plate 93

DEVICE CIRCLE. 1959. (p), Plate 46; p. 40 below

DEVICE CIRCLE. 1960. (d), Plate 58

DISAPPEARANCE II. 1961. (p), p. 91 bottom

DISAPPEARANCE II. 1962. (d), Plate 82

DIVER. 1962. (p), Plate 106; p. 19 below

DIVER. 1963. (d), Plate 103

DRAWER. 1957. (p), Plate 14; pp. 34 bottom, 83 bottom

DUTCH WIVES, THE, *see* THE DUTCH WIVES

EDDINGSVILLE. 1965. (p), Plate 120; pp. 52 top, 95 above

END PAPER. 1976. (p), Plate 172

ENGLISH LIGHT BULB. 1968–70. (s), Plate 140

EVIAN. 1964. (p), p. 50 below

EVIAN. 1968. (d), Plate 134

FACE. 1974. (pr), Plate 154

FALL. 1986. (p), Plate 214; p. 69 middle. *See also* STUDY FOR FALL

FALSE START. 1959. (p), Plate 51; p. 38 below; details: pp. 14 below, 39 below

FALSE START I. 1962. (pr), Plate 94

FALSE START II. 1962. (pr), Plate 95

FEET. 1974. (pr), Plate 158

FIELD PAINTING. 1963–64. (p), Plate 111; p. 93 middle; detail: p. 93 bottom

FIGURE 0 from 0–9. 1960–63. (pr), p. 43 below right

FIGURE 1. 1955. (p), Plate 3

FIGURE 2. 1956. (p), Plate 6

FIGURE 5. 1955. (p), Plate 4, p. 37 below

FIGURE 7. 1955. (p), Plate 5; p. 32 bottom

FIGURES, *see also* 1ST [FIRST] ETCHINGS, NUMBERS IN COLOR, TEN NUMBERS, 0–9, 0 THROUGH 9

FIGURES IN COLOR. 1969. (pr), Plate 139

1ST [FIRST] ETCHINGS. 1967–68. (pr), Plate 135

5 [FIVE], *see* FIGURE 5

FLAG. 1955. (p), Plate 1; pp. 31 top left, 94 bottom

FLAG. 1957. (d), Plate 19
FLAG. 1960. (p), Plate 49
FLAG. 1960. (s), Plate 50
FLAG I. 1960 (pr), Plate 70
FLAG ABOVE WHITE. 1955. (p), p. 33 top
FLAG ABOVE WHITE WITH COLLAGE. 1955. (p), Plate 2
FLAG ON ORANGE FIELD. 1957. (p), Plate 22; p. 35 top
FLAG, WHITE, see WHITE FLAG
FLAG (WITH 64 STARS). 1955. (d), Plate 9
FLAG, see also 1ST [FIRST] ETCHINGS
FLAGS. 1965. (p), Plate 130
FLAGS, THREE, see THREE FLAGS
FLAGS, THREE, Sketch for, see Sketch for THREE FLAGS
FLAGS, TWO, see TWO FLAGS
FLASHLIGHT I. 1958. (s), Plate 30, p. 42 top
FLASHLIGHT II. 1958. (s), Plate 31
FLASHLIGHT III. 1958. (s), Plate 32
FLASHLIGHT, see also 1ST [FIRST] ETCHINGS
FLORAL DESIGN. 1961. (d), p. 34 middle
FOLLY BEACH. 1962. (d), Plate 83
FOOL'S HOUSE. 1962. (p), Plate 98
FOUR PANELS from UNTITLED 1972. 1975. (pr), Plate 169
FRAGMENT—ACCORDING TO WHAT—COAT HANGER AND SPOON. 1971. (pr), p. 13 below; detail: p. 14 above

GOOD TIME CHARLEY. 1961. (p), Plate 85
GRAY ALPHABETS. 1956. (p), Plate 18
GRAY ALPHABETS. 1960. (d), Plate 53
GRAY ALPHABETS. 1968. (pr), p. 16 above
GRAY NUMBERS. 1958. (p), Plate 25
GRAY RECTANGLES. 1957. (p), Plate 36
GREEN ANGEL. 1989. (p), p. 72 above
GREEN ANGEL. 1990. (p), Plate 227
GREEN ANGEL. 1991. (pr), Plate 231
GREEN TARGET. 1955. (p), Plate 12; p. 36 bottom

HANDPRINT. 1964. (d), p. 13 above
HANDFOOTSOCKFLOOR. 1974. (pr), Plate 155
HARLEM LIGHT. 1967. (p), Plate 129; p. 53
HATTERAS. 1963. (pr), Plate 109
HIGH SCHOOL DAYS. 1964. (s), Plate 112
HIGH SCHOOL DAYS. 1969. (s), Plate 141

HIGHWAY. 1959. (p), Plate 66; p. 17 above
HOOK. 1958. (d), Plate 35

IN MEMORY OF MY FEELINGS—FRANK O'HARA. 1961. (p), Plate 84
IN THE STUDIO. 1982. Plate 190; p. 63 bottom; detail: p. 64 top

JUBILEE. 1959. (p), Plate 52; p. 39 above
JUBILEE. 1960. (d), Plate 59

KNEE. 1974. (pr), Plate 160

LAND'S END. 1963. (p), Plate 100; detail: p. 85 above left
LEG. 1974. (pr), Plate 159
LIAR. 1961. (p), Plate 81
LIGHT BULB. 1958. (d), Plate 29, p. 100 top
LIGHT BULB. 1960. (s), Plate 45
LIGHT BULB. 1960. (s), Plate 47
LIGHT BULB I. 1958. (s), Plate 27
LIGHT BULB II. 1958. (s), Plate 28

MAP. 1960. (p), p. 44 middle
MAP. 1961. (p), Plate 74; pp. 17 below, 44 bottom, 92 above
MAP. 1962. (p), p. 84
MAP. 1963. (p), Plate 107
MAP (based on Buckminster Fuller's Dymaxion Airocean World). 1967–71. (p), p. 55
MIRROR'S EDGE. 1992. (p), p. 74
MONTEZ SINGING. 1989. (p), Plate 226; p. 71 below right

NEWS, THE, see THE NEWS
NEWSPAPER. 1957 (p), Plate 16
NO. 1961. (p), Plate 80; p. 47 top
NUMBERS IN COLOR. 1958–59. (p), Plate 26; p. 89 above

OUT THE WINDOW. 1959. (p), Plate 56; p. 47 middle
OUT THE WINDOW. 1960. (d), Plate 60

OUT THE WINDOW NUMBER 2. 1962. (p), Plate 102; p. 47 bottom

PAINTED BRONZE. 1960. (ale cans) (s), Plate 67; pp. 42 middle, 86 second from top
PAINTED BRONZE. 1960. (Savarin can with brushes) (s), Plate 68; p. 42 bottom
PAINTING WITH RULER AND "GRAY." 1960. (p), Plate 73
PAINTING WITH TWO BALLS. 1960. (d), Plate 61
PAINTING WITH TWO BALLS. 1960. (p), Plate 63; p. 46 top
PAINTING WITH TWO BALLS I. 1962. (pr), Plate 92
PASSAGE. 1962. (p), Plate 99, p. 96 top left
PASSAGE II, 1966. (p), Plate 124
PERILOUS NIGHT. 1982. (p), Plate 191; pp. 64 second from top, 96 middle right
PERISCOPE (HART CRANE). 1963. (p), Plate 105; p. 48 below; detail: p. 94 top
PERISCOPE I. 1979. (pr), Plate 182
PINION. 1963–66. (pr), Plate 121

RACING THOUGHTS. 1983. (p), Plate 199; pp. 66 right, 97

SAVARIN. 1977. (d), Plate 173
SAVARIN. 1977–81. (pr), Plate 175
SCENT. 1973–74. (p), Plate 161; pp. 59 left, 86 bottom
SCENT. 1975–76. (pr), Plate 170
SCREEN PIECE. 1967. (p), Plate 131; p. 54 bottom
SCREEN PIECE 2. 1968. (p), Plate 132
SEASONS, THE, see THE SEASONS
SEASONS (SUMMER), THE, see THE SEASONS (SUMMER)
SHADE. 1959. (p), Plate 42
SKETCH FOR CUPS 2 PICASSO. 1971. (d), p. 67 middle right
SKETCH FOR THREE FLAGS. 1958. (d), p. 36 top
SKIN I. 1973. (d), Plate 149
SKIN II. 1973. (d), Plate 150
SKIN WITH O'HARA POEM. 1963–65. (pr), Plate 110

SLOW FIELD. 1962. (p), Plate 104; p. 93 top

SOUVENIR. 1964. (p), Plate 116; p. 49 above

SOUVENIR 2. 1964. (p), Plate 117

SOUVENIR FOR ANDREW MONK, A, see A SOUVENIR FOR ANDREW MONK

SPRING. 1986. (p), Plate 212; p. 69 bottom

STAR. 1954. (p), p. 30 below

STUDIO. 1964. (p), Plate 119; p. 52 middle

STUDIO 2. 1966. (p), Plate 128; p. 52 bottom

STUDY FOR FALL. 1986. (d), p. 98 bottom

STUDY FOR SKIN I. 1962. (d), Plate 86

STUDY FOR SKIN II. 1962. (d), Plate 87

STUDY FOR SKIN III. 1962. (d), Plate 88

STUDY FOR SKIN IV. 1962. (d), Plate 89

SUBWAY. 1965. (s), Plate 113

SUMMER. 1985. (d), Plate 210

SUMMER. 1985. (p), Plate 213; p. 68

TANGO. 1955. (p), Plate 13; detail: p. 32 top

TANTRIC DETAIL. 1980. (d), p. 62 bottom

TANTRIC DETAIL I. 1980. (p), Plate 185

TANTRIC DETAIL II. 1981. (p), Plate 186

TANTRIC DETAIL III. 1981. (p), Plate 187

TARGET. 1955 (d), Plate 11

TARGET. 1958 (p), Plate 23

TARGET. 1960. (d), pp. 31 middle right, 83 top

TARGET. 1960. (pr), Plate 69; p. 43 above right

TARGET. 1974. (p), Plate 153

TARGET WITH FOUR FACES. 1955. (p), pp. 31 bottom right, 83 middle, 90

TARGET WITH FOUR FACES. 1955. (d), Plate 10

TARGET WITH PLASTER CASTS. 1955. (p), Plate 7; p. 31 top right

TARGETS. 1967–68. (pr), Plate 133

TEN NUMBERS. 1960. (d), Plate 55

TENNYSON. 1958. (p), Plate 41

TENNYSON. 1958. (d), Plate 48; p. 18

THE. 1957. (p), Plate 15

THE BARBER'S TREE. 1975. (p), Plate 166; p. 59 above right

THE CRITIC SEES. 1961. (s), Plate 90; angled view: p. 46 bottom

THE CRITIC SEES. 1962. (d), p. 46 third from top

THE CRITIC SEES II. 1964. (s), p. 46 second from top

THE CRITIC SMILES. 1959. (s), Plate 62; p. 41 above

THE CRITIC SMILES. 1969. (s), Plate 143

THE DUTCH WIVES. 1975. (p), Plate 167; pp. 60 top, 88 below left, 96 middle

THE NEWS. 1962. (p), Plate 97

THE SEASONS (SUMMER). 1987. (pr), p. 98 middle

THE SEASONS. 1990. (pr), Plate 229

THERMOMETER. 1960. (d), Plate 64

THREE FLAGS. 1958. (p), Plate 40; pp. 19 above, 36 middle. See also Sketch for THREE FLAGS

THREE FLAGS. 1959. (d), Plate 43

THREE FLAGS. 1960. (d), Plate 44

TORSO. 1974. (pr), Plate 157

TRACING (after The Bride). 1978. (d), p. 65 middle

TRACING (after Cézanne). 1977. (d), p. 65 top

TRACING. 1989. (d), p. 73 middle

TRACING. 1989. (d), Plate 225

TWO FLAGS. 1960. (d), Plate 54; p. 88 below middle

TWO FLAGS. 1973. (p), Plate 152

TWO FLAGS. 1980. (d), Plate 184; p. 88 below right

TWO MAPS I. 1965–66. (pr), Plate 123

TWO MAPS II. 1966. (pr), p. 16 below

UNTITLED. c. 1954. (p), p. 29 above

UNTITLED. c. 1954. (p), p. 30 above

UNTITLED. 1963. (d), Plate 108

UNTITLED. 1964–65. (p), Plate 125

UNTITLED. 1972. (p), Plate 148; p. 57 below

UNTITLED. 1973. (d), Plate 151

UNTITLED. 1974–75. (d), Plate 165

UNTITLED. 1977. (s), Plate 174

UNTITLED. 1978. (d), Plate 177

UNTITLED. 1983. (p), Plate 198; p. 65 bottom

UNTITLED. 1983. (d), Plate 200

UNTITLED. 1983. (pr), Plate 201

UNTITLED. 1983–84. (d), p. 99 middle

UNTITLED. 1983–84. (d), Plate 202

UNTITLED. 1983–84. (d), Plate 203

UNTITLED. 1984. (p), Plate 204; p. 67 bottom right

UNTITLED. 1984. (p), Plate 205

UNTITLED. 1984. (p), Plate 206; p. 67 left

UNTITLED. 1984. (d), Plate 208

UNTITLED. 1984. (d), p. 70 left

UNTITLED. 1986. (d), Plate 216

UNTITLED. 1986. (d), Plate 217; p. 98 top

UNTITLED. 1986. (d), Plate 218

UNTITLED. 1987. (p), p. 71 left

UNTITLED. 1987. (p), Plate 220

UNTITLED. 1988. (d), Plate 222

UNTITLED. 1988. (p), Plate 223

UNTITLED. 1988. (pr), Plate 224

UNTITLED. 1989. (d), p. 73 bottom

UNTITLED. 1990. (p), p. 70 middle

UNTITLED. 1990. (p), p. 72 below

UNTITLED. 1990. (d), Plate 228

UNTITLED. 1991. (p), pp. 70 right, 99 bottom

UNTITLED. 1991. (p), Plate 230

UNTITLED (A DREAM). 1985. (p), Plate 209

UNTITLED (BLUE). 1982. (pr), Plate 196

UNTITLED (RED). 1982. (pr), Plate 194

UNTITLED (YELLOW). 1982. (pr), Plate 195

USUYUKI. 1977–78. (p), p. 60 middle

USUYUKI. 1979. (d), p. 60 bottom

USUYUKI (study for screenprint). 1979. (d), Plate 180

USUYUKI (study for poster for Merce Cunningham Dance Company). 1981. (d), p. 61 left

VENTRILOQUIST. 1983. (p), Plate 197; pp. 66 above left, 99 top

VENTRILOQUIST. 1984. (d), Plate 207

VENTRILOQUIST II. 1986. (pr), Plate 219

VOICE. 1964–67. (p), p. 54 top

VOICE. 1966–67. (pr), p. 54 middle

VOICE 2. 1971. (p), Plate 147; p. 56

VOICE 2. 1982. (d), Plate 193

WALL PIECE. 1968. (p), Plate 136

WALL PIECE. 1969. (d), Plate 137

WALL PIECE. 1969. (d), Plate 138

WATCHMAN. 1964. (p), Plate 118; p. 49 below

WATCHMAN. 1966. (d), Plate 126

WATCHMAN. 1967. (pr), Plate 127

WEEPING WOMEN. 1975. (p), Plate 168; p. 96 middle left

WHITE FLAG. 1955. (p), Plate 8

WHITE NUMBERS. 1958. (p), Plate 24
WHITE TARGET. 1957. (p), p. 21
WINTER. 1986. (p), Plate 215; p. 69 top
WINTER. 1986. (d), Plate 211
WINTER. 1986. (d), p. 100 second from top

0 [ZERO], *see* FIGURE 0; *see also* 0–9,
 0 THROUGH 9

0 THROUGH 9. 1960. (p), Plate 57
0 THROUGH 9. 1960. (d), Plate 65
0 THROUGH 9. 1960. (pr), Plate 72
0 THROUGH 9. 1961. (d), p. 89 below
0 THROUGH 9. 1961. (p), Plate 75
0 THROUGH 9. 1961. (p), Plate 76
0 THROUGH 9. 1961. (p), Plate 77
0 THROUGH 9. 1961. (p), Plate 78

0–9. 1959. (p), Plate 39
0–9. 1960–63. (pr), Plate 96
ZONE. 1962. (p), Plate 101; pp. 48
 above, 92 below
ZONE. 1969. (d), Plate 144

Photograph Credits

The author and publisher wish to thank the owners and custodians for permitting the reproduction of the works of art in their collections. Photographs have been supplied by the following, whose courtesy is gratefully acknowledged: Leo Castelli Gallery, New York; Gemini G.E.L., Los Angeles; Jasper Johns Studio; Universal Limited Art Editions, West Islip, N.Y.; as well as by the photographers and photographic services listed below. Alinari—Art Reference Bureau (Florence): page 50 above. Allison, David: Plate 12. Burckhardt, Rudolph: Plates 4, 14, 15, 16, 17, 23, 24, 27, 29, 30, 34, 35, 37, 42, 43, 44, 47, 48, 49, 50, 53, 54, 58, 59, 60, 61, 66, 76, 77, 78, 81, 96, 99, 100, 103, 113, 123, 126, 127, 130, 131, 132, 134, 136, 137; pages 16 below; 17 above and below; 18; 29 below; 31 top left, top right, and middle right; 32 top left; 33 top; 34 middle and bottom; 35 bottom; 37 below; 38 below; 41 above; 42 top and bottom; 44 middle; 45 middle; 46 second from top; 47 middle and bottom; 50 below; 51 left; 52 middle, bottom; 53; 54 bottom; 83 bottom; 84; 86 top; 88 bottom middle; 93 top and middle; 94 middle; 96 top left; 100 top. Clements, Geoffrey: Plate 119; pages 21; 37 above. Cornachio, Ed: Plates 139B, 139E, 139G, 139J. Darmstaedter, Frank: page 36 bottom. Davies, Bevan: pages 60 middle and bottom; 61 top right; 62 top; 88 bottom right. Hinz (Basel): Plate 67. Jones, Bruce C.: Plates 20, 39, 153. Katz, Michael: page 89 above. Lubliner, Malcolm: Plates 139A, 139H, 141, 142, 143, 157, 159; page 13 above. McDarrah, Fred W.: page 40 above. Mates, Robert, and Mary Donlon: Plate 172. Namuth, Hans: page 24. Pollitzer, Eric: Plates 2, 6, 10, 11, 28, 31, 45, 62, 64, 68, 82, 83, 84, 85, 90, 97, 98, 108, 112, 116, 117, 120, 124, 139, 140, 144, 146, 149, 150, 151, 152, 161, 163, 164, 166, 167, 171, 173; pages 42 middle; 54 top; 56; 57 below; 58 above; 59 above; 86 bottom; 96 middle left; 46 second from bottom. Rule, Lloyd W.: Plate 25. Shunk, Harry: Plate 9. Shunk-Kender: Plates 19, 55 A–J, 65, 86, 87, 88, 89; pages 13 above; 36 top. The Solomon R. Guggenheim Museum: page 63 top. Sonnabend Gallery (New York): Plate 3. Glenn Steigelman Inc.: Plate 192; pages 61 left; 63 bottom and third from top. Strong, Jim: pages 46 third from top; 59 left; 65 middle; 70 left; 72 above; 73 middle; 95 below. Szaszfai, Joseph: page 85 bottom right. Thomas, Frank J.: pages 30 above; 86 second from top. Thompson, Jann and John: Plate 5; page 32 bottom. Varon, Malcolm: Plate 74. Dorothy Zeidman/photography: Plates 177, 178, 200, 203, 210, 211, 221, 222; pages 46 bottom; 61 middle and bottom; 62 middle and bottom; 63 third from top; 65 bottom; 67 top right, middle right, and bottom right; 68; 69 top, middle, and bottom; 70 middle; 71 left and below right; 73 bottom; 74; 98 top and bottom; 99 middle and bottom; 100 middle. Zeidman/Fremont: pages 73 top; 91 top.